GUSTAVE CAILLEBOTTE

Yale University Press · New Haven and London 1987

Kirk Varnedoe

GUSTAVE
CAILLEBOTTE

Typeset in Monophoto Bembo by
Tameside Filmsetting Ltd, Ashton-under-Lyne
and printed in Italy by
Amilcare Pizzi S.p.A., Milan

Library of Congress Catalog Card Number 87-50644
ISBN 0-300-03722-8

Photographic Acknowledgments

Ch. 2, Fig. 2: Photo Bulloz, Paris; Ch. 3, Figs. 14 and 16: Courtesy of Lunn Gallery/Graphics International Ltd., Washington, D.C.; Pls. 5 and 53: Sotheby's, New York; Pl. 7: Photograph by Michael Cavanagh and Kevin Montague; Pls. 8, 29, 51, 54 and 62: Service Photographique de la Réunion des Musées Nationaux © S.P.A.D.E.M.; Pls. 8b, 14b and 18b: Photo Bulloz, Paris; Pl. 14: With the special authorisation of the town of Bayeux; Pl. 18: Courtesy of the Art Institute of Chicago, © 1987 All Rights Reserved; Pl. 18v: Studio Lourmel, Paris; Pl. 31: Photo Claude O'Sughrue; Pl. 38a: Photograph © Copyright 1987 by The Barnes Foundation; Pl. 38b: Photo courtesy of Theodore Reff; Pl. 39: Photograph by Lauros-Giraudon; Pl. 45e: Photo A. J. Wyatt, Philadelphia Museum of Art; Pl. 52: Photo Brenda Derenuik, Art Gallery of Ontario; Pl. 59: Photo Routhier, Studio Lourmel; App. B, Figs 1–9, 11–14: Service Photographique de la Réunion des Musées Nationaux © S.P.A.D.E.M.; App. B, Fig. 10: Photograph © Copyright 1987 by The Barnes Foundation.

Special thanks are due to Philippe Brame and Bernard Lorenceau, Paris, for their kind help in obtaining the following: Pls. 1, 2, 3, 6, 9, 11, 12, 13, 17, 19, 20, 21, 27, 34, 35, 38, 40, 41, 43, 46, 47, 57 and 61 (all photography by Studio Lourmel, Paris).

PREFACE

In 1976 the Houston Museum of Fine Arts, supported by funding from the National Endowment for the Arts, and guided by their then curator, Thomas P. Lee, sponsored *Gustave Caillebotte: A Retrospective Exhibition*. Invited as a guest curator in that project, I contributed essays and notes on paintings to the catalogue of the same title. This catalogue, which also included contributions by Lee and other authors, was published in relatively small numbers, and has long been out of print and hard to find. With the rise in interest in Caillebotte that attended the presentation of several of his major works in Charles Moffett's 1986 exhibition in Washington and San Francisco, *The New Painting: Impressionism 1874–1886*, the lack of a generally accessible monograph on Caillebotte has been evident. Yale University Press thus proposed to me that a new version of the 1976 Houston catalogue be published. The present volume results from that suggestion.

In the decade since the Houston catalogue was published, one major, long-awaited milestone in the Caillebotte literature has appeared, Mlle. Marie Berhaut's *Caillebotte, sa vie et son oeuvre* (Paris, 1978). The existence of Mlle. Berhaut's catalogue raisonné obviates the need for some of the apparatus of the 1976 catalogue, such as the exhibition and provenance history of each work. In reconsidering the original catalogue, I have also taken advantage of freedom from the constraints of an exhibition, by adding pictures that were not available for loan in 1976, and by deleting or moving to a secondary, correlative status others deemed less important. Essentially, however, the skeleton of the present volume is that of the 1976 catalogue, and the majority of the elements are as they were. Errors found in the earlier work have been corrected, and the material updated, with a newly written biography and the addition of a treatment of recent research on Caillebotte's bequest. I have also rewritten several of the commentaries on individual paintings, either in whole or in part, updating where necessary to respond to research published in recent years.

I would like to thank Thomas P. Lee for the wonderul opportunity he gave me in 1976; I will forever be in his debt. Thanks also to the others who worked on the 1976 project: William Agee, then Director of the Houston Museum of Fine Arts; Michael Botwinick, then Director of the Brooklyn Museum; Sarah Faunce, Curator of European Painting at the Brooklyn Museum; and Hilarie Faberman. I am especially grateful to Peter Galassi, now Curator of Photography at the Museum of Modern Art, New York, for agreeing to revise his essay on Caillebotte's working procedures for the present volume. To Mlle. Marie Berhaut, a very special acknowledgement of appreciation and indebtedness both for her lifelong dedication to Caillebotte research and also for the generous cooperation she showed me in my own work. Among those on whom I was obliged to call yet again for help in revising this publication, I would like to acknowledge the valuable help of: Wildenstein & Co., through the good graces of Mr. Harry Brook; Philippe Brame and Bernard Lorenceau of the Brame and Lorenceau Gallery, Paris; Mrs. Walter Feichenfeldt; Charles Moffett and Ruth Berson; François Daulte; and Theodore Reff. My gratitude, too, to Susan Forster of the Institute of Fine Arts, New York University, for her demanding labors in this project.

My final expression of thanks is reserved for the descendants of Martial Caillebotte. The kindness they showed to me during and after the period of preparation for the 1976 exhibition constitutes one of my warmest memories of the time I was privileged to spend in France. Their generosity, hospitality, and friendship are things I will always treasure. I would like to dedicate this new volume to the memory of the remarkable, wonderful lady who was at the center of that kindness, Mme. Albert Chardeau, *née* Geneviève Caillebotte, the daughter of Martial Caillebotte and the niece of the painter.

Kirk Varnedoe
New York, 1987

CONTENTS

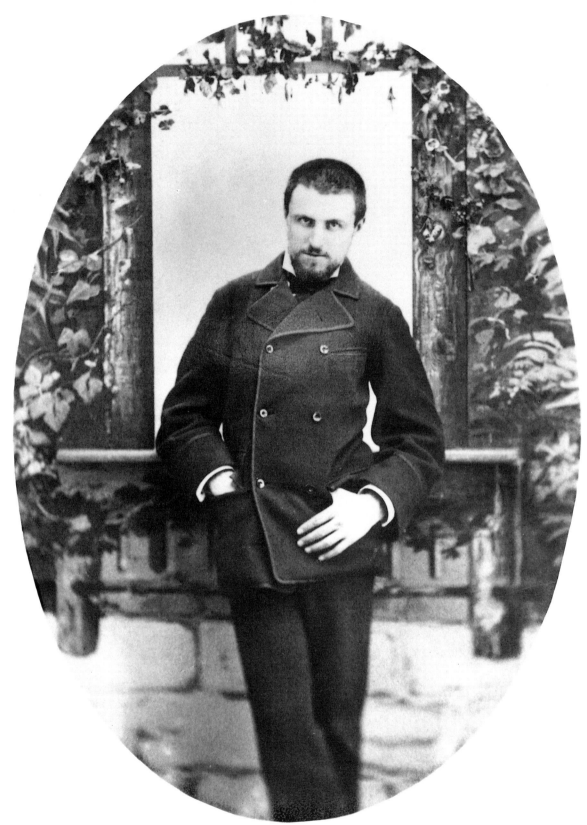

Fig. 1. Gustave Caillebotte, c. 1874–75(?).

1 Biography

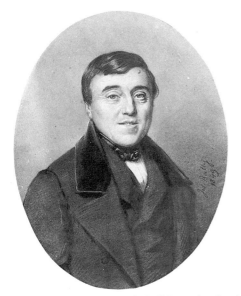

Fig. 2. Jul. Bailly. *M. Martial Caillebotte, the Artist's Father*, 1849. Pastel.

Fig. 3. Jul. Bailly, *Céleste Caillebotte, the Artist's Mother*, 1849. Pastel.

Gustave Caillebotte was Impressionism's anomaly, in his life as well as his art. He was fourteen years younger than his initial stylistic model Degas, and when his eventual close friends Monet and Renoir first began plotting an independent exhibition society in 1867, he was still a teenager working on a bachelor's degree in law. He was also rich: not comfortably getting along like Manet, or living amid the ruins of family wealth like Degas, but deeply and continually wealthy.[1] Caillebotte was assured by a vast inheritance not only of total independence (he could paint without worrying for a moment about sales) but also of the prerogative of liberal generosity toward his friends. These things that set him apart from the other Impressionists—his edge of youthful energy and his reservoir of financial means—were the attributes that helped make him a crucial member of the group in the years of their first exhibitions.

His life, charmed in some ways, was also marked by disappointments, and by a premature end. It unfolded in three main phases: a fairly conventional upbringing and education, through his early twenties; eight years of personal artistic ambition and intense engagement with the Impressionist cause; and a final dozen years marked by a retreat from urban involvements, and increased devotion to yachting and gardening. When death came in 1894, at the age of 45, Caillebotte had been so long out of the public eye that his artistic prominence in the avant-garde of the 1870s had been largely forgotten by all but a few.

Caillebotte was born on 19 August 1848 in a relatively old and popular quarter of Paris, on the rue Faubourg St.-Denis. His mother, Céleste (*née* Daufresne), was 29 when she gave birth to this, her first son in her first marriage; while his father Martial was 49, and twice a widow, with one son.[2] The parental family had long been established in the textile business in the Norman town of Domfront, and it was apparently to expand this trade that Martial came to the capital. Already by 1850, he had moved down the street to a large and impressive building with a garden, bought to house both the growing family (a second son, René, was born in that year, and a third, Martial, would arrive three years later) and the business, which supplied bedding to the French army.[3]

Louis Napoleon's spending on the military doubtless increased the Caillebotte fortune, and Martial *père* (who became a judge on the Commercial Tribunal of the Seine) also purchased a large block of Parisian real estate.[4] The painter grew up in ample comfort, and, just as he turned 18, his father crowned the family's ascent through the society of the Second Empire by building a luxurious townhouse just off the newly extended Boulevard des Malesherbes, in a zone of upper-class residential habitations created by the last great thrust of the Emperor's and Baron Haussmann's rearrangement of the city.[5] At the corner of the rue de Miromesnil and the rue de Lisbonne, the house was a short walk from the Place de l'Europe, newly suspended over the railyard of the expanded Gare St.-Lazare by an extraordinary metal bridge; and beyond the tracks lay the just-developing residential district, the "Quartier de l'Europe". This well-appointed home eventually provided the locale for Caillebotte's first studio, and, with the dramatic new public spaces nearby, the subjects for his first and most personal

paintings (e.g., *Jeune homme à sa fenêtre*, Pl. 10; *Le pont de l'Europe*, Pl. 15; *Rue de Paris: Temps de pluie*, Pl. 18).

There are no indications of early artistic interests on the part of Caillebotte or of an orientation toward art in his family. Marie Berhaut has found evidence of his excellence in literary matters at the Lycée Louis-le-Grand from the ages of 9 to 14; and his law studies brought him the *bachelier* at 21, in 1869.[6] He was briefly in the army, then purchased a replacement to serve while he pursued an advanced law degree.[7] Just days before the *licencié* was conferred, however, in June of 1870, Louis Napoleon declared war on Prussia. With this fatefully ill-advised step, the rapid downfall of the Second Empire ensued, and the nation entered into a year of calamity that marked a watershed in the artist's life and a turning point in modern French history.

During the nine months Caillebotte served in the Garde Mobile de la Seine, from July 1870 to March 1871, the Prussians routed the French army, took the Emperor prisoner, laid siege to Paris, and eventually extracted a painfully severe treaty of peace with the new government of France. Just after Caillebotte laid down his arms, a citizen's rebellion in Paris, challenging the treaty and the new government, formed a secessionist polity, the Commune.[8] This confrontation ended in a week-long civil war in May, when the central government's armies reconquered Paris and eliminated the Commune in exceptionally bloody fashion. Already devastated by the Prussians in its environs, Paris was extensively put to the torch and laid to ruin in its central districts by the last battles of the rebellion.

No Parisian, least of all those who stayed to witness the Commune and its dénouement, can have remained unscarred by these events; they are said, for example, to have brought on a deep crisis of depression in Manet. For someone of Caillebotte's age, just reaching manhood at the end of the Empire, they must have had a special impact. His subsequent association with the innovatively democratic and (at least by reputation) politically tendentious Impressionist exhibitions, and even more the proletarian subject of his first major canvas (*Raboteurs de parquet*, 1875, Pl. 8), tempt one to infer a leftist political bent, born from or confirmed by the "*année terrible*". The changes in his life began, however, in a more conservative vein. In the first year of the new republic, when he abandoned his law career and turned to painting, he did so by entering the atelier of the established Salon master Léon Bonnat; and he made the change while continuing to live in the family home.[9]

Nothing suggests that Caillebotte ever entertained ambitions toward allegorical or historical Salon painting, but Bonnat's sober naturalist manner had other lessons to teach; particularly in portraiture, it was certainly reconcilable with Realist impulses. The first preserved canvases show Caillebotte treating informal subjects from private and atelier life, in an up-to-date Realist style, with a relatively timid but lightened, clear palette (e.g., *Femme nue étendue sur un divan*, 1873, Pl. 4; *Femme à sa toilette*, Pl. 5). An attraction to *plein-air* effects, and indications of a spatial construction that may owe to optic devices, are already evident in the landscape dated to his 1872 voyage in Italy (e.g., *Une Route à Naples*, Pl. 3).[10] Moreover, his studio view (*Intérieur d'atelier avec poêle*, Pl. 6) documents an early engagement with Japanese sources. These few clues suggest that in April 1874 Caillebotte was likely to have been among those most attentive to the first exhibition mounted, as an alternative to the official, yearly Salon, by an independent association of painters that included Degas, Monet, Renoir, Pissarro, Sisley, and Cézanne. In all likelihood, he had already encountered Degas, who was a friend of Bonnat, and through him had come to know the others who would from that spring onward be known as the Impressionists.[11]

In the complex political climate of 1874, as Paul Tucker has shown, this independent exhibition's defiance of the Salon was sometimes appreciated for its initiative; but the paintings were widely blasted as lacking, by subject and execution, the moral fibre that art was called on to provide in a rebuilding nation.[12] Political radicalism and artistic nonconformity were thus often confounded in the critical response. We can only query whether Caillebotte's enthusiasm for such "suspect" painters brought tensions between him

Fig. 4. Jul. Bailly. *The Artist at Age One*, 1849. Pastel.

Fig. 5. Jul. Bailly. *The Artist at Age Five*, 1853. Pastel.

Fig. 6. Gustave Caillebotte's Military Service Card. The card shows his dates of infantry service, and (from a physical examination in late 1875) describes the artist as 1 m. 67 cm. tall, with auburn hair and grey eyes,

and his 76-year-old *haut-bourgeois* father. If so, they were soon dissolved; for Martial Caillebotte senior died on Christmas Day that same year. His passing left his sons with substantial fortunes and newly independent options in life.

Caillebotte apparently began the new year still harboring notions of success as an artist in traditional terms, via acceptance at the Salon. It seems virtually certain that he submitted to the Salon jury in the spring of 1875 the *Raboteurs de parquet* (Pl. 8), and that its rejection definitively sealed his solidarity with Monet, Renoir, and the others, who had so often suffered at the same hands.[13] By the next spring, he was showing with the Impressionists, in their second group exhibition.

There was no timidity in Caillebotte's debut. Of the eight pictures he showed in 1876, five are now known, and they are consistently remarkable (see Pls. 8, 9, 10, 12, and 13). Four were domestic and garden scenes from the house on the rue de Miromesnil and the family's country property, and two showed workers planing and scraping floors (by legend, but unverifiably, in the Caillebotte house itself). One of these, the rejected *Raboteurs* of the year before, was among the sensations of the exhibition, and was long remembered as the artist's "signature" image. The "vulgar" subject was only partly the issue; it was the spatial structure propelling the laboring torsos that redoubled their shock effect.

Caillebotte's brushwork and palette were not tendentious, and a public accustomed to Bonnat could easily appreciate the suave play between daylight and apartment gloom in his interior scenes—Zola in fact found the work too "bourgeois" because of its tight draftsmanship and careful finish.[14] But even those who had been following Degas's experiments with unusual spatial constructions were unprepared for the look of the *Raboteurs* and other works such as *Déjeuner* (Pl. 13). A tautly focused world, meticulously still and quotidian in its narratives, was here given untoward drama by the distension of foreground breadth, the over-acute convergence of receding lines, and the accelerated shrinkage of scale with distance. Viewers found the effects bizarre and discomfiting, and blamed on ineptitude and error what in fact seems a rigorously accurate, though willfully extreme, application of the laws of linear perspective (see Chapter 3).

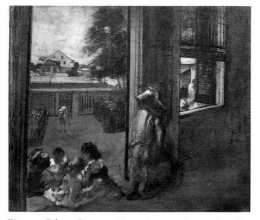

Fig. 7. Edgar Degas, *Cour d'une maison (Nouvelle-Orleans, esquisse)*, 1873. The Ordrupgaard Collection, Copenhagen (shown in the 1876 Impressionist exhibition).

Though Caillebotte's plunging perspectives were not identical with Degas's characteristically skewed viewpoints and stacked-up spatial overlaps, the aims of the two artists were closely parallel in 1876. The younger painter's subjects from working-class and bourgeois life, and his attention to unposed gestures seen from unusual viewpoints, was directly consonant with the Realist "program" exemplified in the portraits and images of dancers and laundresses that Degas showed. In two images of New Orleans life, the *Portraits dans un bureau* and the unfinished *Cour d'une maison*, the older master provided an exceptionally telling model for the newcomer. Caillebotte's debt to Degas is confirmed by the important manifesto of Realism written by Edmund Duranty in response to the 1876 exhibition, *La Nouvelle Peinture*. There, the two painters' works are cited interchangeably, as exemplars of the rebellion against convention and the search for an adequate representation of the truths of modern experience.[15]

Caillebotte's brother René, the subject of two of these Realist views (*Jeune homme à sa fenêtre*, Pl. 10, and *Déjeuner*, Pl. 13), died in the year of this initial showing, at the age of 26.[16] The painter then apparently came to fear, despite the longevity of his father, that premature death was a family curse, and that he, too, might not have long to live.[17] In November of 1876, he thus made an extraordinary will. Providing money to support the next group exhibition, he also bequeathed to France the collection of works by his friends that he had begun to form, on condition that the nation display them first in the Paris museum devoted to living artists, and eventually in the Louvre. Caillebotte's bold stroke shows an unbelievably self-assured prescience—just as the collection in question evidences a remarkably discerning eye. He was at least twenty years ahead of his time, and he knew it. (See the text of the will and accompanying discussion in Appendix B).

The will documents Caillebotte's specific combination of financial and aesthetic commitment to the Impressionists. Already in 1875, at an auction of the "new painting," he had purchased a Monet (an unusual interior view with affinities to Caillebotte's own interests at the time [see Pl. 13b; cf. *Déjeuner*, Pl. 13]). Beginning in 1876 if not before, he provided key support for the exhibitions, and for individual painters—renting, for example, the studio Monet used during his work at the Gare St.-Lazare.[18] The benevolence ranged from direct gifts to purchases of paintings at purposely elevated prices, to the "buying-in" of his own paintings at the 1877 fund-raising auction of Impressionist works.[19] But it would be wrong to infer from this that his collection was merely the corollary result of his charity. His eye was as keen as his heart was large, and he was absolutely confident—in near-clairvoyant fashion—of the enduring quality of the works he acquired, from a select circle of his associates only (see Appendix B for a list of the collection).

In the following years, perhaps under the continuing anxiety of impending death, Caillebotte worked at his highest levels of energy and achievement, in all the roles of painter, patron, and impressario. The 1877 exhibition of the Impressionists was, as Richard Brettell rightly asserts, "Caillebotte's exhibition."[20] He undertook the diplomacy necessary to bring into alliance all the differing factions connected with the enterprise (failing only in his effort to obtain Manet's participation), and then found and rented the apartment where the show took place. The result was not only the most selective, coherent and refined of all the Impressionist exhibitions, but, arguably, the best exhibition ever mounted of the progressive currents in French painting of the 1870s. Even with more than a century's hindsight, it still seems a singular achievement. Caillebotte also helped send out the invitations, joined Renoir in the hanging of the show, and paid for publicity. In the display were several major works from Caillebotte's own collection, by Degas, Pissarro, Monet, and Renoir; and out of the show he purchased one of the most-remarked pieces, Renoir's *Bal du Moulin de la Galette*.[21]

Given this activity, his own representation was all the more remarkable: he contributed six paintings executed in the previous year, including the two most monumental and ambitious of his career, *Le pont de l'Europe* of 1876 (Pl. 15) and *Rue de Paris; Temps de pluie* of 1877 (Pl. 18), aggressively structured vistas of the bullet-straight streets and rawly engineered

architecture of post-Haussmann Paris. Ironically, at the moment when he was most central to the advancement of the Impressionists' cause, these pictures—widely appreciated by critics who otherwise had many doubts about the show—pointedly raised the question of his artistic kinship with the group. His commitment to the depiction of modern life squared conceptually with Monet's views of the Gare St.-Lazare, and with Degas's urban workers. One could even argue that (as was true of Renoir, in the large *Moulin de la Galette*), his larger formats were in sympathy with a recurrent goal of "Salon scale" essayed by Monet and Bazille in the 1860s. But, despite his attention to the shadow-tinting effects of rainy atmosphere and brilliant noonday light, his moderated palette and tight technique were far from answering the impulse to assertive hues and broken brushwork that bound together other core artists of the group.

It may have been partially in response to this gap, in an attempt to move closer to the work that Monet, Renoir and Manet had been doing at Argenteuil, that Caillebotte turned after the exhibition to scenes of boaters and bathers, rendered in far brighter, less modulated blues, greens, and yellows. These latter canvases, much less imposing than the urban views he had just shown (see for example *Canotiers*, Pl. 20; *Partie de bateau*, Pl. 21; *Périssoires*, Pl. 22; *Canotier ramenant sa périssoire*, Pl. 24), dominated his work in the summers of 1877 and 1878. To the degree that they seem more genuinely Impressionist, however, these pictures seem less authentically personal. Loose brushwork and bolder colors were not a vocabulary he adopted with natural ease, and many of the pictures are awkward. Only the enduring eccentricities of perspective give these images a distinctly original character, occasionally bizarre or semi-comic.

The aquatic scenes were based, as were Caillebotte's early garden views (e.g., *Portraits à la campagne*, Pl. 14, and *Les Orangers*, Pl. 25) on life at the family's splendid estate on the Yerres river. Caillebotte vacationed here through 1878, and, as Marie Berhaut has shown, the familiar legends of his residence near Argenteuil in the 1870s have no substantial basis. While nothing excludes the possibility of his having visited with Monet and Renoir at Argenteuil, he did not buy his home in neighboring Petit-Gennevilliers until around 1880, and his activity as a yachtsman began after that date.[22]

The property on the Yerres, as well as the house on the rue de Miromesnil, were both sold following the death of Caillebotte's mother in 1878. This was the third time death had struck close to Caillebotte in four years, and we can imagine that, with the world of his youth definitively closing as he turned thirty, he was deeply affected. Only his younger, musically inclined brother Martial remained (their much older half-brother had become a priest long before), and together they moved into an apartment on the Boulevard Haussmann, behind the Opéra (see *Homme au balcon*, Pl. 40). From this period begins a series of elevated views of the city: melancholy vistas over rooftops, often under snow (e.g., *Vue de Toits* [*Effet de neige*], Pl. 29), and views from balconies and upper windows to the distant street below (e.g., *Rue Halévy, vue d'un sixième étage*, Pl. 28). Caillebotte seems to have virtually stopped painting in 1879, but one of the rare canvases dated to that year is among his most poignant: a still life (Pl. 32) that regroups the same crystalware across which he had viewed his mother and brother René at their noonday meal in the family home (*Déjeuner*, Pl. 13), only three years before—now arranged on an empty table in his bachelor apartment.

Even when little engaged with painting, Caillebotte remained strongly committed to the Impressionist group. No one had been able to bring to fruitful focus the diverse ambitions for a show in 1878, but in 1879 he returned to the task in characteristic fashion.[23] In Monet's absence, he took the initiative of locating and borrowing (and where necessary framing), all the twenty-nine Monet works in the exhibition that year. He also sent to this fourth exhbition an exceptionally large number of his own canvases (many of them *hors catalogue*), including the boating and bathing scenes, rooftop views and portraits of 1878. Having moved closer to the palette and technique of Monet and Renoir, he attracted more of the ridicule that usually fell their way. Formerly noted approvingly as one of the most traditional of the group, he was

now singled out as one of the most extreme—not only for his weird perspectives, but for the excesses of blue in his palette. One correspondent reported that "it is he [Caillebotte], more than all the others, who provokes the public's outrage at this exhibition.

> It is difficult to judge impartially the painting of this artist, for he shows himself to us today in a very different light from the one we met him in three years ago. He has changed so much that you do not know if it is good or bad that he left the path already laid down in his painting of scrapers, a dry painting, full of will and modesty.
>
> On the other hand, should we prefer him now that he gives us almost forty canvases dominated by a palette of bluish tones ranging through all its shadows, and on which color no longer can contain itself, or reels like a bacchante?[24]

A more sympathetic critic counted Caillebotte among those who, as godchildren of Corot and Courbet, were "hardy sowers" of a challenging new vision, not themselves destined to reap the harvest; though he thought his showing would have profited from a much tighter selection. Luckily, this same writer left us an invaluable thumbnail sketch of the artist in 1879:

> Finally, Monsieur Caillebotte, the youngest of the good ones. Scarcely thirty. Former student of Bonnat, in whose studio he still was when, three years ago, he exhibited his *Raboteurs* at Durand-Ruel's. I confess this canvas stemmed rather little from the master's school. It caused a stir, if I remember, at least among painters, and the young deserter hardly thought about getting back on the road to his barracks. The Impressionists welcomed him with warmth as a precious recruit. He brought to them the credential of unyielding youth. The kind of youth, in soul and body, that's headstrong to the point of error, rebellious against disappointments, and victorious over submissive reality. He entered the fray like a spoiled child. Assured against misery, strong with a double strength: will served by fortune. He had that other courage, which isn't the most common, of hard-working wealthy folk. And I know few of them who have forgotten as much as he has that they are *rentiers*, in order to remember only that their fame has to be self-made.
>
> Famous or not, Monsieur Caillebotte is a valiant one. His apartment on the Boulevard Haussmann, which could be luxurious, has only the very simple comfort of a man of taste. He lives there with his brother, a musician. A brotherhood rather bizarre, each one rowing his own boat, cresting different waves with equal ardor—one not knowing where the other's going, pursuing different goals: this one painting, that one doing [musical] notation, without exchanging thoughts, without conflict of feelings—talking neither painting nor music among themselves, and only rediscovering themselves brothers in the most touching of friendships, which covers with a warm, soft shadow these two lives, contiguous and distinct.[25]

The youthful energy and resilience the writer mentions were to be put severely to the test, and badly buffeted, over the next few years. The extraordinary efforts Caillebotte was obliged to make on behalf of Monet—who otherwise would not have contributed to the 1879 show—were symptomatic of the increasing difficulty of preserving the élan of the Impressionist endeavor. Differences of social class and political stripe, conflicting notions as to potential new members, and above all disagreements as to abjurence of the Salon, had begun to assert themselves early on, and became obtrusive in 1880. Renoir, Sisley, and Cézanne had decided not to participate in 1879, and in 1880 Monet also joined the ranks of the missing. After the spotty sales and critical brickbats of the first few shows, these painters had come to feel that the route to public acceptance, and thus commercial success, was inevitably through the Salon. To this end they were (with the exception of Cézanne, for whom sending and being rejected had an almost ritual, defiant aspect) willing to temper their styles and to compromise their commitment to the independent exhibitions. Caillebotte, himself untouched by economic pressures, was understanding with regard to these "defections," and wanted to continue the exhibitions without regard to Salon affiliation, by selecting

participants on artistic merit alone. This brought him into direct confrontation with Degas, for whom the prohibition against sending to the Salon was a more sacred principle of the organization. Furthermore, with the ranks of the original exhibitors thinned, Degas brought newcomers Caillebotte regarded as unworthy. In 1880 the two even fought over the design of the poster, and Degas complained that "All the good reasons and the good taste in the world can achieve nothing against the inertia of some and the obstinacy of Caillebotte. . . ."[26]

Notwithstanding these disagreements, Caillebotte exhibited eight paintings and three pastels in 1880. This was a sharp reduction from the previous year, and the mood of the display—dominated by portraits and interior views—was distinctly different. Leaving behind the exuberance of boaters and bathers, Caillebotte had turned, on resuming painting in 1880, to the theme of urban *ennui* and interpersonal alienation. A large café scene (*Dans un café*, Pl. 39) and two images of conjugal boredom (*Intérieur*, Pl. 34; *Intérieur*, Pl. 35) all treat the latently smothering *longueurs* of modern urban life in a way that recalls certain Realist novels; and it is appropriate that they received their highest praise from the novelist/critic J.-K. Huysmans.[27] Though looser in execution and occasionally more free in touches of color, these images were in some ways a return to the figure/genre scenes shown in 1876, with the high-strung tautness of the latter now replaced by an air of static resignation. Familiar, too, were the critical protests against Caillebotte's use or misuse of perspective, now directed at the befuddling size differential between husband and wife in one of the interiors (Pl. 34).

Not only the conflicts of organization, but also the look of the 1880 exhibition itself left Caillebotte with a grudge against Degas—who had once again failed to produce many of the works he promised for the show. In a long, often-cited letter to Pissarro written at the outset of 1881, Caillebotte poured out his resentment. "What is to become of our exhibitions?" he began, and proceeded to accuse Degas of wasting his own talent, sowing discord in the group, and introducing second-rate cronies into the association. Pleading that those who had tried the Salon route had done so from financial pressures one had to respect, he beseeched Pissarro (who had seconded Degas's insistence on banishing those who submitted to the Salon) that henceforth they should abandon all criteria of membership save those of artistic merit—and thus readmit the original leaders while rejecting the bulk of Degas's friends.[28] After two days' reflection, Pissarro rejected the proposal. He held, to the contrary, that only verifiable rules of loyalty were workable, for judgments on artistic merit would prove even more discordant; and gently recalled that Caillebotte himself figured among those Degas had brought into the association.[29] Discouraged in the face of this stand-off, Caillebotte wrote back: "I don't know what I'll do, I don't think an exhibition is possible this year. But certainly I won't start up last year's again. Degas's vitrine [a reference to the empty case left in the 1880 show when Degas failed to deliver a promised sculpture] is not enough for me."[30] In the long run Degas had his way, and when the sadly truncated sixth exhibition opened, Caillebotte was, for the first time since 1876, among the absent.

In 1882, the battles resumed, but the tables turned. Again, Caillebotte appealed to Pissarro: "There is no exhibition feasible with Degas," and held that, unless one wanted to repeat the poor showing of the year before, a new grouping should be made that would reunite Monet, Renoir, and Sisley—and, inevitably, exclude Degas (though in fact he made the effort to have Degas relinquish his lesser associates, and rejoin alone).[31] At the same time, it appears that Degas was counter-attacking, through the dealer Durand-Ruel, in an effort to have Monet, Pissarro, and Renoir separate themselves from Caillebotte in the next exhibition—obliging Monet to rise to Caillebotte's defense in citing his important contributions in the past.[32] Small wonder that Caillebotte, confronted with this infighting and with the problems of rallying a stubborn Monet and an ailing Renoir from their locales in the provinces, could write to Pissarro that, "Even if we could agree about it, we wouldn't succeed in exhibiting. I'm heartsick, I slink back under my tent. . . . I wait for better days."[33]

When the 1882 show did finally open, its constitution was in principle as Caillebotte had wished. Degas, and several other of the exhibitors of 1881, were absent. Pissarro participated,

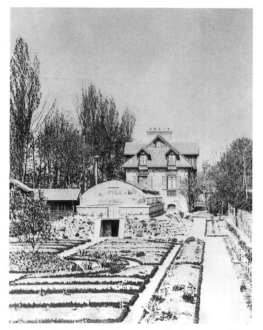

Fig. 8. Caillebotte's home at Petit-Gennevilliers. Photo by Martial Caillebotte, c. 1890.

and Renoir, Monet, and Sisley were once again represented. But, far from being simply a reunion based on pure artistic criteria, as Caillebotte had hoped, the new exhibition was strongly shaped by the concerns of the dealer Paul Durand-Ruel. As Joel Isaacson has emphasized, Durand-Ruel was, in the face of a general financial crisis, bound by a strong necessity to sell from his stock of Impressionist works; and in the long run he overrode the questions of negotiation that occupied Caillebotte and Pissarro, by taking an irresistible hand in impelling the inclusion of canvases he owned by Monet, Renoir, and Sisley.[34] Despite this shift, a leadership role seems to have reverted to Caillebotte; a critic who visited during the installation found him energetically taking charge and "working like a porter, exactly as if he didn't have an income of fifty thousand francs."[35]

It was, however, Caillebotte's swan song. Though his paintings would appear in other countries in the 1880s, this was his final participation in a Parisian exhibition. It was also, and not at all coincidentally, the last of the independent exhibitions that held at all closely to the original constitution of the group. One more show closed the series, in 1886; but by then so many old names had departed, and so many from another generation (e.g., Seurat and Signac) were included, that the display had only the most tenuous association with the Impressionist cause of the 1870s.

As has long been observed and analysed, the years 1880–82 marked a sharp turning point for all those originally involved in the Impressionist exhibitions—a point sometimes called the "crisis" of Impressionism, and associated not only with stylistic change but with a broader shift in the relation of the avant-garde painters to a French Republic itself in the midst of notable political and social metamorphosis.[36] Caillebotte was among those most deeply changed by the events of these years, which in essence closed out the most exciting period of his life. He was doubtless saddened by the dissolution of the original communal ideals of the Impressionist group. But he must also have been aware that, for most of the painters he had so energetically supported, his role had become less crucial. They, and the new kind of art they collectively represented, had begun to find a place in a broader, expanding market.

As the necessity for Caillebotte's patronage expired (with very few exceptions, all his major purchases of art were made before 1883), his artistic ambition slackened as well. After years of intense politicking and critical abuse, he had become tired and discouraged. A critic reviewing Caillebotte's career later recounted that "The noisy notoriety that his submissions to the Impressionist shows brought him, upset him and little by little made him lose his boldness and the steadfast self-confidence that had marked his beginnings."[37] And another writer offered a regret after the artist's death, wondering "what a painter Caillebotte might have been, what a considerable place he would have occupied in our school, if he had not been somewhat thrown off track and discouraged in his art."[38]

Appropriately, there is something of the valedictory about the selection of seventeen paintings he showed at the 1882 exhibition. The best of them took up the characteristic, personally loaded theme that had already announced itself in 1876, the dialogue between the bourgeois interior and the boulevard—but now with a sense of separation and closure, in which the urgency of the early pictures is replaced by a more removed and wistfully contemplative point of view (see Chapter 2). A huge, stolid canvas of card players (*Partie de bésigue*, Pl. 38) extended the world of urban genre begun in the 1880s interiors; its humdrum, all-male concentration provided a counterpoint for the lively outdoor socializing vividly conjured by Renoir in the same exhibition, with his *Déjeuner des Canotiers* (Caillebotte has been said to be among those portrayed in Renoir's group, though this is open to question).[39] Two pictures showed men on the balcony of Caillebotte's apartment (*Homme au balcon*, Pl. 40, and *Un Balcon*, Pl. 41), and one extraordinary view looked straight down from that same perch (*Boulevard vu d'en haut*, Pl. 44). The latter, and a striking still life of a fruit-vendor's display (*Nature morte*, Pl. 48), showed an ability to produce powerfully original pictorial structures by isolating patterns seized "ready-made" in the city's architecture and commerce—a new vision that was unfortunately to be without further issue in Caillebotte's

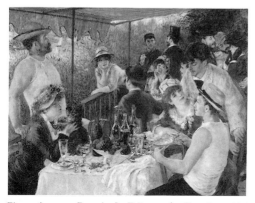

Fig. 9. Auguste Renoir. *Le Déjeuner des Canotiers*, 1881. Oil on canvas. The Philips Collection, Washington, D.C.

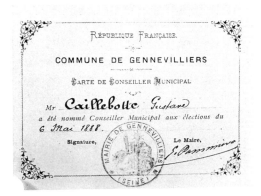

Fig. 10. Gustave Caillebotte's *Carte de Conseiller Municipal*, 1888.

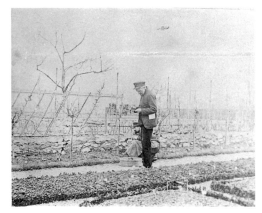

Fig. 11. Caillebotte in his garden at Petit-Gennevilliers, c. 1890.

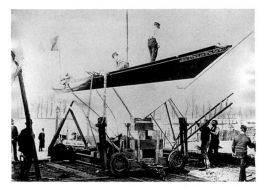

Fig. 12. The launching of one of Caillebotte's boats. Photo by Martial Caillebotte, c. 1890(?).

work. Finally there was a scattering of marine views from the Norman coast, which announced the yachting interests that, occupying him through the next decade, would extract him more and more from the city that had been the focus of his life and art since 1875.

If he no longer had to provide as much in immediate aid to his painter friends, Caillebotte remained committed to the long-term vision of their success he had first fixed in his will of 1876. In 1883 (the same year in which he purchased Manet's *Le Balcon* at the sale following the artist's death), he drew up a codicil specifically reaffirming the bequest of his collection, with all the attendant conditions. In this codicil, as in the second one added six years later, new provisions appear, dealing with the life annuity and property to be bequeathed to Charlotte Berthier (see codicil texts, Appendix B). Though Caillebotte never married, this woman apparently shared at least the last twelve years of his life; she would thus be the figure who appears in his garden scenes of the later 1880s and early 1890s (e.g., *Les Dahlias*, Pl. 58).[40]

During the latter part of the 1880s, Caillebotte painted less and less. A number of canvases dated to 1884 and 1885 are consistent with his production of 1880–82 (e.g., *Homme au bain*, Pl. 52); but gradually his work seems to have become, in the main, a series of boating views and empty landscapes of the fields and river banks near Petit-Gennevilliers, frequently handled in a loose and decidedly unfelicitous manner (many of these works, never shown by the artist, may have only been considered sketches; and their posthumous display and sale has inevitably clouded our view of his style). His works were shown in 1886 in the United States, in the context of an exhibition organzed by Durand-Ruel,[41] and in 1888, surprisingly, at the avant-garde *Salon des XX* in Brussels. The latter appearance may have been an offshoot of Caillebotte's friendship, cemented by a shared love of sailing, with the young Neo-Impressionist painter Paul Signac;[42] both exhibition and association attest that, though no longer strongly engaged as a painter or as a patron, Caillebotte was not out of touch with new artistic developments.

By 1882, Caillebotte owned a house at Petit-Gennevilliers, and was alternating his residence between it and the apartment on the Boulevard Haussmann; and in 1887, when his brother Martial married, he took up full-time residence in the suburban home. He continued, as he would until his death, to stay in regular contact with old friends in Paris, and was a prime mover in the regular artistic-literary dinners at the Café Riche—where his intelligence and powers of debate were apparently so formidable that his tablemate Renoir felt compelled to purchase an encyclopedia as an aid in getting the upper hand in the discussions.[43] He had not lost, moreover, his appetite for organization and patronage. In 1888, he was elected Conseiller Municipal of Petit-Gennevilliers, and his tenure there was reputed to have been extraordinary: convinced that the town needed new lighting, that the roads needed gravel, or that the firemen needed new uniforms, he simply paid for these improvements out of his own pocket, to circumvent the frustrations of bureaucracy and paperwork.[44]

The two Caillebotte brothers had together assembled a superior stamp collection which they sold at the time of Martial's marriage. But Caillebotte's primary passions of the later 1880s were boating and gardening, and he was more than simply a happy amateur in both domains. His garden (see *Les Dahlias*, Pl. 58) grew to be a complex enterprise, complete with sizable greenhouse. This was the period in which private gardening in France began to be enriched by a burgeoning trade in mail-order horticulture, and both Caillebotte and Monet—who doubtless often compared notes on their gardens—profited from the new range of possibilities.[45] He also designed and had built a series of successful racing yachts, and was apparently a lion of the regattas. The boats, often dubbed with facetious names such as the *Roastbeef*, occasionally sported such exceptional amenities as a white silk sail with a red heraldic cat. Though Caillebotte's activities as a successful designer of yachts have fostered the notion that he was formally trained as an engineer, this familiar tale has no basis in proof.[46]

The evidence of larger, more ambitious paintings (e.g., *Régates à Argenteuil*, Pl. 61) suggest that Caillebotte began to renew his interest in painting in 1893; and his friends apparently began to explore the idea of showing his work once more in Paris.[47] However, the 1894

Caillebotte retrospective at the Durand-Ruel galleries turned out to be posthumous and commemorative, rather than a celebration of rejuvenation. In late January or early February, Caillebotte apparently became ill while working in his garden; he was consigned to bed, and his health went steadily, swiftly downhill.[48] He died on 21 February 1894, six months short of his forty-sixth birthday; five days later he was buried in Père Lachaise cemetery. Pissarro wrote to his son Lucien: "We have just lost yet another sincere, devoted friend. Caillebotte died suddenly of cerebral paralysis. And he is one we can really mourn. He was good and generous and a painter of talent to boot."[49]

The critic Gustave Geffroy, Caillebotte's friend and later Monet's biographer, eulogized him in *Le Journal* just before his funeral. In reviewing the career in painting, Geffroy defended the "curious and sometimes bizarre effects of foreshortening and proportions" in Caillebotte's experiments with perspective, asserting that in these pictures, where one might suspect merely an intention to shock, there was "ingenuity and a desire for truth." Singling out Caillebotte's cityscapes and balcony views as his best work, Geffroy held that in them "there was not just research but discovery and originality, and the beginning of something which could well be carried on."[50] The posthumous retrospective of 122 Caillebotte works, organized by his friends, took place in June of that year. There was appreciable press coverage, with some favorable remarks, especially for the *Raboteurs de parquet* and other early works.[51] However, Caillebotte's art was largely treated as a curious remnant of a past epoch; it was difficult to imagine how the same canvases had generated such debate. Paintings were for sale, but few sold.[52] As for the effect of the exhibition on artists, there is reason to speculate that the young Nabi painters Vuillard and Bonnard may have taken an interest in Caillebotte's special treatment of the bourgeois interior (see *Déjeuner*, Pl. 13) and his distinctive manipulations of perspective (*Intérieur*, Pl. 34). In general, notice of Caillebotte as a painter was eclipsed by the attention paid to the bequest that had been revealed when his will had been read. This latter discussion was to keep his name prominently in the public eye for the next few years (see Appendix B).

Caillebotte would probably have been unhappy with such notoriety, as he seems to have been the soul of modesty. A critic wrote of him in 1882 that he was "an inoffensive type of bourgeois" who "lives very quietly, detests compliments, asks only to defend his school, and would never want to carry off a victory."[53] "The testimony that all gave of him [Caillebotte]," Geffroy later recounted, "was that he was a truly rare colleague, of absolute self-denial, thinking of others before himself—if he thought of himself."[54] He did not include any of his own paintings in his bequest, and it was left to his executor Renoir and his brother Martial to add to the legacy the gift of the *Raboteurs de parquet* (Pl. 8) in order to fulfill the modest aspiration that Jean Renoir recalled as Caillebotte's: only to have his paintings "displayed in the antechamber where the Renoirs and Cézannes are hung."[55]

Gradually, with the passage of years, even this latter, modest hope proved steadily less realistic. The Impressionists in general rose ever higher in estimation and market value as they came to be annexed to a canonical geneaology of modern art; and France began, especially after World War I, to embrace as national virtues the values of secular, a-historical *joie de vivre* seemingly implicit in their "spontaneous" brushwork and *plein-air* vision of urbane, sunlit country recreation. In the newly focused estimation of the group, there was little place for the tightly handled, often relatively somber-hued early work that was Caillebotte's most distinctive. The *Raboteurs* hanging in the Musée de Luxembourg was the only Caillebotte canvas accessible to the Parisian public for decades, and it seemed more and more a marginal curiosity. A selected overview of Caillebotte's paintings mounted in 1921 at the Salon d'Automne passed virtually without notice, and histories of Impressionism, when they mentioned Caillebotte at all, concentrated on his role as friend and patron, with only passing mention of his art.[56] If his work was known at all—since it was virtually unavailable in public collections and rarely reproduced—it was categorized as a second- or third-rate Impressionism.

In the following chapter (originally written in 1976 to accompany the Caillebotte exhibition that year) some of the reasons for, and alternatives to, this latter judgment are explored. Suffice it to say here that Caillebotte's own painting has not only been "refloated" by the general market tide that has, since the 1960s, driven sharply upward the prices for all painting that could in any way be deemed "Impressionist" (in this context he is often still regarded, though perhaps with less condescension, as the "poor man's Monet"), but also been newly appreciated for having at its best a special originality, distinct from the work of his Impressionist associates. This turnaround depended upon the broader accessibility of the artist's work, owing initially to exhibitions organized by Wildenstein and Co. in Paris in 1951, in London in 1966, and in New York in 1968. And perhaps the single most important milestone in this new accessibility was the acquisition in 1964 by the Art Institute of Chicago of the *Rue de Paris; Temps de pluie* (Pl. 18).

Shifts in the aesthetics of the art of the 1960s and 1970s—especially the rise of a new Realism and an intensified interest in photography—augmented the sense of fresh interest generated by Caillebotte's art as it began to resurface in public awareness. By the time of the 1976 retrospective in Houston and Brooklyn, Robert Rosenblum could identify in Caillebotte's imagery a unique set of concerns that, far from being *retardataire* in the 1870s, speak with immediacy to the art of the 1970s;[57] and the general critical press and gallery-going public responded with a thrill of discovery to the prominent inclusion of Caillebotte's works in major Impressionist exhibitions of 1974 and 1986. In the later 1970s, the *Raboteurs de parquet* was brought out of the storerooms and put back in the "antechamber" Caillebotte once imagined; it was displayed on a wheel-mounted easel in the Musée du Jeu de Paume, under the staircase which led up to the *Salle Caillebotte* where the treasures of his bequest were hung. In the new Musée d'Orsay, it has regained a place of honor beside them in the Impressionist galleries. Now, with his work more widely available and fully catalogued (Marie Berhaut's authoritative catalogue raisonné appeared in 1978), and with a new generation of scholarship on Impressionism taking a broader view of the movement's meanings, we are in a better position than ever before to assess all the questions of quality and context that surround Caillebotte's contributions to early modern art.

Caillebotte lived in the very center of one of the most important movements in modern art, among some of the most talented and influential artists of his time. His understanding of these facts, and his estimation of his fellows, were uncannily accurate; and by his actions, in his life and legacy, he was a crucial force in making his beliefs become recognized reality. His prescient vision was crucial for posterity, and posterity can now return that favor, by seeing, through the framework of a new art-historical perspective, that this generous and talented man erred in one critical judgment: the one he directed against his own significance.

2 Caillebotte: An Evolving Perspective

Fig. 1. Jean Béraud, *Dimanche près de l'église St.-Philippe du Roule*, 1877, Oil on canvas, $23\frac{3}{8} \times 31\frac{7}{8}$ in. The Metropolitan Museum of Art, Gift of Mr. and Mrs. William B. Jaffe.

Fig. 2. Giuseppe de Nittis, *La Place des Pyramides*, c. 1875. Oil on canvas. Formerly Musée du Luxembourg, Paris.

If we are to assess Caillebotte's work and its place in early modern art, we need to answer two related questions. First, in what context shall we understand his paintings? Second, what shall we say about their intrinsic quality and interest? The latter question can be approached intelligently only after we have considered the former.

Consideration of Caillebotte's context, or his place within the art of his time, must above all be concerned with his more tightly finished realist paintings. Caillebotte produced many paintings that can comfortably be called derivative Impressionism, but these paintings are his least personal, and are peripheral to the heart of the issue. With Impressionist painters as the sole framework of evaluation, his important early work will never be understood as anything but *retardataire*—which it clearly is not. Bazille, whose love of the provinces and nostalgia for older art have little to do with Caillebotte's essentially urban temperament, has some limited appeal as a precedent, but sheds little real light. Comparison with Degas is more just, and more telling with regard to major compositional devices. But, like the comparison with Monet and Renoir, this juxtaposition winds up faulting Caillebotte for supposed errors—scrupulously tight brushwork, frozen sense of time and motion, bizarre spaces—that are in fact not failings at all. These "un-Impressionist" elements, which have traditionally been seen as the marks of incapacity or timidity, are in fact the intended components of a different vision.

Nor can Caillebotte be understood in terms of the Salon painters of the day, the opinion of many of his contemporary admirers notwithstanding. His early work bears a superficial resemblance to that of middle-ground Salon artists who combined attention to modern life with officially acceptable dryness of execution, such as Béraud (Fig. 1) and De Nittis (Fig. 2). However, the variety of his art, the inventiveness of his highly structured compositions, and the reductive austerity of his vision set him fundamentally apart from the prose of these often intriguing but never really substantial or moving chroniclers. The paradox is that Caillebotte was more thoroughly academic, in a better sense of the word, than these latter men, and even than his teacher Bonnat. His art was built at the outset on the most painstaking science of perspective, life drawing, and proportional calculation, more ambitious and more true to the grand tradition of disciplined order than the grandest Salon machines of the day. It is in part this staunch backwardness that keeps Caillebotte's art ahead of its time, more in touch with that of Seurat in the next decade.

Such paradoxes should only further our resolve to discard the artificially over-simplified dichotomy between courageously avant-garde Impressionists and stupidly reactionary academicians; Caillebotte's art, which sits uneasily in both camps, is enough it intself to disprove the utility of this weary cliché. Perhaps if we stepped altogether out of the dichotomy, and out of the limited realm of Caillebotte's associates in Paris, we could glimpse the possibility of other contexts in which the special qualities of his realism might not seem so anomalous.

It might be worthwhile, for example, to compare Caillebotte's early style to the work of Thomas Eakins, roughly his contemporary by birth. Both men studied under prominent

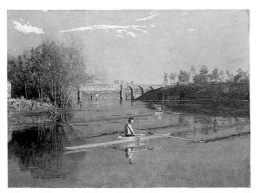

Fig. 3. Thomas Eakins, *Max Schmitt in a Single Scull*, 1871. Oil on canvas, 32¼ × 46¼ in. The Metropolitan Museum of Art, New York. Purchase, Alfred N. Punnett Fund and Gift of George D. Pratt.

French academicians, and both sought to base a realism of modern life on traditional academic disciplines such as perspectival construction. Sometimes parallel in choice of subject (Fig. 3), they share also the desire to combine truth to vision with truth to inner experience—though their sensitivity to the latter differs considerably. Despite the contrast between the anxious tension of Caillebotte and the solemn pathos of Eakins, we should not discount the underlying similarities of intention that link their emblematic musers (Figs. 4 and 5). The two painters are hardly an ideal match, but this comparison seems at least as revealing as any between early Caillebotte and the Impressionists or academicians, and has the virtue of pointing to an alternative outside that too-narrow framework.

We can enlarge the vision of such an alternative, and come closer to Caillebotte in mood, if we examine a special kind of realism that appeared throughout Europe in the 1870s and early 1880s. Often academic in technique and in the training of its protagonists, this realism chose not to follow the landscape-based generalization that became the hallmark of Monet, Sisley, and Renoir's branch of naturalist vision. Instead, it held fast on the one hand to a crisply detailed verism about the world's surfaces, and on the other to a concern for capturing the epoch in terms of human experience. Typically, in its search for a romantic spirit in modern life, this realism had a predilection not for the proletarian who was the original Realist hero, but for the less dramatic complexities of the life of the middle-class urbanite. Little concerned with formal values *per se*, it is a vision not given to overt abstraction of structure in the manner of Degas. Instead it is a stylistic inflection that is aware of photography in a special way, using relatively normative viewpoints but frequently embodying an undercurrent of tension between seemingly mundane objectivity and selected devices of expressive composition.

One example of this strain of style would be the art of J. J. J. Tissot, the erratic French painter and etcher. Tissot's work is far more limited in range than Caillebotte's, but there are moments when his peculiar distortions of proportions and of space, the eerily mannequinlike stiffness of his figures, and his sensitivity to reverie and/or boredom, produce a strange poetry

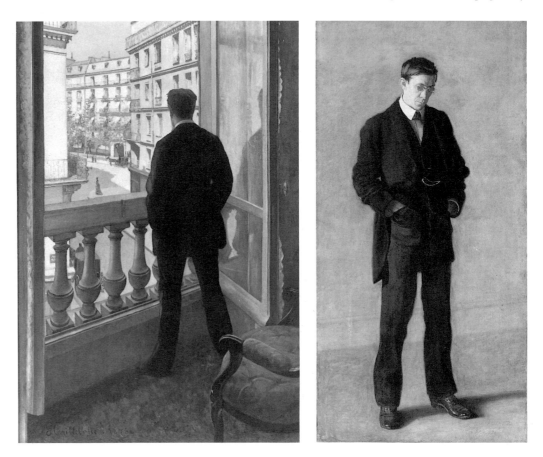

Fig. 4. Caillebotte *Jeune homme à sa fenêtre*, Pl. 10.

Fig. 5. Thomas Eakins, *The Thinker: Portrait of Louis N. Kenton*, 1900. Oil on canvas, 82 × 42 in. The Metropolitan Museum of Art, New York, Kennedy Fund, 1917.

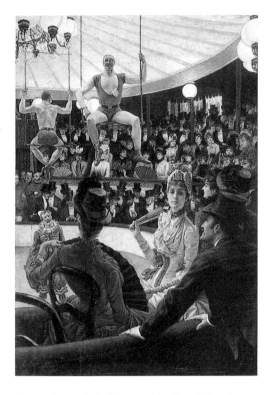

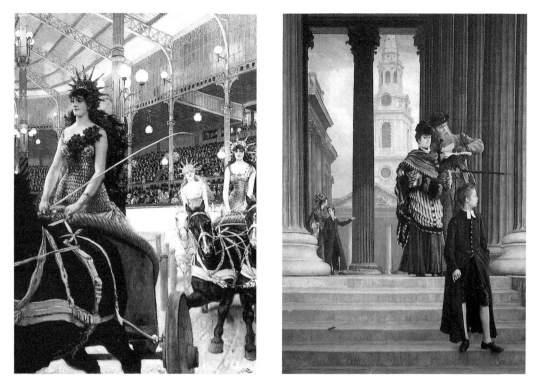

Fig. 6. James J. J. Tissot, *L'Acrobate (The Amateur Circus)*, c. 1884. Oil on canvas, 58 × 40¼ in. Museum of Fine Arts, Boston, Julianna Cheney Edwards Collection.

Fig. 7. James J. J. Tissot, *Les Dames des chars*. c. 1884. Oil on canvas, 57½ × 39⅝ in. Museum of Art, Rhode Island School of Design, Providence. Gift of Walter Lawry.

Fig. 8. James J. J. Tissot, *London Visitors*, c. 1874. Oil on canvas, 63 × 45 in. Toledo Museum of Art, Gift of Edward Drummond Libbey.

that is similar (Figs. 6, 7 and 8). The feeling Caillebotte and Tissot have in common for the inactivity of the leisure classes, whereby rigidity becomes expressive of life-condition in a way that prefigures Seurat, appears also in certain graphic works by the German artist Max Klinger (Fig. 9). Klinger, however, brings to his realism a powerful emotional tension beyond anything found in Tissot, and in this respect comes closer to the more dramatic side of Caillebotte's art, found in a work like *Le pont de l'Europe* (Pl. 15). When we study Klinger's disturbing scene of an impending ambush at a construction site (Fig. 10) or a plate from his proto-surrealist cycle *A Glove* (Fig. 11), we sense a community of spirit with Caillebotte in the expressive use of emptiness and swift perspective, and in the uncanny sense of time arrested.

This unstable strain of later Realism is the product of a peculiar conjunction of forces in a limited time period—often a stretching of the possibilities of Realist style at its last hour. Hence, as is the case with Caillebotte, Klinger, and Tissot, it may appear as a phase in a development, or as a recurring aspect, rather than as a consistently pursued manner. It is, nonetheless, a consequential phenomenon, seeming to look backward and forward at the

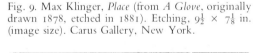

Fig. 9. Max Klinger, *Place* (from *A Glove*, originally drawn 1878, etched in 1881). Etching, 9½ × 7⅞ in. (image size). Carus Gallery, New York.

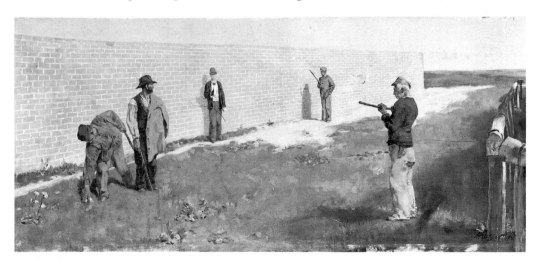

Fig. 10. Max Klinger, *Incident at the Wall* (also known as *The Strollers*), 1878. Oil on canvas, 14¾ × 33⅞ in. National Galerie, Berlin.

Fig. 11. Max Klinger, *Action* (from *A Glove*, originally drawn 1878, etched 1881). Etching, 9¾ × 7⁷⁄₁₆ in. (image size). Carus Gallery, New York.

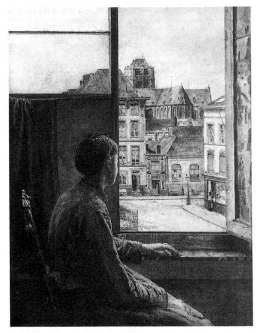

Fig. 12. Henri de Braeakeleer, *The Teniersplaats in Antwerp*, 1880. Oil on canvas, 31⁷⁄₈ × 25¼ in. Musée Royaux des Beaux-Arts, Brussels.

Fig. 13. Caillebotte, *Copy of a Plaster Cast: Standing Nude*, c. 1873–4. Oil on canvas, 21¾ × 17 in. Private collection, Paris.

Fig. 14. Caillebotte, *Copy of a Plaster Cast; Head*, c. 1873–74. Oil on canvas, 16 × 12¾ in. Private collection, Paris.

same time. In the work of many painters relevant to this context (Fig. 12), we find revived the tenor, and sometimes the very motifs, of Romanticism. These same emotive elements in turn announce, and often serve as a direct base for, expressive strains in later art, providing a bridge between the outmoded and the avant-garde that bypasses, in significant ways, the Parisian Impressionism of the 1870s. The bridge effect explains the appeal of this particular realism for Munch, Ensor, and De Chirico; the early work of all three bears its inflection.

As yet little explored, such a late Realist context can at best illuminate only a part of Caillebotte's complex oeuvre; but a recognition of its alternative set of possibilities may at least help us to stop seeing many of his most important early paintings as mere failed Impressionism. This in turn may partially clear the air, too, of the notion of Caillebotte as a derivative artist; and open the way for a more serious consideration of the personal intentions of his work taken as a whole.

Instead of continuing to see Caillebotte in fragmented parts, and comparing these piecemeal to other artists, future assessments must look more closely at his work as a whole; for, despite its variety, Caillebotte's oeuvre has an internal cohesion that suggests an artist truer to himself than to any shared conception of art. This is not to say that his development is consistent, either in style or quality. He was tremendously uneven. However, he was not uneven in the sense that he simply produced some good and some bad pictures in arbitrary alternation. He was instead uneven in exceptional ways, beginning with his astonishingly irregular early development.

The few early exercises preserved (Figs. 13 and 14) show a dutiful student of no particular distinction. Yet in his first two signed and dated canvases (Pls. 8 and 10), this 27-year-old was not only worthy of comparison with Degas, but beyond that, already markedly personal in his vision. After this quantum leap he was, for the next six years, as consistent as (if less productive than) his Impressionist comrades; he had some weak pictures, but then he also produced at least three or four that are among the most premonitorily original of their time. Then, almost as suddenly as it rose in 1875, the flow subsided. After the 1882 exhibition (the slump had apparently already begun before) he painted less; and when he did, with few exceptions, he painted consistently ordinary or mediocre pictures, mostly landscapes lacking any strong mark of originality. His "conversion" from a tight realist style was, moreover, not a simple question of bending to influence. He developed a quite respectable Impressionist

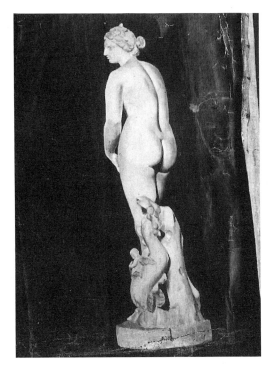

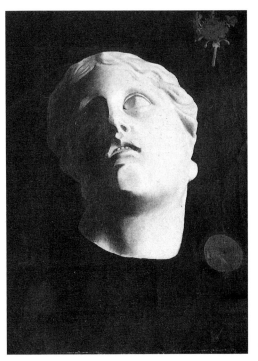

manner around 1878 (see Pl. 28) and continued to alternate this with the other style as he saw fit, up into the 1880s. After 1882, however, he frequently dabbled in an impossibly heavy-handed Impressionism, and almost never returned to the tighter mode. Finally, just before his death, in 1893, the urge to construct on a large scale seems to have returned, and he painted two ambitious canvases, more solid and more carefully planned (Pls. 58 and 61).

Though it is traditional to see Caillebotte's work in terms of semi-passive responses—first to Degas and then to Monet and/or Renoir—the history just outlined suggests an ebb and flow of will and ambition, more than simply a sequence of changes of style. Closer study will show that, not only in these large inconsistencies of effort, but in all aspects of its variety, Caillebotte's development moves in response to an internal personal dynamic. We do not yet fully understand this dynamic, but we can now begin to outline its rhythm.

The rhythm stems from a dialectic between the opposing poles of tension fundamental to Caillebotte's art. The most obvious such opposition, and one of the most central, is that between near and far. Many of his best paintings show this dichotomy: foreground elements loom up, screen our view, while background elements flee away, diminished into unreachable distance. In the early pictures, where space is usually continuous from the viewer's position to the vanishing point, the almost unbearable stretch between near and far is felt in a single image (Pl. 10). For the *Pont de l'Europe* of 1876, however, Caillebotte produces one far version, with a plummeting space (Pl. 15) and one near version (Pl. 16), in which the space is closed from top to bottom. After that date he often alternates between images with no foreground (Pl. 43) and images with no distance (Pl. 45). In 1875–76, his best and most original pictures involve the far, but around 1880 his major works—even when dealing with distant subjects—begin to show a predominance of closed, flat designs. Finally, after the mysterious turning point in 1881–82, this dichotomy disappears almost completely, and with it most of the quality of his art. The near falls away, and his landscapes take on an uncanny emptiness: all far, unchanneled space (Pls. 53 and 57). Briefly, in the spurt of new ambition around 1893, the near reappears, in the looming bush of a garden scene (Pl. 58) and in the spaceless decorative flower pieces (Pls. 59 and 60).

This oscillation might be explained on one level as symptomatic of Caillebotte's time. The idea of the far has, after all, to do with a sense of the painting as a transparent window, or as an illusory view of the world in depth. The near, on the other hand, particularly in Caillebotte's extreme perceptions of it (Pls. 44 and 45) tends to deal with the painting as a surface, with a strong emphasis on flat design. Caillebotte matured as a painter at the time when this latter consciousness—of the picture as a non-illusory surface—began to assert itself in Western art. His work could then be seen as a special case of a typical aesthetic dilemma of his time.

This explanation, however, does insufficient justice both to Caillebotte's position in nineteenth-century art and to the strongly personal nature of his work. The dichotomy between near and far is not simply a set of aesthetic alternatives for him, but a division strongly felt in terms of human experience. It pervades not just the compositions but also the themes of his paintings, determining the very types of consciousness he depicts. There are basically two states of consciousness in Caillebotte's world: either the person is intently absorbed by some activity within arm-span—reading and sewing to cite only the two most recurrent themes—or the person is staring across space at a (usually unseen) distant point. There is no communication between these characters, and rarely (portraits excepted) any communication between them and us. Caillebotte's psychic world is one in which consistent internal isolation or self-enclosure is offset only by the loss of self-consciousness through focused activity or reverie. The near side of activity, the closely held concentration, is habitually associated with closed space and with domestic scenes in gardens or interiors; while the far activity, the externally drawn gaze, is almost exclusively associated with the public spaces of the city. Thus the dichotomy, expressed by the pendulum-swing in Caillebotte's later development between wholly far/open spaces and wholly near/closed scenes, seems to be one that has its roots in a dilemma between private insularity and public society, between

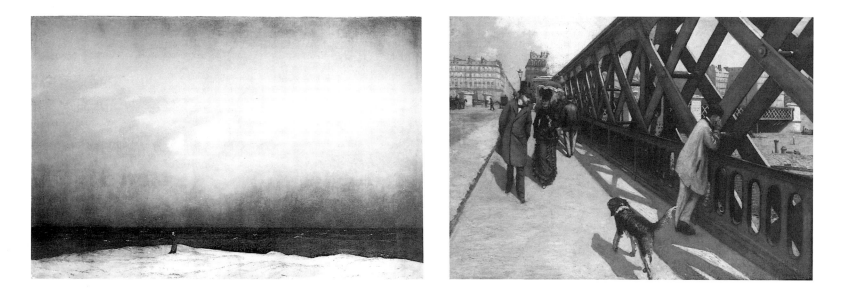

Fig. 15. Caspar David Friedrich, *Monk by the Sea*, 1808–9. Oil on canvas, $42\frac{7}{8} \times 66\frac{5}{8}$ in. Schloss Charlottenburg, Berlin.

Fig. 16. Caillebotte, *Le pont de l'Europe* (see Pl. 15).

home and city; and Caillebotte's recurrent figure of the spectator, poised on the threshhold between private and public worlds (Pls. 10, 40, and 41), thus seems a central emblem in his art, even a symbolic self-portrait.

This emotional involvement with the near and the far is neither simple nor stable, however. On the one hand, the early perspectives of the far—particularly in *Jeune homme à sa fenêtre* (Pl. 10)—would seem to suggest the beckoning beyond of Romantic space. As opposed to the siren call of openness and expansive grandeur, however, Caillebotte's far space more frequently has a distinct air of anxiety in its walled-in convergence. The funneling space of *Le pont de l'Europe* (Fig. 16; Pl. 15), especially in its interaction with the figures, replaces the sublime void of earlier Romanticism (Fig. 15) with something closer to the anxious void of expressionist space in the work of Munch and Van Gogh. Distant space loses this factor of dramatic urgency only when the linking bond of tension with the near element has been severed, as in the cityscapes after 1877 (e.g., Pl. 28). It certainly cannot be merely coincidental that the first "disconnected" views are also his first generalizing "Impressionist" visions of a landscape-like city, in which figures are insignificant. Distance has become detachment rather than separation, a protective buffer more than a magnetic force. In later works (c. 1880–82) the distant gaze becomes increasingly detached from direct communication with deep space, both in the depicted observers and in our viewpoint; and the emotional property of distance lies not as much in its retreat away from us as in the lateral expanse of isolation between figures, seen from afar (Pl. 43).

The world of the near is similarly ambivalent. In the early family pictures and also in the 1893 garden scene (Pl. 58), near activity and the interior have a heavily confining sense of security. Around 1880, by contrast, the same elements are several times pointedly associated in a more negative way with non-communicative personal isolation (Pls. 34 and 35). The protected tenor of enclosure, and the tendency to collapse distance, link Caillebotte to the Nabi intimists of the 1890s, and accounts for the similarity of his work to that of Vuillard and Bonnard. The other side of the coin, the overtone of negative confinement, is, beyond the communality of working method and occasional direct borrowings (see Pls. 13 and 35), the property that links many of the same Caillebotte pictures to the Neo-Impressionist critique of the stifling *ennui* of bourgeois existence.

Such considerations already underline the complex nature of the interrelation between Caillebotte's compositions, his themes, and the feeling of his works. Near and far are, however, only the most obvious elements on either side of a more basic polarization within Caillebotte's vision. One can trace equally well, for example, a similar division between the unique and the patterned in his work. On the one hand, in his figure drawings, he stresses the

individual, arbitrary, inelegant lumps and folds of clothing; and he is highly sensitive to the rich character of idiosyncratic silhouettes (Pls. 10 and 18). At the same time, his is an eye that everywhere sees regular patterns, finding elements of repetition that link individual forms: most obviously in regular structures, but also in echoed poses (Pl. 14), in the love of stripes (Pls. 8 and 14) and in the cinematic-sequential similarities that link figures in groups (Pls. 8, 18, and 43).

This latter dichotomy could in turn be subsumed under another, between the random and the ordered. The sense for the isolated and the unique belongs to that part of his sensibility which is attracted to the specificity of the arbitrary flux of life: the thing, the person, and the moment seen as disconnected fragments of space and time. The contrary attraction to pattern and repetition, on the other hand, clearly belongs to the sensibility that arranges these disconnected fragments by imposing a unifying regular order, making the casual permanent, freezing the moment into suspended duration. Often, especially in Caillebotte's early work, it is the subtle struggle between these two aspects that makes figures, random and specific, slightly disjunctive from space, constructed with insistent regularity. This tension gives those images their special character: the immediacy of experience plus a force of organization more vividly permanent than experience normally contains.

This expanded understanding of Caillebotte's concerns can enrich our previous consideration of his relation to Impressionism. The revolutionary nature of Impressionism was, after all, twofold. It combined heightened sensitivity to the specific nuances and ephemeral immediacies of unstudied visual experience with the more obtrusive presence of the non-mimetic artifice of painting—in Degas's prominent two-dimensional design and Monet's detached strokes, for example. It is an art whose relations with the world are marked simultaneously by a greater keenness of experience and a greater detachment; and to this extent, the oscillating ambivalence of Caillebotte's art is intimately involved with it. A crucial difference, though, intervenes.

In the other Impressionists the duality exists as a substructure. Caillebotte, however, moves it to the forefront of his, and our, awareness. On the one hand, his idea of realism, and doubtless a certain lack of self-confidence in draftsmanship as well, rarely allows him to detach himself from detail and move into comfortable generalization: on the other, his perception of abstract pattern exerts an exceptionally strong force in his vision, prohibiting easy naturalism. Thus his pictures seem to wind up being illustrations of, rather than realizations of, the Impressionist sensibility. Thematically, the fascination with the isolated spectator seems to demonstrate this kind of self-consciousness about the ambivalencies of involvement in, and aesthetic detachment from, experience.

The other Impressionists, Degas being the most relevant example, brought vivid life from high artifice; Caillebotte changes the emphasis, often making life itself seem artificial. The love of design never interferes with Degas's ability to render convincing movement, in a dancer, a pedestrian, a shop-girl; but Caillebotte's self-consciousness about pattern threatens from the beginning to get the better of his figures. In the *Temps de pluie* (Pl. 18), the architectural order literally takes hold of the life of his strollers; and eventually, in the pictures of 1880 where pattern dominates, the self-consciousness seems explicit revealed as a barrier in the way of experience (Pl. 45). From this inescapable awareness of the artificial stems Caillebotte's particular sensitivity to inert, man-made structures (buildings, balconies, bridges) rather than natural forms—to a degree that even his still lifes often deal with nature explicity denaturalized by human patterning more obviously artificial than simply artful (Pls. 48 and 49).

This is not to say that artificial order incapacitates Caillebotte's art; as certainly as it blocks one kind of experience, it provides another. Originally a system at the service of expression, constructed order comes, in the *Temps de pluie*, to be an expressive element in itself, thwarting the anxiety of space, randomness, and external life, but fostering a new awareness of detachment, both as an artistic viewpoint and a life condition. Furthermore, though the most

highly patterned images reduce space and human content to tempering elements (Pls. 44 and 45), they are far from moribund. Paradoxically, it is the engagement with life in the early pictures that results in greater stiffness, while the later, "inert" patterns call forth some of Caillebotte's most exuberant, spontaneous painting.

Such shifts in Caillebotte's art, and indeed the rhythm of its whole development, evince not only a changing dialogue with the world but a continuing dialogue within himself, between the mind and the eye. Caillebotte's recurrent explorations of situations of visual ambiguity (Pls. 15, 34, and 39) show that he had a sophisticated awareness, parallel to that of the advanced psychologists of his time, of the disparity between the world as the eye receives it and the world as the mind perceives it. It might be tempting, then, to say that the dichotomy we have been dealing with in his art illustrates a specially developed self-consciousness about the tug between the chaos of external sensations, in distant randomness and fragmented singularity, and the power of mind, in close order and pattern. His development could then be seen as a movement from youthful work in which rational order is a willed imposition to mature work in which it is a constant factor of experience. However, such a model of progress from dilemma to solution is inadequate, as the oppositions are less simplistic and the different solutions equally ambivalent.

Neither side of the dichotomy belongs wholly to the eye or the mind. Both belong to the eye, in the sense that he finds both structures—plunging deep space and irregular randomness, as well as closed space and repetitious order—pre-formed in the world, and presents them to us as unaltered visual experience. But, more importantly, both belong to the mind, in that no visual experience is for him without consciously sensed and communicated subjective response. It is in fact the subjective response that enables or produces the visual experience. Space, for example, is perceived in terms of personal extension, as a field of human contact. This is why space is most disturbingly urgent in the early horizontal pictures which imply potential for contact with strangers, while the later, theoretically more vertiginous plunges down from above are far less involving, and the greatest spaces in all his pictures—the empty landscapes—are the most uncannily placid. It also explains why Caillebotte's range of concern is so narrow. In his best years no landscapist, he is also no explorer, like Degas, of worlds outside his own: no low-life, and no realm of performing artifice. He paints only those things that are part of his experience in the sense of mind, not only of eye, things that he both knows and feels. He knows above all modern urban experience, in surface and in depth, in the street and in the individual consciousness: the sweeping energy of vast scale and the phenomena of the boulevard's chaotic social variety, but also the depersonalization, detachment, and invidual isolation these same experiences engender. The energetic rhythm of his early years is the pulse of this urban existence, and the straight horizon of the later landscapes, like the flat line of an undisturbed oscilloscope, signals peace, but also the absence of an essential force.

Caillebotte's painting is neither solely for the eye nor solely for the mind. If we seek primarily facility of brush and outspoken command of draftsmanship, we shall—though many of his paintings hold up absolutely on these counts—turn elsewhere. If, on the other hand, we try to make of him simply a self-conscious intellectual stating propositions, we shall neglect the deep involvement with lived reality that informs both the beauty and the feeling of his images. Recognizing reality as neither simply external nor simply internal, it is his unwillingness to compromise either aspect that makes him seem awkward or incomplete as an artist in some traditional senses, but wholly authentic as a sensibility in a particularly modern way. Beyond realism or design, it is this authenticity of life of the mind that rises above the inconsistencies of his career, that resonates with special personal power in his best works, and that draws us to him.

3 *Caillebotte's Space* WITH PETER GALASSI

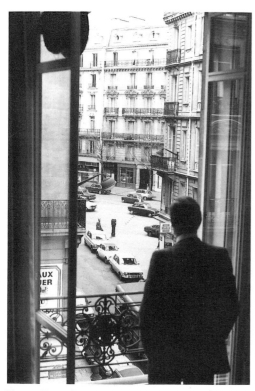

Fig. 1. View from the corner window at 77, rue de Miromesnil (compare Caillebotte's painting, Pl. 10). 55 mm. lens. (Author's photo.)

None of Caillebotte's pictures seems as faithful to visual reality as the tightly detailed paintings of 1875–77. At the same time, none seems so consistently peculiar, even bizarre, in spatial structure: looming foregrounds, tiny backgrounds, and exaggerated convergences. This hybrid nature, a central source of their interest and appeal, is the direct result of Caillebotte's control. The pictures are deliberately true, and deliberately abnormal. Based on the methods of objective realism, they distort the world in a personal fashion that looks simultaneously to the past and the future of painting.

First, in terms of mechanics, the evidence is clear that Caillebotte's early pictures were constructed according to the dictates of the most time-honored system for producing an accurate rendering of the world: Renaissance perspective. The convergences that seem so dramatic, in the *Pont de l'Europe* (Pl. 15) and in the *Temps de pluie* (Pl. 18) for example, were ascertained with an accuracy not simply intuitive, but geometrically objective. The evidence is only slightly less clear that these same pictures were also built with the aid of a camera. Apparently the two methods were used in tandem. Originally tracing major guidelines from a camera image (either from a photograph or directly from an image on a camera's ground-glass), Caillebotte used these lines as a base for the construction of a complete perspective, with straight-edge and calculations (see Chapter 4 for fuller consideration).

Both photography and perspective served Caillebotte as tools. It is significant to know that he used them, because they demonstrate his serious commitment to accuracy; but it is even more important to understand the special way that he used them. The camera, boasting scientific objectivity, and perspective, boasting mathematical infallibility, both guarantee a convincing illusion of the world as we see it, *if*—and herein lies the crucial point—they are used in the proper fashion. If used "improperly," both perspective's rationality and the camera's science can produce images that, though mechanically accurate, grossly distort normal visual experience. This is precisely the potential that Caillebotte exploits.

Perspective systems include conventions of "normal" vision and set rules about how best to imitate what the eye sees. One of the most basic rules has always been that the image should not, to be normal or natural, depict too wide a field of view. Perspective manuals advised the artist to imagine his picture as a window onto the scene to be depicted; and then to stand a proper distance back from the window, so his eye, and eventually the eye of the picture's viewer, could easily take in the framed scene as a whole.[1] For purposes of perspectival construction, this meant moving the point that represented the eye's viewpoint far enough away from the picture's rectangle. The correct distance depended on the width of that rectangle "window" itself; the leading academic textbook of Caillebotte's day, for example, told the artist to set the point back from the picture by three times the picture's width.[2] In the *Pont de l'Europe*, however, calculations show that Caillebotte's viewpoint was five times closer than this, and his field of view almost four times wider than the academician's "normal."[3]

Such a wider field does not simply change the amount seen. If the width of the window

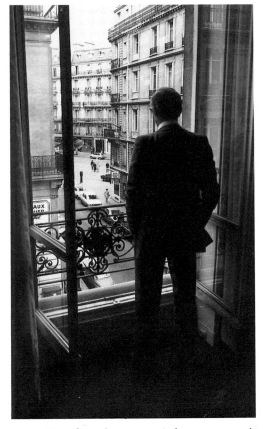

Fig. 2. View from the corner window at 77, rue de Miromesnil (compare Caillebotte's painting, Pl. 10). 28 mm. lens. (Author's photo.)

stays the same, but more of the scene is framed in it, obviously the whole system of proportions and perspective relationships within the scene must change. These changed properties, embodied in an image made from a too-close viewpoint, were predicted by perspective teachers in terms such as "horrifying anamorphoses" and "monstrous deformations."[4] The same effects can easily be demonstrated with a camera, since changing a lens length produces the same effect as moving the viewpoint in a construction: the longer the lens, the narrower the field of view. Photography, too, has always had an idea of a "normal" lens length for each size "window" frame of film. With a modern 35mm. film format, for example, a 55mm. lens is considered the "normal" lens because, like the "normal" viewpoint distance in perspective, it produces a width of view thought most like the eye's normal vision of the scene.[5] If we return to Caillebotte's sites, we will find that such a "normal" view of each site has no rapport with the corresponding view by Caillebotte (Figs. 1, 2, and 3). In order to recreate the look of the paintings, we must use a substantially shorter, wide-angle lens. Only this much broader "window" allows us to take in the whole scene of each work from the up-close points where Caillebotte stood (Figs. 4, 5, and 6).[6] The distortions created in the process are exactly those of the paintings: the foregrounds are now splayed and enlarged, the backgrounds diminished, the convergences made to seem more acute, and the overall sense of space profoundly altered. These are precisely the "monstrous deformations" of normal experience predicted by the perspective teachers; a perspective projection of these large scenes from these too-close viewpoints would of necessity show the same alterations of space and scale relationships. These are, then, structures true to mechanical objectivity, but unsettlingly untrue to normal visual experience; as the academician described it, they deny the world as the soul knows it and substitute the world as only the inhuman "eye" of geometry can see it.[7]

Wide-angle phenomena are the fundamental basis of the "family resemblance" among the spatial structures in Caillebotte's work from 1875 to 1877. However, there are variations from picture to picture such that no single angle of vision pertains to all the works. Also, and more importantly, the wide-angle perspective is only one factor in the compositions. Its acute convergences and scale discrepancies are only an issue because Caillebotte made them so, by positioning figures or objects extremely close in the foreground, by consistently setting the vanishing point far to one side, and by using prominent empty spaces to emphasize the

Fig. 3. View up the rue de Vienne toward the Place de l'Europe (compare Caillebotte's painting, Pl. 15). 55 mm. lens. Note that the girder structure on the right in the painting was taken down in 1930. (Author's photo.)

Fig. 4 (far right). View up the rue de Vienne, looking toward the Place de l'Europe (compare Caillebotte's painting, Pl. 15). 24 mm. lens. (Author's photo.)

Fig. 5. View from the rue de Turin, looking toward the rue de Moscou (compare Caillebotte's painting, Pl. 18). 55 mm. lens. (Author's photo.)

Fig. 6 (far right). View from the rue de Turin, looking toward the rue de Moscou (compare Caillebotte's painting, (Pl. 18). 24 mm. lens. (Author's photo.)

Fig. 7. Projection of a pyramidal form. Diagram from A. Cassagne, *Traité Pratique*. Note use of triangular ladder as model (compare ladders in Caillebotte's painting, Pl. 17).

Fig. 8. Construction of a perspective on an inclined plane. Diagram from A. Cassagne, *Traité Pratique*. Note double vanishing points (compare Caillebotte's drawings, Pls. 15f, g, and h).

Fig. 9. Projection of a form seen from an elevated corner viewpoint. Diagram from A. Cassagne, *Traité Pratique* (compare the piano in Caillebotte's painting, Pl. 12 and also drawing, P. 12a).

Fig. 10. Placement of figures in space on a horizontal plane, Diagram from A. Cassagne, *Traité Pratique*. Note advice to pass horizon through eye level of nearest figure, suspend other figures from that line (compare Caillebotte's painting, Pl. 18).

Fig. 11. Projection of a circle parallel to plane of space. Diagram from A. Cassagne, *Traité Pratique*. Note eliptical distortion from odd viewpoint (compare table in Caillebotte's painting, Pl. 13, and traffic island in Pl. 43).

breadth of the foreground and the swiftness of movement into the background. Elsewhere in the book, in Chapter 2 and in the discussion of individual paintings, I consider the expressive capital Caillebotte made of these devices, stressing over-wide isolation between figures, and the inhuman scale, regularity, and anxious over-openness of modern Paris. In seeking the origins of his spatial structures, it is important to realize that the impact of these pictures depends not only on a variety of different devices, but also on a complex coordination in which the parts assume meaning only within the whole. The wide-angle view by itself could, perhaps, be argued to be an inadvertent quirk of method, but the combination of devices makes it unequivocally clear that Caillebotte intentionally, systematically reinforced the initial subversion of normal spatial experience.

The other individual effects that contribute to Caillebotte's vision of space are, like the basic wide-angle warp, anomalies and/or violations of standard academic order. For this reason, one book in particular seems especially relevant to his method: Armand Cassagne's *Traité Pratique de Perspective* of 1858, published in a new edition in 1873, just prior to Caillebotte's academic training.[8] Cassagne includes a wealth of illustrated discussions of perspectival problems of all kinds, including both the normal and unusual situations, and even the very motifs Caillebotte confronted in 1875–88 (Figs. 7, 8, 9, and 10). Most especially relevant, however, is the fact that, while joining others in warning against the potential oddities of perspective, he is exceptionally clear in illustrating these oddities. His discussions of the anomalies of off-center vanishing points (Fig. 11), odd angles of view (Fig. 12) and too-close wide-angle views (Fig. 13) all demonstrate characteristic devices Caillebotte employs.

Such demonstrations could certainly have been grist for Caillebotte's mill. However, all perspective teachers inveighed against these effects as grotesque aspects of dread abnormality, offenses against reason and art; even in the most graphic of cases, such as Cassagne's, they were dealt with obliquely, as abstract problems.[9] Photography, on the other hand, would seem to have had not only the means but also the greater freedom from tradition to give reality to these unconventional, abnormal ways of seeing. For example, wide-angle lenses equal to Caillebotte's view fields—and with the same potential for stretching space—were common from the 1860s onwards.[10] As technical advances made photography more flexible and released it from the studio pose, the 1860s and '70s saw a steadily rising tide of less conventional photographic images, especially in city views, with exaggerated deep-space

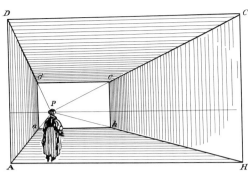

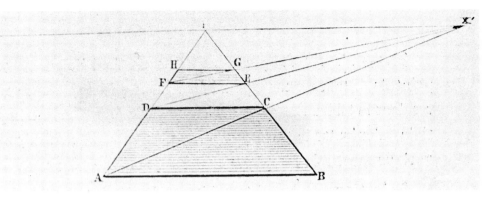

Fig. 12. Effect of vanishing point placed far to one side. Diagram from A. Cassagne, *Traité Pratique*. Note use of imaginary tunnel: painting is central rectangle (compare Caillebotte's painting, Pl. 15).

Fig. 13. Projection of a rectangle, with effects of different distances of points of view. Diagram from A. Cassagne, *Traité Pratique*. Note distortion of shape in foremost figure, from viewpoint "too close" (compare floor in Caillebotte's painting, Pl. 8).

Fig. 14. Alphonse Liebert, *Poste Caserne de la Bastille*, 1870–71. Photograph, albumen-silver print. 4 × 5 in. Plate 38, Vol. 1, *Les Ruines de Paris et de ses environs: 1870–71. Cent Photographies par A. Liebert*. Text by Alfred d'Auney, Paris, 1872.

convergences, peculiar viewpoints, and eccentric "snatch-of-life" figure compositions.[11] Occasionally, we even find a photograph of the day that seems directly to parallel an aspect of Caillebotte's structures (Figs. 14, 15, and 16). It would be tempting then to assume—especially since it seems he used a camera for initial guidelines—that photography provided the models for Caillebotte's unusual compositions. Such a hypothesis is, however, only viable in a limited sense. Nineteenth-century photographers worked from a strong bias that their images should mirror nature—that is, that photographs should reflect the normal conventions by which art saw the world; and thus they, just as assiduously as the perspective professors, sought to exclude anti-artistic deformations of the normal.[12] Serious photographers of the day not only did not explore, but in fact consciously avoided and suppressed, the very effects Caillebotte sought out. Only untutored amateurs blundered into the realm of the abnormal (e.g., Fig. 17), and never controlled the curiosities they found there.

Certainly a man of Caillebotte's day, with his interests and visual intelligence, would have looked closely at photographs. Just as perspective provided Caillebotte with a general model of disciplined order, photography almost certainly provided a model of realism to which he responded: a truth to optical fact at the expense of conventional normality. Neither Cassagne's tiny diagrams nor photography's erratic accidents, however, offer any model for the larger structure of the pictures of 1875–77, for the complex coordination with which Caillebotte exploited so effectively the expressive possibility of optical "errors." It took

Fig. 15 Anon., *L'ancienne place Sainte-Marguerite*, c. 1866. Collection Yvan Christ, from *Les Metamorphoses de Paris* (compare Caillebotte's paintings, Pls. 40, 42).

Fig. 16. Samuel Bourne, *A View in India*, 1863–70. Photograph, albumen-silver print, 29.2 × 23.5 cm. (compare spatial effect in Caillebotte's painting, Pl. 17).

Fig. 17. Martial Caillebotte. (unidentified buildings). c. 1880–1890. Photograph. Note drastic perspectival convergence caused by Martial's standing too close to buildings—a typical mistake of amateur photography of the day.

Fig. 18. Ando Hiroshige, *Nighttime in Saruwakacho*, from *One Hundred Views of Famous Places in Edo*, 1857. Color woodblock print

Fig. 19. Ando Hiroshige, *View from Kasumigaseki*, from *Famous Places in Edo*, 1854. Color woodblock print.

photographers several decades to approach in this regard Caillebotte's sophisticated control of the innovatively eccentric.[13]

Control is the key word in any consideration of the special peculiarities of Caillebotte's spatial designs. The designs are no more simply freaks of mechanical systems than they are naive realist documents. From conception to conclusion they are deliberately controlled, and every evidence shows that the artist knew exactly what he was after. It will not suffice, then, to analyze the tools that produced, and the scattered oddities that may have suggested, individual aspects of these designs. We must instead ask the source of the artistic vision as a whole, the possible model for the overall structuring of these special, essentially anti-normal visual devices.

One such model may lie in Japanese art (which we know Caillebotte admired), in a specific kind of woodblock print that employs, with a naive rigor, the conventions of Western perspective. A view like Hiroshige's night scene of Edo (Fig. 18)—exactly the kind of popular print Caillebotte would have known—resembles strikingly the spatial design of the *Pont de l'Europe*. A long tradition of non-perspectival space left Japanese artists unconcerned with deformations such as extra-sharp convergence, which they enjoyed simultaneously as surface pattern. Combined with a similar lack of concern for rapid diminution of figure scale, this kind of vision bore results that have interesting similarities to Caillebotte's work (Fig. 19). As abstracted, concentrated spatial designs, such images might have informed the spare clarity of Caillebotte's conceptions—an austerity alien to the profuse clutter of contemporary boulevard photographs, for example.

We need not go outside the Western tradition, however, to find precedents for Caillebotte's spaces. If we look back to the time of the codification of perspective itself, on the peripheries of "normal" Renaissance perspective, we can find several artists whose spatial structures bear significant resemblances, not just in detail but in conception, to Caillebotte's early work. The rigid order, strong central vanishing point, and large-scale discrepancies of the *Temps de pluie*, for example, cannot help but recall the work of Piero della Francesca, especially in his *Flagellation* (Ducal Palace, Urbino); while the off-center vanishing points and hyper-exaggerated spatial convergences of works like the *Pont de l'Europe* find a precedent in the work of Mannerist artists such as Tintoretto, as for example in his *Last Supper* (S. Giorgio Maggiore, Venice). Caillebotte's attraction to the confounding anomalies of optical distortion, seen clearly in the later *Intérieur* (Pl. 34), also have their parallel in Mannerism, in a work like Parmigianino's distorted *Self-Portrait in a Convex Mirror* (Kunsthistoriches Museum, Vienna). Though Caillebotte did travel to Italy in 1872, and though copies after Piero were available in Paris, he may never have seen the relevant works. Whether he did nor not, the analogies have an independent significance.

If we can look past the time-locked details of Caillebotte's scenes, the top hats and frock-coats, we may find that beyond being visually just, the comparisons across centuries have a certain base in logic. At the time of the development and codification of perspective, when a standard of its "normal" use was not yet entrenched, it was more susceptible not only to the deformations of error, but to those of experimentation. In the 1870s, when deep space began progressively to be annuled in painting, and a way beyond naturalism was sought, it is understandable that a new detachment from standard perspective, probably in part provoked by photography, would have led to similar explorations of the peripheral, abnormal possibilities of spatial construction. Caillebotte's devotion to perspective's truth at the expense of naturalism, and his exaggeration of perspective's presence by artificial coordination of figure placement with the design, revives, for example, the kind of fascination with the system found in Uccello. Since the combination of consistency and inventive evolution in Caillebotte's paintings of 1875–77 would seem to make the search for some single specific visual model a futile, misdirected one, this kind of general parallel in attitude may be the most helpful key to understanding the special nature of the spaces.

Aside from conceptual similarities and the more evident aspects of hyper-perspective,

Caillebotte's space in fact resembles fifteenth- and sixteenth-century space in quite substantial and consequential ways. In the *Temps de pluie*, for example, Caillebotte used a particular late-Renaissance device, and to much the same end. Each figure in the scene is conceived from a separate, face-on viewpoint, rather than being distorted to conform to the central spatial system; so, too, are portions of the foreground pavement (see Chapter 4 for fuller consideration). Such discrepancies might not be noticeable in a smaller work, but in this large canvas the lateral multiplication of viewpoints has the effect of partially cancelling the deep space and affirming the flat surface. As a French writer on perspective noted in 1859, Raphael used just such a mixed perspective system in the fresco *The School of Athens*, relating each figure in the scene to the wall surface rather than to the central architectural vanishing point.[14] The same system is even more in evidence in Raphael's later frescoes in the Vatican, and is a familiar effect in the dream-like visions of Mannerism.

Furthermore, Caillebotte's particular, unstable combination of separately considered, highly specific details and figures, with strongly exaggerated regular perspective, suggests the hybrid that occurred in Northern European countries when Italian perspective systems were introduced. An artist such as Albrecht Dürer, devoted to scupulous realism but equally obsessed by the desire to rationalize space, often arrived (apparently by virtue of confusion over perspective methods) at expressive "errors" that are similar in structure to Caillebotte's deformations.[15]

It may seem impossible that Caillebotte's space could bear valid comparison simultaneously to two such profoundly different artists as Raphael and Dürer. This split is, however, built into the very center of Caillebotte's concern for perspective. On the one hand, in a Northern fashion, he is attracted to perspective as a device not only for evoking space but for heightening our awareness of its pull. On the other hand, in a more Mediterranean vein, he is attracted to the ideal properties of perspective as a logical system of order in design, to the point of its existing independently of a single viewpoint and in contradiction to spatial plunge. This bivalence is, moreover, central to Caillebotte's special relevance to the generation that followed him.

Caillebotte's careful attention to perspective as a system of idealization and rational domination of pictorial space links him directly to Seurat and eventually to others with strong formalist concerns. In the *Grande Jatte*, for example (Pl. 18g), Seurat employs not only the same part-by-part traditional system of preparation that Caillebotte does in the *Temps de pluie*, but also exactly the same multiplication of figural viewpoints, laid across a basically unified space, to flatten the picture and assert the surface.

By contrast, Caillebotte's manipulation of perspective to produce overwrought sensations of depth links him to Munch, Van Gogh, and later artists of Expressionist bent. Van Gogh in fact greatly praised Cassagne, the same perspective writer who seems so relevant to Caillebotte; and, in his application of Cassagne's principles, Van Gogh introduced precisely the same "error" of moving his viewpoint too close to the construction plane—with the same results of accelerated rush and distended proportions (Fig. 20).[16] The connection is more direct in the case of Munch, who virtually copied directly one of Caillebotte's motifs and may have known the artist himself (see Pl. 41). When we study one of the most disturbed spatial images of the late nineteenth century, Munch's *The Scream* (Fig. 21), and trace it back to its original conception sketches (Figs. 22 and 23), we find that the basic aspects of urgent, skewed recession, looming foreground figure, and rapid diminution of figure scale, all amplify devices already found in—and perhaps literally adapted from—Caillebotte's *Le pont de l'Europe*.[17]

Hindsight permits us to see these kinds of possibilities latent in Caillebotte's work, and they are undeniably interesting additions to our understanding. However, in dissecting and identifying the mechanical, formal, and expressive aspects, we should not lose sight of the way they merge so seamlessly in the pictures themselves, and, moreover, how convincing and compelling these picture are as spatial experiences. The fascination of the spaces results neither

Fig. 20. Vincent van Gogh, *Road Near Loosduinen*, 1882. Black pencil and ink, heightened with white, $9\frac{1}{2}$ × $13\frac{1}{2}$ in. Van Gogh Museum, Amsterdam.

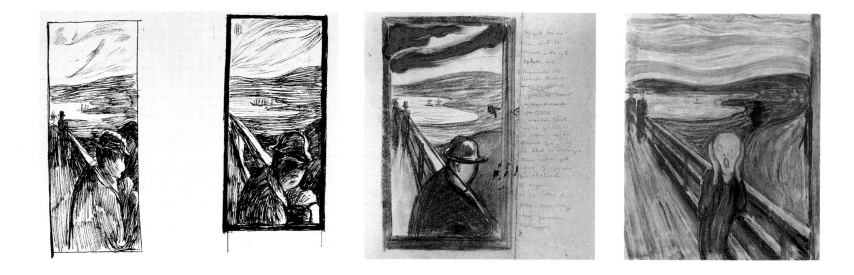

Fig. 21. Edvard Munch, *Despair*, projected illustrations for Emanuel Goldstein's *Alruner*, 1892–93. Pen and ink on paper, 6⅞ × 10⅞ in. Oslo Community Art Collection, Munch Museum, Oslo.

Fig. 22. Edvard Munch, Sketch for *Despair*, 1892–93. Charcoal and oil on paper, 13¾ × 18⅛ in. Oslo Community Art Collection, Munch Museum, Oslo.

Fig. 23. Edvard Munch. *The Scream*, 1893. Oil and pastel with casein on cardboard, 35⅞ × 29 in. Nasjonalgalleriet, Oslo.

wholly from what is correct nor wholly from what is wrong, but from the almost undetectable, subliminal conjunction of the two. The deliberate lies come to us with the disarming conviction of truth, making us more vulnerable to their inroads. This cloaking of abnormal distortion in the sheep's clothing of apparently objective realism is a principle later understood and exploited by the Surrealists, who had a similar ambivalence about the emotional properties lurking in the experience of space.

Caillebotte's space is basically orthodox in method, objectively ordered, and traditional; that it should be at the same time distorted, intuitively subjective, and avant-garde is extraordinary. That all of this should stand before us as realism, with the unconscious synthetic wholeness of lived space itself, is endlessly fascinating and moving.

4 *Caillebotte's Method* BY PETER GALASSI

Caillebotte's paintings of the mid-1870s were carefully and often complexly constructed. His method was most complex for two large, ambitious street scenes: *Le pont de l'Europe*, 1876 (Pl. 15) and *Rue de Paris; Temps de pluie*, 1877 (Pl. 18). The surviving preparatory works for these two pictures make it possible to reconstruct Caillebotte's method in detail.[1]

The analysis draws upon and supports the interpretations offered elsewhere in this book; but as little as possible has been repeated, and the reader who is familiar with those interpretations may find what follows more accessible.

In general, the preparatory works for the *Pont de l'Europe* and the *Temps de pluie* seem to have followed this order:[2]

a. a small drawing of an empty architectural setting, made without a straight-edge.
b. a careful perspective drawing, made with a straight-edge, essentially reproducing *a* but adapting minor discrepancies to the linear construction.
c. drawings and oil sketches of figures and details of architecture.
d. oil sketches for all or part of the picture that pay only cursory attention to the perspective construction and are presumably intended to give an idea of how the figures will fit in the space and of the overall color scheme.
e. a modification, achieved in the finished painting, of the number and position of figures and of the perspective construction, in such a way that an artificially contrived structure is presented as an objective depiction.

This persistent tinkering, in which no detail of the picture is fixed until its relationship to every other detail is resolved, is the subject of the following analysis.

It is remarkable, however, that steps *b* through *e* are only tinkering; the complex real space, accurately depicted in the first drawing, *a*, changes very little. This fidelity to a specific site is important, first, because it provides a mask of realism for a highly contrived order; second, because we can compare the pictures with their respective sites in order to determine the nature of Caillebotte's subtle deviations from straightforward perspective.

There is evidence, though it is not conclusive, that the pictures' fidelity to their sites is founded on photography or on the use of an optical drawing aid, such as a *camera lucida*. There are six paintings by Caillebotte that originate in very small drawings, as small as seven percent of their final size.[3] Three of these drawings are on tracing paper, and all are compatible with photographic plate sizes used by Caillebotte's brother Martial, or with other contemporary photographic formats.[4] The squared drawing (Pl. 20c) for *Canotiers* (Pl. 20), especially implies tracing from a photograph. It measures 8 × 11.5 cm.; Martial Caillebotte often used a plate measuring 9 × 11 cm. The drawing's lines are even and awkward, unlabored and without pentimenti, as if no effort was required to block out the difficult and highly foreshortened spatial configuration. Yet they are essentially accurate and, although refined in the finished work, provide its plan.

The initial drawing (Pl. 30a) for Caillebotte's *Paul Hugot* (Pl. 30) is equally suggestive of a

photographic source. The finished painting measures 204 × 92 cm., but the preparation for it began with this drawing on tracing paper, whose ruled borders measure 14 × 7.2 cm. The vertical dimension of the drawing is precisely that of a cabinet photograph, which by 1880 had replaced the smaller *carte de visite* as the most popular portrait format.[5] The tracing-paper drawing, squared for enlargement, clearly served as the basis for the much larger intermediate charcoal sketch (Pl. 30b), which might otherwise appear to be a life-drawing. Without the explanation of a photograph, Caillebotte's choice of such a small format to begin work on such a large picture would seem very curious.

The following analysis of the *Pont de l'Europe* and the *Temps de pluie* will reinforce this circumstantial evidence that Caillebotte based some pictures on photographs. The proposition is also supported by a consideration of the characteristics shared by many of Caillebotte's paintings and photographs he must have known—an issue that is taken up in Chapter 3.

Nevertheless, nineteenth-century photography offers no counterpart to the highly calculated organization of Caillebotte's early pictures. If indeed Caillebotte made use of photographs, they provided only a starting point for a series of complex pictorial maneuvers.

Le pont de l'Europe

The chosen point of view is significant: the painter faces a rising incline, but the trellis that supports this rising street and railing is horizontal (see photograph of the site, Pl. 15e). In the finished work figures and steam obscure clues to the rise of the railing along the trellis, so that the viewer reads them as parallel in reality. As a result, the *actual* convergence of the railing and trellis collaborates with the *apparent* convergence of perspective to make the space seem much deeper than it really is.[6]

The *Pont* and the *Temps de pluie* contain other related optical illusions, most of them slight deviations from technically correct perspective. But the essential trick of illusion in the *Pont* is not a deviation. On the contrary, the effect of deeper space stems from an idiosyncrasy of a specific site and depends for its impact on technical pictorial fidelity to that site.

Work on the picture appears to have begun with three drawings (Pls. 15f, g, and h, the first two on tracing paper), in which fidelity to the site is first established and then subtly altered. In the terms of linear perspective, the viewer's assumption that the trellis, railing, and sidewalk are parallel means that we read them all as meeting at a single vanishing point. Since, in fact, the sidewalk and railing are not parallel to the trellis, there should be (in a faithful perspective construction) two vanishing points: one for the trellis, another above it for the sidewalk and railing. The perspective construction that Caillebotte developed in the drawings reproduced as Pls. 15g and 15h is faithful to the site in precisely this respect; two vanishing points are visible in each drawing. The higher of the two points marks the convergence of the rising sidewalk and railing; the lower point marks the convergence of the horizontal trellis. By hiding the construction with figures and steam, Caillebotte was able to engender a false reading of a technically correct picture. Given the sophistication of his method, he certainly would have been aware that his choice of site would require a construction based on two vanishing points; Cassagne's *Traité Pratique* would have told him so (see Chapter 3, Fig. 8). It is thus conceivable that he would have begun with constructions like Pls. 15g and 15h.

The easiest and most direct way, however, faithfully to transfer the complexities of the architecture to a two-dimensional surface was by means of a camera. The evidence of the drawing reproduced as Pl. 15f supports this second possibility. The main receding lines and distant architecture of this drawing are made boldly, without a straight-edge. Yet these lines are so accurate as a projection of the bridge that the two vanishing points defining a proper perspective construction of the view are implicit in the drawing. Indeed, it is by tracing from Pl. 15f with a straight-edge (to produce Pl. 15g) that Caillebotte determined precisely where the points should be. Given that Caillebotte chose the site for its challenge to conventional

Fig. 1. Site plan for *Le pont de l'Europe*. This plan of the Place de l'Europe is adapted from a 19th-century plan from *Paris Nouveau Illustré* (supplement to *L'Illustration*), No. 14, n.d. Bold lines indicate the iron trellises that support the Place and the streets that run into it. (The rues de St. Petersbourg and Berlin are today, respectively, the rues de Léningrad and de Liége.) The blank polygons that interrupt the bold lines represent the stone pylons that support the trellises. (See contemporary photograph of the trellis supporting the rue de Vienne [Pl. 15e]). Dotted lines represent the false positions indicated in the painting for buildings A and B and for the trellis between the painter and building A. The small dotted rectangle enclosing the rue de Vienne represents the portion of this plan that is enlarged in Fig. 2.

illusion, it is improbable that he could have recorded it so precisely in freehand—an improbability that is emphasized by the difficulty of recording (let alone conceiving in the eye) such a wide view (approximately 80°; see plan, Fig. 1). The main lines of Pl. 15f, then, like the initial drawings for *Canotiers* and the *Paul Hugot*, may well have been traced from a camera image.[7]

Whether or not the main lines of Pl. 15f are based on a camera image, the lattice of crossing girders was produced independently. The girders are consistent (with reasonable error) to a single projection, but one that is different from the perspective that governs the main receding lines.[8] This fact will play a role later in the analysis of the picture.

Barring further evidence, it cannot be proven that Caillebotte based his pictures on photographs. But the evidence we do have is significant in its own right, for it demonstrates that Caillebotte took pains to begin work with a faithful representation. No matter how Pl. 15f was made, its main lines provide a correct projection of the site. Because it is correct, this drawing can serve as the basis for a consistent perspective construction. Strict fidelity to the site can then be abandoned, yielding its standard of correctness to the constructive system. Subsequent changes in the picture can therefore be both false (to the site) and true (to the construction). Because the construction is based on a correct projection of the site such deviations, if they are not radical, can significantly affect the viewer's experience of the depicted space without seeming to alter its contents. This is the basis but by no means the whole of Caillebotte's method.

Caillebotte's treatment of the sidewalk on which the viewer and figures stand is a simple example of the application of the method to the *Pont*. He widens the angle between the right edge of the sidewalk (where it meets the railing) and the left edge from 80° in Pl. 15f to 83° in Pl. 15h to 85° in the finished picture. This change exaggerates the spatial plunge. Similar experiments with the angle between the railing and the top of the trellis are carried out in each drawing and sketch, although this angle returns in the final picture to match its counterpart in Pl. 15f.

Caillebotte's treatment of the distant buildings on the left (A and B in the plan, Fig. 1) is a much more radical departure from fidelity to the site. In Pl. 15f the buildings are shown, faithfully to the site, as oblique in orientation to the trellis (see plan, Fig. 1). Already in Pl. 15g he has begun to re-align their rooflines parallel to the picture's top edge. In the finished painting, the new rooflines—and the buildings' facades, now parallel to the picture plane— stress the picture's surface design. On the surface of the canvas, the receding diagonals of the main architecture form a lopsided X, at the crux of which lies the gentleman's head. The viewer's inclination to perceive these lines as a flat pattern is increased by the frontal flatness of buildings A and B. Comparison of the painting with Pl. 15f shows that, in addition to flattening the building, Caillebotte has stretched building A and the bridge section in front of it to twice their width. By doing so he allows the over-wide sidewalk room to make its plunge. Throughout the drawings and sketches, however, the painter has kept the buildings' receding right side true to the perspective construction that underlies the picture. Thus it would require on-the-spot comparison of the painting and the site to perceive that Caillebotte's manipulations of the building amount to radical redevelopment. (See plan, Fig. 1, in which the new positions of the buildings and the bridge section are indicated by dotted lines.)

This redevelopment has another and most important effect on our experience of the picture, one that can be described only in the terminology of linear perspective.[9] A perspective picture corresponds to a plane (the projection plane or picture plane) that intersects a pyramid of sight (whose apex is the point of view). For a given point of view and set of objects, of course, there is an infinity of correct projections, because there is an infinity of possible intersecting planes. Though all are correct and depict the same objects, each projection is different from the others. The center of vision of the picture is that point at which a line, drawn from the point of view and perpendicular to the chosen intersecting plane, meets that plane. The location of the center of vision (or central vanishing point) is important not only for the construction of the picture but for the viewer's experience of it. In the same way that a picture in central perspective implies the point of view, even when the viewer does not occupy that point, the picture also implies the direction of the viewer's gaze. Except in extremely simple, symmetrical cases, it may be difficult for the unaided viewer to locate the center of vision with precision. But it *is* possible for the viewer to say—at the very least—whether he is looking up, down, to the left or to the right, at the depicted scene.

For our analysis, it is important to note that a change in the orientation of the picture plane results in a change in the location of the center of vision. In other words, a change in the orientation of the picture plane results in a change in the implied direction of the viewer's gaze.[10]

The following analysis will demonstrate that, with a given arrangement of objects and a stationary point of view, Caillebotte composed a single picture from *two* planes of projection. (There are actually three planes, the third forming a transition between the two major planes.) The *Pont* therefore has two equally valid centers of vision: the viewer is by implication looking in two directions at once. As we look at the picture, of course, we are not conscious of this construction, though it does influence our response. One of the two major planes is decidedly dominant, and we accept it as the only plane.

The redressing of the distant buildings on the left, in addition to producing the effects already mentioned, also helps to establish the dominant projection plane and its

corresponding center of vision. Because Caillebotte realigned the facade of the distant buildings to be parallel to the top edge of the picture, we tend to read the picture plane as parallel to the facades. Moreover, we read the (in reality oblique) distant intersections, through which passes the street on which we stand, as cruciform. This reading confirms our inclination to read the trellis, which runs along the street, as perpendicular to the picture plane. Since all perpendiculars to the picture plane vanish at the center of vision, this reading also makes the vanishing point of the trellis the picture's center of vision. In other words, we are looking at the gentleman, whose head is situated precisely at that point.

The focus of our attention on this man in the top hat—a self-portrait—is perhaps more forcefully demanded by the X design on the surface of the picture. The impact of this flat design is emphasized by the realignment of buildings A and B. But the frontality of A and B *also* gives prominence to the top-hatted man in the picture's space, by locating the dominant center of vision at his head. In the single maneuver of moving and stretching those buildings, Caillebotte has all at once flattened his picture, made it deeper, and most of all, insured that in our tense oscillation between surface and depth, near and far, we have constantly in mind and eye the painter's strolling double. Of necessity these effects have been treated here as if they were separate and sequential. They are neither; and it is characteristic of Caillebotte's method that rarely is a step taken that gains a single neat end. Rather, many and often conflicting elements of the picture's structure are approached, in delicate balance and at the same time— all of this under the guise of realism.

The manipulation just described locates the dominant vanishing point of the picture far to the left. Caillebotte had already made use of radically asymmetrical placement of the center of vision in several important pictures, notably *Les Raboteurs de parquet* (Pl. 8) and *Déjeuner* (Pl. 13). In doing so, he violated a long-standing general rule that the center of vision should roughly coincide with the center of the picture, and produced the effect, as Charles Blanc put it in criticism of Le Sueur, of "half a picture."[11]

In a "whole picture," the spread of space on one side of the center is balanced by similar space on the other side, providing a stability (even in a wide view) that is not to be found in Caillebotte's "half-pictures." The *Déjeuner* and *Raboteurs* exhibit a strong tension between a dominant spatial rush toward the center of vision and a simultaneous sidelong reach toward the yawning space of the rest of the picture.

In the *Pont*, this tension between dominant and secondary centers of interest is emphasized by the gentleman's stare, which we follow from the dominant center of vision across the picture to the worker at the rail. But the perspective structure of the *Pont* is more complex than that of any picture Caillebotte had yet painted—it is a composite of two main planes of projection. The orientation of the second plane reinforces the split in our attention, since *its* center of vision is located at the head of the worker.

The worker is placed, like his wealthier counterpart, at the crux of an X—part of the girder structure of the bridge. The lattice of girders, crossing each other perpendicularly, form a series of diamonds, or bays, which recede in the picture between the top of the trellis and the railing. The worker is located at the bottom apex of the closest and largest of these diamonds, designated here as the "large bay" or "near bay." It has been noted that, from the very first drawing, the girder structure was developed independently of the main receding lines (which form the gentleman's X). From the very first drawing, too, the near bay is too wide and too high by the standard of the rest of the trellis. This jump in size persists through all the drawings and sketches to the finished picture. In Pl. 15g the top edge of the picture is lowered; and since as a result we do not see all of the large bay, its excessive size is less evident. In Pl. 15h, as in the finished painting, the girders that form the large bay are drawn from the same two vanishing points that determine the other girders, giving the large bay the right shape despite its wrong size. This latter accommodation also helps to camouflage the large bay's extra size without depriving it of its effect on our experience of the picture.

Just what is that effect? Like the widening of the sidewalk, the over-largeness of the near

bay of the trellis can be understood simply as a falsification, aimed at a sharper plunge in depth. It certainly has such an effect. But it can also—less simply—be understood not as a distortion of the architecture but as a distortion of the picture plane on which the architecture is projected. Under this latter understanding it can be determined, in geometrical terms, that the size of the large bay in relation to the trellis as a whole produces a second center of vision for the picture, and that this center is located at the worker's head.

The proof of this assertion requires another digression, this time to construct a plan of the bridge and the painter's point of view (Fig. 2).[12] By comparing the distant bridge structure that is seen through the foreground trellis with a plan of the actual site (Fig. 1), it is possible to establish not only the angle of view that is represented by the whole picture (θ), but also that portion of the angle that takes in the trellis from the right edge of the picture to the trellis' termination in a stone bulwark (behind the gentleman's companion). The latter angle (α) is 68°. It is also possible to establish the actual length of this portion of the trellis, and to determine from a contemporary photograph (Pl. 15b) at precisely which bay the worker is standing.[13] Third, analysis of the left side of the picture has shown that the painter is standing on an imaginary line (GH), parallel to the trellis, that passes through the position of his top-hatted double. Because the actual dimensions of the trellis structure are known[14] it is possible to determine, from the picture itself, the distance (GI) of that imaginary line from the trellis.

These facts can be combined to determine the painter's precise point of view. The angle of view required to encompass the section of trellis we have described is different for each position along the imaginary line (GH). Since we know the angle to be 68°, we can establish which point (P), on the imaginary line (GH), represents the painter's point of view. If we draw (dotted) lines radiating from this point (P) and passing through points representing the intersections of the girders, we can construct another line (representing the projection plane) that intersects these radiating lines at points whose distribution corresponds to the distribution of girder intersections on the surface of the canvas. It is possible, in other words, to derive from the plan the orientation of the projection plane for the right side of the picture, and consequently, its center of vision.

This is indeed the case, though the problem is not *quite* so simple, if indeed anything in this picture can any longer be called simple. Since the largest bay of the trellis is slightly too wide in relation to the other bays, a line (ACF) that gives the appropriate projection of its width in relation to the length of the projection of entire trellis will be slightly incorrect in the projected widths it determines for the other bays. In other words, the other bays, as represented in the painting, are projected on another plane (CD) that is at a slight angle to the large bay's plane (AC). This third, middle plane (CD), serves as a transition between the two major planes: one for the larger bay and worker (AC), the other for the gentleman and distant buildings on the left (DE). The center of projection for the plane (AC) is found by drawing a line from P that meets AC perpendicularly (at B). This line passes through the position of the worker, locating him at the center of vision for the right side of the painting.

If the three separate projections were fixed on their respective planes and placed side by side to form a single plane, they would closely approximate Caillebotte's finished painting, deviating from it only to the limited extent that Caillebotte has subtly blended the three planes.

The middle plane (CD) is a transition between the two main planes, forcing the trellis more sharply into depth than would the large bay's plane (AC). Recalling the drawings, we realize that the middle plane is also in a sense the *original* plane (since it corresponds to the main receding lines of the trellis), from which the gentleman's plane (DE) and the worker's plane (AC) are deviations.

The objection may be sensibly made that the deviation of AC from CD is merely a fortuitous corollary of the enlargement of the near bay, rather than a conscious attempt to locate a secondary center of vision at the position of the worker. But very little is fortuitous in the construction of Caillebotte's pictures, and two oil sketches and one detail study, which

Fig. 2. Detail of the site plan for *Le pont de l'Europe*. This diagram represents, in plan, the trellis that dominates Caillebotte's *Pont de l'Europe*. The painter's point of view is represented at P, the picture's field of view by the arc θ. The figures on the sidewalk of the rue de Vienne in the picture are represented by bold dots; the sidewalk is shaded. The structure of the trellis is represented as follows: the double lines perpendicular to the trellis indicate vertical girders, like the one to the left of the worker in the painting. The single lines indicate horizontal ties that join the intersections of the diagonal girders (e.g., the transverse tie clearly visible in the picture above and to the left of the worker).

The bold lines indicate the picture's two major projection planes (AC and DE) and the third (CD), which acts as a transition between the other two. (The construction of these planes and other as of the plan is discussed in the text.) Lines drawn perpendicularly from the two major planes to P define their planes' respective centers of vision at B (for AC) and J (for DE). These lines pass through the positions, respectively, of the worker and the gentleman. This means that in the picture the viewer's implied gaze is split between the worker and the gentleman.

follow the drawings for this picture, indicate that the painter was not only aware, but in deliberate control of the deviation that has just been described.

The two oil sketches provided the painter with the opportunity to see how the figures of his original conception fit in the architectural space he had developed on such a small scale in the drawings.[15] In both full sketches, the main receding lines of the bridge follow closely the structure established in the drawings. The criss-cross of girders is laid in less carefully, but the excessive size of the near bay is maintained at all times. The decision to place the gentleman's head at the vanishing point of the trellis already insured that he would demand attention, and the adjustments in that part of the picture can properly be regarded as sharpening this already strong effect. The problem of *also* calling special attention to the worker was more challenging. The first sketch after the drawing (Pl. 15s), deals especially with this problem. The break in the angle of the railing, occurring where the worker stands is as clear a demonstration one could ask of Caillebotte's attempt to establish a separate projection plane for the near bay of the trellis. In contrast to the space-deepening effect of the looming largeness of the near bay, this bend in the rail has the opposite effect of flattening the space. It can only be what it looks like: an attempt to bend the picture plane. (In the Rennes sketch [Pl. 15u], which follows, and which in general is more finished and complete, the break in the railing is still evident but less sharp: the deceptive blending of planes is underway.)

Even more compelling as evidence for Caillebotte's deliberate investigation of a separate projection for the worker's side of the picture is the detail oil study (Pl. 15t). It depicts only the near bay of the trellis and the railing below it. From it, however, the rest of the trellis can be constructed by projecting the railing and girders. From the construction we can find the ratio between the width of the depicted bay and the length of the projected trellis. This ratio deviates by only two per cent from its equivalent in the final painting. In other words, the projection plane of the detail study, and the projection plane of the corresponding area in the finished picture (AC in the plan, Fig. 2), have the same orientation. The center of vision of the detail thus falls exactly where the head of the worker would be if he were included in the study.[16]

The detail study may be based on a photograph.[17] Whether or not this is so, it represents a

deliberate effort to determine with precision just how the trellis and railing should look when projected on a plane whose center of vision is the position of the worker.

It has been noted that in the finished picture Caillebotte emphasized the worker by directing the gentleman's stare at him. He also added the dog, which appears in none of the architectural drawings nor in the sketches. The dog's body and movement point into space at the dominant center of vision, that is, at the gentleman. Its tail points at the worker. In a sense, then, the dog (except as a touch of realism) has no function other than to emphasize a predetermined structure of space and meaning. It is less a word in the sentence of the painting than an exclamation point.

It may be awkward to admit that so prominent an element as the dog could be added, almost as an afterthought, to a picture whose complex evolution has been equated here with management of a delicate balance. But the complexity of the *Pont* does not lie in its basic pictorial and iconographic structure, which from the initial conception was a simple opposition of one side of the picture against the other. Rather, complexity and delicacy are attributes of the *means* Caillebotte found it necessary to employ in order to give almost graphic impact to that simple structure and at the same time to maintain the impression of objective, unmanipulated realism. It is the simplicity of the picture's polar structure that allows the late appearance of the dog, which simply emphasizes the polarity. Because the dog is independent of the structure, we can conceive of the *Pont* without it as impressive, clear in meaning, and in a sense complete.

The purpose of imagining the dog's absence is not to meddle with a perfectly good picture. But this hypothetical meddling does provide a context for understanding the change in method (and corresponding change in conception and style) that occurs between the *Pont de l'Europe* and *Rue de Paris; Temps de pluie*, the enormous picture that Caillebotte painted the following year. For the latter achieves a complex interdependance of architecture and figures, of depth and surface—a dense structure that allows no last-minute dog—and a method whose arcane complexity takes on a life of its own.

Rue de Paris; Temps de pluie

In nature and sequence, the known preparatory works for the *Temps de pluie* (Pl. 18) are like those for the *Pont de l'Europe*, except that there are fewer. The first drawing for the *Temps de pluie* (Fig. 3) is not on tracing paper, nor is it small enough to have been traced from even the larger of the photographic formats that we know Martial Caillebotte used. But the drawing is close in its ruled dimension (26 × 37 cm.) to a common French plate size of the period (28 × 37 cm.).[18] The freehand sketch, which can be made out under the ruled lines, and which is an accurate description of the site, could therefore have been based on a photograph. Whether or not the picture is derived from a photograph, the essential transformation that occurs for the *Pont*—from freehand outlines to the perspective construction that is abstracted from them— also occurs for the *Temps de pluie*. In the *Temps de pluie* the transformation is accomplished, not in three drawings as in the *Pont*, but on one piece of paper.

This important transformation is followed, as it is in the *Pont*, by careful adjustments in and additions to the perspective construction, which subtly transform the work from a literal representation of the site to an ordered vision based on the site. But these changes in the *Temps de pluie* differ from those in the *Pont* in the same way that the pictures differ in structure.

Despite the secondary importance of the flat X formed on the surface of the *Pont*, Caillebotte's perspective constructions for that picture are articulated essentially in depth; the viewer's response is a response to deep space. By comparison, the surface design of the *Temps de pluie* is much stronger. The origins of the works reflect this difference. While the first drawing for the *Pont* establishes its deep asymmetrical plunge, the first drawing for the *Temps de pluie* establishes a flat, symmetrical structure, a giant plus-sign defined by the lamppost and the ruled horizon, which divide the picture into equal quadrants, organizing if not wholly

Fig. 3. Drawing for *Rue de Paris; Temps de pluie*. This drawing represents two important steps in the development of the *Temps de pluie*: 1) The freehand pencil sketch, which may have been drawn from a photograph; 2) the ruled perspective construction that is based on the sketch. The horizon, on or near which figures' heads and buildings' vanishing points fall, is faintly visible. The vertical zig-zag lines and X's indicate potential figures or objects in space, some of which survive in the finished work.

Those that do survive, and the buildings are mentioned in the text by reference to their numbered counterparts in the diagram for the finished painting (Fig. 4). Aside from the addition of figures, only one major change is made between this drawing and the final picture: Caillebotte made the picture taller by adding to the bottom, thereby emphasizing the spread of space at out feet. Some smaller changes are made in the architecture. For instance, the relationship between the edges of buildings V and VI and the right edge of the picture is altered to produce a golden section ratio (GI/HI = 1.62).

flattening the space. We notice also, in comparing the drawings for the two paintings, that the layout of buildings and streets depicted in the *Temps de pluie* is much more complex than the single span of bridge that occupies most of the *Pont de l'Europe*.

Flatness and complexity—these qualities of the initial drawing are subsequently developed, through the addition of figures, into the dense, ordered interlock of two and three dimensions that characterizes the *Temps de pluie*, and sets it apart from Caillebotte's other pictures.

In the preparatory works for the *Pont de l'Europe*, it is the architectural perspective that changes—subtly but effectively—to manipulate our response to the figures, whose final positions are fixed in the first oil sketch. In the development of the *Temps de pluie*, just the opposite is the case. Some changes are made in the architecture, but after the pencil sketch, the main problem was the addition of figures. These are of course arranged in space, and some trouble was taken to give that spatial arrangement structure. But the guiding principle of figure placement was surface order, an order that grew out of and came to dominate the architectural setting provided in the initial drawing.

How are the figures placed in the space? Since the painter's chosen point of view is at normal eye level, the horizon (defined as the horizontal line that passes through the center of vision) will pass through the head of any figure of normal height in the scene. As Cassagne's *Traité Pratique* points out and illustrates (see Chapter 3, Fig. 10) such a choice of horizon considerably facilitates the addition of figures to a view: any figure placed in an area of the picture that represents a horizontal plane (like the broad intersection in the *Temps de pluie*) will—whatever the figure's size on the surface of the canvas—appear correct in depicted height as long as as his head is placed at the horizon.

This means that Caillebotte could arrange his figures according to whatever surface design he chose and be assured that they would be compatible with and help to define the space of the picture. It also means that he could apply prefabricated figures to his space in whatever size he liked, could make them so large that their feet were not included in the picture, and yet be confident of their technical correctness. The looming presence of the three large figures in the *Temps de pluie* has several important precedents in other painting and possibly in photography. But it is also an example of the compositional inventions so easily engendered by Caillebotte's method. (For further discussion, see Chapter 3.)

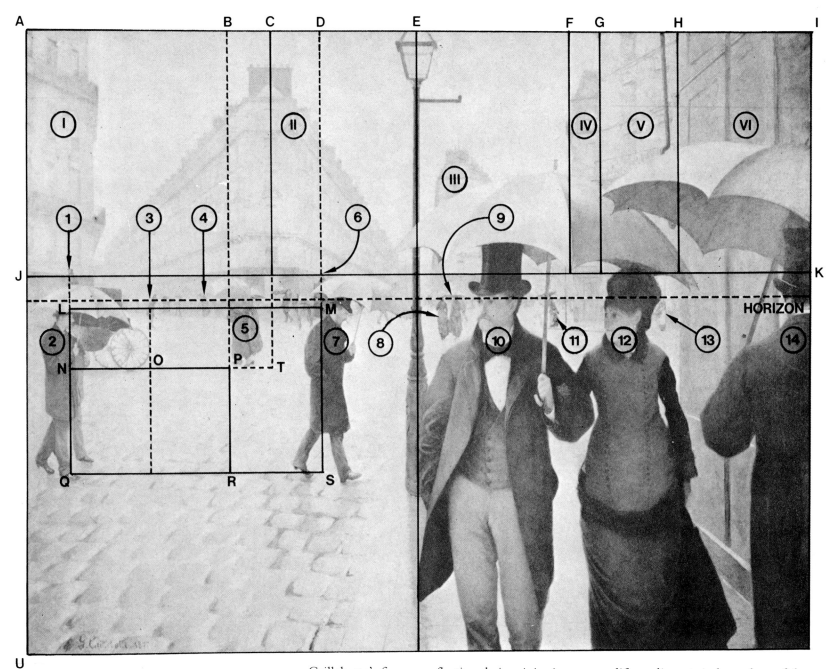

Caillebotte's figures, reflecting their origins in separate life studies, are independent of the picture's spreading space, tending instead to emphasize its surface. Like their counterparts in Seurat's *Grande Jatte*, the figures in the *Temps de pluie* free the viewer's eye from the unified space they occupy. In the *Pont de l'Europe* our attention is split in two; in the *Temps de pluie* and in the *Grande Jatte* it is fragmented, scattered across the picture's surface. Unlike Seurat's figures, however, those in the *Temps de pluie* do not simply fill progressively smaller holes in the surface pattern, but coalesce in a rigid surface design—based in part on the golden section.[19]

The figural design takes its first cue from the giant plus-sign of the horizon and lamppost. Buildings rise while figures hang from the invisible horizon, which makes its presence felt by virtue of locating that juncture of surface design. The vertical division is more emphatically marked by the lamppost and the arrangement of figures. On the right, the erratic silhouette of three large figures (10, 12, and 14 in the diagram, Fig. 4) acts as a flat screen that presses forward. The lack of intermediate spatial cues between these three and the distant figures that alternate with them (8 and 9, 11, and 13) forces a sharp, uneasy tension between near and far.

Fig. 4. Diagram for *Rue de paris; Temps de pluie*. This diagram serves two functions: 1) It labels the buildings (I through VI) and the figures (1 through 14) that appear in the picture. These are referred to by number in the text. 2) It provides a grid based on the picture's surface design. By referring to the grid, whose significant points of intersection are labelled with capital letters (A through U) we can summarize the major elements of the design's proportional system. These are also mentioned in the text.

The grid may seem arbitrary since it reduces figures to lines. But the figures are in fact derived from lines, as comparison with the initial drawing (Fig. 3) and the text make clear. It is not suggested that we see this diagram when we look at the picture. Rather, the diagram is a simplified summary of the surface construction on which the picture is demonstrably built.

That construction is based on two proportions: $\frac{1}{2}$ and the golden section. These proportions are as follows:

Halves

AE = EI = $\frac{1}{2}$ AI
AB = BE = $\frac{1}{2}$ AE
NO = OP = $\frac{1}{2}$ NP

Golden sections

The golden section is a ratio between two quantities, or in this case between two lengths (A, the larger; B, the smaller) such that A/B = (A + B)/A. When A and B are two sides of a rectangle, they form a golden rectangle. Like π, the ratio can be carried to an infinite number of decimal places, but for practical purposes it equals 1.62/1. In "Juan Gris and the Golden Section" (*The Art Bulletin*, 47, No. 1, March 1965, p. 131, n. 19), William A. Camfield states, "When the deviation from golden section proportions exceeds $\pm 3\%$ as determined by calculation, the deviation becomes apparent to the eye of one checking angles with a golden section triangle. Accordingly, $\pm 3\%$ has been set as the accepted tolerance in the analyses presented here." We have followed this guide for tolerance, and all but four of the ratios listed below deviate from 1.62 by no more than $\pm 3\%$. The remaining four (marked with asterisks) deviate by more than $\pm 3\%$ but less than $\pm 7\%$.

Golden rectangles:
LQSM[LM/LQ = (LQ + LM)/LM = 1.62]
NQRP[LP/NQ = (NQ + LP)/LP = 1.62]
Golden section divisions in one dimension:
AI/DI ★EI/EH GI/HI QS/QR ★DF/EF
AE/AC ★EI/FI NT/OT AU/JU ★CE/DE

By contrast, the left side of the picture provides an even, orderly progression into space. Figures 10, 7, 5, and 4 lie in one diagonally receding plane, establishing a transition from the right side's flatness to the left side's depth. Another diagonally receding plane, intersecting the first, is defined by figures 2, 5, and 6's coach; and a third by figure 2, figure 1's coach wheels, and figure 3. The arrangement of such planes in space, ordering the picture's configuration in depth, might have been a simple matter, since in a perspective construction figures whose feet lie on a single line define a single plane in space. The arrangment is in this case extraordinary, though, because the same figures also define part of the picture's mathematically proportioned surface order.

In the drawing (Fig. 3), vertical zig-zag lines indicate potential figures. The longest of these (just to the left of the lamppost) marks the golden section division of the width of the drawing. The left point of the arc that will become figure 10's umbrella marks the same division. The umbrella point does not just occur there but is *placed* there, as the vertical tickmark it touches proves. In the finished picture the umbrella has moved, but the care of its initial placement emphasizes the calculated placement of the proto-figure. This proto-figure becomes figure 7, who marks the golden section division of the finished painting.

Figure 7's role in the design of figures in the left half of the picture is, if anything, more deliberately controlled. His body and that of figure 2 mark the vertical sides of a golden rectangle (LQSM). These bodies are not lines, but, as we have seen in the case of figure 7, they are derived from lines. Even if we did not know this, the painting itself shows us the precise width of the golden rectangle; it is defined by the horizontal distance between the heads of coachmen 1 and 6, which rise like signposts above the heads of 2 and 7, respectively. The heads of 1 and 6 are themselves located on a horizontal like (JK) that marks the vertical golden section division of the whole picture.

The foot of figure 5 (at P) defines a smaller golden rectangle (NQRP) within the golden rectangle LQSM. Figure 5's foot (at P) *also* defines the mid-point between the lamppost and the left edge of the canvas. Similarly, figure 3 divides the smaller golden rectangle (NQRP) vertically in half.

The reader who cares to decipher this list and compare it with the earlier list of depth relationships will find that all but the most insignificant figures and objects in the left half of the picture fit (at least) two patterns of order—one in depth, and the other on the surface. The surface pattern is based primarily on the golden section.

This dense structure is only a part of the entire picture's interlocking proportional system of halves and golden sections. The major elements of the system are listed in the caption for the diagram (Fig. 4). Even this list omits a number of less important relationships for the purposes of clarity. (Perhaps it should be noted that these relationships, although tiny in the diagram, are plainly legible to a viewer standing before the huge painting itself.) For the present discussion, the interlocked order of the figures in the left half of the picture must serve as an example of the entire picture's order.

Faced with the problem of placing figures in the left half of his picture, Caillebotte resorted to a time-honoured system of proportions. Perhaps he felt the golden section would insure an effect of order; perhaps he used it, in this large, ambitious picture, in emulation of great painters of the past; perhaps it was just a convenient tool. Whatever the case, he clearly felt the need of a tool.

Linear perspective is a similar tool, and because we can identify these tools, the temptation arises to view the pictures as a product of their machinations, to see the painter as a technician. We might conclude on grounds of his method that Caillebotte was in control of his pictures, not just in the sense that any good painter is in control, but in a technical, scientific, theoretical sense. This interpretation would look upon his pictures as solutions to problems in visual psychology, and upon his method as a process where intuition counted for less than system.

Another interpretation of the same facts might view the system as an excuse, a justification for the dictates of intuition. After all, the golden section analysis cannot prove that the *Temps*

de pluie looks ordered—which anyone can see. The presence of golden section proportions tells us less about the viewer's experience of the picture than about Caillebotte's experience of it and its making—that is, about his intention.

The endless perspective manipulations in the *Pont de l'Europe*, the tight mathematical order of the *Temps de pluie*, suggest a mind obsessed with control. Further attention to the picture's construction will amplify the suggestion.

In the drawing's perspective construction, and in the finished picture, the orthogonals of building VI and those of the sidewalk curb vanish at two separate points on the horizon. (The points are visible in the drawing just above the base of building III.) This pair of vanishing points recalls the pair in the *Pont de l'Europe*. There, two points were required for a technically correct perspective by the incline of the street relative to the trellis. In the *Temps de pluie*, however, the orthogonals of building VI and the curb are parallel in space and should, in a correct perspective, vanish at a single point. The two-point construction, then, is a deliberate falsification; receding lines of building VI (meeting at the left point) and the curb (at the right point) converge too rapidly, giving extra force to the depth they help to define. A simple manipulation—a subtle falsity—with a simple effect.

The falsity, however, may also have a technical justification. Two vanishing points, two centers of vision, are the hallmark of binocular vision and of the type of picture made to satisfy it—the stereoscopic view. Stereo photographs were a growing fad at the time;[20] their potential influence on Caillebotte's work is discussed in Chapter 3. Binocular vision was also a frequent topic in perspective manuals, since it was considered the only obstacle to illusion that could not be overcome by means of perspective. La Gournerie's important treatise, for instance, cited Leonardo's observation that a mirror surpasses any painting in the illusion it offers, since it provides a separate reflection for each eye.[21] Caillebotte's sophistication in these matters is not to be doubted, nor is his concern with the paradox of truth in illusion; perhaps he had in mind a challenge to the mirror's illusion, a condensed stereoscopic view.

At best this is hypothesis, and in conventional terms counter-productive: a plausible but obscure technical rationale for a simple manipulation with a simple effect. But further consideration of Caillebotte's pair of vanishing points turns up evidence that the painter sought similarly obscure justification for a related aspect of the construction.

Though it represents objects in space, central perspective is a system on a surface. It is successful as illusion to the extent that we do not read it as a surface pattern. A vanishing point is a point of reference *in the surface pattern*, defining the surface orientation of a set of lines that are parallel in space; but the vanishing point is not meant to represent any point in real space. In the *Temps de pluie*, however, the pair of vanishing points we have discussed actually appear—as the heads of figures 8 and 9.

Like everything else in the picture, the presence and position of figures 8 and 9 is justified by their part in a logic of order. But in a masterful twist of this system, a paradox of perspective, these figures draw their justification not from the logic of the space in which they necessarily exist, but from the construction, which must *not* appear if the viewer is to read the space. Already this indicates Caillebotte's obsession with the construction as an abstract system, even as he is using it to represent space. There is more.

Figures 8 and 9 are not the only heads in the picture that are located at vanishing points. The heads of figures 3, 11, and 13 are located, respectively, at the vanishing points of buildings V, I, and the right side of building III. Caillebotte's hallmark—deliberate constructive control—is operative here, but in a way that we have not yet seen, in a way that is not directly reflected in the appearance of the work.

Standing before the *Temps de pluie*, we can see that the lamppost bisects the picture and that the figural design is divided into near and far halves. Perhaps we can also intuit the ordered design of the figures on the left. But never can we deduce the constructive connection between buildings and distant figures, much less ascribe a role to that connection in the picture's order. This aspect of Caillebotte's method, then, has a life somewhat apart from the

picture's appearance. It is justified more by its obscure, self-sufficient rationality than by anything we can see in the picture, much in the same way that the elegance of a mathematical proof can be appreciated independently of its content.

But obscure as this far reach of Caillebotte's method may be in terms of its visual effect, it is not irrelevant to the picture's meaning. Kirk Varnedoe interprets the picture as a vision of individuals dominated by the oppressive regularity of the modern city (see Pl. 18). We have found that this is literally—disturbingly—true: the distant figures are pinioned by the architectural perspective.

Caillebotte's method has shifted gears. Earlier, this analysis attempted to trace the painter's deliberate, sophisticated manipulations of the viewer's perceptual inclinations. Now, that connection between method and appearance has been replaced by a short-circuit between method and meaning. Caillebotte's method can no longer be described by a model of causality; it is no longer possible to view his pictures simply as solutions to problems. For Caillebotte, methodical control was not only means; it was also meaning. For us, the *Temps de pluie* offers a dense hierarchy of method, appearance and meaning, each of its levels confirming the independent propositions of the other two.

Retrospect

In the discussion of Caillebotte's method for the *Pont de l'Europe* it was convenient to adopt a model of causality, to trace a change in the picture and describe its effect on the viewer's experience of the picture. The painter began with a faithful record, probably based on a photograph, and invoked a series of subtle manipulations. These seemed, clearly, the means to a pictorial and ultimately expressive end: an artificial tension between the gentleman and worker presented as an unaltered document. The causal model provided a convenient unity of intention and expression. Method was only the glue between.

The model served well for much of the *Temps de pluie*, where golden section proportions told of the painter's goal of order, and offered a handy explanation for the picture's ordered style. Again: deliberate control, realism refined, intention realized.

Provisionally, Caillebotte seemed an art historian's painter—a man who knew how to manipulate perspective and build golden rectangles in order to express his intention. Or, from the art historian's point of view, to intend his expression.

But the causal model proved inadequate. The investigation of the *Temps de pluie* turned up elements of the construction that were equally deliberate in execution but dramatically less obvious in pictorial implication. Tiny heads, beyond the pale of pictorial function, had been carefully located at the vanishing points of buildings. Bypassing the level of appearance, this recondite construction claimed meaning for itself: its figures are literally dominated by the architecture of the modern city. How could it be that the constructive system—only a means—had significance in its own right?

Just as intention and expression are two sides of a single coin, perspective is a double-edged tool. On the one hand, a perspective construction is, by science and convention, a representation of space. On the other hand, it is an abstract ordered system—a pattern on a surface. For Caillebotte, significantly, it was both at once.

The Janus-head of perspective defines the two poles of Caillebotte's artistic consciousness—two opposing levels of intention, if you will: one, an intense involvement with the scene before him; the other, a detached aesthetic awareness through which that involvement is filtered. The tension between these poles, reflected in his work, is never stable.

In the *Pont de l'Europe* and in many works before it, the former of these poles is dominant; the pull of deep space implicates the viewer in the scene and its tensions. In the *Temps de pluie*, the other pole challenges the first. The space is as impressively deep as before, but the figures—visually and ontologically—are separate from it. To be sure, they exist in space, but

just as surely they belong to the surface order. They scatter our formerly riveted attention across the surface, easing us from direct involvement in the scene.

As Caillebotte's art moved through the warp of the *Temps de pluie*, its polarities became inverted. Before, the perspective pattern had been an excuse for producing space, deep demanding space. After, space became the excuse for pattern, comfortably detached order. The *Temps de pluie* is not only a high point of complexity and ambition in Caillebotte's art; it is also a turning point, emblematic of his opposing concerns.

Like all of Caillebotte's work, the *Temps de pluie* honors realism; it appears to be a faithful record, appears true. The initial steps of Caillebotte's method confirm what we can see: that this realism originates not in the truth of convention but in the truth of optics. Here is the relevance of photography. That medium, invented to satisfy convention, did so reluctantly. For technically faithful as it was, it produced not the whole of reality but a flattened, distorted aspect, in which space sometimes collapsed altogether and lampposts grew from heads. Many nineteenth-century photographers shrunk from such distortions, trying instead to call up the remembered whole they had seen through painter's eyes. Caillebotte—whether or not he actually used photography—embraced both its technical realism and the oddities of aspect, presenting, in the *Temps de pluie*, for instance, a figure cut in half and another who is only a pair of legs, dangling from an umbrella.

Oddities, but not for oddity's sake; these figures—whole in the picture's convincing and demanding space—give up their parts to the picture's design, offering a level of detached contemplation in a picture that is also irresistibly real. Here, decisively, Caillebotte left behind photography's passivity, building that design with traditional tools—perspective and proportion. His obsessive tinkering in the *Temps de pluie*, his deviations from technical fidelity, gave life—order and meaning—to the flattened aspect without denying the whole in space. The opposite tools of photography and the golden section, mediated through linear perspective, gave form to Caillebotte's ambivalence toward the world: a desire at once to possess and to contemplate it. Caillebotte's method, more than a means to an end, embodies the paradox that for him was the matter of being an artist.

PLATES

1. Autoportrait, fragment

(*Self-portrait, fragment*) c. 1873–74(?)
Oil on canvas, 47 × 32.7 cm. (17⅜ × 13 in.)
Private collection, Paris
Not included in Berhaut catalogue

An engaging image of the young Caillebotte at the very outset of his career, this belongs to a small group of unmounted fragments of his earliest essays in painting. Among these remnants, which include a diverse array of juvenilia—copies after plasters, landscapes, and studies of horses—this is the most accomplished, and almost certainly one of the latest. The resemblance to an early photo of the artist (Pl. 1a) is unmistakable. It is bittersweet to note how jovial and open Caillebotte seems here, in comparison with the more melancholy and reticent image of himself he offers later in life (Pl. 62).

1a. Anon. Gustave Caillebotte. Photograph, c. 1874(?).

2. Femme assise sur l'herbe, fragment
(*Woman seated on the grass, fragment*)
c. 1873–4
Oil on canvas, 42.5 × 31.2 cm. (16¾ × 12¼ in.)
Private collection, Paris
Not included in Berhaut catalogue

From the same group as the previous fragment (Pl. 1), this is another undated study from the artist's youth. However, the systematically broad conception of light and color accents, and indeed the very idea of painting such a figure seated on the lawn in sunlight, suggests that it was done with some knowledge of the work of the Impressionists. Though the color is relatively timid, and though we cannot consider this as more than a fragmentary sketch, memories of Monet's works of the later 1860s—the *Déjeuner sur l'herbe* especially—come to mind. With an early boating scene (Berhaut, 1978, No. 2), the *Femme assise* suggests that Caillebotte may have gone through a brief phrase of early development in which he re-explored the ground covered by Monet, Bazille, Renoir, *et al.* a decade before.

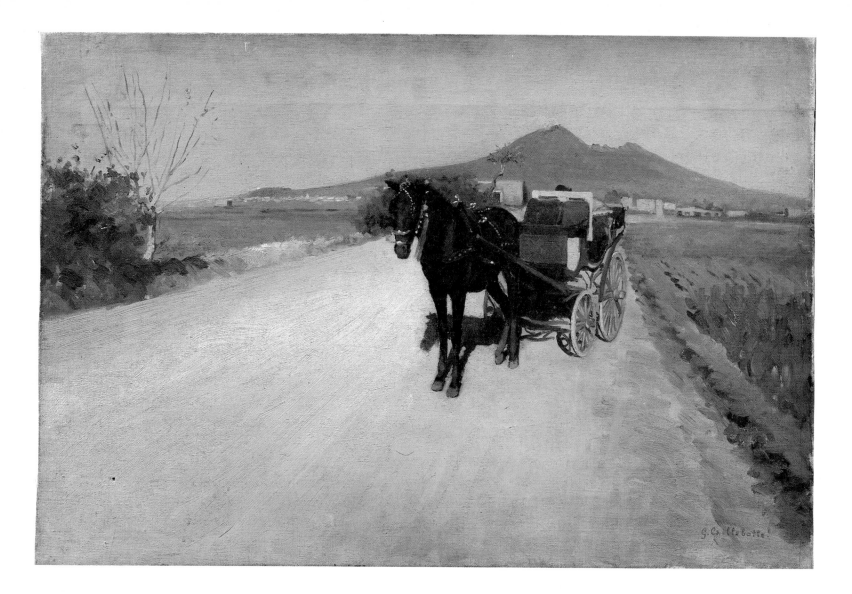

3. Une Route à Naples
(*A Road near Naples*) 1872
Oil on canvas, 40 × 60 cm. (15¾ × 23¾
 in.)
Stamped l.r.
Private collection, Paris
Berhaut, 1978, No. 3

Marie Berhaut has recorded a trip by Caillebotte and his father to Italy in 1872, and associated this and another small landscape (Berhaut, 1978, No. 4) with that journey. Taken from the country-side around Naples, these views may also be, as Mlle. Berhaut has suggested, evidence of an early visit paid by Caillebotte to the family of the painter Giuseppe De Nittis (De Nittis showed in the first Impressionist exhibition and kept up a solid friendship with Caillebotte, who was godfather to his son).[1]

Painted in the first year of Caillebotte's academic training, the present study would be wholly unremarkable were it not for the peculiar spatial organization, which features a broad empty foreground, a sharply converging road perspective, and foreshortening (in the horse and carriage) that seems to shrink scale abruptly. The strong shadow of the horse, in an otherwise bleached-out light, adds to the sense of impulsion into space.

The camera obscura and camera lucida—

optical devices that allowed one to trace the projected outlines of a scene—had been the tools of travelling artists for many decades, and relatively portable photographic cameras were available for serious amateurs by the 1870s. Perhaps the use of one of these devices may have been a factor in this image's wide-angle perspective. The activity documented is, however, unmediated *plein-air* painting: notice the back of a canvas's stretcher propped up vertically in the carriage, and what seems the tip of a painter's hat visible at its top edge.

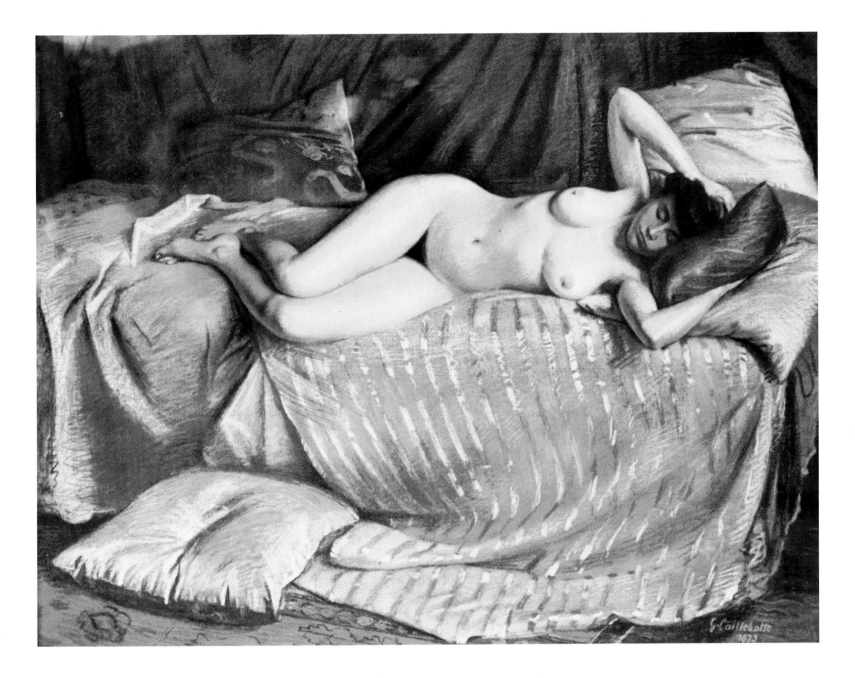

4. Femme nue étendue sur un divan

(*Nude woman on a sofa*) 1873
Pastel, 87 × 113 cm. (34¾ × 45⅜ in.)
(sight)
Signed l.r. *G. Caillebotte/1873*
Private collection
Berhaut, 1978, No. 7

This large, highly accomplished pastel is the earliest dated work from Caillebotte's hand. Similar in its cool, grey-silver light and smooth modeling to the *Femme à sa toilette*, which may depict the same woman (Pl. 5), it also provides a counterpoint to the artist's later essay in the genre of the Realist nude, the *Nu au divan* of c. 1880–82 (Pl. 36). Here—as opposed to the more assertively novelistic later nude—the pose of a

model and the trappings of the atelier still assert themselves, and the mood of quiet somnolence is relatively unproblematic. In conception and execution, this figure recalls the work of Frédéric Bazille, the painter who had been the close companion of Renoir, Monet, and Sisley in the 1860s, but who had died in the Franco-Prussian war. Bazille, the scion of a wealthy family from Montpellier and originally a medical student, had pursued a style combining the vivacity of *plein-air* light with the sharp focus and taut handling of a more academic technique; in all these aspects of station and style, Caillebotte might be seen as initially assuming the place he left vacant within the movement.

The suaveness of the treatment of flesh and cloth here, and especially the artist's attraction to

the satiny sheen of the striped drape, remind us that at the outset of his career—in instances such as the wet-and-dry wood floor and curled shavings in the *Raboteurs de parquet* (Pl. 8)— Caillebotte was attracted not only to linear structure but simultaneously to the subtle discrimination of shifting plays of interior light on surfaces. With the adoption of a more boldly brushed technique inspired by the work of Manet, Monet, and Renoir, he eventually sacrificed something of this latter aspect, and not without loss for the personal character of his work.

5. Femme à sa toilette

(Woman at a Dressing Table) c. 1873
Oil on canvas, 65 × 81 cm. (25⅝ × 31⅞ in.)
Stamped l.l.
Private collection, Los Angeles
Berhaut, 1978, No. 8

The place of this work in Caillebotte's oeuvre is somewhat uncertain. By its subject and mood it might well be associated with the domestic interiors painted around 1880 (e.g. *Intérieur*, Pl. 35, or *Nu au divan*, Pl. 36). In her 1951 catalogue of Caillebotte's work, Mlle. Marie Berhaut in fact assigned the picture to 1880;[1] but she has subsequently redated it to c. 1873. The smaller format, more precise rendering of form, and restricted palette all separate this work from the later figure pieces, and establish for it a position close to such early works as *Une Route à Naples* of 1872 (Pl. 3) and especially *Femme nue étendue sur un divan*, dated to 1873 (Pl. 4). The canvas is also identical in dimensions, and similar in style, to the early *Intérieur d'atelier avec poêle* (Pl. 6).

This seems clearly a domestic, rather than a studio, setting, and the informality of the scene does not suggest that the picture was ever intended for submission to the Salon. As with the *Intérieur d'atelier avec poêle*, we may presume the picture was essentially private and autobiographical in content. If so, it provides a glimpse of Caillebotte's early life that is intriguingly different from those afforded by the more formal family scenes of 1875–76 (e.g., *Déjeuner*, Pl. 13). The image is casual, insistently undramatic, and spacious. Caillebotte chooses an unexceptional moment (fastening or unfastening the crinolines), stands back at a distance, and focuses with loving care on incidental detail. Yet his sensitivity to the young woman's combination of concentration and daydreaming self-absorption, and especially the inclusion of the "second presence" in the lovely passage of the hanging mirror, make the picture quietly tender and appealing.

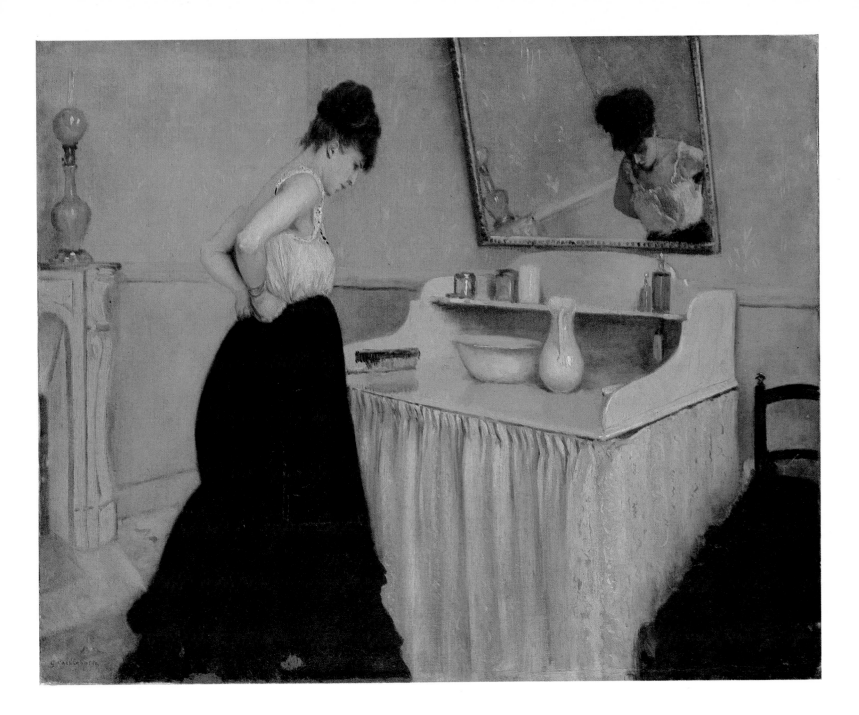

47

6. Intérieur d'atelier avec poêle

(*Interior of a studio with stove*) c. 1872–74
Oil on canvas, 81 × 65 cm. (31⅞ × 25⅝ in.)
Initialed on the back of a depicted canvas at left, *GC*; stamped l.r.
Private collection, Paris
Berhaut, 1978, No. 6

Quite accomplished but relatively impersonal in style, this study must date from the time during or near Caillebotte's tenure at the Ecole des Beaux-Arts. The scene is very likely a corner of the two-story studio space in the family home at 77, rue de Miromesnil.[1]

In execution and spirit the picture resembles similar studio studies by Monet, Bazille, and Cézanne, and stands in a tradition going back through Delacroix to artists like Chardin, whose influence speaks clearly in the treatment of the earthenware bowls and pitcher near the stove.[2] Though the style and the conception of the work are in a realist vein of straightforward unpretension, the objects shown document Caillebotte's more sophisticatedly eclectic interests at the time. Dominating the dresser-top in the center is a small copy in plaster of Jean-Antoine Houdon's *écorché*, or flayed figure, an indispensable element in the traditional academic instruction of anatomy. Next to the stove chimney on the right hangs an oil painting, apparently of a dark-skinned woman with white, shoulderless blouse and a shawl and headdress; this note of romantic exoticism may have been a copy after another painting, or even, given its substantial frame, possibly the work of another artist. The small unframed canvas that hangs just above it to the left is more probably a landscape study by Caillebotte himself. Directly behind the plaster statue, a decorated ceramic dish is hung, and a Japanese lantern suspended from its top. The image hung to the left of these, and partially obscured by the statue, resists identification; but, given its size, its color, and its margins, it would appear to be a Japanese print, most likely of the Ukiyo-e type. The decorated plate on the wall, the vase on the dresser (with another lantern behind it) and the even larger vase on the shelf above, all appear to be Japanese porcelain of the relatively ordinary type known as Imari ware.

The two horizontal panels on the left wall are, finally, the most significant items of all. Though painted indistinctly, they seem to show the strong diagonal compositions and bird's-eye, roofless view-point of the Yamato-e style of Japanese painting. It is unlikely that these are Japanese prints, given the coloration and format; but it is even more unlikely that Caillebotte could have acquired original Japanese paintings at this date.[3] It seems more plausible that they are reproductions, or painted copies after reproductions, of paintings. In any event, the combination of oblique perspective and elevated, horizon-less viewpoint they display is premonitory of the tipped-up grounds and diagonal linear organization of numerous major Caillebotte pictures beginning with the *Raboteurs de parquet* (Pl. 8) and continuing through the early 1880s.

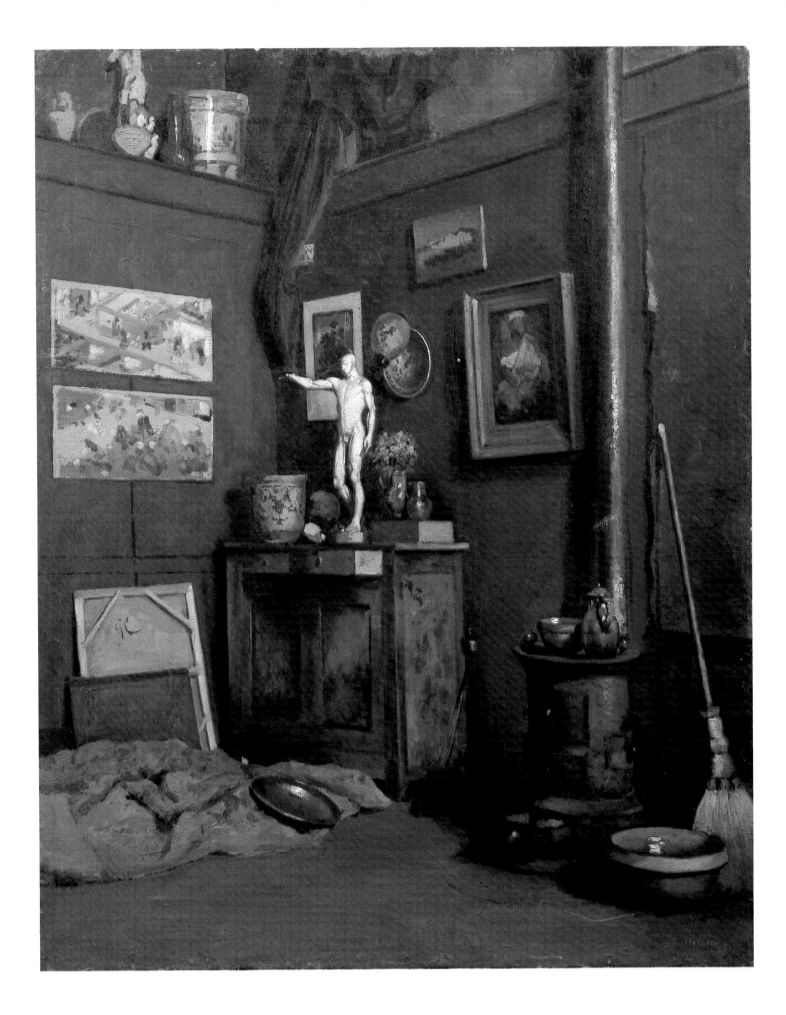

7. L'Yerres, effet de pluie

(*The Yerres, rain;* also known as *River bank in the rain*) 1875

Oil on canvas, 81 × 59 cm. (32½ × 23¾ in.)

Signed l.l. *G. Caillebotte 75*; stamped l.r.

Indiana University Art Museum, Bloomington. Gift of Mrs. Nicholas H. Noyes

Berhaut, 1978, No. 17

Water is a crucial, recurrent subject in Impressionist painting, as its surface—unifying and flattening the world it reflects, while simultaneously breaking up that image into dappled glimmerings—often stands as analog for the painter's activity. The present picture holds a singular place in Caillebotte's own work, and in that larger pool of Impressionist images. The composition is remarkably abstracted, with the heavy diagonal below and the frontal screen of trees above, and lacks any of the anecdotal liveliness of Monet's and Renoir's scenes of the suburban Seine in the early 1870s. The dominant subject is simply the water itself, and specifically the play of ripples on the narrow Yerres river (the site of the artist's family property; see also Pls. 20, 21, and 22). The glassy stillness and the rhythm of repeated, delicate circles of motion meld in contemplative silence. The picture is traditionally understood as dealing with a rain effect, and so it may; but shallow country rivers such as this may also be seen to bubble from their beds.

There is nothing strikingly original about the palette or brushwork of the painting, and the "stacked," climbing perspective suggests a Japanism that would have been the common property of many artists by the mid-1870s. Nonetheless, the conception and framing of this subject results in a certain uncanny aspect—of a place both empty and "inhabited"—that does not derive from, or fit easily with, the vision of any other painter of the day.

8. Raboteurs de parquet

(*Floor-scrapers*) 1875
Oil on canvas, 100.6 × 145 cm. (39⅝ × 57¼ in.)
Signed l.r. *G. Caillebotte/1875*
Musée d'Orsay
Berhaut, 1978, No. 28

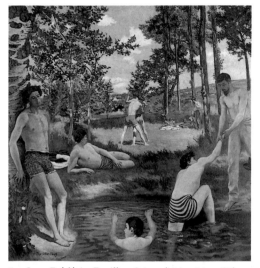

8a. Jean-Frédéric Bazille, *Scène d'été*, 1869. Oil on canvas, 160.7 × 160.7 cm. (63¼ × 63¼ in.). Courtesy of the Fogg Art Museum, Harvard University. Gift of M. and Mme. F. Meynier de Salinelles.

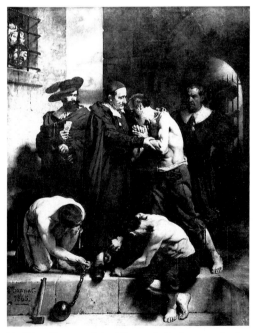

8b. Léon Bonnat, *Saint Vincent de Paul prenant la place d'un galerien*, 1865. Oil on canvas, 320 × 245 cm. (126 × 96½ in.). Eglise Saint-Nicholas-des-Champs, Paris.

This canvas brought Caillebotte instant notoriety when it was shown in the Impressionist exhibition in 1876. Best-remembered of all his works at his death, it was given to the Louvre by Martial Caillebotte and Renoir in conjunction with the bequest of Gustave's collection, and has remained the picture most consistently associated with his art.[1]

We must put aside the experience of the twentieth century, in politics as well as in the conventional distortions of photography, to understand fully the impact the *Raboteurs* had in 1876. First, the "vulgarity" of the subject offended; as with Degas's washerwomen shown in the same exhibition, the celebration of the urban worker was taken as a debasement of art, and, possibly, as a leftist political statement.[2] Furthermore, the space and figural proportions of the picture were upsetting; the arms of the men were found impossibly elongated, and the tipped-up floor seemed threateningly unreal.[3]

The subject may have been partly a pretext for showing the nude torsos: an essay, like Bazille's *Scène d'été* (Pl. 8a), at finding academic subjects in modern life. The sinewy, un-ideal anatomies here do in fact recall academic work by Caillebotte's teacher Léon Bonnat (Pl. 8b). The scrupulous documentary accuracy of the picture, however, demonstrates far more than a casual interest in the labor depicted.

Tradition has it that the occasion for the painting was the reconditioning of floors in the family home.[4] The activity depicted, however, is more familiar in connection with a new building where humidity trapped during construction has caused the floorboards to buckle upwards along their edges. The dark shining surface of the floor does not owe to old wax being removed, but to the water with which the scrapers initially soaked the bare floor to prevent splintering of the wood. The "stripes" in the floor are dry wood exposed by the first step in the process, the passage of a heavy-duty, two-handled plane, the *rabot*, over the buckled edges of the planks. The right-hand worker here holds the *rabot*. The broad light area at lower left is the result of the second step, the overall scraping with a smaller, finer blade, the *racloir* (Pls. 8c and d), which is held by the middle worker and cupped in the far hand of the leftmost worker. The hammer between the two men at the right was used to pound down loose nails. The knife-like tool intruding from the lower left edge of the picture is (like the similar blade reached for by the leftmost man) a file, used every few strokes to keep the blade of the *racloir* at peak sharpness (Pls. 8c and e). In the back, against the wall, lie the sacks used by each man to carry his equipment.[5]

Offsetting this patiently objective realism in the details is a strikingly willful, personal sense of pictorial organization, for which nothing in Caillebotte's previous work prepares us. Here,

suddenly, we find fully formed the major elements of his vision: the raised horizon line, the laterally expanded foreground and swiftly plunging perspective; the interest in effects of back-lighting and reflection; the bold use of asymmetry and void in the composition; and the mesmerizing fascination with pattern, in the floorboards, the dado, the balcony grill, and the triple accent of the nude torsos. The willful nature of these effects can partly be determined by studying the surviving oil sketch (Pl. 8j). There, the three-part rhythm of the molding details on the wall does not yet appear, and the kneeling pose of the left-hand man leaves him as yet unlinked to the movements of the other two.

Beneath the repeated elements that provide

8c. Floor-scraping: *racloir* and file. Author's photo.

8d. Floor-scraping: working with the *racloir*. Author's photo.

8e. Floor-scraping: sharpening the blade of the *racloir*. Author's photo.

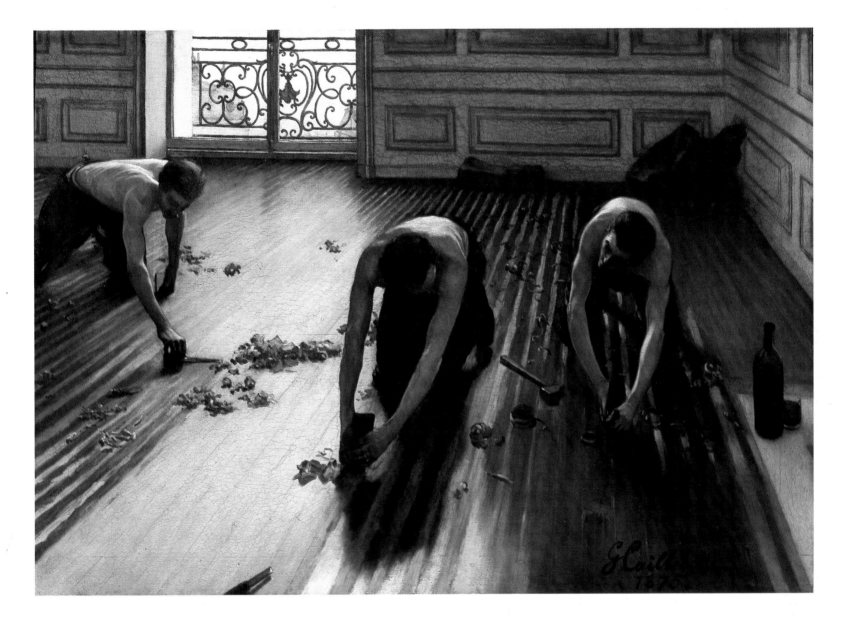

patterning, there is an insistent spatial order. The major inward thrust, defined by the lines of the boards, converges toward a point just above the top edge of the picture, on the right. This swift, lop-sided recession, whose direct axis is emphasized by the vertical frontal symmetry of the right-hand worker's pose, is echoed on the other side of the picture by the pattern of incoming light. The middle mullion of the window serves as the focal point for a radiating light field, and is emphasized as a point of convergence by the diagonal of the hammer and the pointing wedge of the marble hearth-stone at the lower right. (Again, Caillebotte "forced" these effects; between the sketch [Pl. 8j] and the final canvas, he skewed the hearth on the right so that it would recede directly from the corner, and created the large bare patch of floor on the left to link the foreground with the window light). Against this twin convergence, the forward-

pushing wedge of the three workers asserts itself, its leading point emphasized by the gaze of the worker on the right and the reach of the one on the left.

The ostensible triviality of the subject and the arbitrariness of a random slice of life are confounded by the organization of the composition, and also by the solemn absorption in the task: initially arresting by virtue of its palpable immediacy, the scene fixes itself in the mind with a permanence not given to casual experience. Part of this frozen quality owes to the similarity of the three figures. All bare-chested, similarly posed and intently engaged in separate phases of the same activity, they seem to be one man in three moments. Works by Degas often show a similar repetition of like figures, treating in simultaneity successive phases of an action or views of a pose; and it seems entirely possible that both artists were aware of the

similar effects obtained in pre-cinematic dissection of motion through photography, beginning with multiple-pose *carte-de-visite* sheets in the 1860s and scientifically pursued by Eadweard Muybridge and E.-J. Marey in the 1880s.[6]

Tightly painted, severe in its geometry and somber in its tonalities, the *Raboteurs de parquet* is subtly poetic as well, in the study of diffused window light on flesh, wet wood and metal, and especially in the broadly brushed wood shavings, whose curls seem to restate in natural, "accidental" terms the decorative liveliness of the iron window grill.

8f. Study for *Raboteurs de parquet*: Kneeling man, bare-chested, seen from front with left hands before left knee. Charcoal with gouache, 47.3 × 32.3 cm. (18⅝ × 12⅝ in.).

8h. Study for *Raboteurs de parquet*: Balcony grill. 30.3 × 46.3 cm. (11⅞ × 18¼ in.).

8i. Studies for *Raboteurs de parquet*: Two studies of arms/hands; one kneeling man. 31.2 × 47 cm. (12¼ × 18½ in.).

8j. Sketch for *raboteurs de parquet*, 1875. Oil on canvas, 27 × 41 cm. (10⅝ × 16⅛ in.). Private collection, Paris. (Berhaut, 1978, No. 26).

8g. Study for *Raboteurs de parquet*: Three kneeling men. 47.0 × 30.6 cm. (18½ × 12 in.).

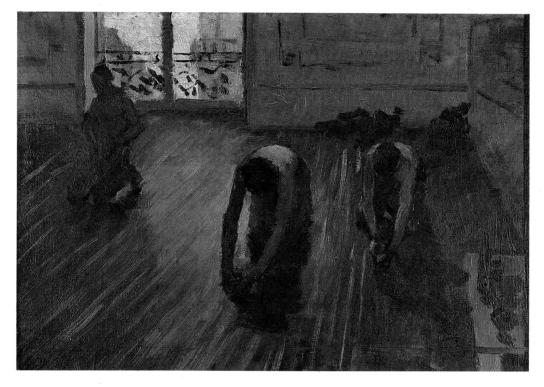

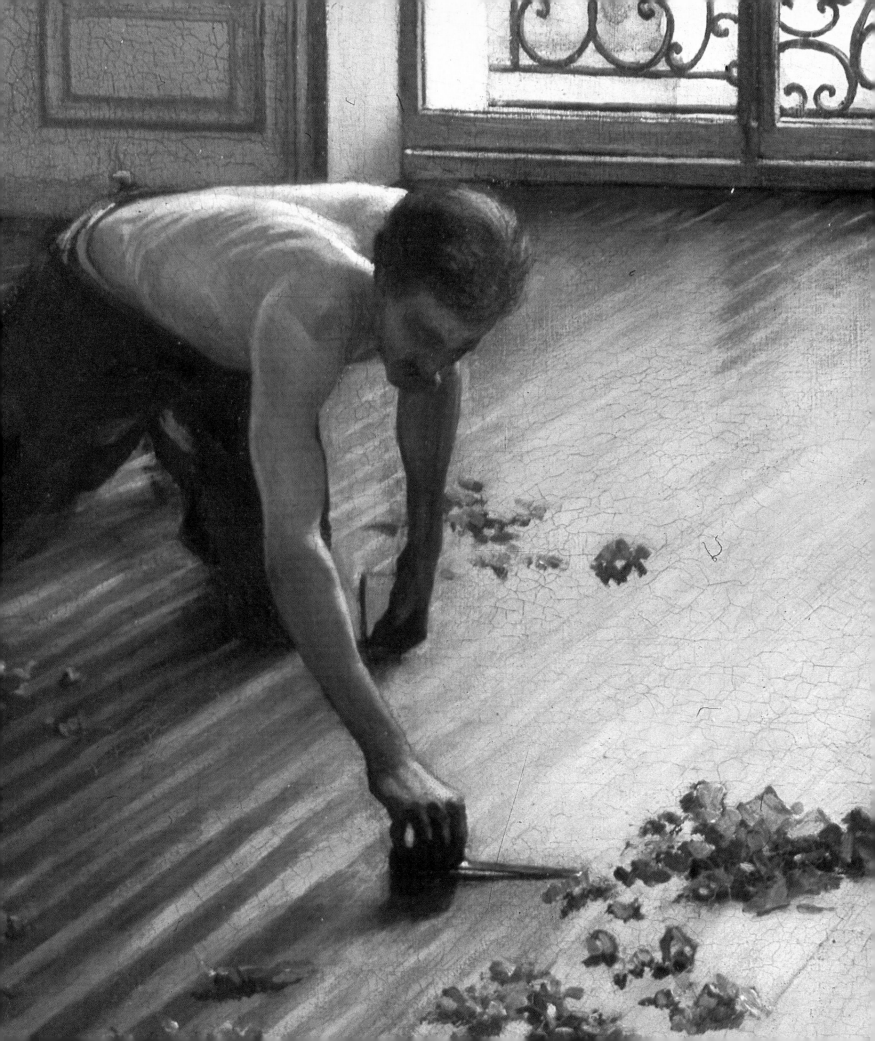

9. Raboteurs de parquet, variant

(*Floor-scrapers, variant*) 1876
Oil on canvas, 80 × 100 cm. (31½ × 39⅛ in.)
Signed l.l. *G. Caillbotte 1876*
Berhaut, 1978, No. 29

9c. Study for *Raboteurs de parquet* (variant): Man kneeling in profile facing left. 34 × 31.8 cm. (13⅜ × 12½ in.).

9a (left). Study for *Raboteurs de parquet* (variant): Kneeling man facing left. 47.7 × 30.6 cm. (18 3/16 × 12 in.).

The second version of the *Raboteurs*, also exhibited in the 1876 Impressionist exhibition, was the first instance of a practice that later would become common in Caillebotte's work: the reconsideration of a single theme in multiple compositions. For this later canvas, Caillebotte chose two further figures from the group of preparatory life drawings (Pls. 9a–f), and brought them together on the similarly uptilted but less perspectively insistent floor of another, more austere room. More clearly visible now, and responsible for the apparent awkwardness of the seated figure's legs, are the bulky knee pads that were an essential part of the floor-scraper's equipment. A contemporary critic, already put off by the vulgarity of the subject matter, imagined that this seated boy was pulling a louse off of himself, and found the taste of the image dubious;[1] in actuality, the boy is sharpening his *racloir* with a file. The trade of floor-scraping was learned by an apprentice system, and Caillebotte may have intended a note of humor in this figure, contrasting the boy's laborious concentration (he apparently has yet to scrape an inch) with the vigorous action of the older worker. The picture, quite strong and interesting in its own right, inevitably suffers by comparison with the Musée d'Orsay version, which is both bolder and more complex.

9b. Study for *Raboteurs de parquet* (variant): Seated man with hands at stomach, feet forward. 48 × 30.7 cm. (18⅞ × 12 in.).

9d. Studies for *Raboteurs de parquet* (variant): Two views of man seated in profile facing left, hands before stomach. 47.7 × 31 cm. (18 11/36 × 12¼ in.).

9e. Two studies for *Raboteurs de parquet* (variant): Kneeling man, seen from three-quarters rear facing left, hands to floor; and seated man seen from front, hands to stomach. 48 × 30.2 cm. (18⅞ × 12 in.).

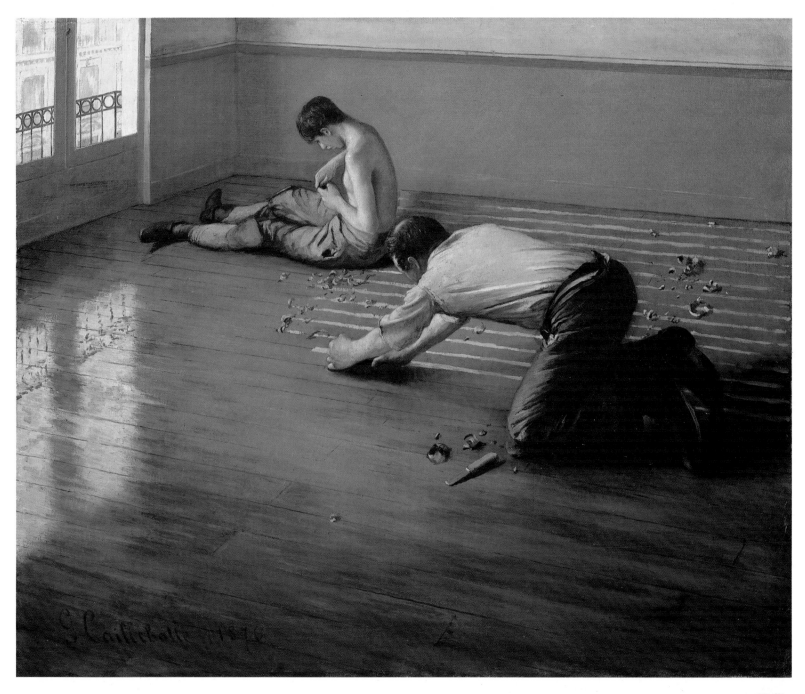

9f. Study for *Raboteurs de parquet* (variant): Two men
on floor. 62.8 × 48 cm. (24¾ × 18⅞ in.).

10. Jeune homme à sa fenêtre

(*Young man at his window*) 1876
Oil on canvas, 116.2 × 80.9 cm. (45$\frac{3}{4}$ × 31$\frac{7}{8}$ in.)
Signed l.l. *G. Caillebotte 1876*
Private collection
Berhaut, 1978, No. 26 (incorrectly dated 1875)

The Raboteurs de parquet of 1875 (Pl. 8) announced, already in full force, the character of Caillebotte's personal approach to space and composition. In this masterwork from the following year, we encounter a similarly complete formulation of two themes that inspire several of his most impressive paintings: the spectator and the city. The spectator in this case is René Caillebotte, a younger brother who died in the same year, 1876.[1] The section of the city is that seen from the third-story (*deuxième étage*) window of the family home at 77, rue de Miromesnil (Pl. 10a). From the corner of the building on the rue de Lisbonne, René looks past the rue de Miromesnil into the Boulevard des Malesherbes.

Marie Berhaut has observed how closely this image echoes the program for *La Nouvelle Peinture* (The New Painting) written by Edmond Duranty in 1876: "Hands held in pockets can also be eloquent," noted Duranty in discussing the new subject matter of realism, and he continued: "From within, it is by way of the window that we communicate with the outside; the window is another frame that incessantly accompanies us. . . . The frame of the window, according to whether we place ourselves seated or standing, crops the exterior spectacle in the most unexpected way."[2] Duranty's essay, a major document of realism, prescribes subjects and devices of composition that offer a greater truth to visual experience. In Caillebotte's treatment of the window, however, there is a psychological or emotive dimension that would seem to have more to do with the heritage of Romanticism, and most especially German Romanticism. As Lorenz Eitner has pointed out, the German painters of the early nineteenth century returned again and again to the motif of the open window (Pl. 10b), not simply as a picturesque scene, but as a symbolic motif, juxtaposing enclosure and escape, contrasting the "poetry of possession" within the room to the "poetry of desire" in nature beyond.[3]

Though Caillebotte's image recalls these German windows, it differs importantly, both in structure and meaning. The huge stone balustrade against which René presses provides a massive line of division between the world inside and the world beyond; but by placing the figure off center and by slightly elevating our viewpoint, Caillebotte allows our movement over this hurdle into the deep space beyond.[4] He in fact gives this movement an irresistible urgency, by lining up the in-rushing diagonals of the window mouldings and those of the exterior cornice and pavement lines. Since the middle distance is virtually eliminated, the inward movement becomes an immediate plunge from René to the other figure, about one-sixteenth his size, in the street below.

A standard charm of the window view is our

10b. Caspar David Friedrich, *Woman at the Window*, 1822. Oil on canvas, 43.8 × 32 cm. (17$\frac{1}{4}$ × 12$\frac{5}{8}$ in.) Nationalgalerie, Berlin.

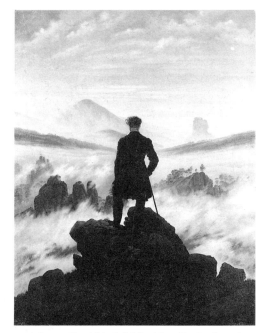

10c. Caspar David Friedrich, *Traveller Looking Over the Sea of Fog*, c. 1818. Oil on canvas, 94.6 × 74.7 cm. (37$\frac{1}{4}$ × 29$\frac{3}{8}$ in.). Kunsthalle, Hamburg.

bemused curiosity as to what the observer is looking at; but Caillebotte's structure replaces this curiosity with something quite different. Since he urges us along the spectator's line of sight, a double focus occurs, an oscillation of concentration between the depicted seer and

10a. View from a corner window at 77, rue de Miromesnil. (Author's photo, with 28 mm. lens; for discussion of optic properties of this wide-angle space, see Chapter 3.) *Note*: the balustrade has been removed and replaced with a grill since Caillebotte's day.

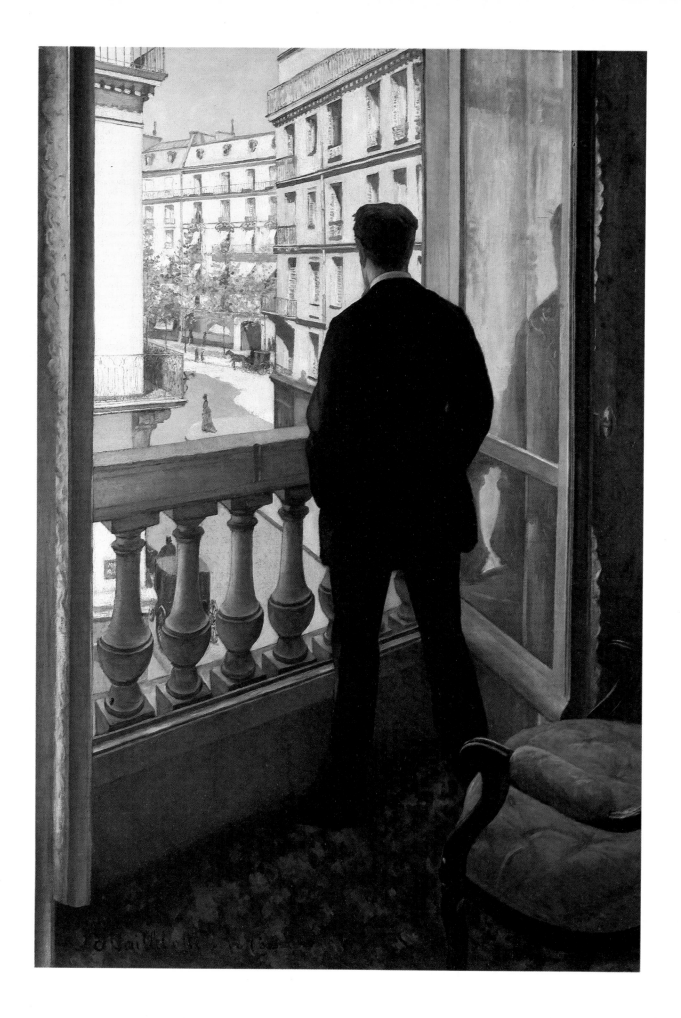

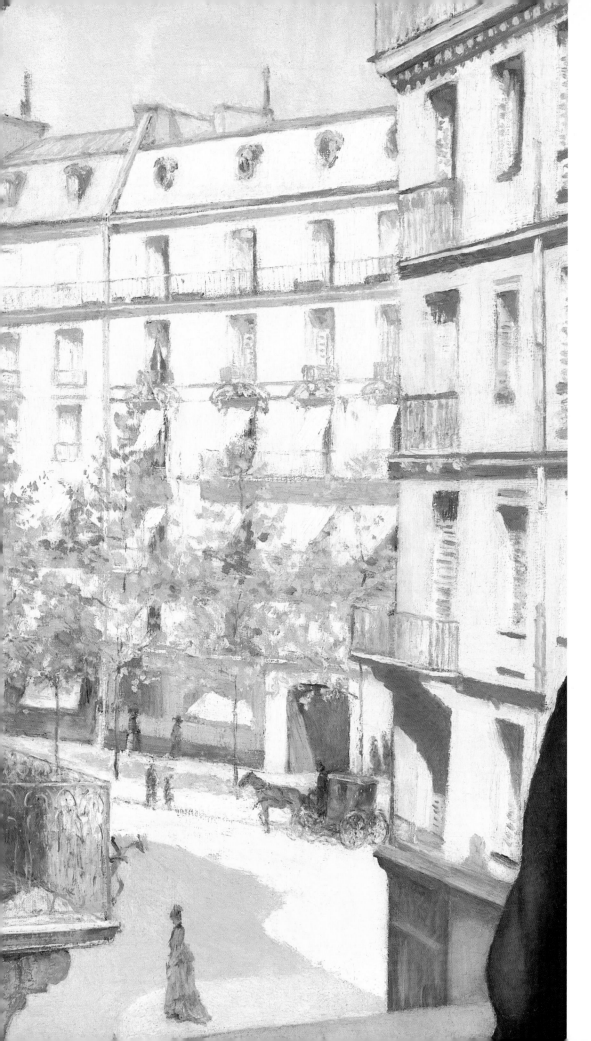

what he sees. The man and the foreground dominate, push towards us; but the perspective, and the gaze itself, draw us beyond. The normal interior-exterior oppositions of the window are thus combined in a charged relationship, competitive or covalent, that is seemingly unprecedented.

Not only in structure, but in import, the motif has been changed. What lies beyond the window here is not nature, as in Romanticism, but nature's antithesis, the metropolis. The iconography is not that of the dilemma Eitner delineated—essentially that of domestic confinement versus freedom in nature—but a new one, opposing private and public spheres of urban existence: the private life of the dark, warmly upholstered home versus the societal life of the bare, bright, restlessly angular boulevard. Furthermore, in Caillebotte's oscillating image, the confrontation is not between two polar opposites, but between two different forms of a common human condition, solitude: the man alone within the close, dark box of the window and balustrade, and the diminutive object of his gaze, isolated in the emptiness beneath and between the walls of the enclosing facades.

The German Romantic image of the window was part of a general attraction to expansive space, seemingly owing to a yearning for a kind of religious unification with the infinite; in Caspar David Friedrich's images, for example, space extends, vast, wide, and unobstructed before the spectator (Pl. 10c). In Caillebotte's modern metamorphosis of Romantic consciousness, the observing figure is more prominent, and the urgent space more narrowly channeled—closing down, rather than opening up. This sharply divided construction seems an emblem of a spirit intense but literally walled-in. Implying both a heightened self-consciousness and an exacerbated awareness of the isolating power of fleeing distance, Caillebotte's window view seems to be a symbolic self-portrait.[5] For immediate graphic power as well as for the enduring fascination of its psychological energies, it is one of the artist's most memorable images.

II Le Billard
(*Billiards*) c. 1875–76
Oil on canvas, 59 × 80.9 cm. (23¼ × 31⅞ in.)
Private collection, Paris
Berhaut, 1978, No. 25

It is difficult to understand why Caillebotte did not finish this painting, as he had already completed the most difficult passages of radical *contre-jour*. He may have intended, given the proportions of the remaining blank section, to include another standing figure. The person now playing without opponent (and without cue or billiard balls as well) is not clearly identified, but the setting is probably the billiard-room of the family country house at Yerres, looking onto the garden that Caillebotte often painted. In coloring and mood, the picture evokes strong reminiscences of Degas, but the extraordinarily sharp perspective of the table and the alignment of its leading edge with the vertical of the wall-bay behind seem more personal. This little canvas is, beyond its intrinsic charm, an instruction in Caillebotte's working method, demonstrating his willingness to bring parts of the image to near-complete definition before even beginning others.

12. Jeune homme jouant du piano

(*Young man playing the piano*) 1876
Oil on canvas, 81.3 × 116.8 (32 × 46 in.)
Signed l.r. *G. Caillebotte 1876*
Private collection, Paris
Berhaut, 1978, No. 50

This is the first painting of the person who was the artist's closest lifelong companion, his younger brother Martial. Twenty-three years old at the time, Martial had already manifested the interest in music that, along with photography, stamps, faïence, and gardening, was to remain a principle avocation in his life (like Gustave, Martial never had a profession). The music he composed was, according to his daughter, "Wagnerian."[1] The subject of the picture, is however, not simply Martial himself, but the *haut-bourgeois* environment in which the family lived at 77, rue de Miromesnil. With great care, the artist has detailed the ornate, warm-hued rug and wallpaper; the heavy drapes; and the lace curtains through which a grey light filters. Dominating the space, the black mass of a huge Erard piano reflects the vertical accent of the wall moulding and the tentatively lifted hands of the young pianist. Caillbotte studied the perspectival construction of the piano carefully in his preparation (Pl. 12a), but when the painting was shown in the 1876 Impressionist exhibition, more than one critic was disquieted by the seeming imbalance of the instrument seen from this elevated viewpoint.[2]

12a. Study for *Jeune homme jouant du piano*. Perspective study of a piano. 47.5 × 60.2 cm. (18¾ × 24¾ in.).

12b. Study for *Jeune homme jouant du piano*: Martial at piano. 31.0 × 48.2 cm. (12¹³⁄₁₆ × 19 in.).

12c. Study for *Jeune homme jouant du piano*: Martial at piano. 36 × 23.7 cm. (14⅛ × 9⁶⁄₁₆ in.).

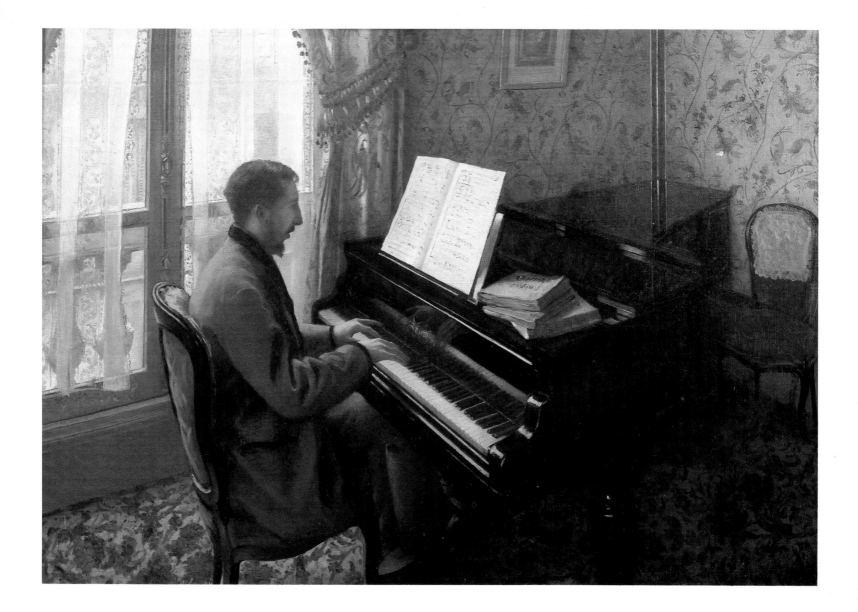

13. Déjeuner

(*Luncheon*) 1876
Oil on canvas, 52 × 75 cm. (20½ × 29½ in.)
Signed l.r. *G. Caillebotte/1876*
Private collection, Paris
Berhaut, 1978, No. 32

At luncheon in the family home, the artist's mother is served by the family valet, while René, the younger brother who was to die before the year was out, intently slices his food. Before them spreads a splendid array of glasses and vessels, islands of crystal translucence on the deep black expanse of the circular table. The afternoon light, broken by heavy drapes and screened by lace curtains, glows from the windows behind to disperse the gloom of the large salon.

This small painting is one of the most intensely personal in Caillebotte's early work; it is impossible to think of another painter of the time who would have conceived it. The patterning of the image, with the doubling of objects by repetition and reflection, approaches the obsessive, and the distortions of space become a disturbingly dominant element. In a manner unprecedentedly audacious, and somewhat bizarre even to our eyes, a portion of a plate looms up in a near half-circle at the lower edge, giving the viewer an uncanny—and unsettling—sensation of his place in the scene. The huge arc of the table then sweeps away from us to the diminutive figure of the mother, seemingly, as one contemporary critic estimated, twelve meters away.[1]

By certain standards of Impressionism—in comparison, for example, to Monet's bright landscapes of the same date—this canvas is impossibly retrograde: a bourgeois interior painstakingly detailed in near-monochromatic somberness. Paradoxically, it is also, in terms of

13b. Claude Monet, *Un coin d'appartement*, 1875. Oil on canvas, 81.5 × 60.5 cm. (32⅛ × 23¾ in.). Musée d'Orsay.

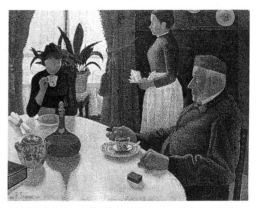

13c. Paul Signac, *Le Petit Déjeuner*, 1886–87. Oil on canvas, 88.9 × 115 cm. (35 × 45¼ in.). Rijksmuseum Kröller-Müller, Otterlo.

13a. Claude Monet, *Le Déjeuner*, 1868. Oil on canvas, 191.6 × 125.2 cm. (75½ × 49¼ in.). Staedel Institute, Frankfurt.

13d. Edouard Vuillard, *La Famille au déjeuner*, 1896. Oil on canvas, 31.8 × 45.7 cm. (12½ × 18 in.). Collection of Mr. and Mrs. Ralph Colin, New York.

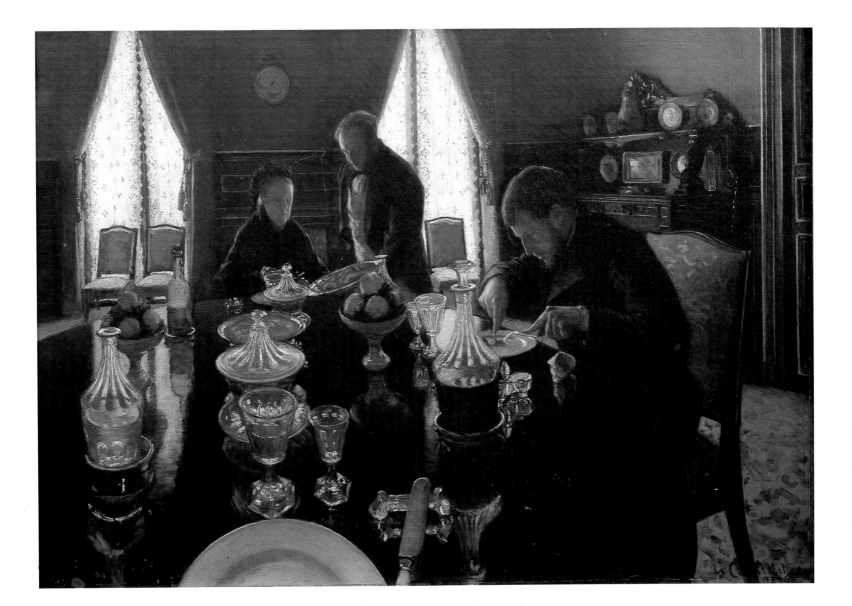

apparent direct influence, one of the most prophetically modern of the works Caillebotte showed in the 1876 exhibition. Little appreciated at the time, *Déjeuner* had to await another generation of painters, more interested in abstract pattern and in the closely bound intimacy of interior life, to have its effect. The Neo-Impressionist Paul Signac, who could have known this work through his friendship with Caillebotte, re-stated the scene in 1884–86 as the stiffly ritualistic breakfast of a bourgeois pensioner (Pl. 13c); and Edouard Vuillard, who could have seen *Déjeuner* in the 1894 retrospective of Caillebotte's works, echoed the general configuration and feeling for dark interior domesticity (while eliminating altogether the sharp linearity and radical spatial distortions) in his *La Famille au déjeuner* of 1896 (Pl. 13d).[2]

Preceding Caillebotte's painting in this lineage of bourgeois table scenes is Claude Monet's *Le*

Déjeuner of 1868 (Pl. 13a). Monet's device of leaving his own chair empty at the place set for him might be said to connect the two pictures even more specifically. However, Caillebotte's use of his place-setting is incomparably more extreme, and the overall feel of the Monet— sunlit breakfast conviviality animated by the small child—is hardly that of the Caillebotte. A more suggestive similarity exists between the Caillebotte work and Monet's 1875 *Coin d'appartement* (Pl. 13b). The latter (which Caillebotte acquired for his collection) seems an anomalous work in Monet's development at the time, and it is not at all unlikely that it relates to Caillebotte's ideas—not simply in the conception of a dark, back-lit bourgeois interior, but also in the uncharacteristic (for Monet) compositional devices of steeply tilted floor with sharp perspectival midline, and dominant symmetry of repeated forms.[3]

The mood of Caillebotte's picture is not easy

to define. The dimensions of the interior are relatively expansive, and the accoutrements are splendidly deluxe. Yet through all the quiet bourgeois comfort breaths an air of claustrophobic *ennui*. The acute consciousness of our place established by the plate is such that the yawning separation from the other figures, and their uncommunicative self-absorption, contribute to a feeling of interpersonal isolation. The details of conspicuous abundance, furthermore, pile up to a point of discomfiting clutter. The picture combines this delicate psychology, simultaneously *gemütlich* and disquieting, with a structure remarkably aggressive in its unconventionality. The blend is permanently unstable, and thereby the more intriguing.

13e. Study for *Déjeuner*: Man seated at table reading. 47.5 × 30.2 cm. (18¾ × 12⅞ in.).

13g. Study for *Déjeuner*: Seated man carving. Charcoal, 46.8 × 30.2 cm. (18½ × 30.2 in.).

13i. Study for *Déjeuner*: Valet. Full sheet 46.2 × 62 (18 3/16 × 24⅜ in.); format shown here 46.5 × 30.6 cm. (18 5/16 × 12 in.). (Same sheet holds Pl. 13h.)

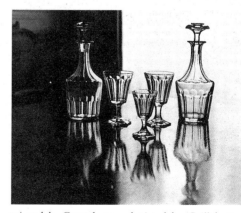

13f. Study for *Déjeuner*: Man carving. 47.5 × 30.7 cm. (18¾ × 12⅛ in.).

13h. Study for *Déjeuner*: Valet and Mother. Full sheet 46.2 × 62 (18 3/16 × 24⅜ in.); format shown here 46.5 × 30.6 cm. (18 5/16 × 12 in.). (Same sheet holds Pl. 13i).

13j and k. Crystal-ware depicted by Caillebotte in *Déjeuner*, and still owned by the artist's descendants. (Author's photos—ensemble seen with 24 mm. lens.).

68

14. Portraits à la campagne

(Portraits in the country) 1876
Oil on canvas, 95 × 111 cm. (37⅜ × 43¾ in.)
Signed l.l. *G. Caillebotte/1876*
Museé Baron Gérard, Bayeux, Gift of M. et Mme. Chaplain in Memory of Mme. Fermal, born Zoé Caillebotte
Berhaut, 1978, No. 31

This is a view of the garden of Caillebotte's family property at Yerres, a village situated on the river Yerres, not far from Paris in the general direction of Fontainebleau. Many of the artist's earliest oil sketches show the river, the woods, and the farm around this summer residence, and a later series of boating pictures (Pls. 20, 21, and 22) document the life of leisure sport Caillebotte enjoyed there. The garden itself, with its central bed of brilliant red geraniums, also appears in other canvases, such as Pl. 25.

Shown in the 1877 exhibition along with the three large cityscapes of 1876–77, the *Portraits à la campagne* not only held its own, but often received more favorable notice from the critics.[1] Writers displeased by the limited grey harmonies of the city pictures expressed admiration for this scene's brighter hues and more sunlit atmosphere. They were uneasy, though, about the upward tilt of the foreground, and by the perspective, "bizarre though true."[2]

The picture is easily the brightest of Caillebotte's early years. The chromatic strength of passages such as the geranium bed in the background, in combination with the tight execution, cannot help but bring to mind the work of Frédéric Bazille, the early member of the Impressionist group who died in the war of 1870. Bazille's *Réunion de famille* of 1867 (Pl. 14a) seems an especially close precedent, as Caillebotte's picture is also a family portrait, showing a cousin, an aunt, a family friend, and the artist's mother reading in the background.[3] In contrast, however, to the highly posed look of the Bazille family, with their somewhat unsettling assemblage of unblinking stares, Caillebotte's sitters seem unaware of the artist, and are deeply absorbed, each in their own activity. Caillebotte painted numerous views of sewing, reading, embroidery, etc., in these early years of his career (see also Pl. 19) and the theme of close concentration may have had for him a specific association with his family life (see Chapter 2).[4] The subject and the way it is treated also recall an early work by his teacher Léon Bonnat (Pl. 14b), which Caillebotte would certainly have known as it hung in Bonnat's studio.[5] Both the Bonnat and the Caillebotte reflect an obvious heritage of the calm simplicity of Dutch genre, and it is interesting with regard to Caillebotte's numerous seamstresses to note that Vermeer's *Lacemaker* was acquired by the Louvre in 1870.[6]

Despite these affinities, however, the picture is quite personal, not only in the perspectival composition but in the love of pattern: in the stripes of the awning, shutters, and bench, but most importantly in the symmetrical repetition of near-identical poses that locks the group together.

14a. Frédéric Bazille, *Réunion de famille*, 1867. Oil on canvas, 152 × 230 cm. (59¾ × 90½ in.). Musée d'Orsay.

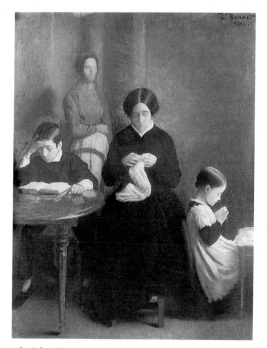

14b. Léon Bonnat, *Portrait de la mère, du frère, et de la soeur de l'artiste*, 1853. Oil on canvas, Musée Bonnat, Bayonne.

15. Le pont de l'Europe

(*The Europe Bridge*) 1876

Oil on canvas, 124.7 × 180.6 cm. (49⅛ × 71⅛ in.)

Signed l.r. *G. Caillebotte / Paris 1876*

Musée du Petit Palais, Geneva

Berhaut, 1978, No. 44

Le Pont de l'Europe is the first of three large Parisian street scenes Caillebotte showed in the Impressionist exhibition of 1877. In these paintings, the most complicated and most carefully prepared of his career, Caillebotte focused specifically on the new Paris, choosing three vistas that owed to construction under the Second Empire (1852–1870). In an intense fifteen-year program of massive demolitions and wholesale new construction, Napoleon III and his Prefect of the Seine, Baron Georges Haussmann, had transformed Paris from a semi-medieval agglomeration into the first modern metropolis. Their new network of boulevards, pierced with a still-controversial authoritarian thoroughness, facilitated traffic flow, brought light and air to the city in unprecedented fashion, and changed forever the look and feel of life in the capital.[1] After 1870, the new life of these boulevards became a popular theme for painters, both among the Impressionists and in the Salon.[2] Caillebotte's vision of the modern city, however, stands apart, quite distinctively personal.

At least two (and likely all three) of Caillebotte's 1876–77 street scenes are set in a neighbourhood that adjoined his own: the Quartier de l'Europe, a new residential district so called because many of the streets bear the names of the capitals of Europe. On one side of the district, six of these streets converged on one of

15a. The Pont de l'Europe, a bird's eye view looking toward the Gare St.-Lazare. From *Paris Nouveau Illustré*, No. 14 (n.d.). Author's arrow indicates approximate point from which Caillebotte painted.

the engineering marvels of the Second Empire, the Pont de l'Europe, an immense bridge that spanned the yards of the St.-Lazare train station (Pl. 15b). The trellises of this bridge appear in other canvases by Monet (Pl. 15c) and Manet (Pl. 15d) as well; but nowhere in Impressionist painting does the call for artistic recognition of the forms of modern life receive as unequivocal a response as here, where these raw grids of iron (erected about a decade before) rise up to dominate a painting of major dimensions.

In contrast to Monet's contemporary views of the Gare St.-Lazare, which cloaked the railroad in vapor, Caillebotte's sharp-focus image does

15b. The Pont de l'Europe, seen from the Gare St.-Lazare. Photograph, n.d. (1860s?). Bibliothèque Historique de la Ville de Paris. (Author's arrow indicates point occupied by man leaning on railing in Caillebotte's painting.)

15c. Claude Monet, *Le Pont de l'Europe*, 1877. Oil on canvas, 64 × 80 cm. (25¼ × 31½ in.). Musée Marmottan, Paris.

15d. Edouard Manet, *Gare St.-Lazare*, 1873. Oil on canvas, 92.9 × 112 cm. (36½ × 44 in.). National Gallery of Art, Washington, gift of Horace Havermeyer in memory of his mother Louisine W. Havermeyer.

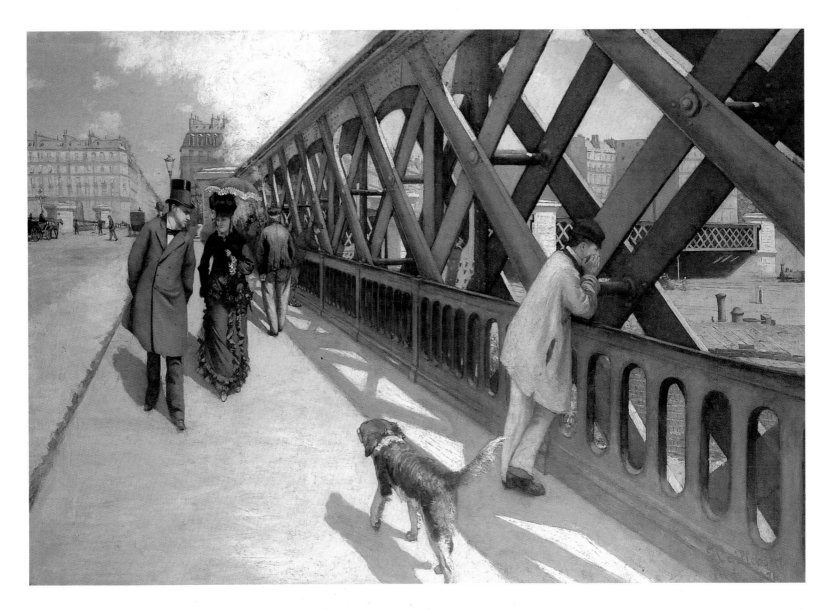

nothing to temper the brute industrial severity of these girders. A glare-bright sunlight, casting a pervasive blue-violet tint in the shadows, bleaches the picture's tonalities to an almost grisaille paleness, with strong notes of local color left only in subsidiary details.[3] From the ruffs and buttons on the strollers' costumes, to the white cloud of steam that rises against a clear blue sky, to the awning-shaded windows of the distant buildings, the details are etched with a seemingly banal objectivity. But this relatively conservative palette and technique, hardly advanced by Impressionist standards of the date, are offset by the willful geometry of the composition—a structure as aggressively untraditional as that of the bridge itself. The dominant form is a skewed, lopsided X: one bar links the curb-line at lower left and the trellis top at upper right, and the other bar is formed by the prolongation of the diagonal of the railing (or the shadow on the sidewalk) into the receding line of the buildings at upper left.

Family tradition has it that Caillebotte worked on the site of the Pont de l'Europe, from a windowed carriage so that he could continue in all weather.[4] However, the evidence that we have suggests that the basic composition and many of the most important individual elements were carefully worked out in the studio. Building the picture through numerous preparatory studies (Pls. 15f–u), Caillebotte carefully exploited the steep uphill slant of the road at this point on the bridge (Pl. 15e) in order to produce a misleadingly sharp apparent convergence of perspective, based on a system of two vanishing points. The X-form geometry of the picture, and the exceptionally fast plunge into depth that it defines, are the results of these manipulations (for detailed consideration, see Chapter 4).

The positioning of the figures is no less calculated. Studied in separate drawings (e.g., Pls. 15m and 15r), they were then set into place on the already-determined spatial design. In the most signal choice, Caillebotte fixed the crux of

the compositional X, and thus the main force of the vertiginous spatial plunge, squarely on the head of the top-hatted stroller coming towards us. This figure is especially significant since he

15e. Detail of Pl. 15b. Author's arrow indicates position of man leaning on railing in Caillebotte's painting. Note sharp uphill slant of railing and road ed, from low point at left toward convergence with top of girder trellis at right.

15f. Study for *Le pont de l'Europe*: Architectural and perspectival study "A." Pencil and ink on tracing paper, 12.4 × 16.4 cm. (4⅝ × 6⅜ in.).

15g. Study for *Le pont de l'Europe*: Architectural and perspectival study "B." Pencil and ink on tracing paper, 13.8 × 19.9 cm. (5½ × 7¹³⁄₁₆ in.).

15h. Study for *Le pont de l'Europe*: Architectural and perspectival study "C." Pencil and ink, 16 × 19 cm. (6⁵⁄₁₆ × 7½ in.).

represents, by contemporary account as well as family tradition, the artist himself.[5] Thus Caillebotte made his own head, though set back in space and off to the left, the principal focus of the picture.

15i. Study for *Le pont de l'Europe*: Head and shoulders of man in top hat. 26.8 × 19 cm (19⁹⁄₁₆ × 7½ in.).

We are drawn to his face with a rush, along the receding slanted girders, urged on by the extra emphasis of the dog, whose body acts as a spatial arrow in its parallel thrust along the shadow line. When we arrive at the focal crux, however, we encounter a conflicting demand; his diverted gaze redirects our attention back against the grain, toward the prominent figure leaning on the railing at the right. The unity of the basic spatial thrust is then undercut by a persistent back-and-forth oscillation of interest between these two figures, of the stroller and the man at the railing.[6]

The men are similar in scale, both are situated at the point of converging lines (the junction of the girders in the case of the railing figure), and both stare off to the right; but they are clear opposites in type. The figure of Caillebotte is, with his elegant lady companion, that of the stereotypical upper-bourgeois *flâneur*, or wandering idler, dressed in the smartest style; while the other figure wears the shapeless blouse and trousers that were the mark of the Parisian manual laborer. Though realist city scenes

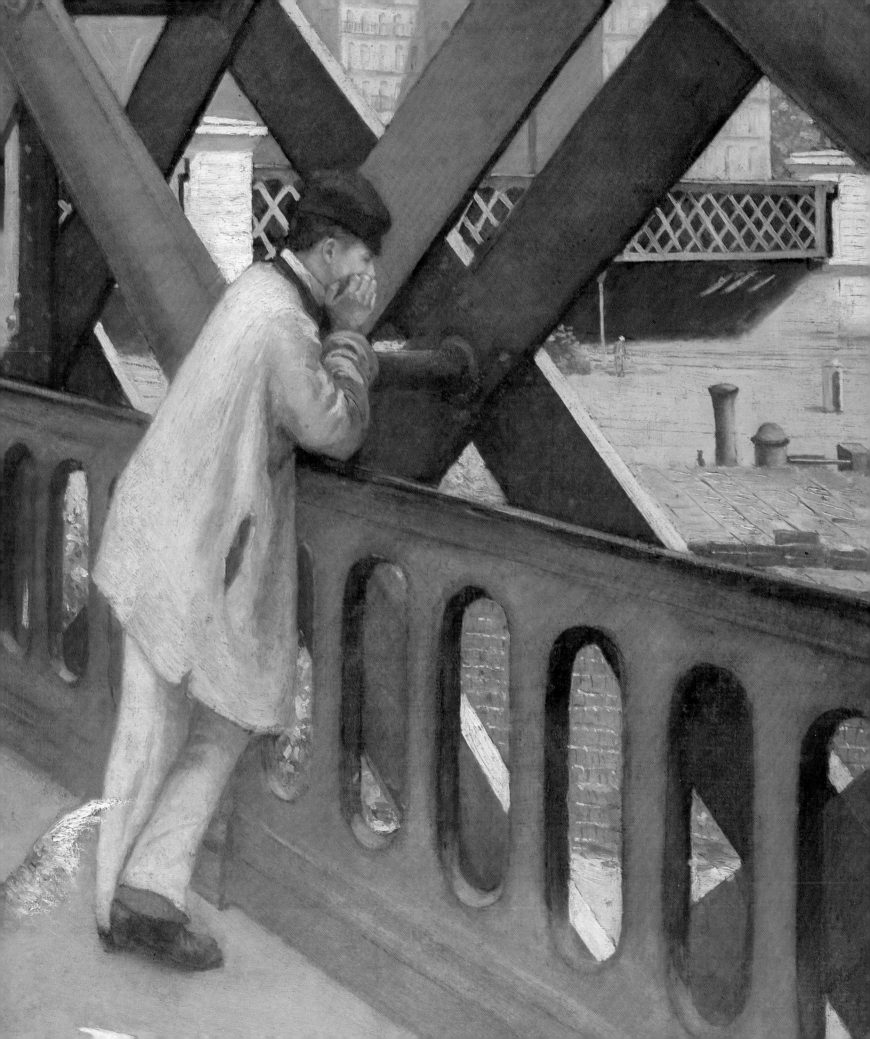

frequently made a point of the mix of classes on the boulevard, the opposition has an emblematic clarity here that may be significant in relation to the artist's own life at the time. A very wealthy young man, Caillebotte had the upbringing of the sheltered, privileged upper bourgeoisie. Yet the picture with which he first caused a sensation was a forceful realist presentation of the "low" subject of the urban laborer (Pl. 8); and the major commitment of his early maturity was to the Impressionists' attempt to counter the official artistic establishment. Especially during the early years of his career, when he continued to live in the family home with his widowed mother (Pls. 13 and 19), there must have been an incredible disparity between the two aspects of Caille-botte's life: between the tradition-bound, richly appointed world of monied idleness in which he had grown up; and the active involvement in the avant-garde democratic milieu of the Impressionists, with their dedication to the exploration of modern life at all levels. The tension of such a disparity is already quite clear in the dialogue between the home within and the world beyond in Pl. 10; and it may be restated here in the visual tug-of-war between *flâneur* and worker in the street.

When he painted this, his largest work to date and his first full image of the city, Caillebotte had just exhibited for the first time with the Impressionists. Barely twenty-eight years old, he had reached a cusp point in his life. The pressures and complexities of this moment in his personal experience may help to explain the dramatic concentration, as well as the underlying tensions, of this most unusual self-portrait.[7]

15k. Study for *Le pont de l'Europe: L'homme au chapeau haut de forme*, 1876. Oil on canvas, 54.5 × 38 cm. (21$\frac{3}{4}$ × 17$\frac{3}{4}$ in.). Private collection, Houston.

15m (right). Study for *Le pont de l'Europe*: Striding man in top hat, hands behind. 53.7 × 19.7 cm. (21$\frac{1}{8}$ × 7$\frac{3}{4}$ in.).

15j (below left). Study for *Le pont de l'Europe*: Woman with parasol. 60 × 46 cm (23$\frac{5}{8}$ × 18$\frac{1}{4}$ in.).

15l. Study for *Le pont de l'Europe*: Man in top hat, woman with parasol. 61 × 47.7 cm. (24 × 18$\frac{3}{4}$ in.).

15o (above). Study for *Le pont de l'Europe*: Man in cap, leaning on elbows, crossed-legged. 60.2 × 46.4 cm. (23$\frac{11}{16}$ × 18$\frac{1}{4}$ in.).

15n (top left). Study for *Le pont de l'Europe*: Man in cap leaning on rail. 25.1 × 17.5 cm. (9$\frac{7}{8}$ × 6$\frac{7}{8}$ in.).

15q. Studies for *Le pont de l'Europe*: Three views of a dog, from behind and above. 47 × 31.5 cm. (18$\frac{1}{2}$ × 12$\frac{3}{8}$ in.).

15r. Studies for *Le pont de l'Europe*: Standing man seen from rear, with studies of head and hand. 48 × 31 cm. (19 × 12$\frac{1}{4}$ in.).

15p (left). Study for *Le pont de l'Europe*: Two studies of a coach with driver and horse. 31 × 47.5 cm. (12$\frac{3}{16}$ × 18$\frac{11}{16}$ in.).

15s (right). Sketch for *Le pont de l'Europe*, 1876. Oil on canvas, 54 × 73 cm. (21$\frac{1}{4}$ × 28$\frac{3}{4}$ in.). Private collection, Paris. (Berhaut, 1978, No. 40).

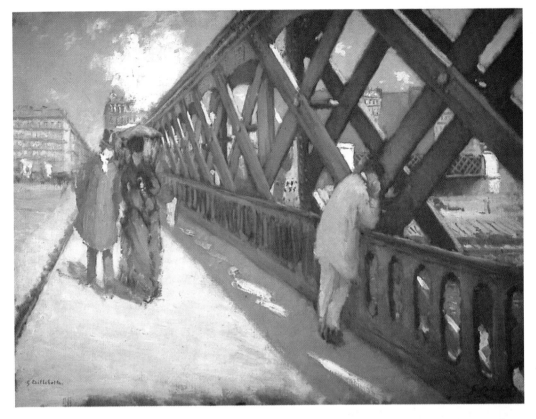

15t. Study for *Le pont de l'Europe: Les poutres en fer*, 1876. Oil on canvas, 55.5 × 45.7 cm. (22 × 18 in.). Private collection, Paris.

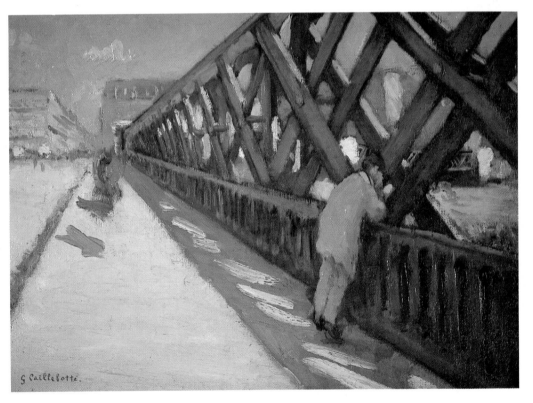

15u. Sketch for *Le pont de l'Euorpe*, 1876. Oil on canvas, 32 × 46 cm. (12$\frac{5}{8}$ × 18$\frac{1}{8}$ in.). Musée des Beaux-Arts, Rennes. (Berhaut, 1978, No. 39)

16. Le pont de l'Europe, variant

(*The Europe Bridge, variant*) 1876–77(?)
Oil on canvas, 105 × 131 cm. ($41\frac{3}{8}$ × $51\frac{5}{8}$ in.)
Stamped l.r.
Kimbell Art Museum, Fort Worth, Texas
Berhaut, 1978, No. 46

Though this picture has been described as a partial study for the large *Pont de l'Europe* exhibited in 1876 (Pl. 15),[1] it seems more properly a variant version, complete in its own right. It is highly finished, and is preceded by its own sketch version (Pl. 16a). Furthermore, though the main protagonists are similar, the picture represents an entirely different point on the bridge, and is conceived completely differently in terms of composition and coloration.[2]

The view has none of the lateral stretch of the other *Pont de l'Europe*, but is instead severely cropped on all sides; no figure is complete, and neither the top of the trellis nor the ground line is visible. The effect is more like that of a telephoto lens than, as in the other version, of a wide-angle lens. In contrast to the deep spatial rush of the other version, this composition emphatically blocks our penetration, by the edge-to-edge interposition, in shallow depth, of the giant lattice of steel, parallel to the picture plane.[3] Offsetting the near-absolute symmetry of this huge angular pattern, Caillebotte sets all of the figures into the left half of the canvas, providing a mixture of regular geometry and snap-shot-like imbalance similar to that of the *Rue de Paris; Temps de pluie* (Pl. 18).

We may assume that the central character here represents, as does his counterpart in the larger version, the artist himself—though little more is shown of him than of the anonymous passer-by who exits at the left. His gaze away from us brings to mind the earlier *Jeune homme à sa fenêtre* (Pl. 10); but the plunging sight line of that earlier work is here replaced by the intervening screen of the girders, seemingly blocking the figure's view as well as ours. What a baffling conception this is, so devoid of information and yet so evocative. The subtle notes of the white scarf and glove, pristinely elegant against the dark dirty severity of the trellis, accent the stand-off between man and machined metal.

Curious, too, is the coloration: a virtually unrelieved uniformity of grey and blue. If we see this and the other *Pont* as being, like the two *Raboteurs* (Pls. 8 and 9), separate considerations of the same basic motif, we can perhaps see them, too, in the context of the kind of series paintings Monet did throughout his life, taking essentially the same subject under different conditions of weather and light.[4] The contrast between the bright sunlight of the larger *Pont* and the deep wintry overcast of this version may even suggest a conscious attempt to embody a separate mood here, literally "blue."[5]

Given all the substantial differences of emotion, composition, and execution that separate it from the view of the Pont de l'Europe shown in 1876 (Pl. 15), this "variant" work may in fact have been painted at a different date altogether, closer to 1880. The palette, brush-work, figure scale, spatial closure and mood would all be consistent with Caillebotte's work of c. 1880–82. Allowing for obvious differences in color, this from-behind view of a viewer seems to belong more to the world of the *Homme au balcon* of 1880 (Pl. 42) than to that of the *Jeune homme à sa fenêtre* of 1876 (Pl. 10). If this were a later reconsideration of the early bridge theme, it would be consistent with Caillebotte's reconsideration of the family crystal from the 1876 *Déjeuner* (Pl. 13) in a still life painted after his mother's death (*Nature morte*, Pl. 32). There, as in this second bridge scene, a wide-angle perspective is replaced by a more limited space and closer cropping.

16a. Sketch for *Le pont de l'Europe* (variant), 1876–77. Oil on canvas, 64 × 80 cm. ($25\frac{1}{4}$ × $31\frac{1}{2}$ in.). Private collection. (Berhaut, 1978, No. 45)

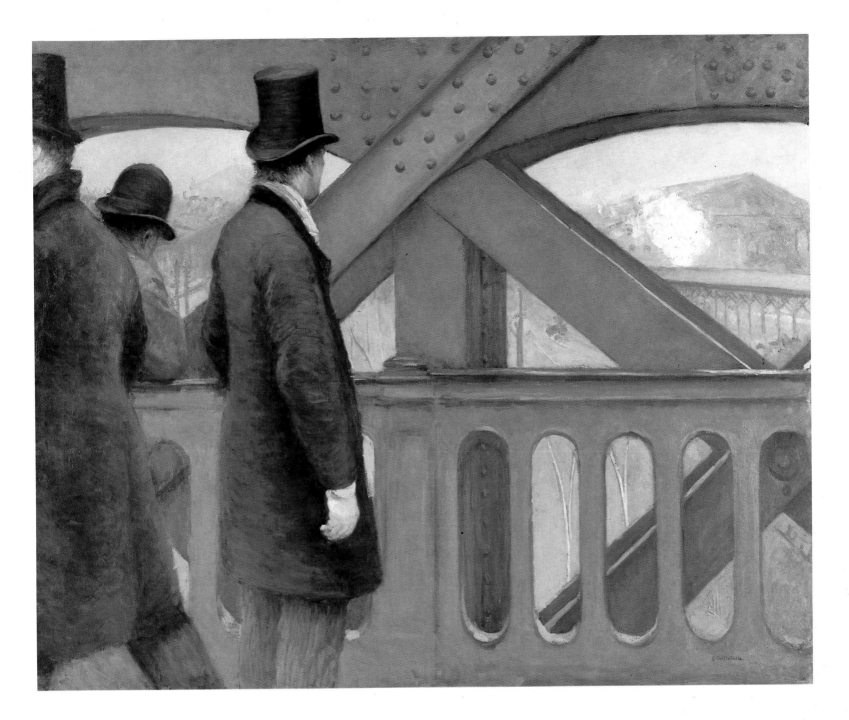

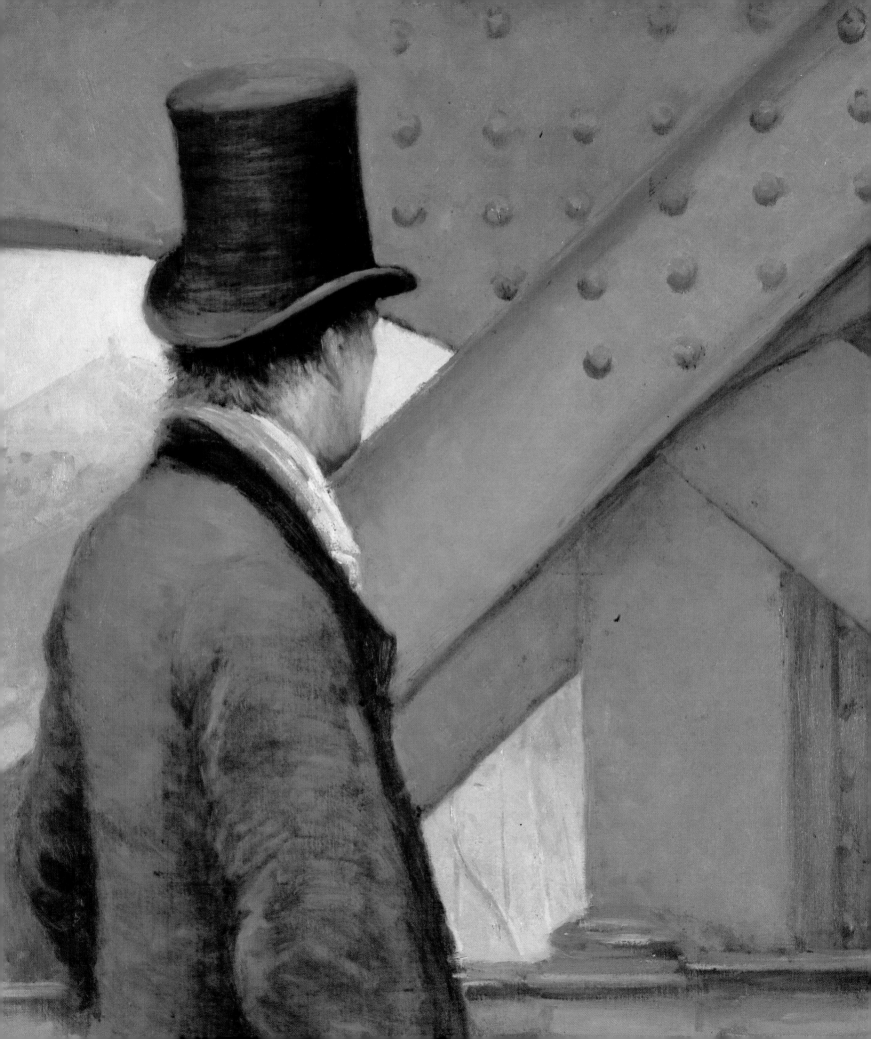

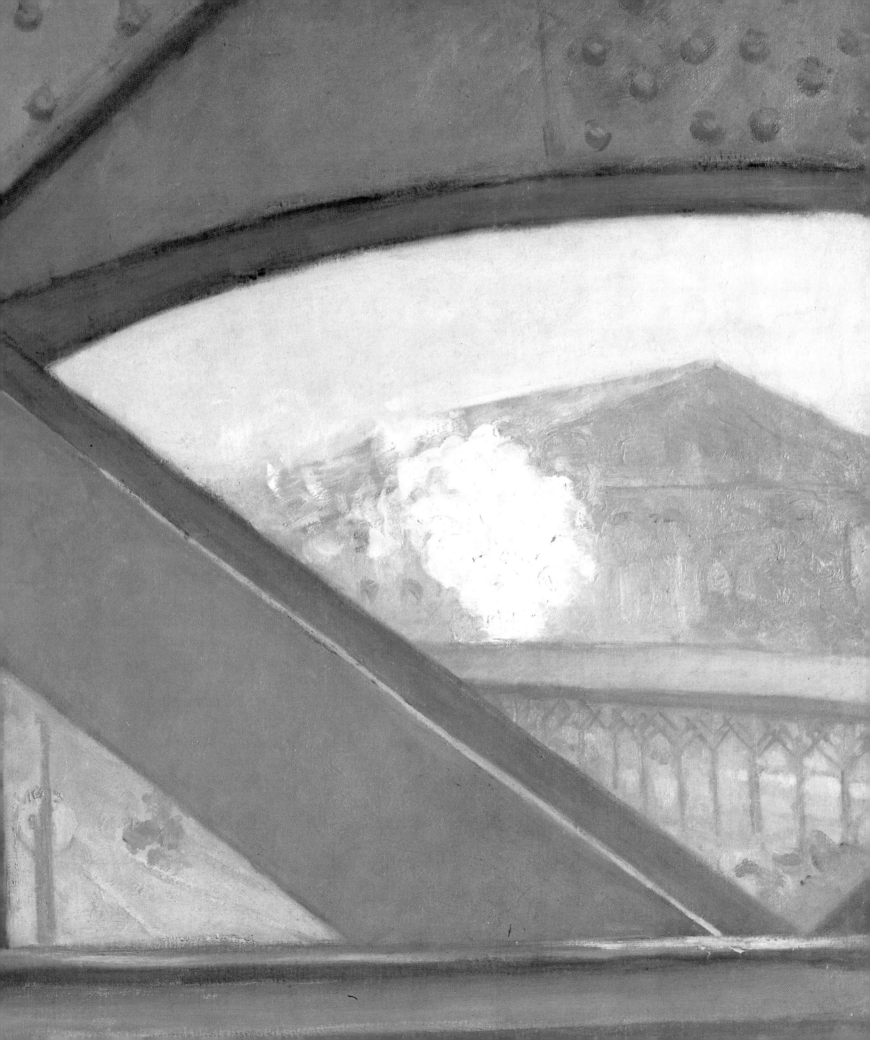

17. Peintres en bâtiment

(*The House-painters*) 1877
Oil on canvas, 89.2 × 116.2 cm. (35⅛ ×
 45¾ in.)
Signed l.r. *G. Caillebotte 77*
Private collection, Paris
Berhaut, 1978, No. 48

Each of the three city views in the 1877 exhibition seems to treat, from within the confines of a consistently limited palette, a different effect of weather. *Peintres en bâtiment* lies between the hot bright sunlight of the *Pont de l'Europe* (Pl. 15) and the silvery moistness of the *Temps de pluie* (Pl. 18), and depicts a day light but shadowless, overcast but not misty or inclement. Amidst a restricted range of creams, chalky light greys, and muted blue-whites, the only notable area of local color is the medium-dark tone of the building facade at the right. Critics of the day did not find the coloration pleasing, and had positive remarks only for the well-observed painters, amusing in their procrastinating contemplation of the task at hand.[1] In retrospect, however, both aspects seem secondary to the effects of the extraordinary design of the picture.

Like that of the *Pont de l'Europe*, the basic composition is a tilted *X* skewed to the left. Here, however, that perspectival convergence into depth passes the figures by with such un-challenged authority that the space of the street becomes a subject in itself—a subject as modern in its way as the iron girders of the Pont de l'Europe.

Before 1852, thoroughfares as uncurving and uninterrupted as this were virtually non-existent in densely packed Paris, except in ceremonial

17b. Study for *Peintres en bâtiment*: Man in smock, from rear. 48.3 × 31 cm. (19 × 12⅜ in.).

17a. Sketch for *Peintres en bâtiment*, 1877. Oil on canvas, 60 × 73 cm. (23½ × 28¾ in.). Private collection, Paris. (Berhaut, 1978, No. 47)

17c. Study for *Peintres en bâtiment*: Man in smock, standing on one foot on ladder, facing right and reaching to upper right. 48 × 31 cm. (18⅞ × 12¼ in.).

rarities like the rue de Rivoli. But under the boulevard program of Baron Haussmann, the look of this street—incredibly broad, bullet-straight, and seemingly stretching to infinity—became the pervasive hallmark of the new city. Victor Hugo wrote with sarcasm in 1869: "How handsome it is, from Pantin one sees all the way to Grenelle! / Old Paris is no longer anything more than one eternal street / Which stretches out elegant and straight like the *i* / In saying 'Rivoli, Rivoli, Rivoli.'"[2]

Caillebotte's pictorial design emphasizes this look of monotonous vastness, as the plunging perspective produces a highly regular diagonal joining gutter edge and roofline at the vanishing point. This effect of great depth leading to

surface linearity was not uncommon in photography (see Chapter 3), but the artist has given it extra clarity here, after beginning with a less direct diagonal in the sketch (Pl. 17a).

This diagonal is, moreover, only a part of the complex dialogue between deep space and surface in the design. The pie-wedge shapes of the overall composition are vectors into depth; but when Caillebotte restates the same form in the vertical-pointing pyramidal ladders, he makes us aware of the flat triangular geometry of the picture, and sets up conflicting demands on our eye.[3] The construction of the picture, so complex in this interplay of triangles with crossing systems of parallels (the rungs of the ladders and the vertical divisions along the

facades), and so dramatic both in urgent depth and obtrusive flatness, seems curiously at odds with the casual laziness of the painters.

17d. Study for *Peintres en bâtiment*: Man bending over, painting. 46 × 30 cm. (18⅛ × 11¹³⁄₁₆ in.).

17f. Study for *Peintres en bâtiment*: Man in top hat from back. 46 × 29.5 cm. (18⅛ × 11⅝ in.).

17h. Study for *Peintres en bâtiment*: House painter, in profile right, with lady with parasol. 37 × 23.7 cm. (14⁵⁄₁₆ × 9⅓ in.).

17e. Study for *Peintres en bâtiment*: Man in smock, standing on ladder, facing right, right arm extended forward. 48 × 30.8 cm. (19 × 12⅛.).

17g. Study for *Peintres en bâtiment*: Man on ladder. 48 × 32 cm. (18⅞ × 12⅝ in.).

17i. Study for *Peintres en bâtiment*: Man standing on ladder, bare-headed, facing right, arm at side.

17j. Study for *Peintres en bâtiment*: Standing man in smock, leaning forward, seen from three-quarters rear. 47.7 × 30 cm. (18⅞ × 12 in.).

17k. Studies for *Peintres en bâtiment*: Man squatting with stick and bucket; and study of hands. 47 × 30.7 cm. (18⅝ × 12⅛ in.).

18. Rue de Paris; Temps de pluie

(*Paris street; Rainy weather*) 1877

Oil on canvas, 212 × 276 cm. (83½ × 108¾ in.)

Signed l.l. *G. Caillebotte 1877*

The Art Institute of Chicago, Charles H. and Mary F. S. Worcester Fund Income

Berhaut, 1978, No. 52

This is, to waste no words, Caillebotte's masterpiece. Many of his other pictures are appealing and important, but none is so monumental (approximately seven by ten feet), so complex, and so endlessly spell-binding as this vast intersection in the still, cool air of a rainy day. It is also one of the most lovely and subtle of his paintings. A pervasive grey-blue atmosphere cloaks the limestone buildings. The almost shadowless grey light of the sky, reflected by the rain-washed surfaces, gives the picture a cool, pewter tonality, accented by the slate and chestnut costumes of the strollers, and offset by notes of earthier hue: the copper-rust of the building fronts on the right, the deep green patina of the bronze lamppost, and the lighter green accents of the umbrella handles. The elegance of the picture stems not only from the formal feel of the costumes and the overall understatement of the harmonies, but from the subtlest touches of gleam; in the gold of the PHARMACIE sign on the building at the left, and most especially in the pure magic of the one pearl (or diamond?) that shines from the ear of the delicately veiled lady on the right.

The picture is not, however, one whose visual qualities are contemplated from a comfortable aesthetic distance. The near life-size strollers loom so immediately before us, and the sweep of the space is so compelling, that we are drawn irresistibly into a greater involvement with the scene and the subject. The scene is, in precise terms, an intersection crossing the rue St.-Petersbourg (now rue Leningrad) between the tracks of the Gare St.-Lazare and the Place de Clichy; but, in larger terms, the subject is new Paris and by extension the modern city.

It requires an act of the imagination to appreciate the extraordinary effect of raw modernity this scene had for Caillebotte. When the artist was born, this district was a relatively unsettled hill outside the city limits. Then, under the Second Empire, as he grew up nearby, it was developed, literally from the ground up, as a planned residential district for the upper bourgeoisie. Every street here was pierced, and every building built, within the artist's lifetime.[1] The whole ensemble was an exceptionally unified and undiluted microcosm of the new look that Haussmann's boulevards had imposed throughout Paris—an environment that represented a complete, drastic change from the semi-medieval scale and crooked, irregular variety of Paris as it had been. The new look was impressive in size, elegant in an anodyne way, impeccably clean and regular. All of these qualities of modernity Caillebotte captures, insisting on them even in his figures, who are uniformed in the very latest in fashion.[2] However, he captures as well a sensation of a different, less positive tenor.

When other painters of the time took the city

as a subject, they saw, as Monet did (Pl. 18a), a carnival of form and light, a generalized landscape of bustle; or, in a realist vein (Pl. 18b), they dwelt novelistically on the pseudo-democracy of the modern thoroughfare, detailing the diversity of stations and conditions of life in a jumble of amusing or moralizing anecdotes.[3] However, where these others show a richly teeming crowd, Caillebotte gives us emptiness, stretching into far-reaching perspectives and peopled by isolated wanderers. Where others sing picturesque prolixity, Caillebotte laconically proposes only selected randomness within a framework of insistent, regular order.

His picture is structured on a giant plus-sign, split horizontally by the line through the head-

18a. Claude Monet, *Boulevard des Capucines*, 1873–74. Oil on canvas, 79.4 × 59 cm. (31¼ × 23¼ in.). William Rockhill Nelson Gallery and Atkins Museum of Fine Arts, Kansas City. Acquired through the Kenneth A. and Helen F. Spencer Foundation Acquisition Fund.

18b. Giuseppe de Nittis, *Trafalgar Square*, 1877. Oil on canvas, Musée du Petit Palais, Paris.

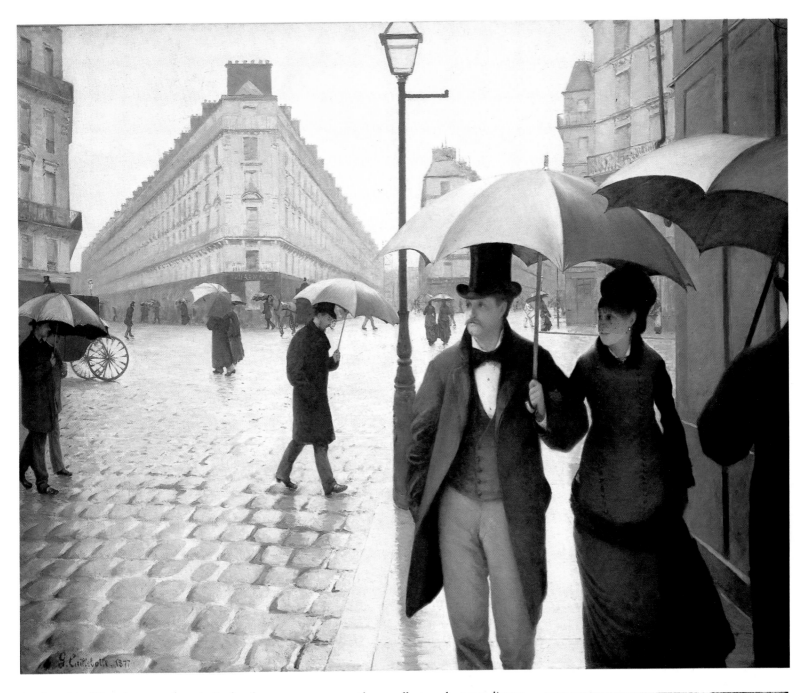

levels and building bases, and vertically by the lamppost with its reflection. The whole expansive space is furthermore channeled, in a kind of visual suction, toward the deepest point, almost exactly at the center of the canvas. The clear order of the basic axes is then picked up in the smaller elements, which repeat a subtle rhythm of regularity throughout: in the measured beat of the pristine cobblestones, echoed in the monotonous notes of the distant chimneys, and most evident in the cadence of the uniformly silvered umbrellas that provide our visual stepping-stones back across the rain-slick street.

These sensations of disciplined order are confirmed in the method of the picture's making. For the figures that traverse this space,

even among the smallest and most distant, Caillebotte plotted positions that coincided with the perspectival plan and with harmonic proportional divisions of the canvas's surface. (For a detailed consideration, see Chapter 4.)

Though the *Temps de pluie* may at first strike us as boldly random in composition, the more we look, the more we come to feel that the architecture of the picture, visible and covert, dominates everything within it. This overriding order affects even our awareness of time, stifling the Impressionist sense of a glimpsed moment found in a view like Degas's *Place de la Concorde* (Pl. 18c). Caillebotte replaces Degas's opposing diagonals and idiosyncratic postures with a more frozen, monumental structure, both in space and

18c. Edgar Degas, *Place de la Concorde (Le Vicomte Lepic et ses filles)*, c. 1873. Oil on canvas, 80.6 × 120.4 cm. (31¾ × 47⅜ in.). Formerly in Gerstenberg collection, Berlin (believed destroyed).

18d. Study for *Rue de Paris; Temps de pluie*: Architectural and perspectival study. 30 × 46 cm. ($11\frac{13}{16}$ × $18\frac{1}{16}$ in.).

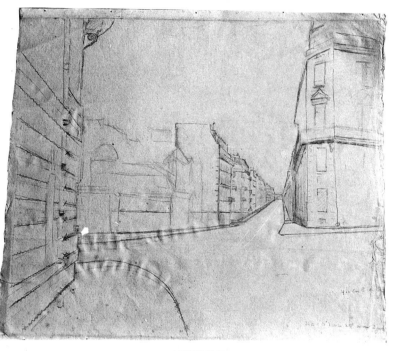

18e. Study for *Rue de Paris; Temps de pluie*: Intersection in perspective. 43.2 × 47 cm. (17 × $18\frac{1}{2}$ in.).

18f. Study for *Rue de Paris; Temps de pluie*: Intersection in perspective. 62 × 92.5 cm. ($24\frac{3}{8}$ × $36\frac{7}{16}$ in.).

on the surface, that saps movement of its spontaneity. His regimentally aligned strangers, their verticals inflexibly paralleling those of the frame and buildings, seem strolling somnambulants, bound to a repetitious similarity of dress, carriage, and pace that echoes their modern environment.

The *Temps de pluie* is not, of course, a simplistic manifesto of urban malaise. Beautiful and marvellously calm, the picture even has, for eyes now accustomed to more violent intrusions of modernity, a charming nostalgia. Clearly, too, Caillebotte was attracted to and moved by the spectacle of modern Paris, or he would not have given to it so much of his artistic energy. His vision does consistently point up those aspects of the city—the outsized scale of its spaces and the inhuman regularity of its architecture—that one finds cited again and again in the late-nineteenth-century reaction against Haussmann's legacy.[4] However, beyond polemic, and more than just a document of its time, the picture has a complexity of feeling that befits a personal insight into a new human phenomenon. The uncommunicative isolation of these strollers—particularly the foreground couple, so close and yet so psychically remote from us as well as from each other—touches in premonitory fashion a familiar truth of modern urban life.[5]

Not only in terms of this perception, but also in its aesthetics, Caillebotte's picture seems ahead of its time. Its scale, method, and structure stand outside the Impressionism of the 1870s and relate more closely to the principles of the Neo-Impressionists of the 1880s. Indeed, the relation between the *Temps de pluie* and Georges Seurat's *Un Dimanche après-midi sur l'île de la Grande Jatte* (Pl. 18g) seems quite striking. There are similarities in look, such as the prominent couple with umbrella on the right of both; but more importantly there is a strong similarity in the approach to constructing a picture, and in the basic conception of a regular geometric order as a device for monumentalizing the random ban-

18g. Georges Seurat, *Un Dimanche après-midi sur l'île de la Grande Jatte*, 1884–86. Oil on canvas, 205.7 × 305.8 cm. (81 × $120\frac{3}{8}$ in.). The Art Institute of Chicago. Helen Birch Bartlett Memorial collection.

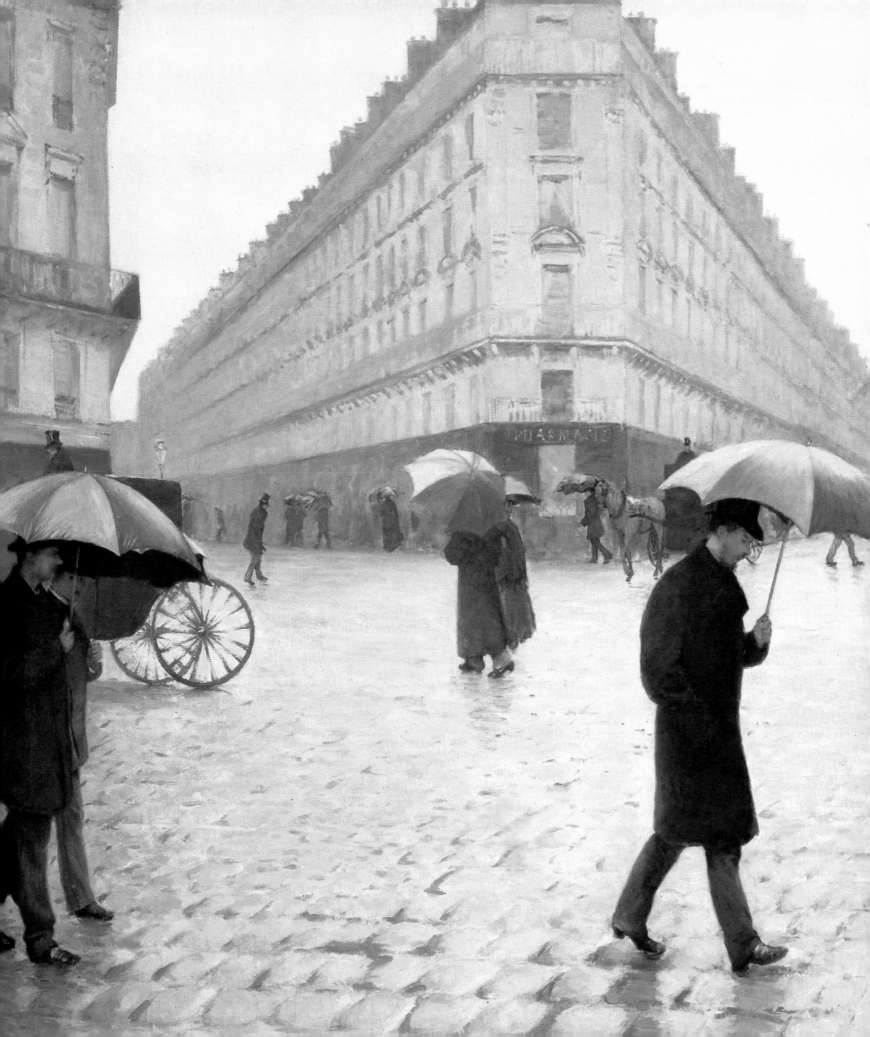

ality of bourgeois *ennui* into a permanent poetry. The Belgian Symbolist Fernand Khnopff apparently responded to this same melding of repetitive rhythmic order and strong asymmetry as a telling form for the psychological experience of urban modernity; his *En Passant, Boulevard Regent* of 1881 (now lost; see sketch, Pl. 18h) seems an homage to Caillebotte's rainy-day view, and a mid-point between it and the more forceful strictures of Seurat. In the *Temps de pluie*, the stylized order is less obtrusive, and the sense of suspension more subliminal, seeming to

18h. Fernand Khnopff, *En Passant, Boulevard Regent*, 1881. Pastel, 9 × 17.2 cm. (3½ × 6¾ in.).

emanate from beneath the lovingly rendered surfaces of an apparently casual reality.

So much, indeed, lies beneath the beautiful appearance of this scene that no description or explanation can easily encapsulate it. On this vast canvas, painted when the artist was 28, and a turning point in his career, Caillebotte brought together as never again the major poles of his vision; perhaps it is the invisible locking force of these polarities—of surface and space, of order and randomness, of discipline and feeling—that imprints the picture so indelibly in the mind.

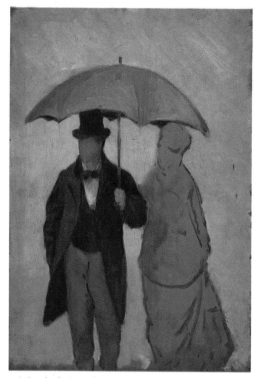

18j. Study for *Rue de Paris; Temps de pluie*, 1877. Oil on canvas, 46 × 32.5 cm. (18¾ × 11¾ in.). Private collection, Paris. (Berhaut, 1978, No. 50).

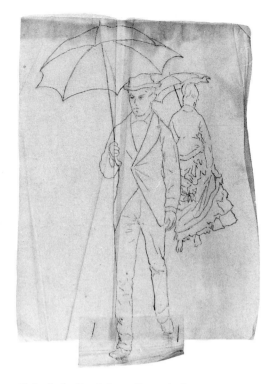

18l. Study for *Rue de Paris; Temps de pluie*: Young man with umbrella and woman from rear. 61 × 44.5 cm. (24 × 17½ in.)

18i. Study for *Rue de Paris; Temps de pluie*: Horse and carriage. 31 × 46.6 cm. (12³⁄₁₆ × 18⅜ in.).

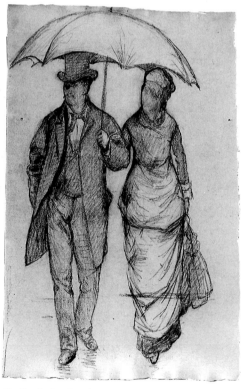

18k. Study for *Rue de Paris; Temps de pluie*: Man and woman walking arm in arm, with umbrella. 47× 30.9 cm. (18½ × 12³⁄₁₆ in.).

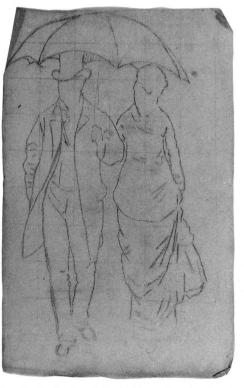

18m. Study for *Rue de Paris; Temps de pluie*: Couple with umbrella. 46.7 × 30.7 cm. (18⅜ × 12⅛ in.).

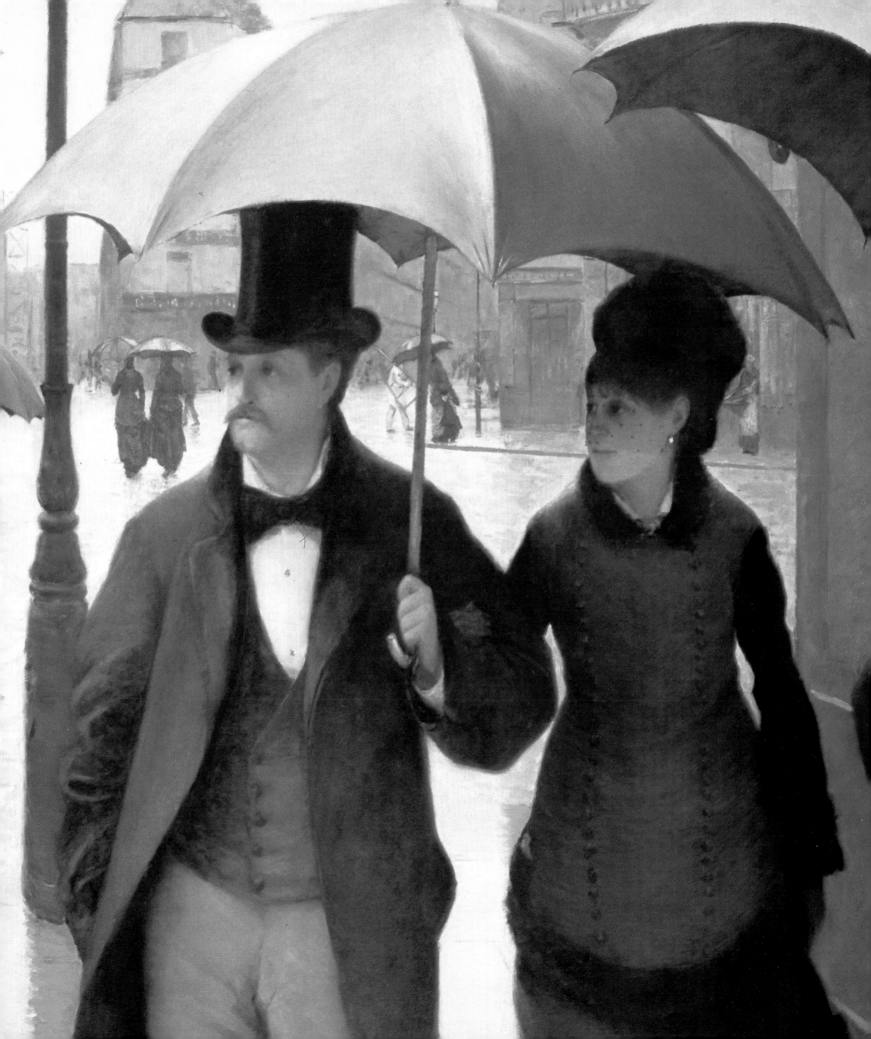

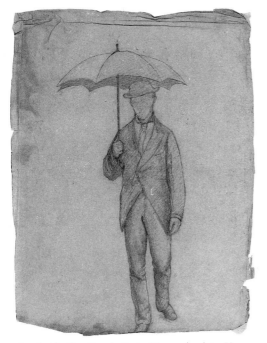

18n. Study for *Rue de Paris; Temps de pluie*: Young man walking forward with umbrella. 62.5 × 48.5 cm. ($24\frac{5}{8}$ × $19\frac{1}{8}$ in.)

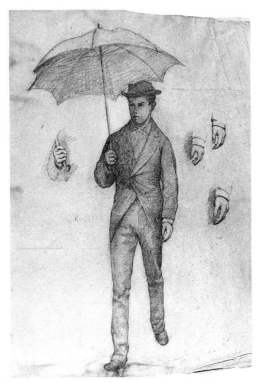

18p. Studies for *Rue de Paris; Temps de pluie*: Young man with umbrella, seen from front; and four studies of hands. 62 × 48.2 cm. ($24\frac{3}{8}$ × 19 in.).

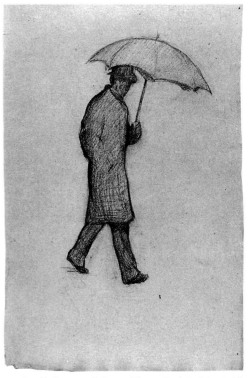

18r. Study for *Rue de Paris; Temps de pluie*: Man with umbrella, walking to the right. 48.5 × 31.2 cm. ($19\frac{1}{8}$ × $12\frac{1}{4}$ in.).

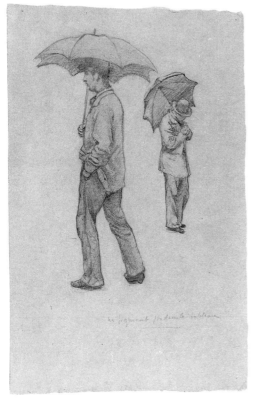

18o. Study for *Rue de Paris; Temps de pluie*: Two men with umbrellas. 46.5 × 29.2 cm. ($18\frac{5}{16}$ × $11\frac{1}{2}$ in.).

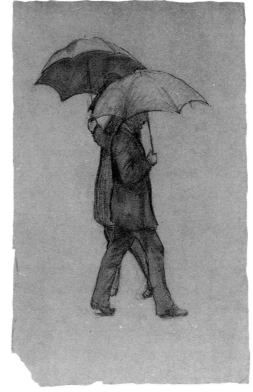

18q. Study for *Rue de Paris; Temps de pluie*: Two men with umbrellas. 46.1 × 30 cm. ($18\frac{1}{8}$ × $11\frac{13}{16}$ in.).

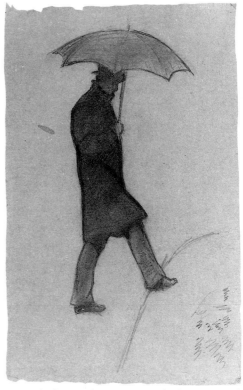

18s. Study for *Rue de Paris; Temps de pluie*: Man with umbrella, profile right, right foot raised. 45.1 × 39.2 cm. ($17\frac{3}{4}$ × $15\frac{7}{16}$ in.).

18t. Study for *Rue de Paris; Temps de pluie*: Two women with umbrellas. 48 × 30.5 cm. (18⅞ × 12 in.).

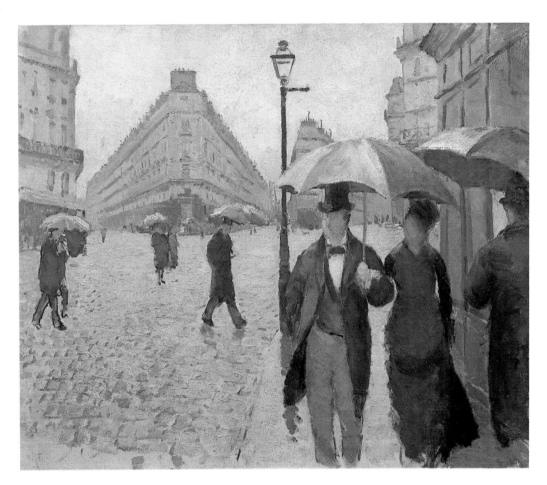

18v. Sketch for *Rue de Paris; Temps de pluie*, 1877. Oil on canvas, 54 × 65 cm. (21¼ × 25⅝ in.). Académie des Beaux-Arts, Musée Marmottan, Paris. Formerly collection of Claude Monet. (Berhaut, 1978, No. 51)

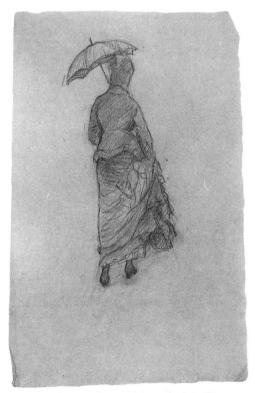

18w. Study for *Rue de Paris; Temps de pluie: Les pavées*, 1877. Oil on canvas, 32.5 × 40 cm. (12¾ × 16 in.). Private collection, Paris.

18u. Study for *Rue de Paris; Temps de pluie*: Woman with umbrella, seen from rear. 47 × 31.7 cm. (18⅝ × 12 5/16 in.).

18x. Study for *Rue de Paris; Temps de pluie*: Pavement, two figures with umbrellas. Oil on canvas, 54 × 65 cm. (21¼ × 25½ in.). Location unknown. (Berhaut, 1978, No. 49).

19. Portrait de Madame C.[aillebotte]
(*Portrait of Madame C.[aillebotte]* 1877
Oil on canvas, 83 × 72 cm. (32¾ × 28¼
 in.)
Signed l.r. *G. Caillebotte 77*
Private collection, Paris
Berhaut, 1978, No. 53

Caillebotte's widowed mother was 58 when this portrait was painted. She doubtless saw it hanging in what was her son's most impressive exhibition, the Impressionist exhibition of 1877; but she would be dead, at 59, before he showed his work again. The picture is part of a series of images by Caillebotte of the women in his family—aunts and cousins—intently sewing (see for example *Portraits à la campagne*, Pl. 14; and also Berhaut, 1978, Nos. 54 and 68).

19a. Study for *Portrait de Madame C. [aillebotte]*: Woman sewing, seen from front. Charcoal, 47.5 × 30 cm. (18¾ × 12 1/16 in.).

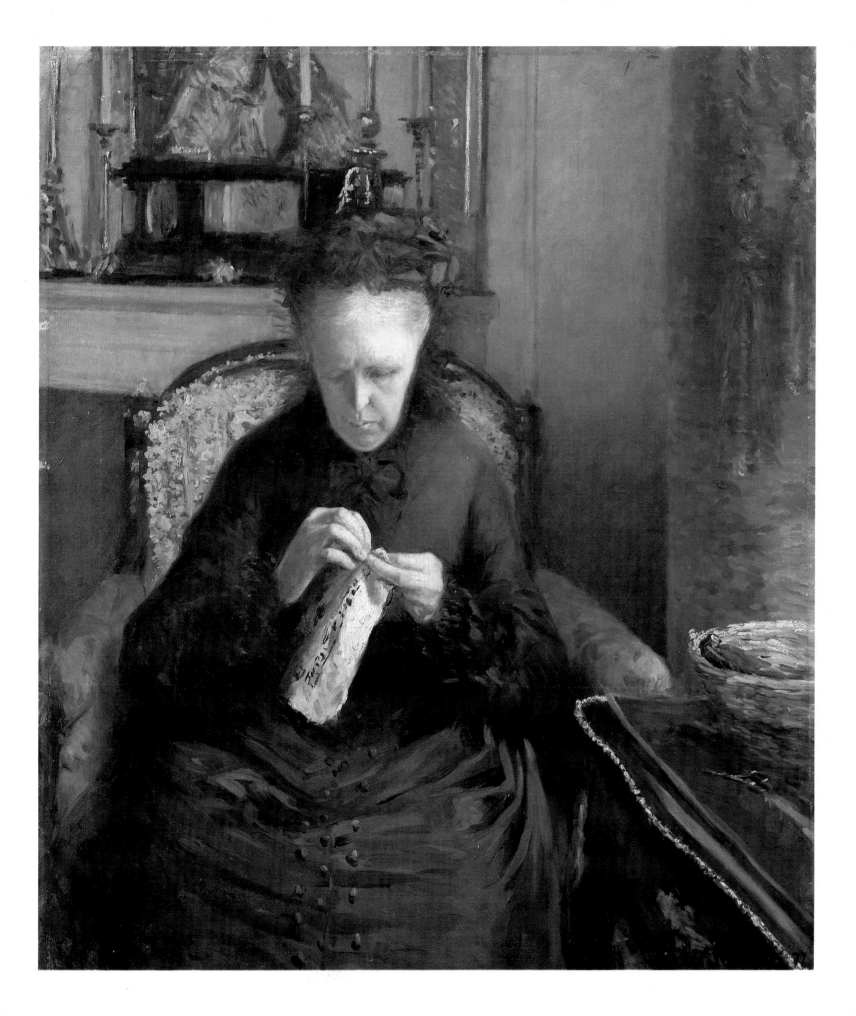

20. Canotiers

(*Oarsmen*) 1877
Oil on canvas, 81 × 116 cm. (31⅞ × 45⅝
in.)
Signed u.r. *G. Caillebotte 1877*
Private collection, Paris
Berhaut, 1978, No. 75 (*Canotiers ramenant
sur l'Yerres*)

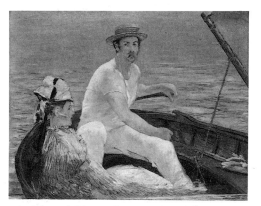

20a. Edouard Manet, *Boating*, 1874. Oil on canvas, 97.1 × 130.2 cm. (38¼ × 51¼ in.). The Metropolitan Museum of Art, New York. The H. O. Havermayer collection, bequest of Mrs H. O. Havermayer.

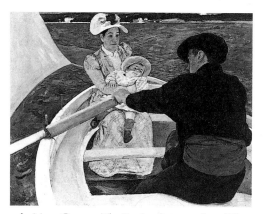

20b. Mary Cassatt, *The Boating Party*, c. 1894. Oil on canvas, 92.7 × 117.1 cm. (36½ × 46⅛ in.). The National Gallery of Art, Washington, D.C. Chester Dale collection.

Soon after the series of street scenes of 1876–77, large and complicated canvases that must have precluded almost any other work for quite a while, Caillebotte began another series, dealing with rowing on the river Yerres. None of these canvases were shown before 1879 (there was no Impressionist exhibition in 1878), but the present picture is dated 1877. Probably done in the summer following the exhibition of that year, it is thus one of the first such scenes. It is also the most forceful, as it carries over some of the aggressive dynamics of space and scale found in the street views.

In a *tour de force* of illusory projection, the arms of Caillebotte's forward oarsman seem to extend out over the bottom of the canvas, surging toward us like forms in a 3-D movie. This exceptional forward thrust is answered by an equally accentuated inward movement. The latter is really as much upward as inward, since the converging sides of the boat form a symmetrical triangle against the horizon-less plane of the water; and the axis along the left leg of the near figure leads us straight up toward the prow, almost precisely along the midline of the canvas. The forceful push-pull of the relatively shallow picture space seems to act as a direct correlate for the physical energies of the activity depicted.

Caillebotte's viewpoint, situating us directly in the boat, has a partial precedent in Manet's *Boating* of 1874 (Pl. 20a). Manet's picture, though, simultaneously allows us more space (in the lateral movement out over the water) and less (in the non-sculptural flatness of the figures, and in the adjustment of their postures to parallel the picture plane). Caillebotte's more vigorous attack on the frontal plane and greater interest in crisp silhouette make his picture an intermediary between Manet's and Mary Cassat's *The Boating Party* of c. 1894 (Pl. 20b).[1]

The *Canotiers* makes an interesting comparison with the earlier *Raboteurs de parquet* (Pl. 8). The subject has changed from urban labor to country leisure, but the fascination with concentrated physical activity is the same, as is the device of repeating near-identical figures in sequential stages of a motion. Caillebotte's palette has brightened considerably in the interim between the two pictures, no doubt influenced by the work of Monet and Renoir; and his design is now far simpler, with fewer elements. The recession is no longer askew as in the *Raboteurs*, but, more like that of the *Temps de pluie* (Pl. 18), centered. The lower viewpoint, eliminated horizon, and closer cropping of the scene give this image, too, a higher degree of concentration and a more sensational "punch," at the cost of the subtleties and complexities found in the *Raboteurs*.

Tiny, gridded-over drawings related to this image (Pls. 20c and 20d) strongly suggest that,

somewhere in the origins of the composition, either an optic device (such as a camera lucida) or a photograph may have served as an aid.

20c. Study for *Canotiers*, 1877. Pencil on tracing paper. Full sheet size 30.7 × 27 cm. (12 × 10⅔ in.); each square shown here 2 cm. each side.

20d. Study for *Canotiers*. 29.8 × 45.3 cm. (11¾ × 17⅞ in.).

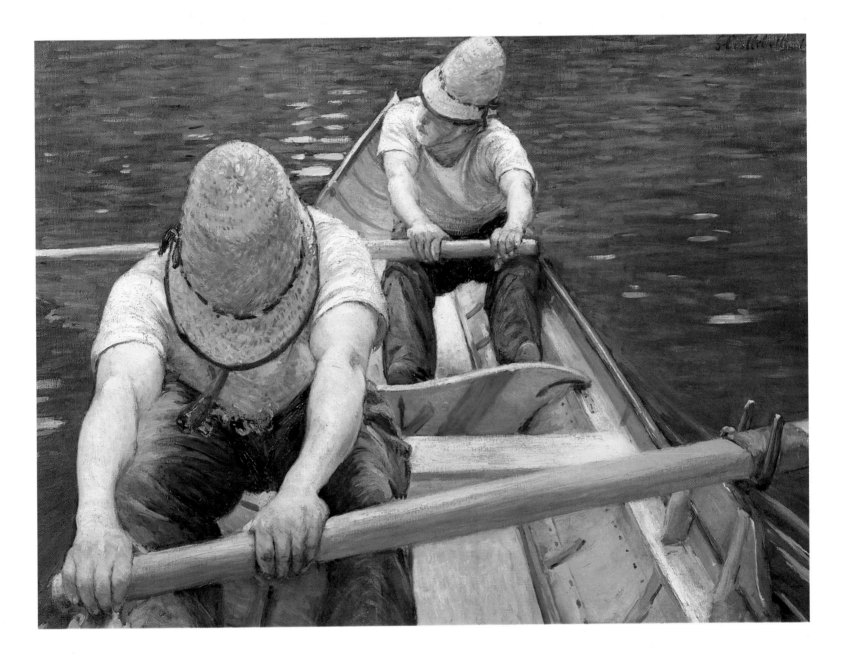

21. Partie de bateau

(Boating party) 1877
Oil on canvas, 90 × 117 cm. (35½ × 46⅛ in.)
Signed l.l. *G. Caillebotte*; stamped l.r.
Private collection, Paris
Berhaut, 1978, No. 93 (*Canotier au chapeau haut de forme*)

It has often been remarked that the Impressionists, especially in the years before 1880, painted nature with the eyes and attitudes of city dwellers; their sites, either in the suburbs or at resorts along the rail-lines from Paris, were usually quite civilized, and the people they painted in nature were more often urban vacationers than men of the sod. Nowhere does the point seem more well taken than here, where the city comes to the country in the figure of the sporting bourgeois on excursion in full boulevard dress.

Once again, as in *Canotiers* (Pl. 20), Caillebotte places us in the boat with his figure, implying a direct continuation of the spatial "shelf" of the boat's bottom into our domain. However, in contrast to Pl. 20, there is only one boater, upright, leaning away, and screening off the pointed prow of the boat. Hence the space within the boat itself is less dramatic; and the picture as a whole is, with its lowered horizon and less closely concentrated cropping, less audacious. The power of the central figure is still quite commanding, though; and certain passages of painting—for example, the striped sleeves—are beautifully handled. The picture seems less a study of an activity than a portrait, though the subject is not known. It is not out of the question that Caillebotte himself is represented (cf. Pl. 1a).

Rowing, like so many other sports that flourished in France in the later nineteenth and early twentieth centuries—horse-racing being the most prominent—was an import from England. The surge in the popularity of boating was part of a broad interest in the English style of life that, steadily growing in France after the rancor of Waterloo subsided, reached the proportions of "Anglomania" under the Second Empire.[1] The particular appeal of boating and boating-related activities for Impressionist painters may have other roots, beyond the simply picturesque quality of the motifs. The kind of image Caillebotte shows here, of the man in the small boat, of the sporting amateur civilized but in nature, independent and at leisure to move happily with the tides and the wind, may have been for these painters an emblem of the ideal, much in the way that the man astride the fiery horse is an emblem of the concerns of the Romantic generation.

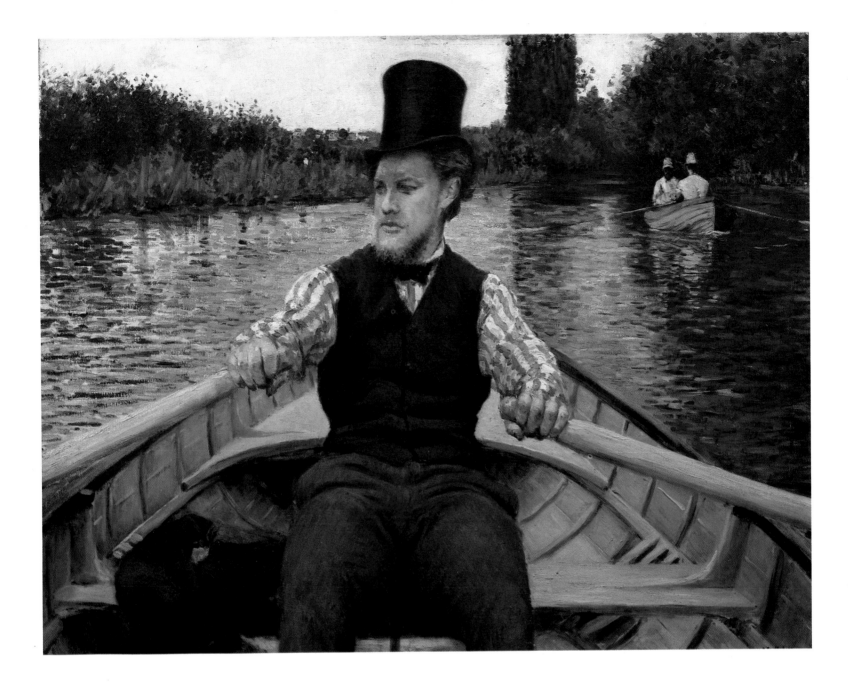

22. Périssoires

(*Périssoires*) 1877
Oil on canvas, 103 × 156 cm. (40¾ ×
 61⅜ in.)
Signed l.l. *G. Caillebotte 1877*
Milwaukee Art Center collection. Gift of
 the Milwaukee Journal Company in
 Honor of Miss Faye McBeath
Berhaut, 1978, No. 76

Périssoires are fragile flat-bottomed skiffs. Less sophisticated than actual rowing skulls, but lighter and nimbler than the sturdy boats seen in Pls. 20 and 21, they are propelled with a two-bladed kayak paddle, as shown here. The site, like that of the other two rowing scenes, is the quiet, narrow, and well-protected river Yerres on which Caillebotte first learned his boating skills. Ambitiously large, this canvas is signed and dated, and seems to have been one of the three exhibited under the title *Périssoires* at the 1879 Impressionist exhibition. Other examples, from this year and the next, are in the collection of the National Gallery of Art, Washington D.C. (Pl. 23) and of the Musée de Rennes (Pl. 23a). In all three of these *Périssoires*, Caillebotte deploys strong greens and high-key yellow and white accents against the blues and darker hues of the water. The large, broad brushstrokes often declare themselves forcefully as a pattern, sometimes with disconcerting independence.

This particular canvas is constructed relatively undramatically by Caillebotte's standards of the time: a gently sloping diagonal horizon traverses, without strong spatial recession, the three vertical bands of the trees and their reflections. As in the *Raboteurs de parquet*, there is a cinematic sense (also in the National Gallery, Washington, version, Pl. 23) in the sequential alternation of paddling positions by the three, nearly identically dressed boatsmen.

22a. Gustave Caillebotte (at right, with paddle on shoulder) and friends in boating attire. Photograph, c. 1878(?).

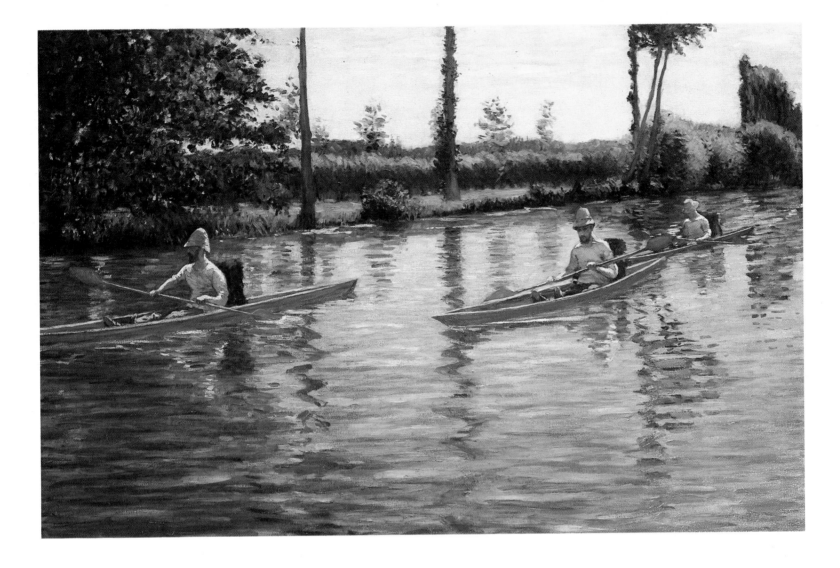

23a. *Périssoires*, 1878. Oil on canvas, 157 × 113 cm. (61¾ × 44½ in.). Musée de Rennes. (Berhaut, 1978, No. 91).

23. Périssoires

(*Périssoires*) 1877
Oil on canvas, 88 × 117 cm. (35 × 45¾
 in.)
National Gallery of Art, Washington
 D.C.: Collection of Mr. and Mrs. Paul
 Mellon
Berhaut, 1978, No. 95

Caillebotte should have been advised that, given the legs-flat posture of the paddlers and the long-lozenge form of these pointed craft, head-on views of the boats were going to make for awkward perspective problems. He was undaunted, but the results are distinctly odd, and notably different from the muscular force of the pair-oared *Canotiers* (Pl. 20). The peculiar foreshortening of the men and their attenuated canoes give this scene a certain charmingly comic quality, as if the worlds of Uccello and Jacques Tati had met on the Yerres river under the sunlight of Impressionism.

24. Canotier ramenant sa périssoire

(*Boater pulling in his périssoire*) 1878
73 × 91 cm. (28½ × 35⅛ in.)
Virginia Museum of Fine Arts,
 Richmond: Collection of Mr. and Mrs.
 Paul Mellon
Berhaut, 1978, No. 96

Here Caillebotte sidesteps the problems of composition and perspective that had troubled some of his earlier boating views (see Pl. 23), by taking an elevated viewpoint that flattens space, and by choosing a composition that makes the disparities in form between figure and flimsy craft work to better advantage. The bold simplicity of the up-tilted, diagonal organization of the canvas, underlined by the parallel placement of the paddle, allows the colorfully broken texture of the water surface to dominate the picture. A comparison with Caillebotte's earlier view of the Yerres (*L'Yerres, effet de pluie*, Pl. 7) will show how much the artist had learned about boldness of hue (from Monet and Renoir) and design (from Degas) in the intervening years.

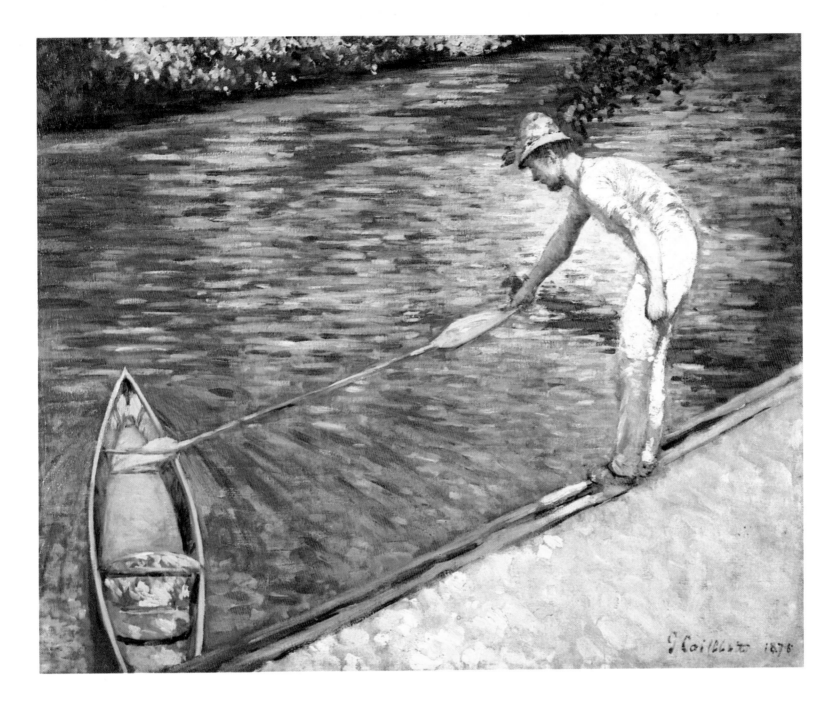

25. Les Orangers

(*The Orange-trees*) 1878

Oil on canvas, 157.2 × 117.1 cm. (61⅞ × 46⅛ in.)

Signed l.l. *G. Caillebotte/78*

The Museum of Fine Arts, Houston: The John A. and Audrey Jones Beck Collection

Berhaut, 1978, No. 87

In some ways, this large figure piece seems to belong more to the Impressionism of the 1860s than to that of its actual date. In the mid-1860s, Monet and Renoir, among others, were drawn to the ideal of a large canvas that would render a modern-life scene of figures outdoors, with the full brilliance of *plein-air* painting. The notion itself proved paradoxical; the time and careful preparations necessary for a large figure composition were nearly impossible to reconcile with the demands of on-the-spot response implicit in their *plein-air* work. Two of Monet's most concerted attempts, the *Déjeuner sur l'herbe* (1864–65) and a project for a scene of La Grenouillère (1869), never came to fruition; and at the end of the decade only the *Femmes au jardin* of 1866–67 stood as testimony to the ambitions. After 1870, the Impressionists tended to move in the direction of smaller canvases. These were more portable and more manageable within the terms of an essentially landscape-based aesthetic stressing rapid, spontaneous painting; and they were, with less of an investment, better prospects for easy sale.

As early as 1873, however, in the *Déjeuner* (which Monet showed as a "decorative panel" in 1876), larger scale began to reassert itself, and Renoir's *Bal du Moulin de la Galette* of 1877 represented a full-fledged, new masterwork, engaging figures set in the complex play of daylight and shadow. Caillebotte owned both these latter canvases when he painted the present large picture of his brother Martial and their cousin Zoé in the garden of the family estate at Yerres. The Monet *Déjeuner* (p. 196, Fig. 13) in particular must have been a direct inspiration, for Caillebotte here works with a similar play of cool garden shadows in the foreground and brilliant light behind, and within a similar mood of the contemplative pleasures of outdoor privacy.

In contrast to the complexly mottled effects of light in the Monet and Renoir works, however, Caillebotte's garden scene is reductively simplified: a background of bright green, white gravel, and the brilliant red-vibrating flower bed is set behind the dominant foreground of darkened green and purple-tinted shadow. (One should compare this scheme with that of the garden picture of two years earlier, *Portraits à la campagne* [Pl. 14], to judge how much bolder Caillebotte had become.) The opposition of evenly shaded coolness and shadowless brightness, as opposed to their co-mingling, underlines the sense of early afternoon heat (as does the sleeping dog on the path) and reinforces the quiet absorption of the figures. The picture is devoted to domestic tranquility, in a garden more of cerebral pleasures than bolder earthly delights. Its focus is on the individual inwardness, and consequent separation-within-community, of well-to-do family leisure. In matters of mood and spirit (as opposed to size and figure scale), an appropriate ancestor might be the static family gathering in Monet's 1867 *Terrasse à Ste.-Addresse*, and a proper descendant Matisse's 1917 *Music Lesson*.

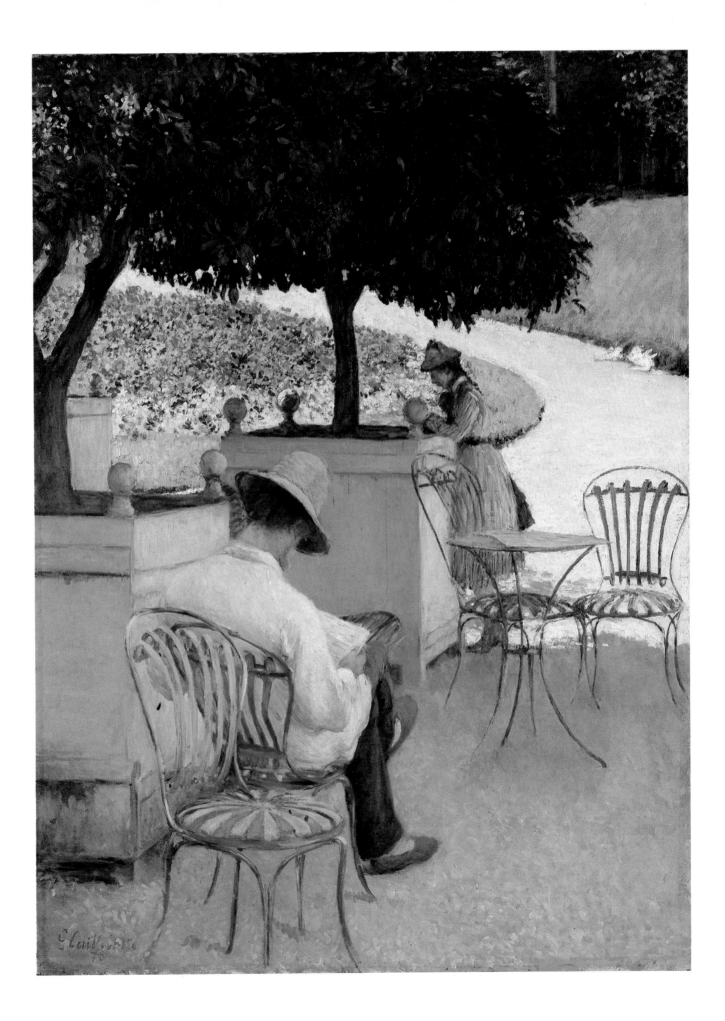

27. La Caserne de la Pepinière

(*The Pepinière Barracks*) 1878
Oil on canvas, 54 × 65 cm. ($21\frac{1}{4}$ × $25\frac{5}{8}$ in.)
Signed l.r. *G. Caillebotte*
Private collection, Paris
Berhaut, 1978, No. 113

This view and the identically sized *Place St.-Augustin* (Pl. 26) were almost certainly conceived as pendants. The building on the right here is that seen on the left in the other picture; and when the two canvases are side by side, they form (with some overlap) a panorama of the intersection. Caillebotte stood with his back to the juncture of the Boulevard Haussmann and the Boulevard Malesherbes; the *Place St.-Augustin* frames the continuation of the Boulevard Haussmann, while the view at hand takes in the rue de la Pepinière and the large military barracks, the Caserne de la Pepinière, on the left. Even more informal and sketch-like than the *Place St.-Augustin*, this view eliminates altogether the concern for strong foreground elements which had been so important to the images of 1875–77, and focuses our interest much more securely in the middle distance. The horizon line has been considerably lowered as well, eliminating the rapid upward slope that we still sense, residually, in the *Place St.-Augustin*. For all of the appeal of its sparkling light, the *Caserne de la Pepinière* is, finally, perhaps the least exceptional, least personalized of Caillebotte's city views.

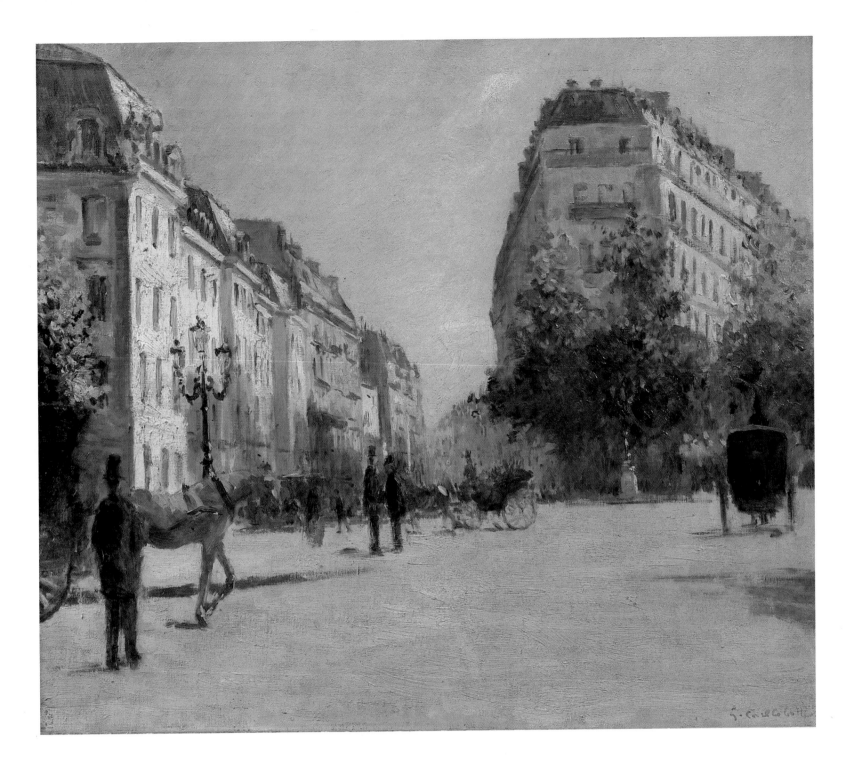

28. Rue Halévy, vue d'un sixième étage

(*Rue Halévy, seen from a sixth floor*) 1878
Oil on canvas, 59.7 × 73.3 cm. (23½ ×
 28⅞ in.)
Signed l.l. *G. Caillebotte | 1878*
Private collection, New York
Berhaut, 1978, No. 116

This is one of the first in a long series of views Caillebotte painted looking down onto the boulevards in the area immediately behind the Opéra. From an attic window at the corner of the rue Lafayette and the Boulevard Haussmann,[1] he frames the rue Halévy running past the side of the Opéra building (second back on the right) into the Place de l'Opéra. Closest on the right is the building in which Gustave and Martial lived (at the other end) from this period until the later 1880s. In a device typical of Caillebotte's elevated street views, a near element—in this case, the inclined edge of the window-bay, at left—cuts into the field of vision.

To this image, Caillebotte brings a compositional device—that of a ground rising to a horizon roughly two-thirds up the canvas or higher—used in many earlier canvases (e.g., Pls. 8 and 15). The effect is markedly different here, however, in that the ground now falls away far below the bottom edge, and there is no continuous linkage between our position and the picture space; the detachment from the scene is far greater. The funneling perspective, by now familiar, is actually subdued here, and the space more shallow and more solidly closed-off than those of the 1876–77 street views. The wide-angle horizontal stretch of the latter is also absent,[2] and the inward plunge, as for example in the balcony lines of the far buildings, is less insisted upon. Instead, the vertical depth of the canyon-space between the building masses is emphasized, and the center of interest lies in the thinly trafficked expanse of the intersection just below the center of the canvas.

The detachment of viewing position is accompanied by a marked shift toward a less linear, less focused, more loosely brushed Impressionist technique, in which the carriages and pedestrians appear as indistinct "tongue-lickings" like those in Monet's earlier *Boulevard des Capucines* (see Pl. 18a). The picture, which seems to treat a late winter afternoon with the sun weakly gilding the streaked clouds behind the Opera, is also characterized by what critics called "violettomania" or "indigomania" in the (some thought pathological) stress on blue-violet tones.[3]

Caillebotte's views of boulevards from above have often been compared to those Pissarro painted in the 1890s (Pl. 28b), and the resemblance is nowhere stronger than in this early example.

28a. The rue Halévy. Author's photo. (*Note*: photo is taken from one floor below Caillebotte's vantage point in Pl. 28; view from proper vantage point now blocked by sign.)

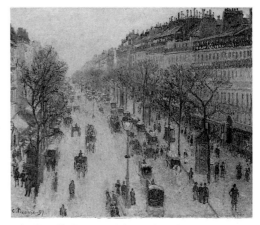

28b. Camille Pissarro, *The Boulevard Montmartre on a Winter Morning*, 1897. Oil on canvas, 64.8 × 81.3 cm. (25½ × 32 in.). The Metropolitan Museum of Art, New York. Gift of Katrin S. Vietor in Loving Memory of Ernest G. Vietor, 1960.

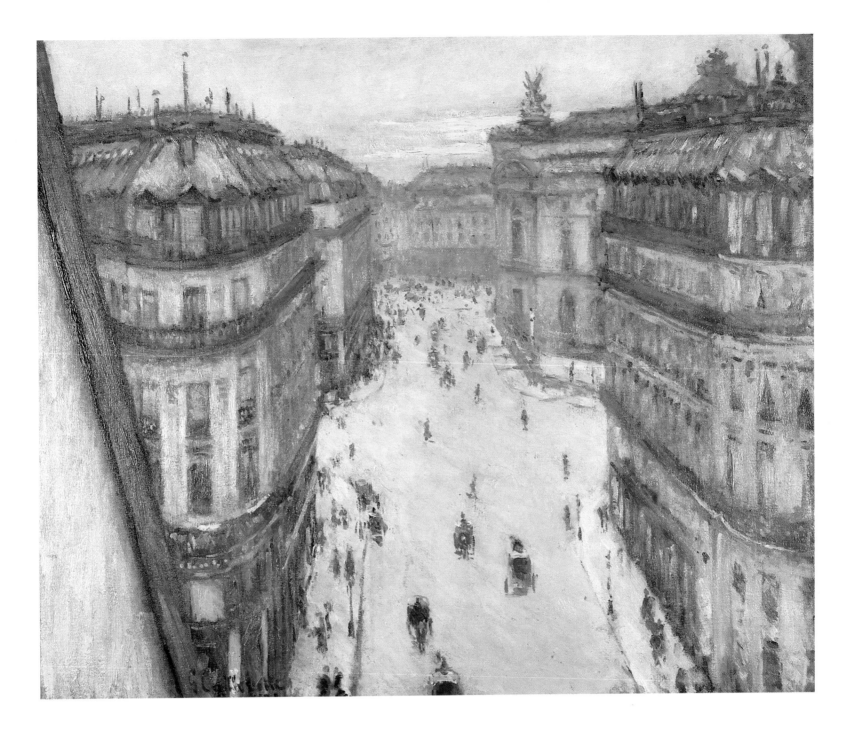

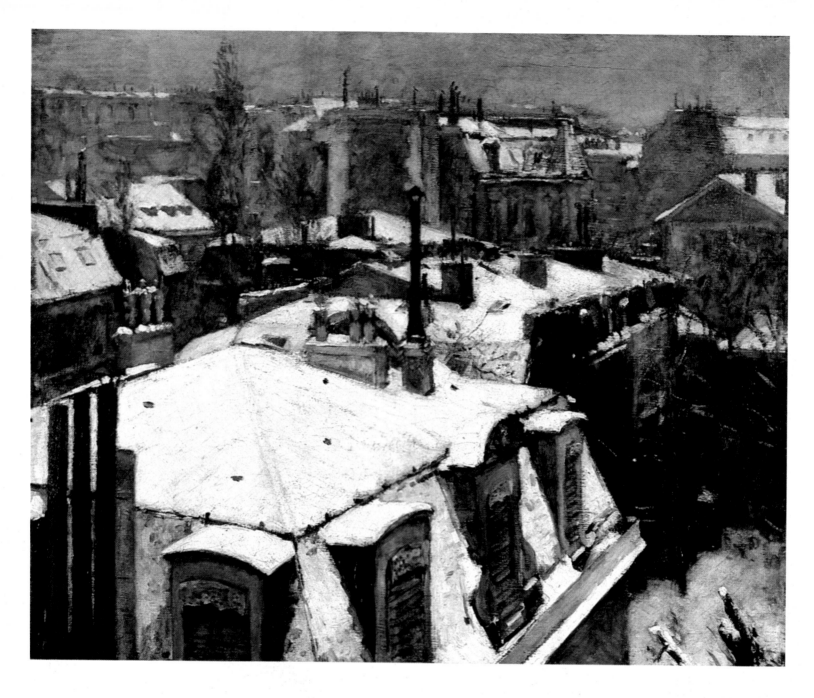

29. **Vue de Toits (Effet de neige)**

(*Rooftops [Snow]*) 1878
Oil on canvas, 65.1 × 81 cm. (25⅝ × 31⅞ in.)
Signed, l.l. *G. Caillebotte*
Musée d'Orsay
Berhaut, 1978, No. 107 (*Toits sous la neige*)

Impressionism is generally thought of as an art of sunshine, but it is better reckoned in terms of an attention to atmospheric effect, in which all the forms of airborne water—steam, rain, clouds, snow, and fog—have prominent importance. Some of the most brilliant of Monet's early canvases, for example, exploit the unifying, simplifying effects of mist, fog, and snow on the landscape or cityscape. This picture, part of a series of rooftop views executed around 1878 (and shown in 1879), is certainly one of Caillebotte's most clearly "Impressionist" works—one in which the envelope of atmosphere is of primary concern, cloaking and diffusing the definition of the individual forms. The interest in such an unpromising jumble of indistinct roofs, mansards, and chimneys would however be unlikely in the work of Caillebotte's painter associates. The "back-window" vista's very lack of focus or drama, and its wintry sense of contemplative overlook, may reflect changes brought on by the death of Caillebotte's mother in this same year.

30. Portrait de Paul Hugot

(*Portrait of Paul Hugot*) 1878
Oil on canvas, 204 × 92 cm. (85 × 38 in.)
Signed l.r. *G. Caillebotte / 1878*
Collection of Mr. and Mrs. Joseph E. Levine, New York
Berhaut, 1978, No. 81

The spaceless background here may suggest to some the legacy of Manet, but in dominant impression this tightly handled portrait owes more to the example of Caillebotte's academic master Léon Bonnat—a much-sought-after portraitist—than it does to avant-garde currents. The drawing that appears to be preparatory to the portrait is so tiny (Pl. 30a) that it may reflect use of an optical device or photograph. As Peter Galassi suggests (see Chapter 4), the size of the drawing corresponds to known photographic formats of the day. The self-presentation of the figure, with outdoor dress (including walking stick), casual pose, and informal accessories (the packet stuck in the vest), also bring to mind the repertoire of poses made familiar in the *carte-de-visite* photographs that became popular in the Second Empire.[1]

According to Marie Berhaut, Hugo was a close friend of Caillebotte, and owned several of his paintings. An etching—unique in Caillebotte's oeuvre—exists of this portrait (Berhaut, 1978, No. 81a).

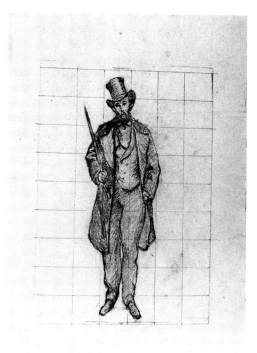

30a. Study for *Portrait de Paul Hugot*: Standing man in top hat with left hand in pocket, raised cane in right hand.

30b. Study for *Portrait de Paul Hugot*: Paul Hugot and map of France. 30.7 × 24.5 cm. (12$\frac{1}{8}$ × 9$\frac{5}{8}$ in.).

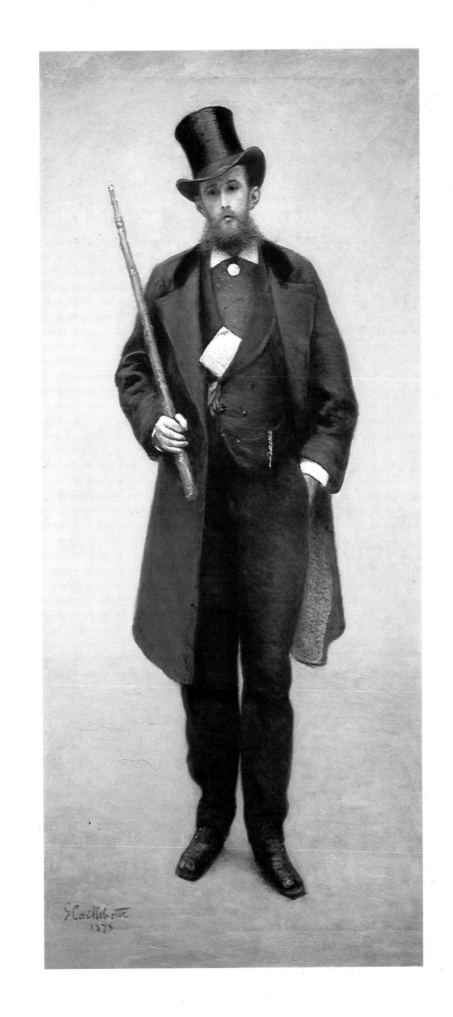

31. Portrait de Madame X. . . .

(*Portrait of madame X. . . .*) 1878
Pastel, 65 × 50 cm. (25½ × 19¾ in.)
Signed l.r. *G. Caillebotte 78*
Musée Fabre, Montpellier
Berhaut, 1978, No. 83

The peculiar visual wit of this portrait—or in a sense double portrait—is exceptional in Caillebotte's work; but the odd spatial leap from the woman to the tiny man behind recurs in a different fashion in one of the interior views he showed in 1880 (see *Intérieur*, Pl. 34). The lady here is dressed for the street, rather than for a portrait sitting; and the asymmetric, cropping-within-cropping composition emphasizes that the relationship between this sitter and her "companion" behind is truly the subject of the work. Neither her identity nor his is known, and no other record exists of the apparent oil portrait shown. Could this background "portrait" be construed as a mirror, despite its frame and placement on an easel? If so, it would be consistent with a love of reflected conundrum Caillebotte later revealed in *Dans un café* (Pl. 39), and explain the lady's stare in terms of a silent dialogue.

Caillebotte's work in pastel may have owed its basic inspiration to Degas. The Degas works in his collection were all pastels, including some superb early examples shown in the 1877 Impressionist exhibition.

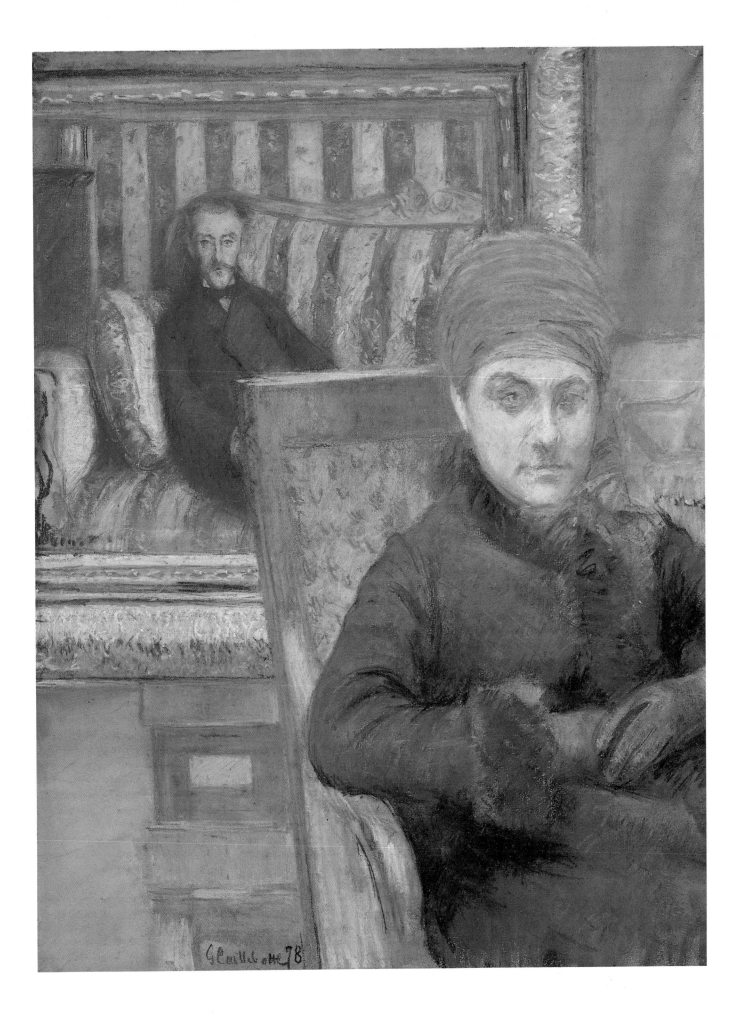

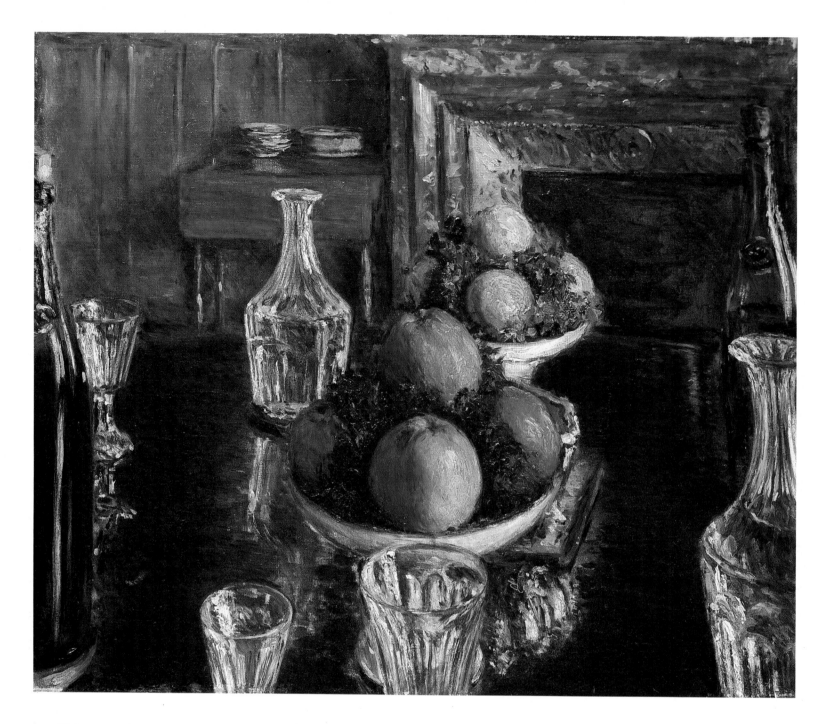

32. Nature morte
(*Still life*) 1879
Oil on canvas, 50 × 60 cm. (19¾ × 24 in.)
Signed l.r. *G. Caillebotte 1879*
Private collection
Berhaut, 1978, No. 123 (*Nature morte: verres, carafes, et compotiers de fruits*)

This picture begs comparison with Caillebotte's *Déjeuner* of 1876 (Pl. 13); it depicts the same set of crystalware, and the same *compotiers* piled up with fruit, once again set on a dark glossy table. With those raw facts, however, virtually all similarity ends. The busy fullness of that earlier back-lit table-setting was viewed through an extraordinary perspective that emphasized the artist's place within the family scene. The perspective structure has radically changed here, with a narrowed field of vision that stresses cropping exclusion, and a relatively compressed depth. More importantly, however, the implied family narrative that contributed to the complex feeling of the earlier scene is now gone. Both of the family members shown in the *Déjeuner* had died in the interim, and the home shown there had since been sold. The formal arrangement of the objects now has no binding thread of domestic sociability (there are no plates, no forks or knives to suggest a meal to come), and one cannot resist the intuition that Caillebotte has here undertaken a conscious reprise, confronting these memory-laden objects explicitly as a *nature morte*, still or stilled life.

33. Autoportrait au chevalet
(*Self-portrait at the easel*) c. 1879–80
Oil on canvas, 88.9 × 116.2 cm. (35 ×
 45¾ in.)
Stamped l.r.
Private collection, Paris
Berhaut, 1978, No. 118

This self-portrait offers a tantalizing glimpse of Caillebotte's extraordinary collection of Impressionist paintings as it hung in his apartment on the Boulevard Haussmann. The only work clearly recognizable is that hanging over the sofa directly behind: it is Renoir's *Le Moulin de la Galette*, painted in 1876 and acquired by Caillebotte soon thereafter.

Aside from this documentary appeal, the picture is noteworthy in regard to the unusually deep shadow into which the artist casts half his face; and for its demonstration of his fascination with the ambiguities of scale diminution across space. Caillebotte placed the mirror he used to paint this image at such a level that it did not permit a view of the floor. We are thus unable to gauge the distance between his figure and the

wall behind; lack of knowledge of the height of his stool *vis-à-vis* the sofa behind furthers the confusion. Just as in *Intérieur* (Pl. 34), the point of view produces a direct juxtaposition of two figures of vastly different scale, and we are left in uncertainty as to how to relate their sizes. Here, for example, Caillebotte almost seems to be sitting on the background sofa, with the other figure posed on his knee. This effect would have been a natural result of the artist's moving the mirror too close and thereby disproportionately enlarging his own form. Caillebotte does nothing to alleviate the peculiarities, and the evidence of the later picture (Pl. 34) suggests that he was consciously intrigued with exploring the look of this kind of spatial conundrum.

34. Intérieur

(Interior) 1880
Oil on canvas, 65 × 81 cm. (25¾ × 32 in.)
Signed l.l. *G. Caillebotte 1880*
Private collection, Paris
Berhaut, 1978, No. 127 (*Intérieur*)

In 1880, Caillebotte began a second series of interior views. Though family interiors (e.g., Pls. 12 and 13) had comprised a major part of his 1876 showing, he exhibited only one in 1877 and none (portraits excluded) in 1879, concentrating instead on the city and on outdoor scenes. When he returned to the theme in 1880, the world of the early interiors no longer existed. Caillebotte's mother had died, and he and his brother Martial had moved from the rue de Miromesnil to bachelor quarters at 31, Boulevard Haussmann, just behind the Opéra. In the relatively bare apartments, so different from the dark, ornate family home, Caillebotte distilled a special poetry from less formal, more intimate, and often uncomfortably tedious scenes of bourgeois domesticity. More than any others by Caillebotte, these works attracted the eye of the writer and critic Joris-Karl Huysmans, and established Caillebotte for him as the painter *par excellence* of the reality of upper-middle-class Parisian life.[1] It seems no accident that Huysmans should have found the pictures so appealing, given his Realist novels at that time;[2] for there is often a novelistic quality in the detailing of implied narrative in these scenes.

This little picture, of a seated woman, and the larger *Intérieur* (Pl. 35) could not strictly be considered pendants. However, they were shown together at the 1880 Impressionist exhibition; and, treating similarly the theme of bourgeois marriage, they must have been conceived as complementary pieces.[3] In both pictures the man and the wife are apparently posed by Caillebotte's mistress and one of his friends.

When the picture was shown, some attention centred on the way in which the woman's face was painted.[4] More than any other aspect of the picture, though, the large discrepancy of size between the two figures was remarked upon by critics and visitors. One writer noted that the picture "amused the spectators a great deal," and that "they've laughed a lot about the little husband by Monsieur Caillebotte."[5] The bewildered amusement is quite understandable, as the figure of the man does appear impossibly tiny. This is one effect of Caillebotte's perspective whose upsetting nature has not been blunted by time; easy to see, it is, however, less easy to explain and justify.

The juxtaposition of radically different planes of scale is a commonplace occurrence in Degas's views of café-concerts and ballets, but those images never seem as incongruous as this one. Degas's near and far elements—audience and performer, for example—are never on the same plane: the floor is sharply tilted, or we look over heads to a raised stage, or we peer out of a box down to the lower stage. Thus there is no feeling that the two spaces are to be judged with the same scale referents. Here, however,

Caillebotte's figures are clearly on the same level, within the same room. We thus read the sofa and chair as being approximately the same height, and this assumed similarity becomes in turn a scale reference in common for the two figures. The problem is not entirely that of the smallness of the man in relation to the woman, but also that of his smallness in relation to the sofa he reclines upon. If we eliminate him from the sofa, the space poses no problem; and conversely, if we eliminate the sofa, or even just the back pillows, the distance between the two people can be read as longer, and the problem will not seem as grave. A similar situation exists with the wall mouldings, which seem fine without the man, but disproportionately broad and high with him as a scale reference. The depth of the space is thus highly ambiguous: the pieces of furniture seem to be quite close together; while the man is diminished in size to a degree that implies a greater distance—the room, as one critic estimated, must be the length of the Gallery of Apollo at the Louvre.[6]

The effect may stem in part from Caillebotte's attention to photography; the grotesque enlargement of things brought too near the camera was well known at the time as a common danger. It is clear, however, from other instances, that Caillebotte was no blind slave to photography; if indeed he used a camera, he selected from its effects and adjusted them to suit his purposes. (For a fuller consideration, see Chapter 3.) It is virtually impossible that a man of his visual intelligence would not have seen, as well as every visitor did, the confounding nature of this view. If one then concludes that he intended this disturbing anomaly, it remains to explain the purpose of such a gesture. On the one hand, the effect is consistent with the artist's interest in perspectives that are systematically or photographically accurate, but that appear distorted (see Chapter 3). Taken in the particular context of the accompanying picture (Pl. 35), another hypothesis would be that, in making the distance across the room so problematic, he thought to stress the separation of the people from each other; and that in vastly expanding the size of the woman, he intended some statement about her role in the relationship and/or her personality, as opposed to those of her husband. The picture would then be an eccentric and (perhaps inevitably) unsuccessful attempt to employ devices of meaningful distortion quite familiar in later expressionist painting, while holding fast to a Realist style of rendering. Its descendants would then be found in later, more obviously stylized manipulations of space for the purposes of condensed narrative and emotive impact, in the work of artists such as Munch. Munch's photographic self-portraits of the early twentieth century in fact frequently employ just this kind of composition, with his figure

34a. Edouard Vuillard, *Thadée Natanson and Misia*, c. 1895. Photograph.

looming large on one side of the frame,
sometimes in profile, and a rapid drop-off in-
to the space of an empty room. There may even
be a direct connection between Caillebotte's
strange little picture and Vuillard's investigations
of space and scale in the context of his intimist
investigations of the ambiguous comforts of
bourgeois domestic life: Vuillard's photographic
study of Thadée Natanson and his wife (Pl. 34a)
raises a pointed question as to whether he might
not have seen the *Intérieur* (possibly in the 1894
retrospective after Caillebotte's death, though
the picture was not listed in the catalogue).

35. Intérieur

(*Interior*) 1880

Oil on canvas, 116 × 89 cm. (45¾ × 35 in.)

Signed l.r. *G. Caillebotte / 1880*; stamped l.l.

Berhaut, 1978, No. 130 (*Intérieur, femme à la fenêtre*)

This interior, in contrast to its companion piece Pl. 34, drew praise from the critics of 1880.[1] J.-K. Huysmans found it "a simple masterpiece," by virtue of "that supreme quality of art, life," which he found "comes out of this canvas with a truly unbelievable intensity. . . . A whiff of the household in a situation of easy money escapes from this interior."[2] The picture is, nonetheless, uneven in execution, and the lovely treatment of the light on the curtains is needed to redeem a certain clumsiness in the figure of the seated man.[3]

Again, as in Pl. 34, we are confronted with the partners in a comfortable but uncommunicative marriage, set in the artist's own apartment (note the familiar balcony grill of *Vue prise à travers un balcon* [Pl. 45]). Instead of the mutual isolation by identical activity seen in Pl. 34, Caillebotte now poses an opposition: between the daydreaming woman absorbed in the world beyond the window (perhaps gazing across at the figure standing in the window opposite?) and the placidly unaware husband buried in his newspaper. The theme of marital alienation was a familiar concern of Realist and Naturalist novels, most prominently in the work of Flaubert, whom we know Caillebotte admired.[4] The subject found its way into painting as well, notably in works like Degas's *Sulking* (Metropolitan Museum of Art, New York) or Tissot's *A Passing Storm* (Beaverbrook Art Gallery, Fredericton). Caillebotte's picture differs from these latter, however, in that the discord is not seen as the result of any specific incident, but as an enduring condition of boredom and unfulfillment built into the relationship.

Intérieur must have strongly impressed Paul Signac, the younger Neo-Impressionist painter who became a friend of Caillebotte in the 1880s (see Chapter 1). Signac's 1890 *Un Dimanche Parisien* (Pl. 35a) restates the same theme in virtually the same terms, though with a more pointed edge of class criticism in the detailing of the accessories. The relationship between Signac's image and Caillebotte's is even closer in Signac's preparatory drawings.[5]

Recent analysis of the critical response to the 1880 exhibition has shown that Charles Ephrussi, admiring this painting, refers to it as No. 12 of the catalogue.[6] This would mean that the proper title of the work at hand is *Vue prise à travers un balcon*—leaving the painting otherwise thought to be *Vue prise à travers un balcon* (Pl. 45) out of the 1880 exhibition, and opening to new question the identity of the painting shown as *Intérieur*, No. 10 of the 1880 catalogue. The close thematic relationship of this painting with the other *Intérieur* (Pl. 34) makes it plausible, however, that they would have had similar titles, and would have been grouped together in the listing; while the title *Vue prise à travers un balcon* fits perfectly with the image shown in Pl. 45. On

these grounds, one would be justified in supposing that Ephrussi's reference was simply a confusion on his part or a printer's error.

35a. Paul Signac, *Un Dimanche Parisien*, 1890. Oil on canvas, 150 × 150 cm. (59 × 59 in.). Private collection, Paris.

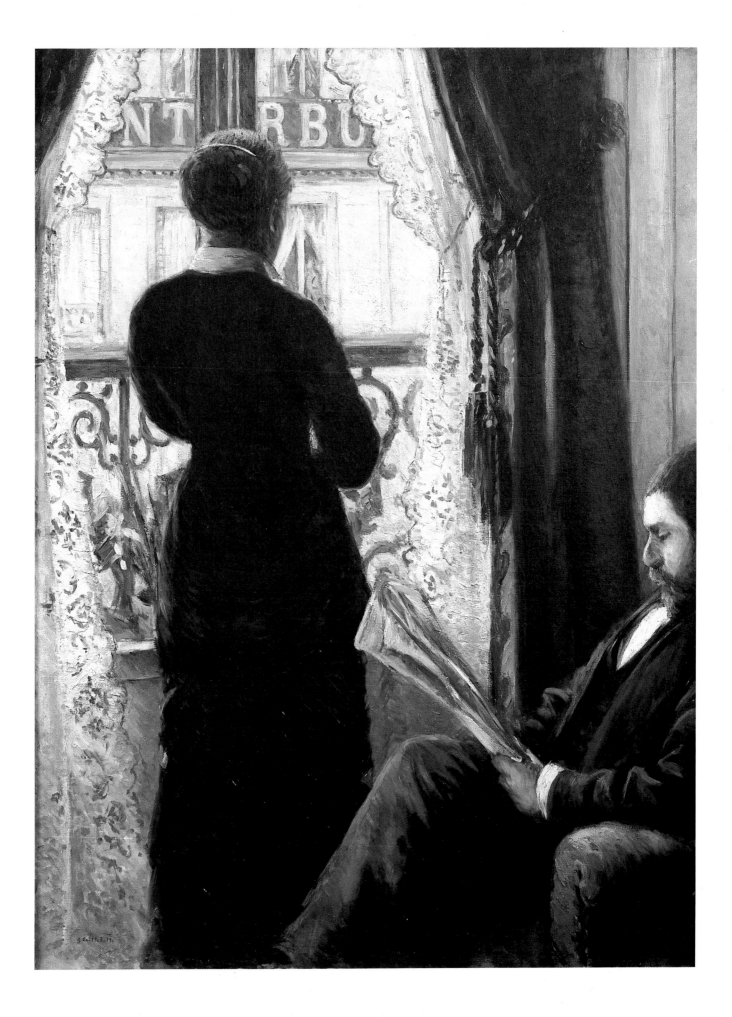

36. Nu au divan

(*Nude on a couch*) 1880–82
Oil on canvas, 132 × 196.2 cm. (52 × 77¼ in.)
Signed l.r. *G. Caillebotte*
Minneapolis Institute of Arts
Berhaut, 1978, No. 184

The nude was often a problematic subject for early modern painters and sculptors, as it seemed integrally linked to notions of classicizing idealism held antithetical to the aims of a truly progressive art; nudes were, for example, one of the subjects the Futurists wanted to banish altogether. For the artists of the Realist era, truth to the up-to-date and everyday, including matters of top hats, frock-coats and bustles, was an imperative. The "universal" or "timeless" aspects of the nude were inimical, and the challenge of making the genre modern was taken up only sporadically in early Impressionism—notably in Renoir's work and in Cézanne's. With the shift in Impressionism after 1880, these latter artists turned more frequently to such traditional nude themes as that of bathers, with less concern for Realist strictures. But it was Degas (appropriately, given his desire to turn the heritage of his classical admirations into the stuff of modern Realism) who most aggressively and continuously pursued the notion of the Realist nude, both in his monotypes of prostitutes and in his larger pastels of women at their bath or toilette. Caillebotte owned examples of these monotypes and pastels, and it was doubtless against Degas's example that he measured his own attempts to paint a modern nude (see also *Homme au bain*, Pl. 52)—though, as regards the combination of major format and unflinching attention to untempered nakedness, even Degas's nudes seem idealized in comparison to this unusual Caillebotte.

Clearly Caillebotte's figure is not simply a model at her pose (a theme by which Seurat, for example, got around the idealism of nudity), but a woman who belongs to a story. Her clothes and shoes are discarded nearby but her hair is still arranged, and her gesture suggests, ambiguously and simultaneously, equal parts of autoeroticism, somnolence and remorseful shame. One plausible interpretation would be that the sofa (the same outsized divan that appears in *Intérieur*, Pl. 34, and in *Partie de bésigues*, Pl. 38) has been the site of a daytime tryst, and that we are spying on the aftermath. Such a theme would not be inconsistent with the exploration of male-female relationships in the two interior views Caillebotte exhibited in 1880 (Pls. 34 and 35), and would once again beg the question whether some actual narrative, in the vein of Huysmans's Realist novels, may not have been in Caillebotte's mind when he conceived the scenes.

Henri Gervex's infamous painting *Rolla*, expelled from the Salon of 1879 and something of a *cause célèbre* in the Parisian art world, may have had a direct connection with Caillebotte's conception.[1] Gervex, in conceiving his scene of a man and a prostitute, had given a prominent place to the woman's discarded clothes; and much of the discussion of the picture focused on the scandalous specificity of these prominent accessories.[2] Caillebotte has pushed further in this direction, including not only the discarded clothes but also depicting a body that still seems to bear their mark (as in the woman's waistline). And he has, in contrast to the dreamy smile and youthful sensuality of Gervex's whore, insisted on a specifically ungainly nakedness troubled by apparent post-coital sadness. The nude—whose setting and demeanor hardly suggest a *fille publique*—is made all the more problematic by her solitary self-caress, without evidence of a (now departed?) lover. As a final Realist touch, still taboo in works like Gervex's and not included even in Degas's pastels of bathers, Caillebotte has insisted (in a fashion still "difficult" for some post-1970 audiences[3]) on showing an ample growth of armpit and pubic hair.

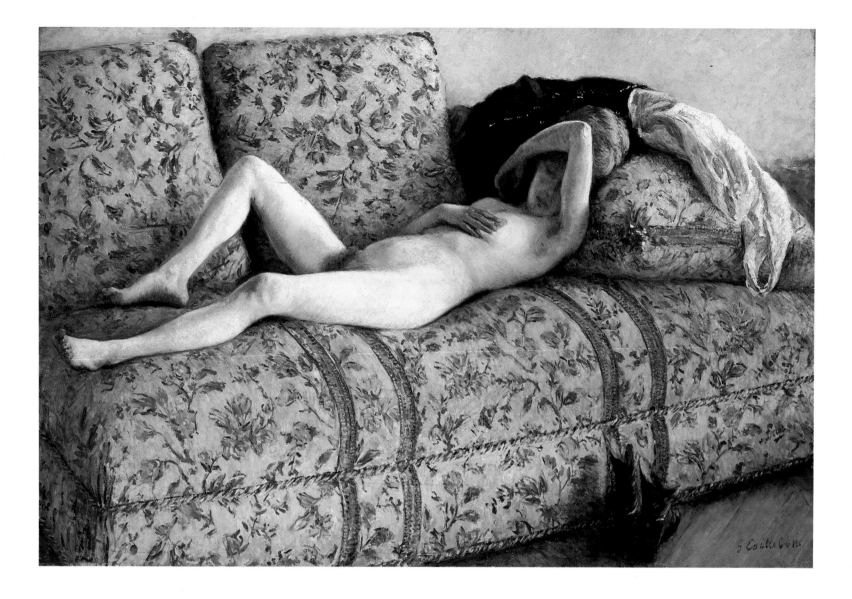

37. Homme au chapeau haut de forme, assis près d'une fenêtre

(*Man in a Top Hat, Seated Near a Window*) 1880

Oil on canvas, 100 × 81 cm. (39⅓ × 31¾ in.)

Signed u.l. *G. Caillebotte 1880*

Musée des Beaux-Arts d'Alger

Berhaut, 1978, No. 129

Similar in scale and setting to *Intérieur* (Pl. 35), this canvas also takes as its subject the play of filtered window light against apartment gloom, and by implication the dialogue of city society and private enclosure. The restless boulevardier shown here has neither the time to remove his hat and coat, not even to sit down; half-perched on the corner of a table, his dark bulk, in its awkward and temporary posture against the light, reinforces a sense of confinement. As with others in the series of views that Caillebotte painted in the rooms and on the balconies of his upper-floor apartment on the Boulevard Haussmann (e.g., Pls. 34, 41, 42), the picture treats the superficially banal idleness of Parisian bourgeois life in a manner that is reportorially realist, yet at the same time reductively schematic in a fashion that looks forward to the imagery of later, more overtly expressive art. In this case the sharp *contre-jour* profile of the top-hatted street-dweller by the window almost seems premonitory of the more nocturnal and melancholy image of private malaise in Paris, Edvard Munch's *Night (St. Cloud)* of 1891.

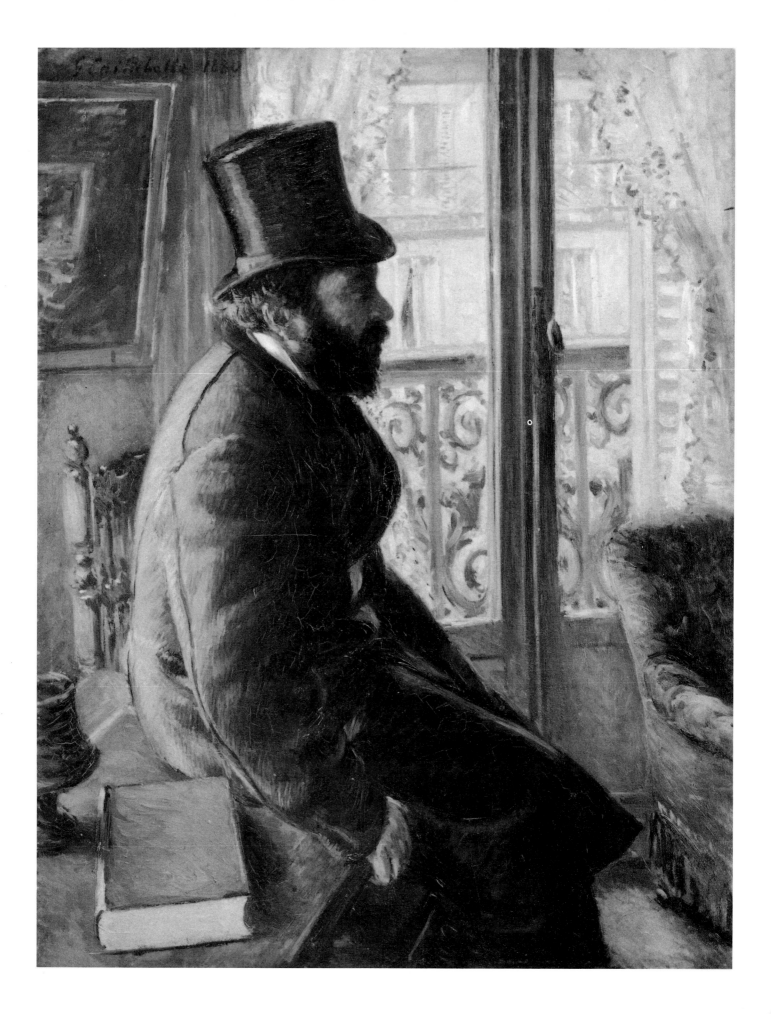

38. Partie de bésigues

(*The Besique game*) 1880
Oil on canvas, 125 × 165 cm. (49¼ × 65 in.)
Private collection, Paris
Berhaut, 1978, No. 165

In several of the interior scenes of 1880, particularly Pls. 34 and 35, the air of implied narrative is so strong one has the suspicion that the poses of Caillebotte's friends may relate to some as yet unidentified text. Here, by contrast, the scene is more plausible as one drawn from the private life of the artist himself. The people in the group are all identifiable, thanks to notes made by Martial Caillebotte, who is himself depicted, smoking his pipe and reaching for a card, on the right side of the table.[1] The game being played is a less familiar relative of pinochle, involving 64 cards.

Though the incident may be taken from life, the image cannot help but evoke connections with other art. On the side of tradition, for example, the theme of card-playing is most familiar in Northern and Northern-influenced (e.g., seventeenth-century Italian) genre painting; and the *Partie de bésigues* could thus be seen as another of the numerous instances in which the realism of France in the nineteenth century recalls that of the Netherlands in the seventeenth century. This parallel was noted by critics of the day. However, Caillebotte's picture, as the critics noted, differs from the Dutch tradition in important respects.[2] It is larger than any Dutch treatment of the motif, not only in physical dimensions but in the scale of the figures, who dominate the foreground area. Furthermore, its air of quiet concentration is alien to the raucous merriment or brawling associated with the Dutch gambling scenes. In these aspects of scale and mood, Caillebotte's picture is closer to the card-playing scenes painted repeatedly by Cézanne. Indeed, in the largest (and apparently one of the first) of Cézanne's *Card Players* (Pl. 38a) we can find interesting points of resemblance not just on these general levels, but in specific compositional elements.[3] Since Cézanne was in fact in Paris when the *Partie de bésigue* was shown in 1882, a speculation as to his possible memory of Caillebotte's picture seems more than legitimate.[4] Theodore Reff, examining the various sources for Cézanne's compositions of card players, has suggested that an illustration by Jean-François Raffaëlli (Pl. 38b), apparently based on Caillebotte's painting, may have served as an intermediary, and as Cézanne's more immediate point of reference.[5]

38d. Study for *Partie de bésigues*: Man seated with arms folded on table. Full sheet 61.3 × 47 cm.; format shown here 47.3 × 30.9 cm. (18½ × 12³⁄₁₆ in.).

38a. Paul Cézanne, *Card Players*, c. 1890–92. 131 × 181 cm. (51½ × 71¼ in.). Barnes Foundation, Merion, Pa.

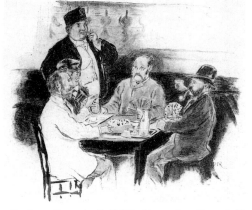

38b. Jean François Raffaëlli, illustration from J.-K. Huysman's essay "Les Habitués de Café," in E. de Goncourt, A. Dondet, *Les Types de Paris*, Paris, 1889, p. 151.

38c. Study for *Partie de bésigues*: Study of a left hand. Full sheet 47 × 61.3 cm.; format shown here 30.9 × 47.3 (12³⁄₁₆ × 18½ in.). Verso of sheet with pl. 38d as recto).

134

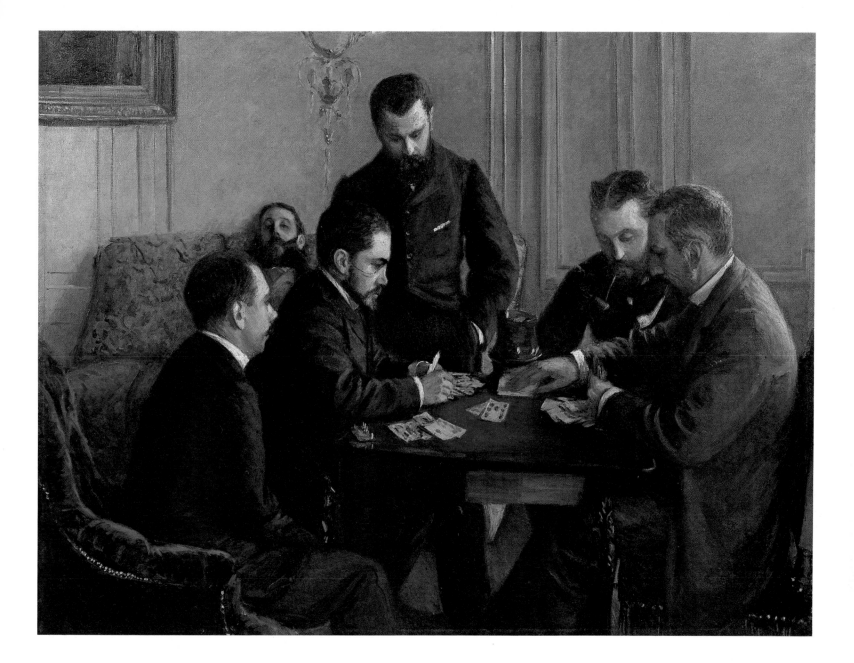

39. Dans un café

(*In a café*) 1880
Oil on canvas, 155 × 115 cm. (61 × 45¼ in.)
Signed l.r. *G. Caillebotte 1880*
Musée des Beaux-Arts, Rouen
Berhaut, 1978, No. 134

A *monsieur*, standing, faces us, propped against the edge of a table where stands a bock of mediocre beer, which, by its turgid color and small soapy head, we recognize immediately as that filthy donkey-piss brewed, under the rubric of beer of Vienna, in the caves of the Flanders road. Behind the table, a bench of amaranth-purple velvet, turning the color of wine dregs from the wear brought on by the continual rubbing of backs; on the right, a pretty stroke of light tempered by an awning of pink-striped ticking; in the center of the canvas, fastened above the bench, a big mirror with a gold frame, speckled with fly-spots, reflects the shoulders of the standing fellow and echoes the whole interior of the cafe. Here again no precaution, no arrangement. The people glimpsed in the mirror, messing with dominoes or greasing up cards, don't mimic the antics of vigilance so dear to poor Meisonnier; these are people at a table who forget the bother of the professions that make them a living, turn over no great thoughts, and play quite simply to distract themselves from the dreariness of bachelorhood or marriage. The posture a little knocked-over, the eye a little puckered, the hand a little trembling of the player who hesitates, the head inclined forward, the uplifted and brusque gesture of the man who strikes trump, all that is sketched on the run, snatched down, and this barfly, with his hat crushed back on the nape of his neck, his hands planted in his pockets, haven't we seen him in every beer-hall, hailing the waiters by their first names, chatting and joking about backgammon and billiards, smoking and spitting, stocking himself up with beers on credit!

J.-K. Huysmans-

What Huysmans found admirable in this picture was its truth to life: not only a scrupulous attention to the telling details of beer-color and fly-specks, but, in a larger sense, an honesty—"no precaution, no arrangement"—about the banal, unexceptional characters and actitivies that make up so much of the random run of existence. We do not entirely contradict Huysmans's praise, however, if we find the picture most striking by virtue of its "precautions and arrangements": by the amazingly contrived structure of order Caillebotte imposes on this casual scene. The image is, first of all, like a Chinese puzzle of rectangles within rectangles, an interlocking pattern of horizontals and verticals echoing the sides of the canvas, paralleling or nearly paralleling the picture plane, and dividing the surface into segments carefully proportioned. The near edge of the foreground table, for example, lies half-way between the bottom of the mirror and the bottom of the picture; and the hanging coat reflected in the mirror falls along the mid-line of the canvas.[2] Reinforcing this more obvious scaffolding, a pattern of rhythmic repetition of elements operates on an almost subliminal level of subtlety: four "figures" (one real and three reflected), four saucers on the table, four "hats" (two real and two reflected) hung up, repeated accents of the lamps and their reflections on either side of the midline.

Most contrived of all, however, is the problematic "picture within a picture" of the mirror view. To understand the problem, the viewer must study the hats hung over the heads of the seated men. All goes well until we see that the "shadow" of the hat on the right falls over the edge of the "window" and thus onto empty space. In fact, the window is not there where it seems to be, but is itself another reflection, partially screened at this small point by the reflection of the hat. The two seated men are in front of a mirror exactly like that immediately behind the standing figure. Their hats are hung on a brass rack fixed to the surface of the mirror. Because of the slightly angled position from which the artist paints (he stands just far enough to the left to exclude his own reflection), he sets up a series of diagonal reflections such that the mirror behind the seated men in fact reflects an area—with its lamps, mouldings, and window—that actually exists further to the right along the foreground wall (see diagram, Pl. 39a). This confounding game of optics is not immediately

39a. Diagram of site of *Dans un café* (approximate reconstruction). *a* = artist's position; *b* = principal figure in derby; *c* and *d* = two card players seated at table. Shaded area I = principal mirror behind derbyed man; shaded area II = mirror behind men seated at table; and shaded area III = approximate true location of "window" seen behind seated men in painting (actually a reflection in mirror behind them).

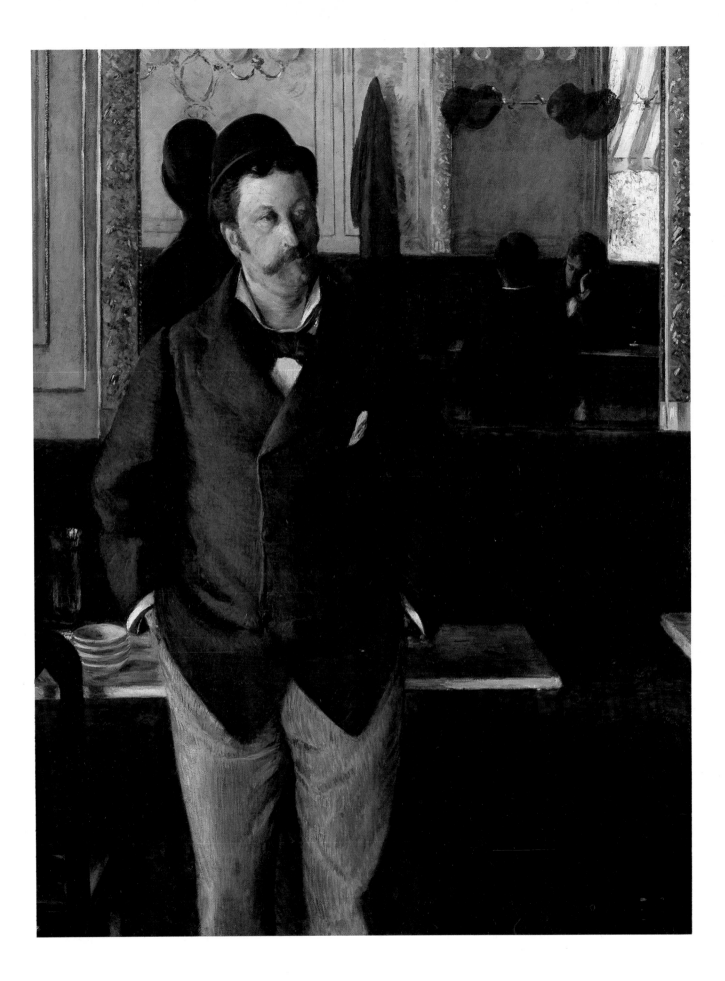

39b. Edouard Manet, *Un Bar aux Folies-Bergère*, 1882. Oil on canvas, 95.3 × 129.5 cm. (37½ × 51 in.). Courtauld Institute Galleries, University of London.

39c. Edouard Manet, sketch for *Un Bar aux Folies-Bergère*, 1881–82. Oil on canvas, 47 × 56 cm. (18½ × 21¾ in.). Stedelijk Museum, Amsterdam.

detectable for at least two carefully plotted reasons: the seated men cast no visible reflections behind them, and the wall-mouldings reflected in their mirror line up precisely with the top of their bench; thus we do not see that there is a mirror, and the reflections read as parts of a wall actually existing behind them.

This kind of deception is typical of the artist's continuing attraction to situations of ambiguity, where the world faithfully described comes out as an illusion, and accuracy masks a lie. We clearly do not have to understand the anomaly, though, or even to notice it, in order to enjoy the picture. On the initial level of rendering its genre subject, it already captures both the particular interior light of the café on a bright day, and the mood of bored indolence; furthermore, the oscillation of our attention between the detached observer and the objects of his gaze—a clever variant, via the mirror, on a familiar Caillebotte theme (see Pl. 10)—provides an enduring fascination.

Not simply in the elements of the composition, but in all the aspects we have discussed—emphasis on structure parallel to the picture plane; ambiguity about spatial position and depth; and sensitivity to *ennui* in modern life—Caillebotte's picture bears an interesting relationship to Manet's *Bar at the Folies Bergère* (Pl. 39b) of 1882. There can be little doubt that Manet saw *Dans un café* at the Impressionist exhibition of 1880; and in his first sketch for the *Bar* (Pl. 39c), the relationship seems even closer, in the sidewise gaze of the barmaid, the self-contained gesture of her hands, and the juxtaposition of principal/large and secondary/small/reflected figures.

39d. Study for *Dans un café*: Standing man in derby, hands in pockets. Charcoal, 39.5 × 26.5 cm (16¼ × 11½ in.). Yale University Art Gallery. Bequest of Edith Malvina K. Wetmore.

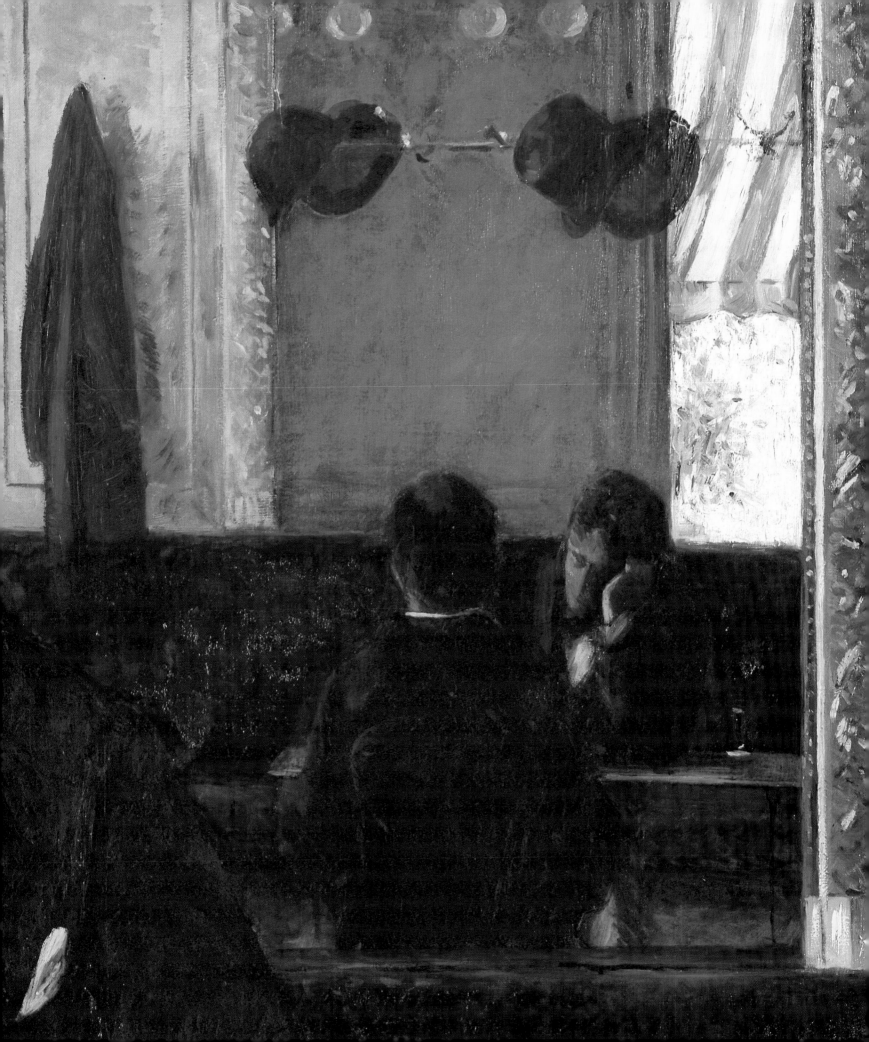

40. Homme au balcon

(*The Man on the balcony*) c. 1880
Oil on canvas, 116 × 90 cm. (45¾ × 35 in.)
Stamped l.r.
Private collection, Paris
Berhaut, 1978, No. 137

As he renewed the theme of the interior, so in 1880 Caillebotte also returned to another subject from his early work (Pl. 10), that of the urban onlooker, the man who studies the street from a detached and elevated point of view. In the 1880 series, the spectators are not seen at the window, but on the balcony, the narrow platform that extends the private space of the home out over the public space of the street. The balcony had flourished as an architectural form in Parisian construction under the Second Empire, partly for practical and partly for sociological reasons;[1] it occurs sporadically as a motif in the work of other painters of the day, though nowhere else as prominently as in Caillebotte.[2] Like that of the oarsmen, or the city stroller, the image of the man on the balcony is one that appears, is worked on in several different canvases, and then drops out of the artist's work, all the while linking to and renewing ongoing preoccupations of his vision (see Chapter 2).

40a. View from Caillebotte's balcony, looking up the Boulevard Haussmann toward the Place St.-Augustin. Author's photo.

This particular picture, extremely loose in execution and probably considered unfinished by the artist, superficially recalls Monet's image of balcony spectators in his earlier *Boulevard des Capucines* (Pl. 40c, note men on balcony at right edge). However, Caillebotte effects important changes that personalize the motif. Eliminating Monet's comfortably enclosed middle-distance spatial pocket, Caillebotte insists upon precisely the aspect of the new city that Monet camouflages: the inexorable straight-line rush of Haussmann's boulevards (see also Pl. 17). Caillebotte's image is, moreover, far more sharply divided. The human content is simultaneously more emphasized, in the prominent, solitary spectator; and more effaced, in the relatively denuded blur of the boulevard sweeping past far below.

In contrast to the earlier man at the window (Pl. 10), Caillebotte's spectator is now at a right angle to the movement of the street, extricated from the perspectival rush. His gaze is not sighted along the axis into space, but across its grain, so that the street literally passes him by, rather than drawing him out, as before. Our attention, like that of the depicted spectator, is also drawn away from the street. The focus of this picture, in contrast to the tense oscillation of the 1875 picture (Pl. 10), is squarely on the musing figure, emphatically detached, and cloaked in grey shadow against the bright greens and tans of the sunlit cityscape.

40c. Claude Monet, *Boulevard des Capucines*, 1873–74. Oil on canvas, 79.4 × 59 cm. (31¼ × 23¼ in.). William Rockhill Gallery of Art and Atkins Museum of Fine Arts, Kansas City. Acquired through the Kenneth A. and Helen F. Spencer Foundation Acquisition Fund.

40b. Société Générale Building, 29 and 31, Boulevard Haussmann, Paris. Caillebotte and his brother lived in the apartments along the higher of the two ornate balcony grills. Their apartments took up almost the entire near (right) end of the building on that floor. Author's photo.

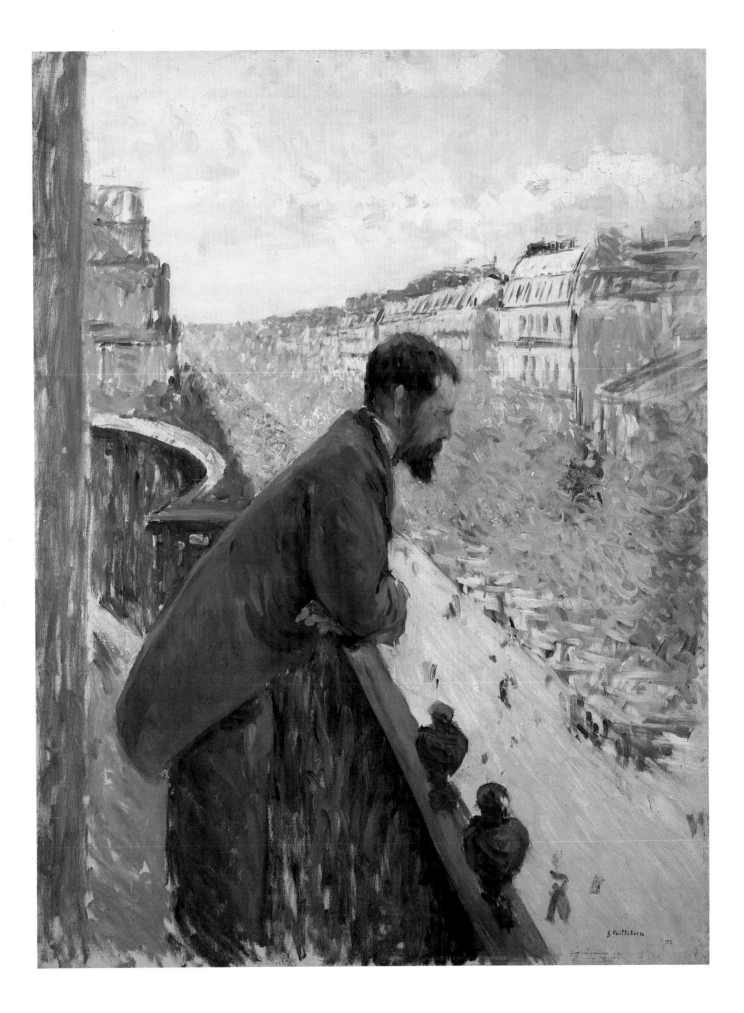

41. Un Balcon

(*A Balcony*) 1880
Oil on canvas, 67.9 × 61 cm. (26¾ × 24 in.)
Signed l.r. *G. Caillebotte*
Private collection, Paris
Berhaut, 1978, No. 136 (*Un Balcon, Boulevard Haussmann*)

Though painted from the same balcony as Pl. 40, this view looks in the opposite direction along the Boulevard Haussmann.[1] Neither of the two men are precisely identified, but the closer, derbyed figure resembles the central character in *Dans un café* (Pl. 39) of the same period.

Here, even more than in Pl. 40, Caillebotte emphasizes the remoteness of the balcony world from that of the street. The plunging diagonal severely demarcates the balcony zone, cast in darkly blue-tinted shadow, from the sunlit city beyond. More significantly, the mass of the tree foliage, dabbed thickly in high-key greens, completely blocks the view of the boulevard below. This greater detachment carries over into the figures as well. One has only to compare the slightly leaned-back slouch of the near figure here to the superficially similar, but energetically charged posture of the earlier man at the window (Pl. 10) to become aware of the self-contained inertia that has now come into Caillebotte's vision of the man in the city.

Un Balcon has a special significance as a link between Caillebotte and the younger Norwegian painter Edvard Munch. Munch's *Rue Lafayette* (Pl. 41a), painted during a visit to Paris in 1891, seems to owe a debt to the present picture, which Munch could only have seen in Caillebotte's own collection.[2] Perhaps Munch painted his view independently, but if he did so, he painted from Caillebotte's own balcony (Pl. 41b).[4] Combining the deeper street view of Pl. 40 with the general format of the present picture, Munch takes a more elevated, precarious viewpoint. The younger painter restores to the image a spatial vertigo, and a tension between individual and city, that Caillebotte had reduced to a residual, almost wistful undercurrent in his treatment of the motif.

41a. Edvard Munch, *Rue Lafayette*, 1891. Oil on canvas, 92 × 73 cm. (36³⁄₁₆ × 28¾ in.). Nasjonalgalleriet, Oslo.

41b. View from the balcony at 29/31 Boulevard Haussmann, looking toward intersection with rue Lafayette. Author's photo.

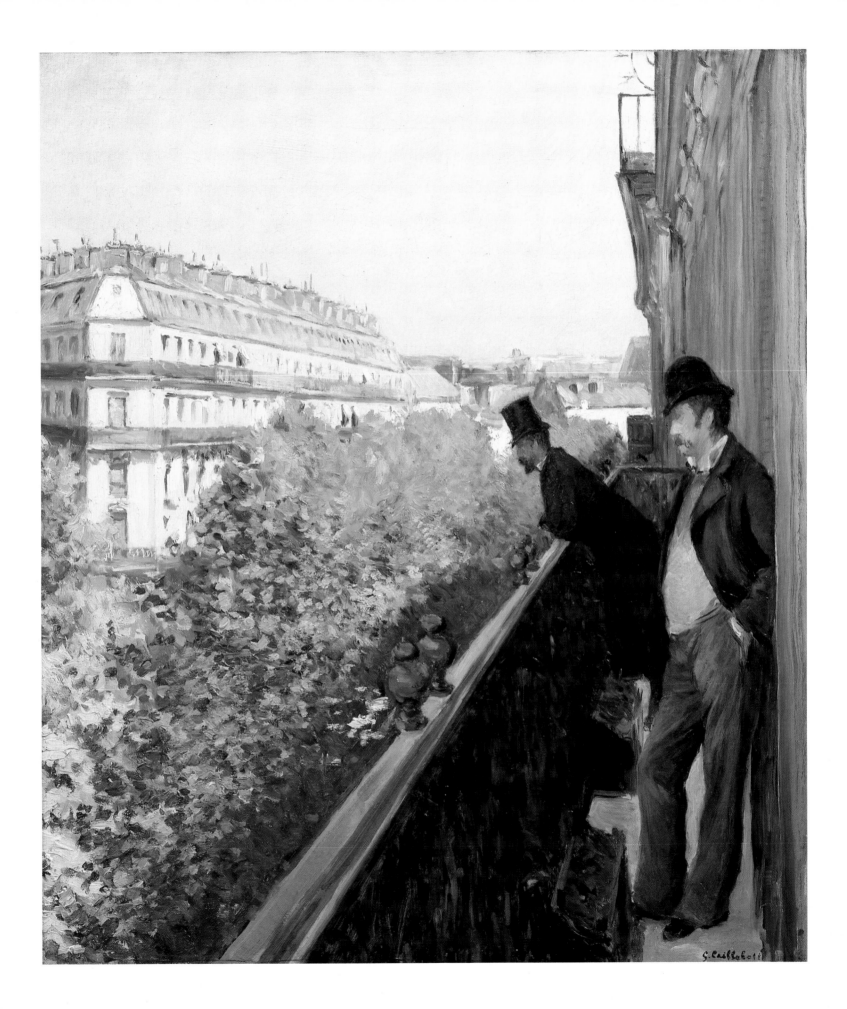

42. Homme au balcon

(*The Man on the Balcony*) 1880
Oil on canvas, 117 × 90 cm. (46 × 35⅜ in.)
Signed l.l. *G. Caillebotte 1880*
Private collection, Switzerland
Berhaut, 1978, No. 139 (*Homme au balcon, Boulevard Haussmann*)

In size, figural scale, and force of construction, this is the most important of Caillebotte's treatments of the theme of men on balconies (the apparently unfinished *Homme au balcon* [Pl. 40] is just as big but has none of the solidity). Though its sunlit brightness and open vista are opposite, the picture is virtually identical in dimensions, and similar in impact, to the view of a woman at the window, painted in the same year and shown in 1880 (*Intérieur*, Pl. 35). Perhaps the two might be considered pendants—and even in turn related to the much earlier treatment of the same theme, *Jeune homme à sa fenêtre* of 1876 (Pl. 10), which is almost exactly the same size.

The view here is that looking down the Boulevard Haussmann in the same direction shown in the unfinished *Homme au Balcon* (Pl. 40); but the viewpoint is from the end of the building overlooking the intersection of the rue Glück and the rue Scribe, roughly the same place from which Caillebotte painted *Un Refuge, Boulevard Haussmann* (Pl. 43). Following an interest in fans inspired by Japanese art and pursued by Degas, Pissarro, and others, Caillebotte sketched a project for a fan based on this same theme (though the figure is added only lightly) and this same viewpoint (Pl. 42b).

Shown in the 1882 exhibition that also included Renoir's *Déjeuner des Canotiers*, this canvas attracted much favorable comment; though the caricaturist Draner, who had targeted Caillebotte before, did not miss the chance to poke fun at the man in the "stove-pipe" hat prominently, in the very center of his parodies of the show (Pl. 42b). For the Norwegian artist Christian Krohg, who would be a central conduit of the influence of advanced French painting on Scandinavian artists (and especially on his young associate Edvard Munch), this picture was immediately inspirational. Krohg returned to the Scandinavian artists' colony outside Paris in Grez-sur-Loing after seeing the 1882 exhibition and painted his fellow artist the Swede Karl Nordstrom in a fashion that echoes Caillebotte directly (Pl. 42c).[1]

Like another of Caillebotte's entries that year, the *Nature morte* (Pl. 48), this canvas was given by the artist to his friend the notary Albert Courtier, who was entrusted with Caillebotte's will and would eventually play an important role in resolving his bequest (see Appendix B).

42b. Detail from Draner, "Une Visite aux impressionistes," *Le Charivari*, 9 March 1882.

42a. Study for *Homme au balcon*: View of Boulevard Haussmann (Project sketch for a fan): 47.4 × 60 cm. (18 11/16 × 23⅝ in.).

42c. Christian Krohg, *Portrait of Karl Nordström*, 1882. Oil on canvas, 61.5 × 46.5 cm. (24¼ × 18¼ in.). Nasjonalgalleriet, Oslo.

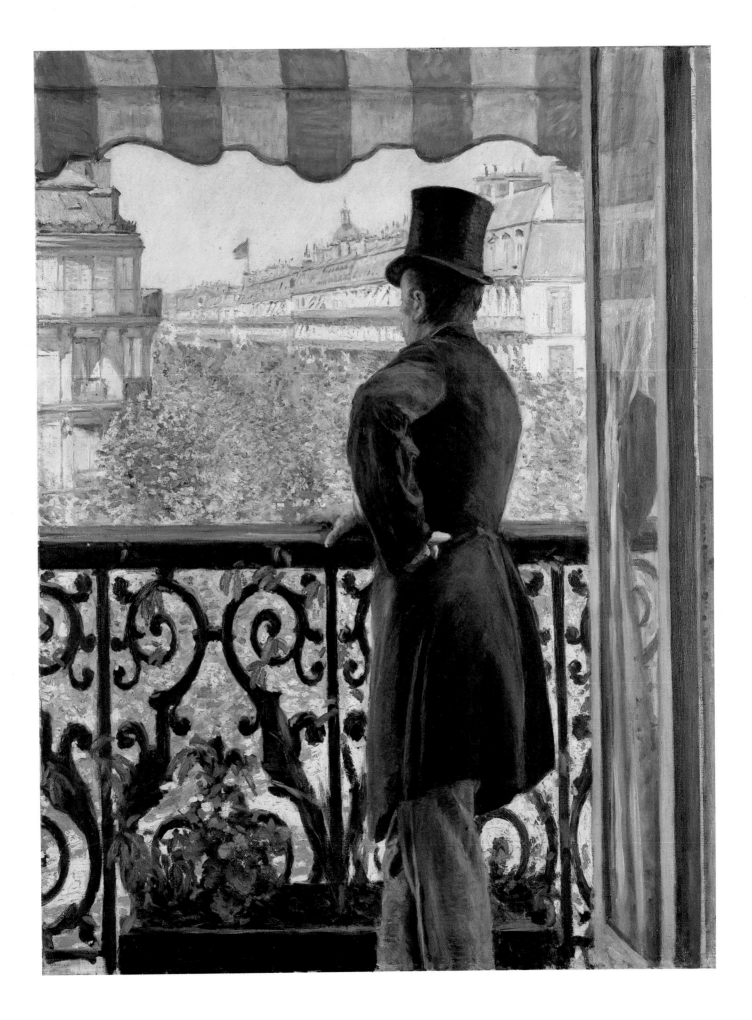

43. Un Refuge, Boulevard Haussmann

(*A Traffic Island, Boulevard Haussmann*)
c. 1880
Oil on canvas, 81 × 101 cm. (32 × 39¾ in.)
Stamped l.r.
Private collection, Paris
Berhaut, 1978, No. 141

The huge traffic island shown here formerly existed at the juncture of the Boulevard Haussmann, the rue Scribe, and the rue Glück, immediately behind the Opera. Caillebotte thus painted the view looking down from the balcony at the end "point" of the building at 29/31 Boulevard Haussmann. Eliminating not only the horizon but virtually all reference to surrounding buildings, he framed the intersection as a large, simplified pattern of curves and bands, without appreciable receding perspective. Since the pattern is stronger at the top of the picture, this area pulls forward visually, flattening the space.

Aaron Scharf has convincingly compared the curious oval distortion of the traffic island in this picture to effects seen in contemporary stereoscopic photographs taken from elevated vantage points.[1] However, no known photograph of this date, or for a long time afterward, omits the horizon so completely or produces such emphasis on the flat shape-content of a scene. Moreover, Caillebotte need not have used a lens to obtain the deformation of the shape, as this effect could have resulted from a correct but uncommon use of standard perspective geometry. (See Chapter 3 for a fuller consideration.)

Across the nearly monochrome white-grey ground, Caillebotte has scattered spare grey and grey-blue accents of carriages, lampposts, and pedestrians. After the exceptional boldness of the basic abstract pattern, the selective focus with which these latter features are seen is the picture's most striking aspect. Most of the elements are suggested in very summary fashion, with hardly decipherable loose clusters of brushstrokes; but the three men in top hats (actually two men and one half), and especially the man on the near edge of the island, stand out with singular, sharply contrasted clarity. This anomaly, which seems intentional rather than a result of incompletion, has precedents in the selective focus of several of Monet's paintings in the 1870s.[2] Here, however, it seems to aim at a truth, not simply of limited-focus foveal vision, but of urban psychology as well. There is, for example, no central field of focus, nor any consistent gradation of clarity. Instead, the strolling men, widely separated, each determine individual pockets of strong contrast and crisp definition. Note, for example, the marked shadows cast by the two men on the island, in contrast to the virtual absence of shadow elsewhere in the picture. On the one hand, Caillebotte uses these shadows, and the selective crispness of contrast, to emphasize the isolation of these tiny figures in the vast white space. On the other hand, by their nearly identical costumes and poses, these men belong to a pattern of repetition that links their random wanderings. They seem, in accord with an effect already announced by Caillebotte in the *Raboteurs* of 1875 (Pl. 8), to be one figure

perceived at three moments of motion across a fixed stage. The abstract structure of the composition, and the obviously far-removed vantage point, may suggest a detached aesthetic; but the sharp isolation and repetitive anonymity of the figures, in conjunction with the tremendous emptiness of the space, suggest an involvement with the human experience of the city: a conception whose overtones prefigure the disquieting vision of modern works such as Giacometti's *City Square* (Pl. 43a).

43a. Alberto Giacometti, *City Square*, 1948. Bronze, 21.6 cm. (8½ in.) high (base 64.5 cm. long × 43.8 cm. deep [25⅜ × 17¼ in.]). Collection, The Museum of Modern Art, New York.

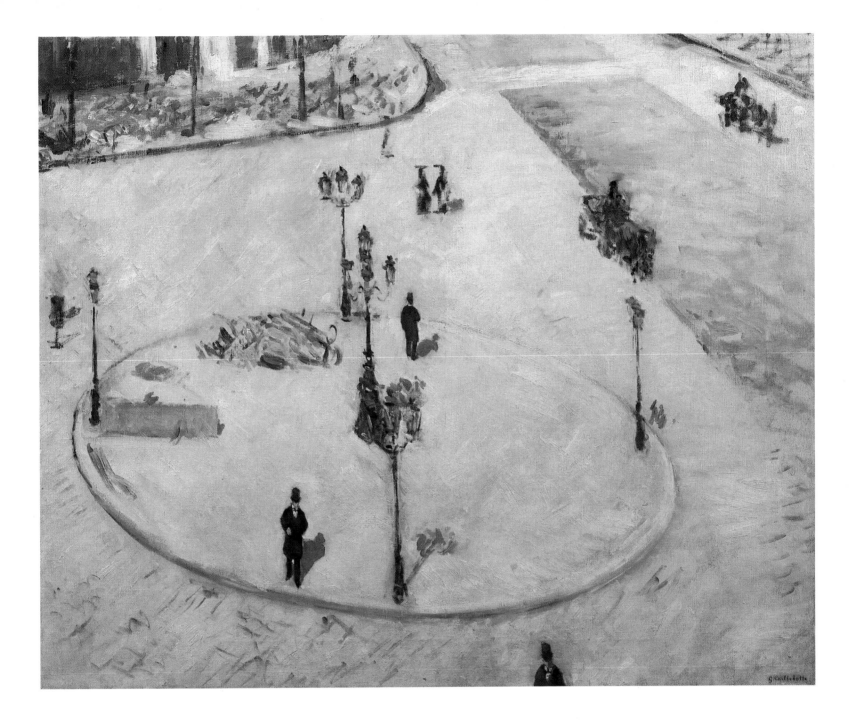

44. Boulevard vu d'en haut

(*Boulevard seen from above*) 1880
Oil on canvas, 65 × 54 cm. (25⅝ × 21¼ in.)
Signed l.l. *G. Caillebotte 1880*
Private collection, Paris
Berhaut, 1978, No. 143

This is without question one of the most astonishingly modern paintings in Caillebotte's oeuvre. Its origins, and its uniqueness in its time, defy simple explanation. The influence of Japanese design would seem evident, but no Japanese print takes a viewpoint that so radically compresses human content. Similarly, the relation to photography would seem incontestable, given the eccentric framing of this slice of sidewalk life. However, the abstraction of the view looks far beyond any photograph of the nineteenth-century to constitute an exact premonition of city views taken, under the influence of Russian Constructivist design, by photographers of the 1920s and '30s (Pls. 44a and b).[1] The *Boulevard vu d'en haut* is, moreover, no simple accidental curiosity; the unusual viewpoint and the abstract pattern are only the initial parts of its blend of boldness and subtlety.

Despite the remarkable flatness of the design, for example, the picture has a quite palpable space. The green of the leaves produces this effect, as it optically lifts off the grey ground to convey the feeling of separation between the branches and the sidewalk. The variety of the greens, and the subtle effect of impasto by which certain of the leaves pucker off the otherwise smooth surface of the canvas, further provides a sense of space within the tree itself.

The fanning pattern of the branches then generates a spiral movement that is picked up and reinforced in the placement of the figures. This flow, spinning back on the circular grating at the base of the tree, conveys a sense of animation on the street and binds together the disparate shapes of the composition. Thus, despite its brutal cropping at the edges and its internal segmentation, the picture feels absolutely complete and unified.

If we were to look for a precedent for Caillebotte's extreme foreshortening of space, beyond the amusing fantasies of the illustrator Grandville (Pl. 44c), we might think of the similar effects, in reverse, found on baroque ceilings. In the final analysis, though, despite its great originality and unique position in its time, the picture is so consistent with the development of Caillebotte's art that it is as unnecessary as it is unfruitful to search a specific external model for it.

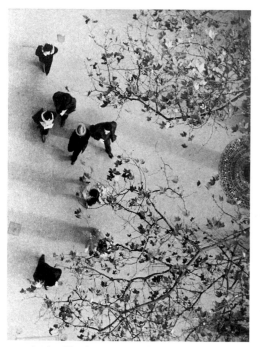

44a. Andre Kertész, *Avenue de l'Opéra, Paris*, 1929. Photograph. Estate of André Kertész ©.

44b. Alexander Rodchenko, *Assembling for a Demonstration*, 1929. Photograph, 49.5 × 35.3 cm. (19½ × 13⅞ in.). Collection, The Museum of Modern Art, New York. Mr. and Mrs. John Spencer Fund.

44c. Grandville (Jean-Ignace-Isidore Gérard), illustrations from *Un Autre Monde*, 1844. These views relate to the balloon flight over Paris of one of the story's characters.

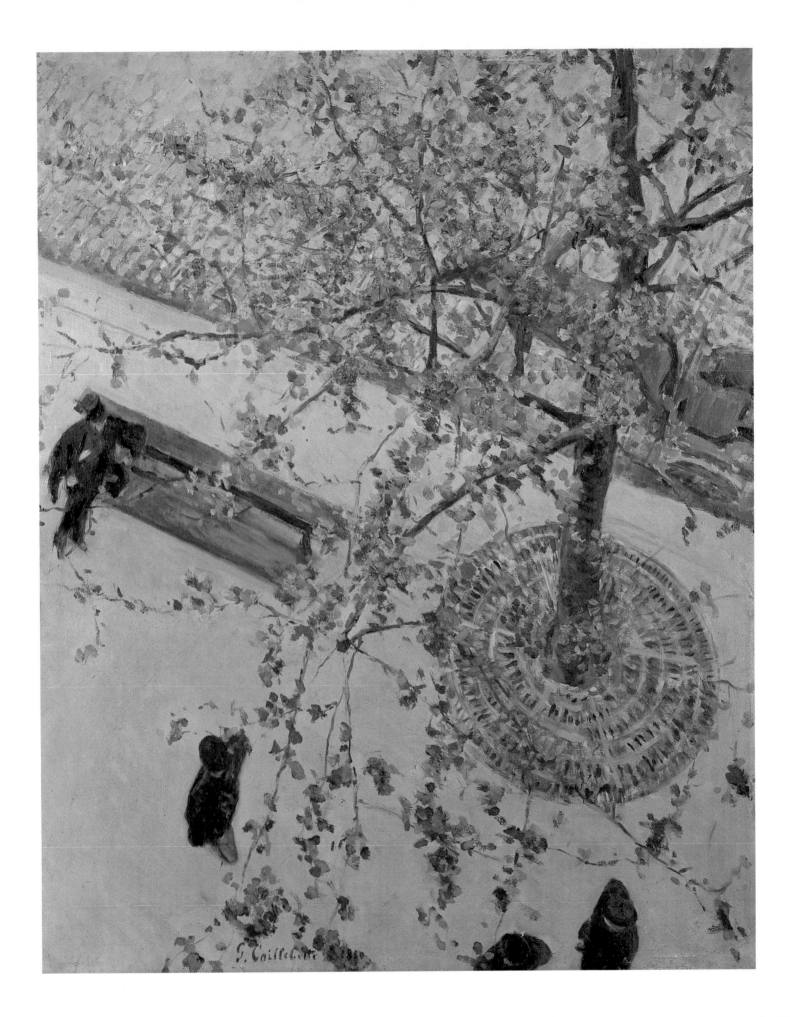

45. Vue prise à travers un balcon

(*View through a balcony*) 1880
Oil on canvas, 65 × 54 cm. (25¾ × 21¼ in.)
Stamped l.l.
Private collection
Berhaut, 1978, No. 138

45a. The balcony grill of Caillebotte's appartment in the Boulevard Haussmann.

45b. *Boulevard Haussmann, effet de neige,* c. 1880. Oil on canvas, 66 × 81 cm. (26 × 31⅞ in.). Private collection, Paris. (Berhaut, 1978, No. 133)

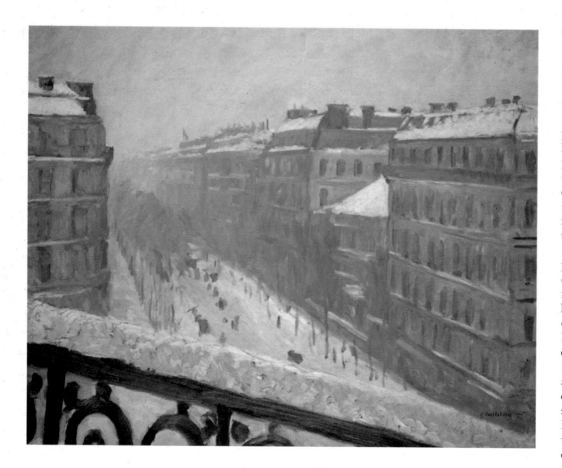

It is impossible to say with certainty whether or not Caillebotte conceived this small, unsigned canvas as a partial study for a larger picture. Other views from the artist's apartment on the Boulevard Haussmann (e.g. Pl. 45i and *Homme au balcon,* Pl. 42) contain significant passages in which this same ironwork railing is shown. However, no known larger work subsumes this precise composition; and, in degree of finish, the picture is as complete as other, exhibited Caillebotte canvases of the period. In the 1880 Impressionist show, Caillebotte's exhibit No. 12 was entitled *Vue prise à travers un balcon.* Though there is some dispute on the question,[1] it seems that—lacking record or mention of another work in Caillebotte's oeuvre resembling this view—the present canvas is that 1880 *Vue.*

The picture is not only one of the most original conceptions in Caillebotte's art; it is also a pivot point in the history of painting, standing within one tradition while announcing another. Not just in connection with the specific motif of the window, but also in the larger genre of view painting, there is a long history of images in which a foreground element becomes a prominent framing division between the viewer and the vista. Prior to the nineteenth century, however, there are few such images in which there is more than a playful competition between this proscenium and the bright, expansive world

45c. Caspar David Friedrich, *Studio Window (right),* 1805. Sepia on paper, 31 × 24 cm. (12¼ × 9½ in.). Kunsthistorisches Museum, Vienna.

beyond. Then in Romanticism we find views in which the window itself becomes the subject (Pl. 45d), and the feeling of enclosure dominates. Nowhere, however, do we find a precedent for the fusion of foreground and space Caillebotte effects. His iron grill dominates the field of vision from top to bottom and from edge to edge. Unlike Friedrich's window (Pl. 45d), the grill is segmented on all sides, so that we do not stand back from it, but visually press against it. The view beyond, flattened into a subsidiary pattern that offers no horizon and little receding perspective to encourage "escape" into depth, hardly competes. In fact, in various subtle parallels, tangents, and contiguities, the distant street partially locks itself into the foreground design. Even in the pattern of brushwork, the space beyond is not continuous, but fragmented into pockets, filled-in following the contours of the ironwork.

The radical change in structure of this kind of proscenium/distance image can be seen as emblematic of a crucial moment in the origins of modern art. Zola, seeking to describe the realism he sought, defined a work of art as "a corner of creation seen through a temperament" and Duranty in 1876 insisted on the window as the ever-present frame shaping our view of life.[2] Now the window is emphatically closed, as if announcing that the temperament—the individual consciousness filtering received sensation—has become a more opaque screen. From this point on, we find in art a new kind of window, one in which the emphasis is not on the contrast between beckoning distance and fram-

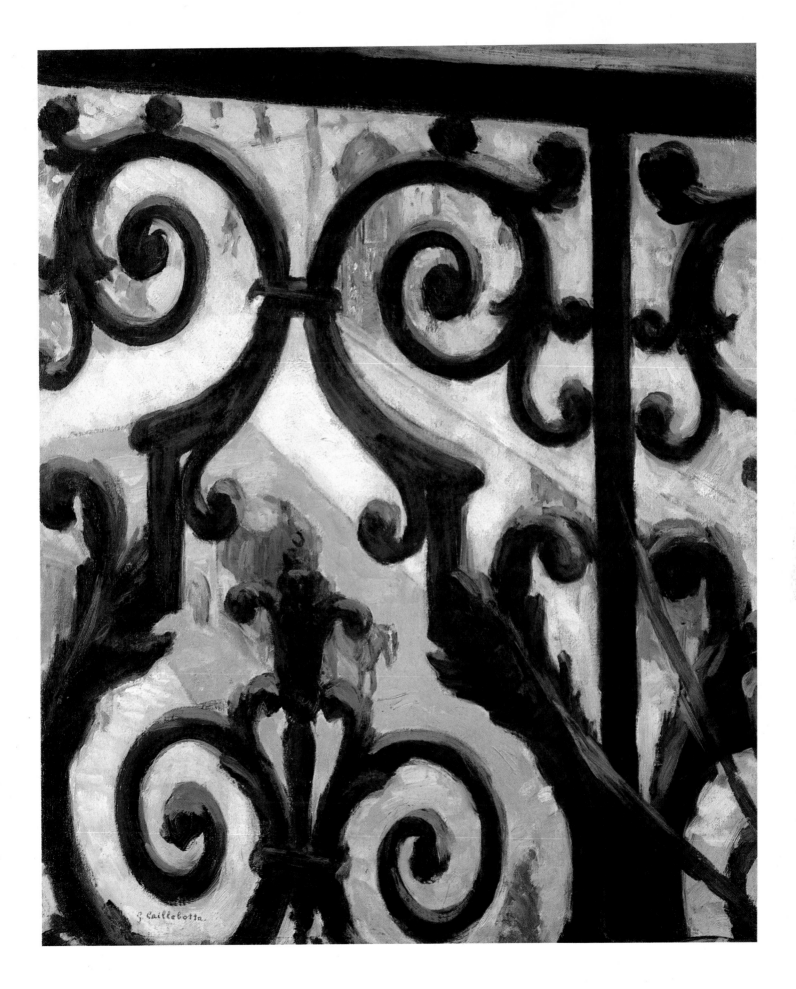

45d. Vincent Van Gogh, *A Pork-Butcher's Shop*, 1888. Oil on canvas, 39.4 × 31.8 cm. (15½ × 12½ in.). Van Gogh Museum, Amsterdam.

45e. Paul Cézanne, *The Balcony*, c. 1895. Watercolor on paper, 55.9 × 39.4 cm. (22 × 15¼ in.). Philadelphia Museum of Art, A. E. Gallatin collection.

ing foreground, but on the collapse of the two into one plane (Pls. 45d, e and f).³ The closing of the window, or the dominance of the balcony grill, becomes a vehicle of the destruction of illusory spatial penetration into the canvas, and an emblem of a new self-conscious removal from nature through concentration on the surface of the picture.⁴ In Caillebotte's case, at least, this closure seems to bear complex psychological implications as well (see Chapter 2).

45f. Georges Seurat, *View Through the Balcony Grill*, c. 1883. Conté-crayon on paper, 31.6 × 24 cm. (12⅜ × 9⅜ in.). Private collection.

In its beautiful rhythmic interlock of positive and negative shapes, Caillebotte's image may owe something to the model of Japanese prints (Pl. 45g). Like the *Boulevard vu d'en haut* (Pl. 44), however, *Vue prise à travers un balcon* is not a single-mindedly flat pattern. The oblique orientation of the grill (emphasized by the diagonal at the top), and the subtle notes of the plant branches that intrude in front of the ironwork at lower left and lower right, literally add another dimension to the life of the design. The picture also shares with the *Boulevard vu d'en haut* an uncanny premonition of the interests of Constructivist photographers of the 1920s and '30s (Pl. 45h).

One can find screening devices, and an increased sense of closure of view, in works by other artists in the 1870s.⁵ *Vue prise à travers un balcon*, however, seems to move well beyond any precedent. The image embodies not only a striking graphic beauty—a design before whose exuberance the name of Matisse springs irresistibly to mind—but also an extraordinary creative leap of the visual imagination.

45g. Ando Hiroshige, *Moon Pine at Ueno*, 1858. Colored woodcut, 37.5 × 25.4 cm. (14¾ × 10 in.). The Newark Museum.

45h. Lazlo Moholy-Nagy, *Marseilles, 1928*. Photograph. International Museum of Photography at George Eastman House, Rochester.

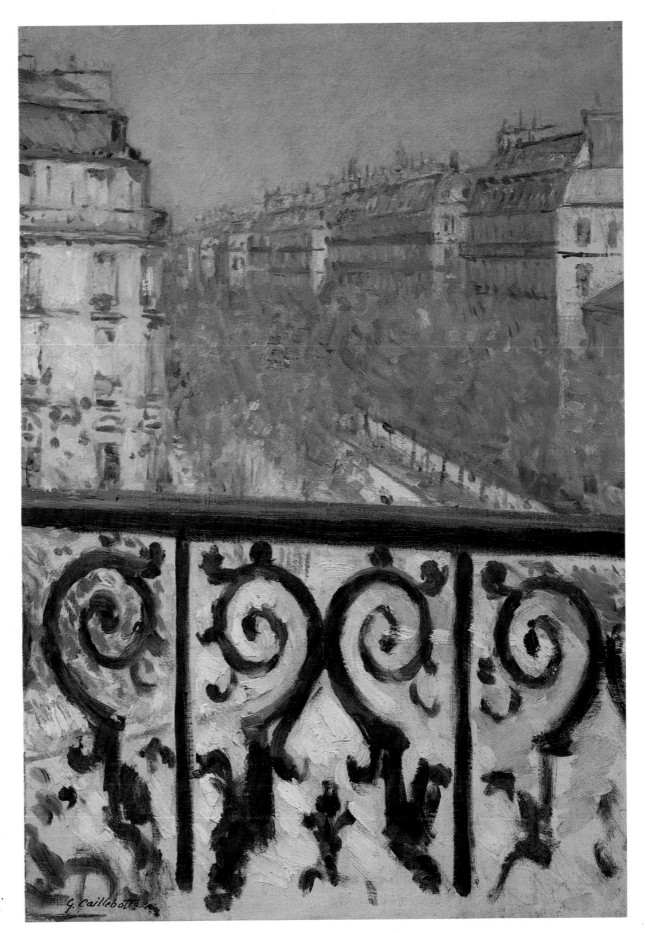

45i. *Un balcon à Paris*, c.
1880–81. Oil on canvas, 55.2 ×
39 cm. (21¾ × 15¼ in.).
Courtesy Paul Rosenberg & Co.,
New York. (Berhaut, 1978, No.
140).

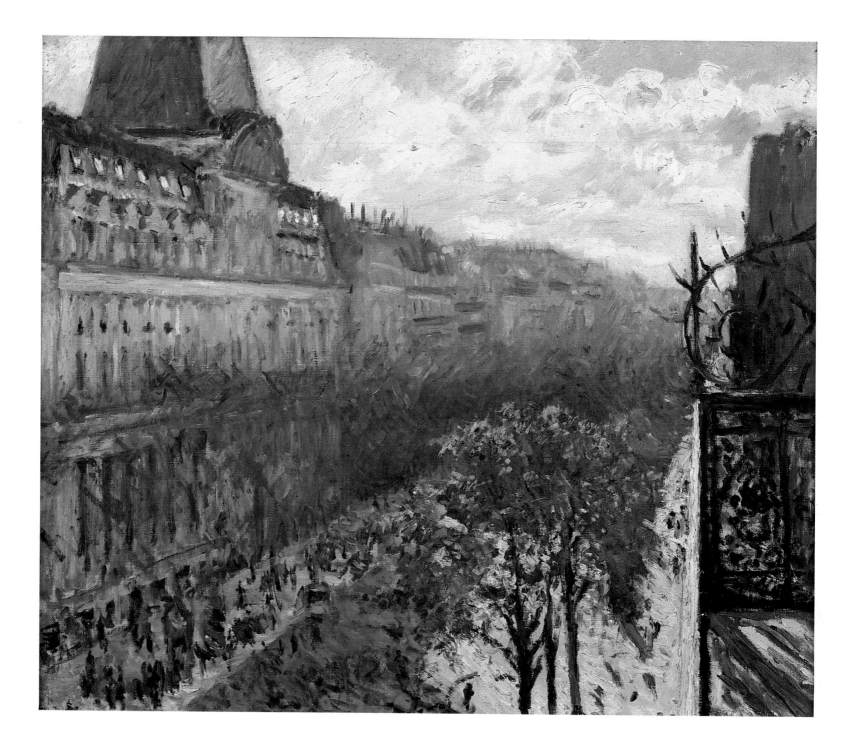

46. Boulevard des Italiens

c. 1880

Oil on canvas, 54 × 65 cm. (21¼ × 25⅝ in.)

Private collection, Paris

Berhaut, 1978, No. 139

In this canvas, Caillebotte approached as closely as he ever could Monet's vision of Paris (compare Pl. 18a). The presence of the near balcony grill, with its climbing perspective defining a flat design, marks this as a Caillebotte composition. The execution, though, is unusually energetic and free, albeit not as deftly controlled as Monet's. The boulevard, its trees, and its pedestrians are suggested by dabs of dark blue, grey, green, and yellow in the near space at lower left. Beginning in the middle ground, near the center of the canvas, all the far elements merge into one broad web of brush activity, with strokes of muted green accenting a grey-blue atmosphere. Though the whole far side of the boulevard lies in shadow, the scene is shot through with the feel of brightness, keyed by the sky and the more densely painted, buttermilk-rich afternoon sunlight raking through the right half of the picture. In this light, in the bustle of the crowd below, and in the brushwork, there is a positive exuberance that we rarely find in Caillebotte's work, especially when he views the city.[1]

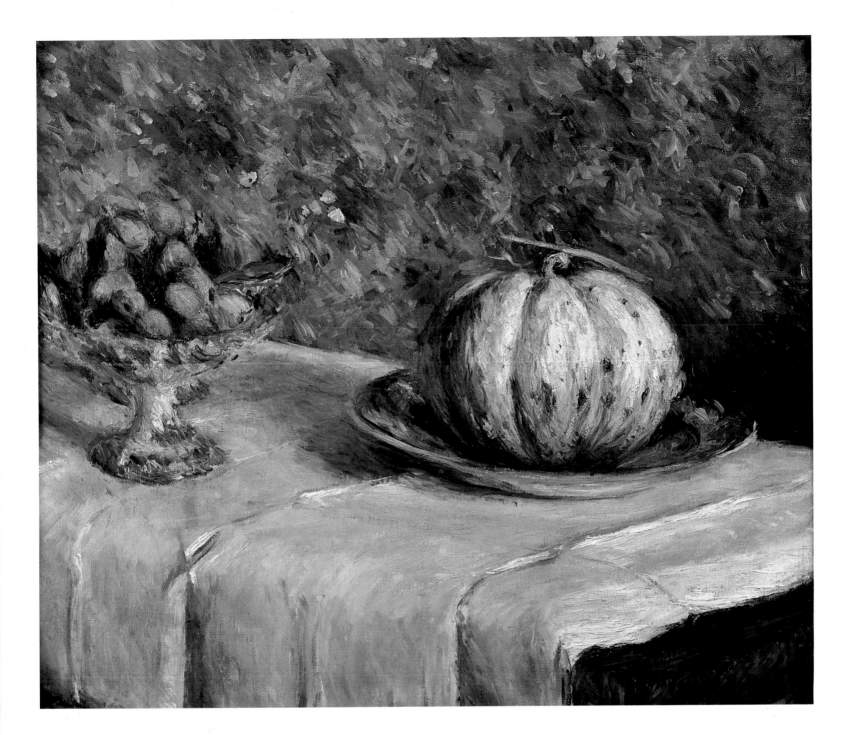

47. Melon et compotier de figues

(*Melon and bowl of figs*) 1880–82
Oil on canvas, 54 × 65 cm. (21¼ × 25¾ in.)
Signed l.r. *G. Caillebotte*
Private collection, Paris
Berhaut, 1978, No. 211

Marie Berhaut has pointed out that there is a very close resemblance between this work and one painted by Renoir in 1882 (reproduced in *L'Opera completa di Renoir*, Milan, 1972, No. 553), and surmises that the two artists worked on the subject together in Trouville, while Renoir was staying with his patrons the Berards, at Wagremont. Caillebotte's still lifes are perhaps the least-recognized, least-appreciated part of his oeuvre, but in fact he produced several of remarkable originality and quality, including in particular the one shown in 1882 (*Nature morte*, Pl. 48). Though painted at or near the same time,

the present canvas lacks the latter's distinctively personal composition. It shows Caillebotte moving toward what might be called a canonical Impressionist palette and brushwork, resembling that of Monet's still lifes of this period perhaps even more than Renoir's. The strong blues of the shadows, and the optical differential between the softly blurred forms in the foreground and the heavily worked, virtually illegible wallpaper pattern behind, represent lessons learned from such friends; just as the basic format of the angled table with white cloth must ultimately derive from the earlier still lifes of Manet.

49. Nature morte—poulets, gibiers à l'étalage

(*Still life, display of chickens and game birds*) c. 1882

Oil on canvas, 76 × 105 cm. (29$\frac{7}{8}$ × 41$\frac{3}{8}$ in.)

Stamped l.r.

Private collection, Paris

Berhaut, 1978, No. 220

Here two of Caillebotte's still life interests, dead game and patterns of commercial display, come together in a disconcerting fashion. This insistently inelegant arrangement bears to the tradition of hunt trophy and/or market still lifes somewhat the same debunking relation that Caillebotte's naked female (*Nu au divan*, Pl. 36) bears to the tradition of the idealized nude. Caillebotte likes and adopts the no-nonsense A-A-A, B-B-B rhythms of the butcher's display, using the cropping at the edges and the internal balance to suggest a random slice from an ongoing, unvarying line-up; but inevitably this bloodless assembly-line review of fur, feathers, and plucked raw skin, fixed on the horizontal bands of cold marble and metal, also has about it a particular aura of death, not residually noble as in other game still lifes (see *Faisans et bécasses sur un table de marbre*, Pl. 50), but chillingly mechanical. The picture winds up as a disturbing hybrid of Goya and (the recent California painter) Wayne Thiebaud.[1]

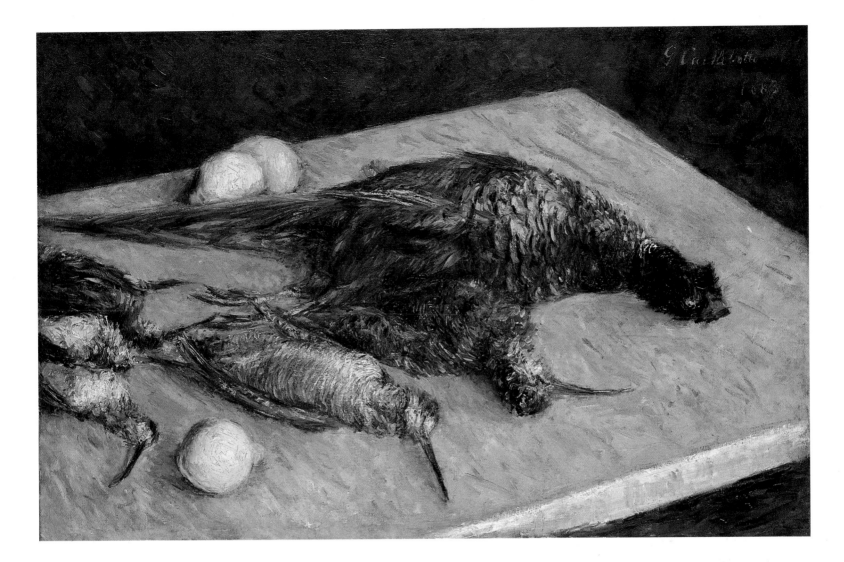

50. Faisans et bécasses sur une table de marbre

(*Pheasants and woodcocks on a marble table*) 1883

Oil on canvas, 52 × 81.9 cm. (20½ × 32¼ in.)

Signed u.r. *G. Caillebotte 1883*

Museum of Fine Arts, Springfield, Mass. The James Philip Gray Collection

Berhaut, 1978, No. 236

With its lemons and game birds, this still life suggests both sport and banquet, an aftermath of the hunt and the preparations for a meal, with overtones both of the rustic outdoor life and the civilized pleasures of the table. Lacking the macabre originality of Pl. 49, the picture's subject and conception are nearly identical with earlier still lifes by Monet.[1]

51. Portrait d'Henri Cordier

(*Portrait of Henri Cordier*) 1883
Oil on canvas, 65 × 81.3 cm. (25⅝ × 32
 in.)
Signed l.l. *G. Caillebotte 1883*
Musée d'Orsay
Berhaut, 1978, No. 235

Henri Cordier (1849–1925) was an eminent expert on the language and literature of China. Born in New Orleans of French parents, he was educated in France and for two years in England before moving to the Orient in 1869. Beginning at that date, he undertook the catalogue of the holdings of the Societé Royale Asiatique. He returned to France in 1876 as a member of a commission sent by the Chinese government; the mission, initially planned as temporary, lasted until 1883, and Cordier then continued to live and travel in Europe. Perhaps the single most important work of his life was the *Biblioteca Sinica*, for which he received the Stanislas Julien Prize in 1880; he was elected to the Academy in 1908.[1]

It is tempting to think that Cordier acquainted Caillebotte with oriental art. However, the early studio view (Pl. 6) proves Caillebotte's interest prior to Cordier's return to France; and, furthermore, all of Cordier's extremely impressive library was lost in a shipwreck on its way from China to France in 1877. Little is known of the relationship between the two men, but friendship with such a scholar offers a suggestive glimpse of the range of Caillebotte's apparently keen and broad intellectual life.

The portrait of Cordier at work inevitably recalls the series of great portraits of French writers of the later nineteenth century, but the most specific connection must certainly be to Degas's earlier *Portrait of Edmond Duranty* (Glasgow). No preparatory sketches exist for the picture, which is painted loosely, with varying degrees of finish and a certain lack of success in the form of the body. It is inconceivable that the work could have been a formal commission, and it was more probably a gesture of friendship on Caillebotte's part. The artist in fact did a considerable number of portraits of his friends, at all stages of his career, but they are not, with rare exceptions, among his most impressive works.

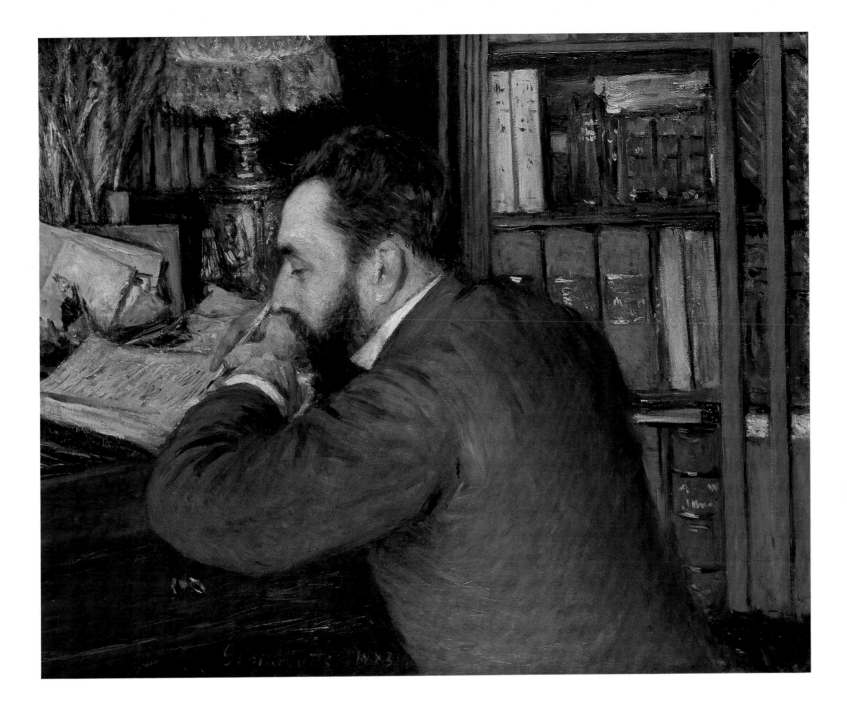

52. Homme au bain

(Man at his bath) 1884
Oil on canvas, 170.1 × 125 cm. (67 ×
49¼ in.)
Signed l.l. *G. Caillebotte 1884*
Josefowitz Collection
Berhaut, 1978, No. 267

This vertical picture is roughly comparable in
scale, and obviously generally related in
conception, to the horizonal *Nu au divan* (Pl. 36).
Yet it is quite different in spirit and in design.
The moment chosen is more casual, with none of
the problematic sexual overtones of the Min-
neapolis picture. The construction of the *Homme
au bain* is, on the other hand, far more severe, as
the pose of the figure locks him into a strong grid
of horizontals and verticals. Not only in the
more sober color and more precise detailing, but
also in this rectilinear architecture, Caillebotte's
picture differs markedly from the numerous
scenes of women at their baths by Degas in the
1880s. Caillebotte's pose and design are more
planar and less complex than those in Degas's
images, but the sculptural modeling of the body
is more insistent, and the stretch of the towel
combines with the accented flex of musculature
to convey a strong sense of torsion in the shallow
space. Among Caillebotte's numerous views of
private, interior life, this is simultaneously the
most anonymous and the most intimate, and
certainly the most powerfully conceived. As one
of the most imposing, most solidly executed of
Caillebotte's works dated after 1882, this picture
confirms that his ambitions as a painter did not
simply dissolve when the Impressionist group
split up.

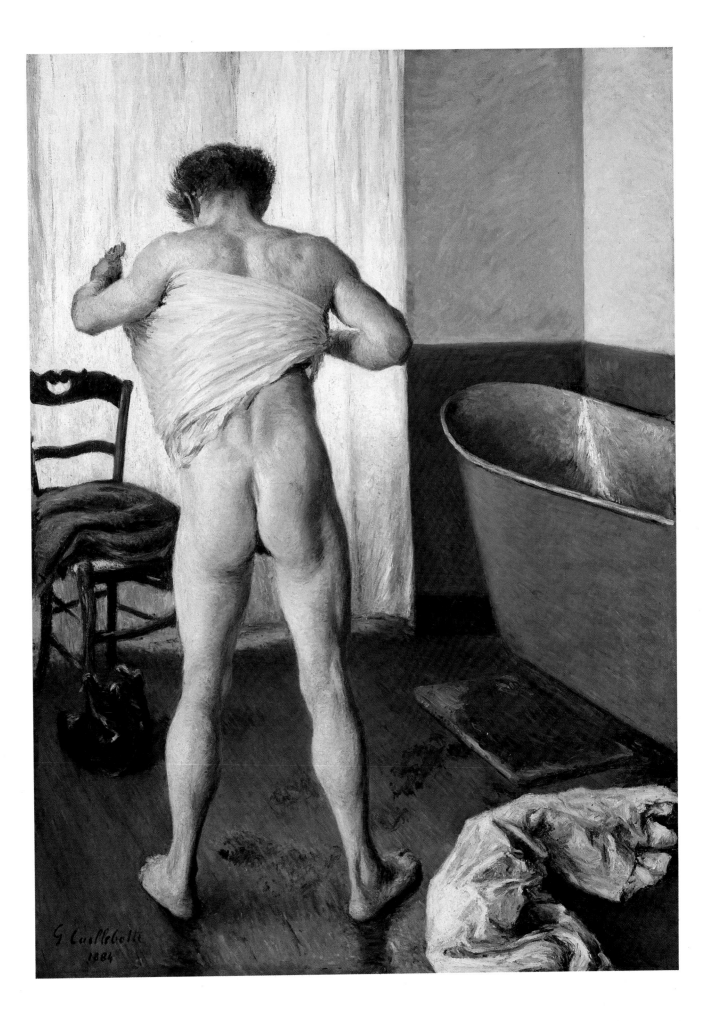

53. Marine, régates à Villers

(*Seascape, regatta at Villers*) c. 1880–84
Oil on canvas, 73.6 × 100.3 cm. (29 ×
 39½ in.)
Signed l.l. *G. Caillebotte*
Private collection, New York
Berhaut, 1978, No. 152

Beginning around 1880, Caillebotte painted frequently along the Normandy coast, presumably in conjunction with sailing expeditions there. This coast was in important senses the birthplace of Impressionism, and Monet returned often to the area—to Pourville, Etretat, and other resort towns—to paint in the 1880s. Caillebotte doubtless knew, and drew inspiration from, these Monet paintings.

The lower half of the canvas, between the bottom edge and the lone yacht at the left, mingles areas of creamy pale blue (picked up from the sky) with a slightly greyed sea-green, conveying the combination of translucency and reflection in the water as it rolls into the shallows. The diagonal stroking of this area is cut by the horizontal slashes of the white wave-crests, set down in a rich impasto. Beyond the yacht, the brushwork solidifies into a horizontal band of unmottled, purer, light sea-green. Offset by the subtly darker horizon and by the near shoals, and keyed up by the white of the sails and the clouds, this green sings out as the primary source of light. The clouds, evoked in short, multi-directional chopping strokes of grey, cream-blue, and white, permit the purer blue of the sky to show only at the top edge of the canvas, at center right. The deepest blue of the scene is reserved for one of the most evocative

components: the broken shadow pattern falling across the vast horizontal flatness of the sea's surface. The body of the yacht at the left is also evoked with slashes of this same darker blue.

This boat, conjured in a few strokes, has little substance but an important role. Its size, set against the tiny sails dotted along the horizon, gives scale to the reach into space, and its movement from the left combines with the shadow pattern to accentuate the grand lateral sweep of the vista. Even among the seemingly perfunctory boats along the horizon, Caillebotte has taken care: anchoring the center of the composition with three sails turned broadside, he creates a sense of varied spatial position and movement that, with no sail really breaking the horizon, contributes to the sensation of the ocean stretching out far beyond their distant line.

Marie Berhaut has dated this work in 1880, identifying it as the *Marine* exhibited in 1882. The tremendous sense of emptiness here, however, and the strictness of the horizon, seem close in spirit to works dated in the middle and later 1880s (e.g., Pls. 56 and 57). Whenever painted, this seascape is unquestionably one of Caillebotte's most "Impressionist" visions, full with the sense of the ephemeral richness of weather, and confident in its execution.

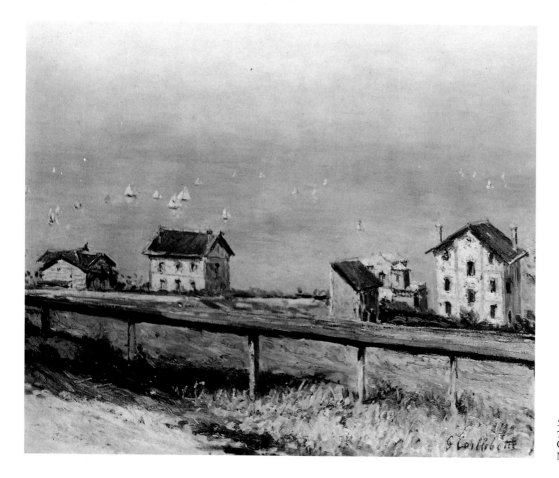

53a. *Régates à Villerville*, 1884. Oil on canvas, 60 × 72 cm. (23¾ × 28¾ in.). Toledo Museum of Art. Gift of the Wildenstein Foundation. (Berhaut, 1978, No. 269)

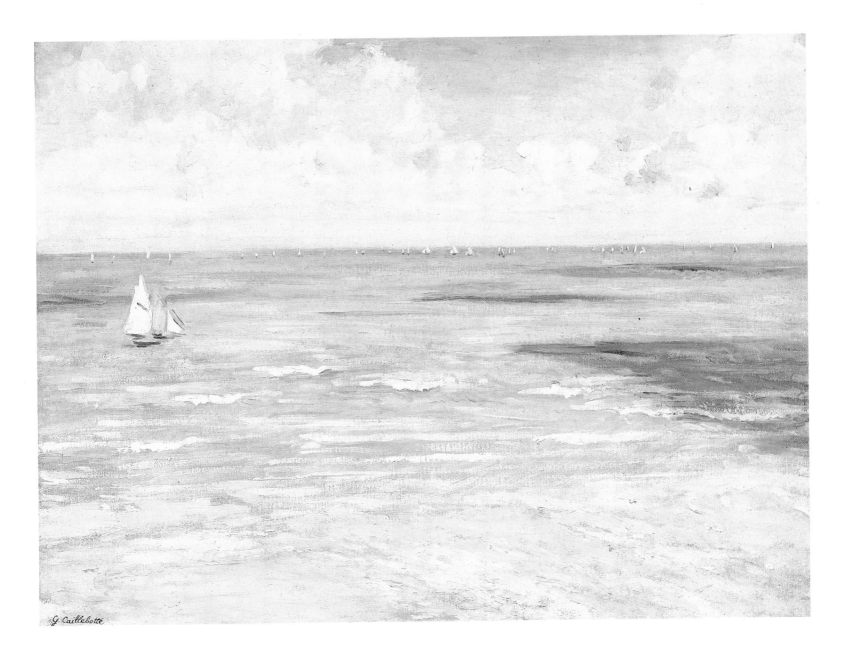

54. Bateaux à voile à Argenteuil

(*Sailing boats at Argenteuil*) c. 1885–90
Oil on canvas, 65 × 55 cm. (25½ × 21⅝ in.)
Signed l.r. *G. Caillebotte*
Musée d'Orsay
Berhaut, 1978, No. 359

This picture would seem to belong naturally with those Monet and Renoir (and in a few instances Manet) painted at Argenteuil in the period 1873–77, and many histories of Impressionism describe Caillebotte as a participant in those early Argenteuil days. However, as Marie Berhaut has argued, there is good reason to believe Caillebotte did not acquire his property at Petit-Gennevilliers (adjacent to Argenteuil) until after the sale of his family's country property at Yerres, following the death of his mother in 1878 (see Chapter 2). Certainly he never showed a painting in any of the Impressionist exhibitions, up to and including that of 1882, that could be used to prove his presence at Argenteuil. The present canvas is especially likely to have been executed after he purchased his Petit-Gennevilliers home, since the view here—looking toward the road bridge at Argenteuil so often painted by Monet—would have been the view from the riverside directly in front of his home (see photo on p. 14 of Berhaut, *Caillebotte, sa vie et son oeuvre*, 1978). This picture would then constitute, with Caillebotte's other views of the Seine (see *Le Pont d'Argenteuil et la Seine*, Pl. 55), an extended postscript to an important chapter in early modern painting.

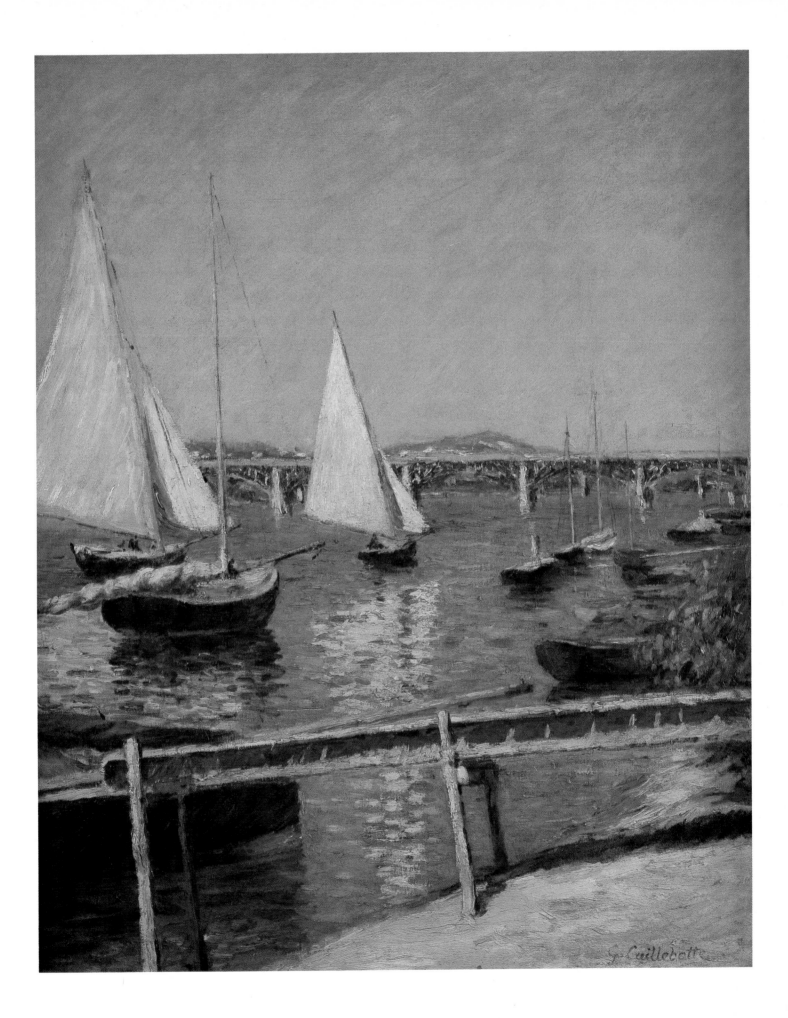

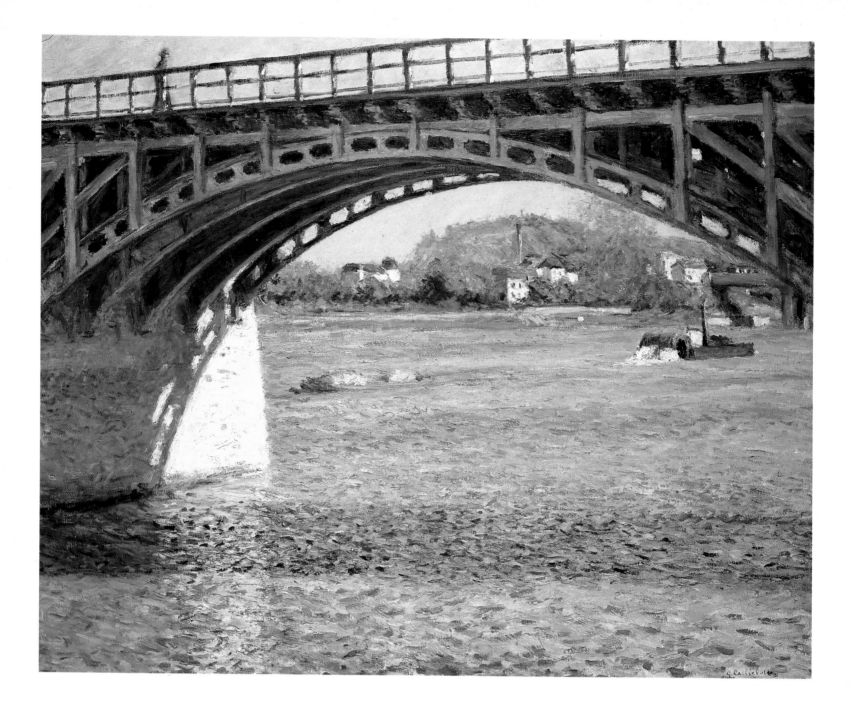

55. Le Pont d'Argenteuil et la Seine
(*The Argenteuil Bridge and the Seine*)
c. 1880–85
Oil on canvas, 65 × 82 cm. (25⅝ × 32¼
in.)
Stamped l.r.
Josefowitz Collection
Berhaut, 1978, No. 310

This striking view of a road-bridge near Caillebotte's home at Petit-Gennevilliers recalls the work of Monet, in design, in the thatched brushwork, and in the brightness of the blue-green-violet palette. In fact, Monet painted this same bridge, from several different points of view, in the 1870s.[1] The particular treatment of the underside of the bridge, however, shows an interest, more personal to Caillebotte, in the play of space and flatness. Using the shadow on the bulkwark at left and the pattern of transparencies of the perforated structure at the right, Caillebotte creates an interplay between arches in depth and on the surface of the canvas. Also, the isolation of one tiny figure—here played up

both as a silhouette and by highlight—against a massive pictorial architecture, strikes a note familiar in Caillebotte's work (see Pl. 43).

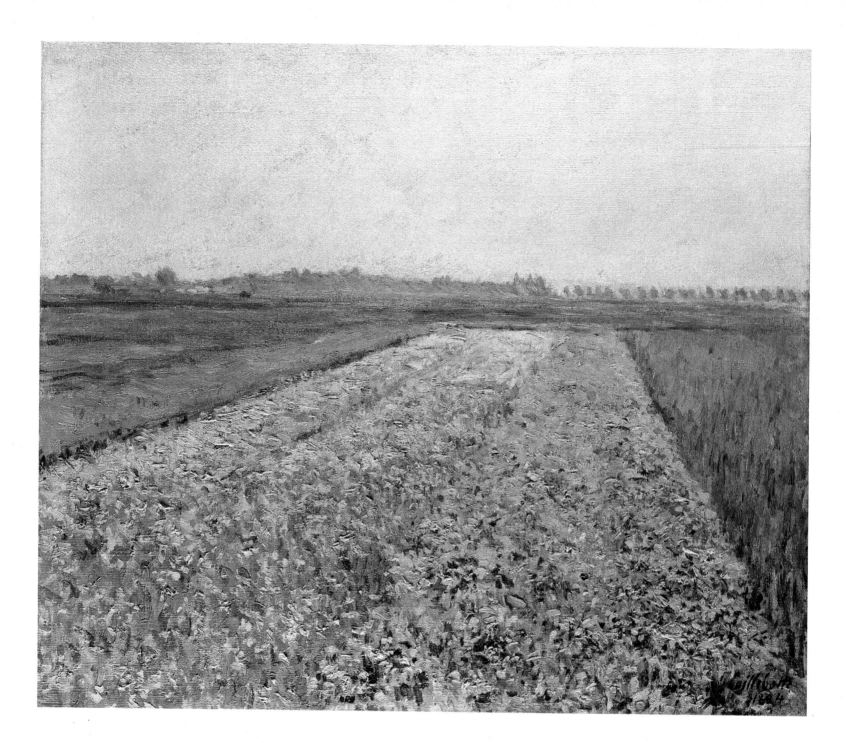

56. La Plaine de Gennevilliers, champs jaunes

(*The Gennevilliers Plain, yellow fields*) 1884
Oil on canvas, 54 × 65 cm. (21¼ × 25⅝ in.)
Signed l.r. *G. Caillebotte 1884*
Private collection, Paris
Berhaut, 1978, No. 277

In this extremely simplified composition Caillebotte seems to be in touch with the changes Monet had been implementing in his landscapes of the early 1880s—changes that led to a decreased emphasis on perspectival recession, and a matching organization of the canvas in terms of fewer, larger shape-units and color fields. Especially in regard to the dominance of the wedge-shaped mass of yellow flowers here, a relevant comparison might be Monet's *Poppy Field Near Giverny* (1885, Boston Museum of Fine Arts). In opposition to the rolling, hilly enclosure of the Monet, however, Caillebotte's low and insistently flat horizon stresses spatial openness, echoing the panoramic sense of freedom and lack of tension in his marine views of the same period (see Pl. 53)—in sharp contrast to the tectonically structured spaces that had marked his urban views in earlier years.

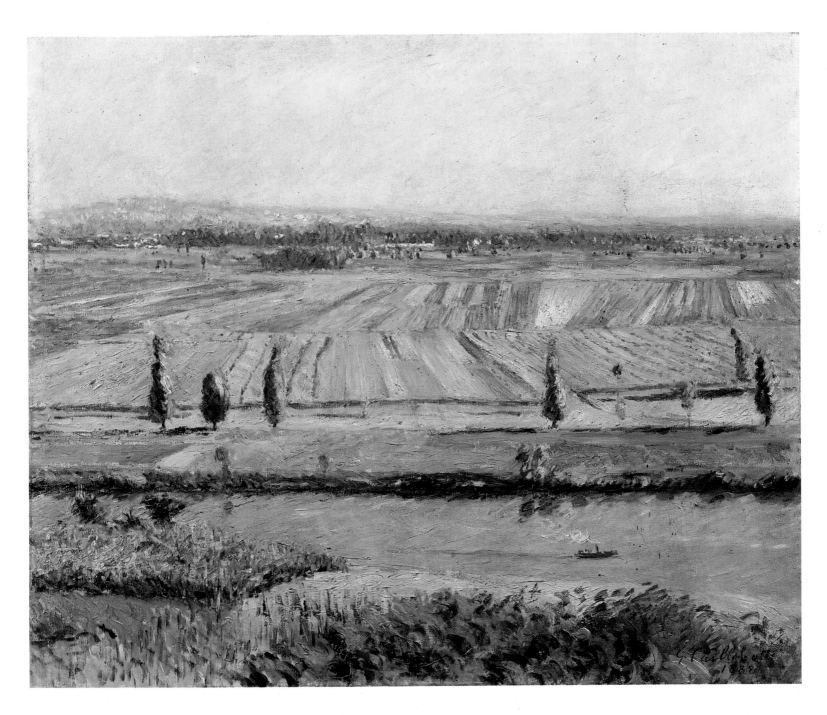

57. La Plaine de Gennevilliers vue des coteaux d'Argenteuil

(*The Gennevilliers Plain, seen from the slopes of Argenteuil*) 1888
Oil on canvas, 65.1 × 81.3 cm. (25⅝ × 32 in.)
Signed l.r. *G. Caillebotte 1888*
Private collection, Paris
Berhaut, 1978, No. 556

In his city views of the early 1880s, Caillebotte used elevated viewpoints to nullify space, looking downward in a way that excluded the horizon (Pls. 43 and 44). In this landscape, however, he seems to station himself above the scene for precisely the opposite reasons: to eliminate any obstruction to the sweep of space, and to make more regular and more prominent the distant horizon. The afternoon sun beats down on the yellow fields, which Caillebotte textures by following with his brush the irregular patterning of cultivation; the banded,

chevron-like pattern emphasizes the flatness of the fields, while only a few solitary trees, in one plane along the river bank, break the sunlight and the regular horizontality of the view.

The brightness of the fields, and their density of execution, draw our attention past the far more loosely conceived foreground, out over the river. Only one sign of activity intrudes: the boat chugging along at the lower right, its jarringly tiny scale serving to emphasize further the vast, placid emptiness of the space.

58. Les Dahlias, jardin du Petit-Gennevilliers

(*Dahlias, the garden at Petit-Gennevilliers*)
1893
Oil on canvas, 157 × 114 cm. (62 × 45 in.)
Signed l.l. *G. Caillebotte/1893*
Private collection, California
Berhaut, 1978, No. 443

This picture is a throwback. It represents in Caillebotte's art a resurgence of old ambitions and ways of working; and it shows in his life a retrieval of a sense of private pleasures that seemed to have departed after he lost the comforting world of his youth. After almost a decade largely given over to smaller, more informal landscapes and seascapes, Caillebotte showed a renewed interest, in the last year of his life, in painting large pictures of figures in landscape. He went about preparing these pictures in a way that looks back to his work of 1876–77; for this picture and the *Régates à Argenteuil* (Pl. 61) there exist preparatory drawings, gridded for enlargement, and smaller preparatory pictures of the scenes without the figures (Pl. 58c). The theme of the picture also has a retrospective air, bringing Caillebotte back to the realm of private pleasures that he celebrated in pictures like *Les Orangers* of 1878 (Pl. 25), but that seemed to vanish from his art with the death of his mother. The spatial organization also seems to leap back across the work of the 1880s, to correspond more closely with Caillebotte's early imagery. A dark, cool, enlarged foreground partially screens and sets off a brightly lit world beyond, suddenly distanced in its reduced scale.

As in some early pictures, the basic composition may stem from a camera image, either via a photograph or some other sort of optic device. The small preparatory drawing (Pl. 58a),

58c. *La maison de Gennevilliers*, 1893. Oil on canvas, 116.7 × 89.2 cm. (46 × 35⅛ in.). Collection of the Tri-Suburban Broadcasting Company, Columbia, Maryland. (Berhaut, 1978, No. 441)

in its absolutely exact, seemingly effortless delineation of the picture both in structure and detail, does not seem a freehand sketch but a transposition of a preformed image. The overlaid grid may have been the system of transcription, and certainly served as the system of enlargement by which the drawing became the composition on the canvas.

Though we have several still lifes of flowers from Caillebotte's hand, there are remarkably few images of the garden at Petit-Gennevilliers that was one of his major concerns in the final decade of his life. Much remains to be clarified about the exact exchanges between Caillebotte and Monet in regard to their gardens, but it seems certain they frequently shared information and ideas on the subject. Caillebotte's interest, like Monet's, was far from casual—as attested by the elaborate greenhouse whose side is visible in this view.

The theme underlying *Les Dahlias*, of a woman juxtaposed to and/or admiring flowers in a garden, was a favorite of Monet in his early work, especially in the early 1870s. In the context of the 1890s, beside the work of artists such as Gauguin, van Gogh, and others, and even beside the later work of Monet or Renoir, this image has a quiet sweetness that seems wholly anachronistic.

58a. Study for *La maison de Gennevilliers*. Pencil on laid paper, 24 × 31.4 cm. (9½ × 12⅓ in.) (size of framed image 15.5 × 12 cm. (6 × 4¾ in.).

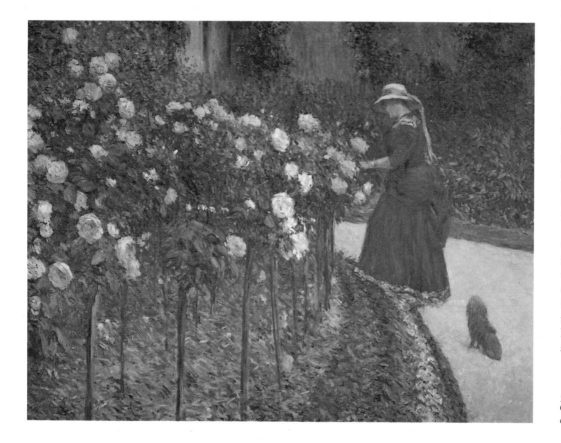

58b. *Le jardin à Petit-Gennevilliers—les roses*, c. 1886. Oil on canvas, 89 × 116 cm. (35 × 45⅝ in.). Private collection, Paris. (Berhaut, 1978, No. 314)

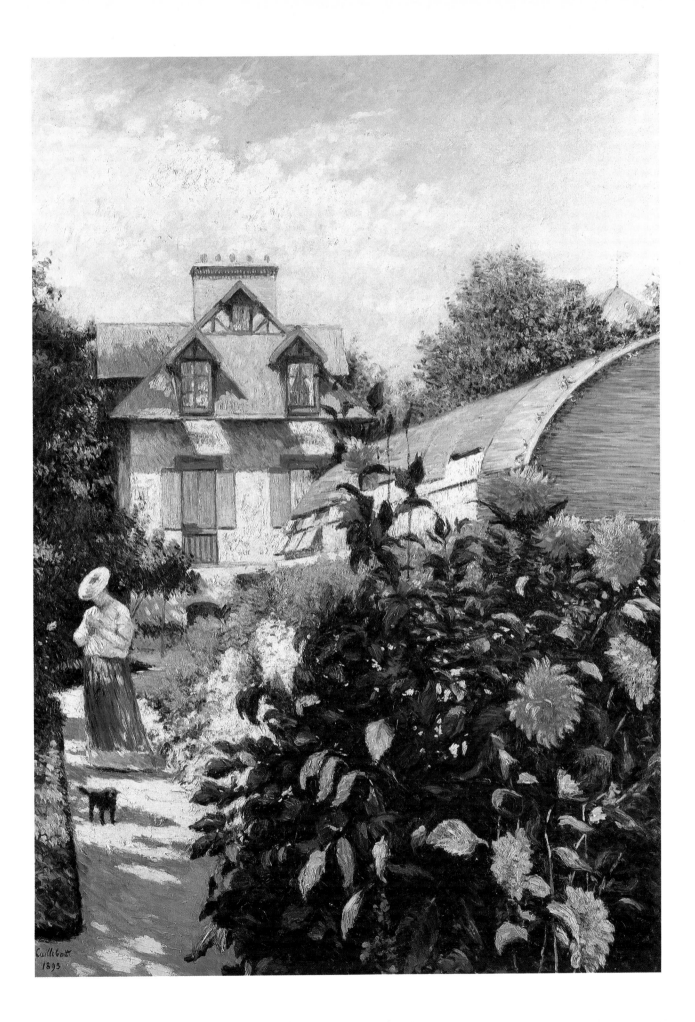

59. Chrysanthèmes blancs et jaunes, jardin du Petit-Gennevilliers

(White and yellow chrysanthemums, garden at Petit-Gennevilliers) 1893

Oil on canvas, 73 × 60 cm. (28¾ × 23⅝ in.)

Académie des Beaux-Arts, Musée Marmottan, Paris. Bequest of Michel Monet

Berhaut, 1978, No. 457

Along with other Caillebotte works such as the sketch for *Rue de Paris: Temps de pluie* (Pl. 18v), this flower still life belonged to Monet. It was an especially appropriate gift on Caillebotte's part, for he owned a superb still life of chrysanthemums by Monet (one of the paintings eventually rejected by France in the bequest settlement),[1] and the two men shared a love of gardening and a respect for things (such as this particular flower) associated with Japan. The linkage with Monet is even more interesting, though, in that this painting doubtless belongs to the work Caillebotte did toward a series of decorative panels of flowers and greenhouse scenes—a project that has affinities with Monet's own schemes, forming in the 1890s, for ensembles of decorative paintings based on his own garden.[2] In this picture and in another of the same subject (Pl. 60), the notion of a decorative panel may help to explain the shallow-field spatial organization and edge-to-edge even dispersal of the composition.[3]

The softly indistinct depth of the visual field, and the sensitive handling of the delicate structure and hues of the blooms set these late flower still lifes miles apart from Caillebotte's earlier still lifes, which were often marked by stricter rhythmic organization, sharply defined pattern, and a certain chilliness that could border on the macabre (see *Nature morte, poulets, gibiers à l'étalage*, Pl. 49).

59a. Doors with decorative inserts (oil on canvas) originally painted by Caillebotte for installation, in this fashion, on the doors of his dining-room in Petit-Gennevilliers. The uppermost panels, showing orchids in the painter's greenhouse, are 108 × 42 cm. (For the individual panels on this and the matching door, see Berhaut, 1978, Nos. 464–474). Private collection.

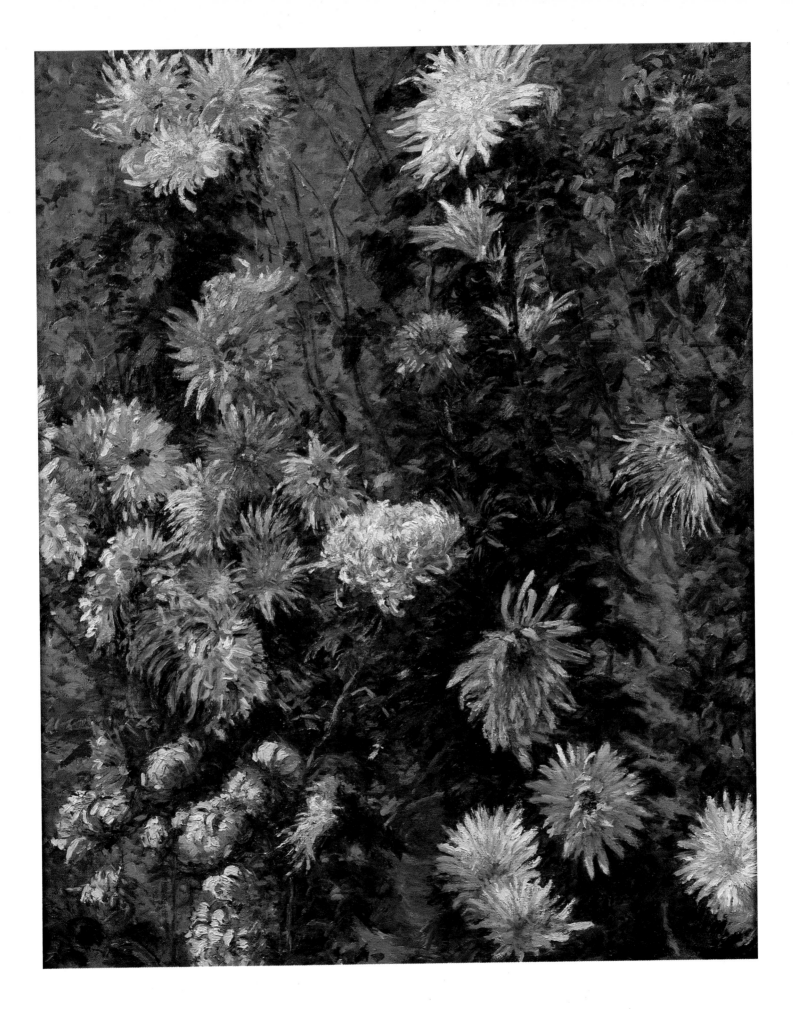

60. Massif de chrysanthèmes, jardin du Petit-Gennevilliers

(Clump of chrysanthemums, garden at Petit-Gennevilliers) 1893
Oil on canvas, 98 × 59.8 cm. (39 × 24⅛ in.)
Private collection, New York
Berhaut, 1978, No. 458

Like Pl. 59, this canvas is undoubtedly related to Caillebotte's project for a decorative scheme based on views of his greenhouse. Studying it, we are challenged to rethink our notions that the artist's primary penchant for linear composition generally balances a relative weakness in terms of brushy, painterly execution. Virtually spaceless, the picture depends heavily for its interest on its rich, subtly modulated surface. The unusual massing of the composition offsets a lower, relatively thinly executed field of green branches with a densely choked field of spidery blossoms, rendered in rich impasto of white-on-white, yellows, oranges, and reds.

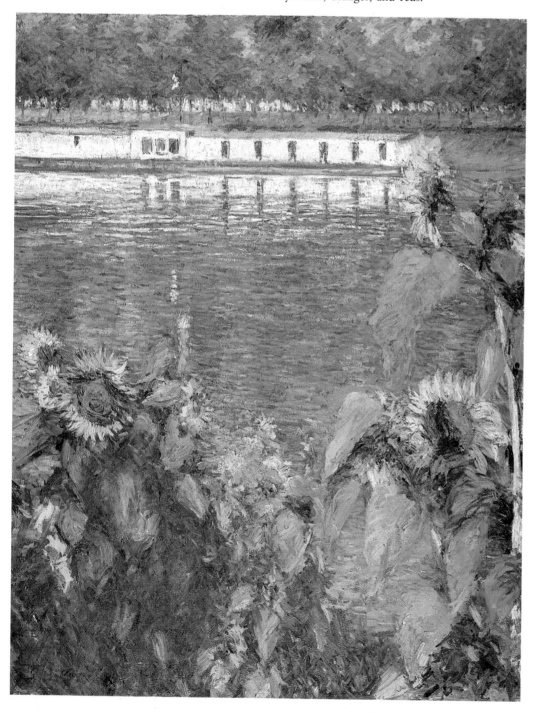

60a. *Soleils au bord de la Seine,* c. 1886. Oil on canvas, 92 × 73 cm. (36¼ × 28¾ in.). Private collection. (Berhaut, 1978, No. 311)

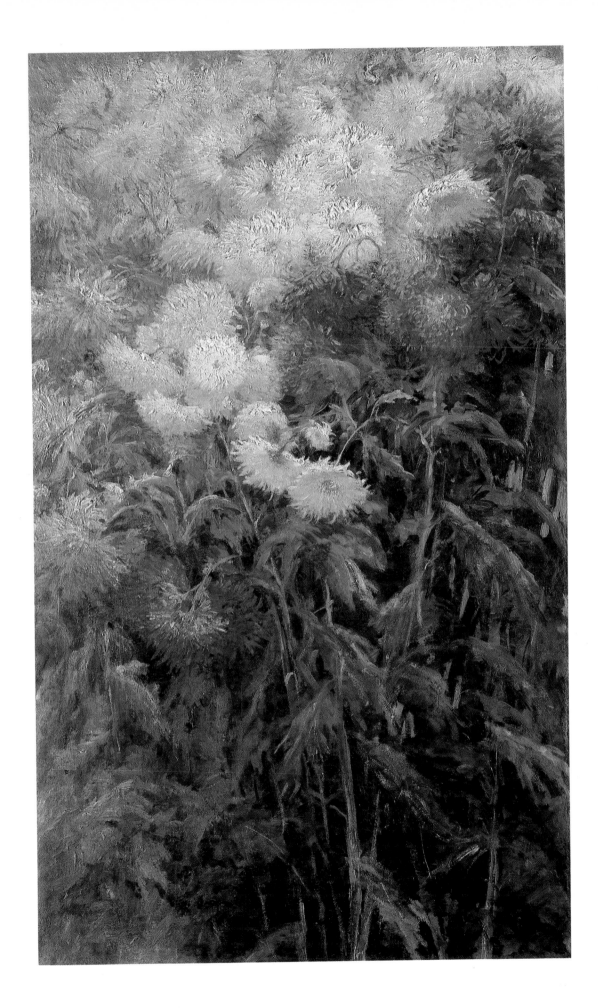

61. Régates à Argenteuil

(*Regattas at Argenteuil*) 1893
Oil on canvas, 157 × 117 cm. (62 × 46 in.)
Signed l.l. *G. Caillebotte/1893*
Private collection, Paris
Berhaut, 1978, No. 447

If we remove the large boat in the right foreground from this picture, the basic scene is quite close to several views of small sailboats at anchor painted by Monet in the boat-basin at Argenteuil in the 1870s. In the preparations for the painting, that basic scene was composed in a separate drawing, and the large boat—itself the subject of several drawn studies—was added at the last. The addition did not work; with discrepancies in scale and brushwork evident, the boat remains unintegrated into the larger setting.

Though awkward as a result of these problems, and not one of Caillebotte's most successful conceptions, the picture is painted with patient care, and is certainly one of the most ambitious of the artist's later years. It is almost identical in scale (about five by four feet) with *Les Dahlias*, its pendant mate in the depiction of Caillebotte's domestic and sporting life; together they signal a new desire, in the last year of Caillebotte's life, to paint large, solidly constructed pictures. Also, this sailing view revives a strategy not seen in Caillebotte's art since *Le pont de l'Europe* of 1876 (Pl. 15), as he places his own self-portrait prominently within the scene he depicts. The man at the tiller of the large boat is, as study drawings confirm, the painter himself.

61b. Study for *Régates à Argenteuil*: Man at tiller (self-portrait). 47.8 × 31.4 cm. (18¹³⁄₁₆ × 12⅜ in.).

61a. Study for *Régates à Argenteuil*: Boat, squared. 24.8 × 30½ cm. (9¾ × 12 in.) (detail of sheet).

61c. Study for *Régates à Argenteuil*: Man at tiller (self-portrait). 47.6 × 31.8 cm. (18¾ × 12½ in.).

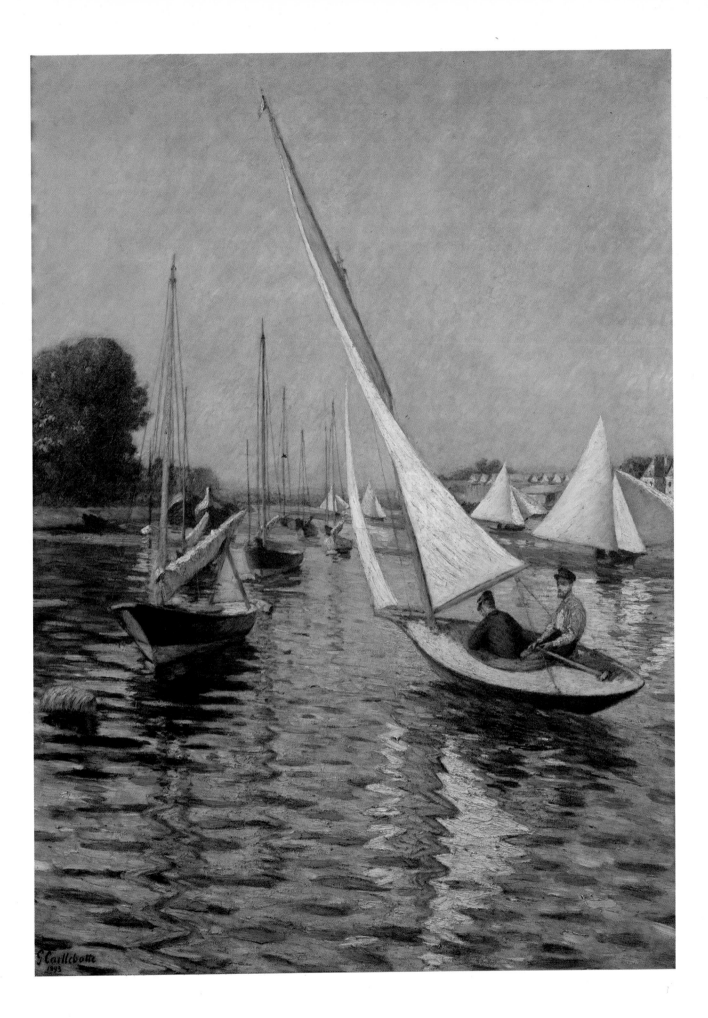

62. Autoportrait

(*Self-Portrait*) 1892
Oil on canvas, 40.5 × 32.5 cm. (16 × 12¾ in.)
Stamped l.l.
Musée d'Orsay
Berhaut, 1978, No. 411

Aside from those of the early Degas and of Cézanne, self-portraits by the Impressionist painters are rare, and usually not especially revealing. To the latter characterization, though, this small canvas makes an emphatic exception. When we call it a late self-portrait, we may almost forget how young Caillebotte was—only 45—when he died in 1894. We can be forgiven the error, for the mood here is decidedly un-youthful. The artist's pose is one of indirection and reserve; his gaze is oblique, and his features are set with seriousness. The shaping of the bust form emphasizes the severity of self-enclosure: in contrast to a superficially similar earlier self-portrait (Pl. 62a), Caillebotte now fixes his head upright with military rigidity, so that his frontal silhouette is flattened into a cliff-like verticall fall. The combination of intensity and almost defensive reserve is highly personal, and the casting of half of the face into shadow brings a distinct note of Romanticism to the presentation.[1]

62a. *Autoportrait*, c. 1888. Size and present location unknown.

62b. *Self-portrait*. 48.8 × 31.3 cm. (19¼ × 12 5/16 in.).

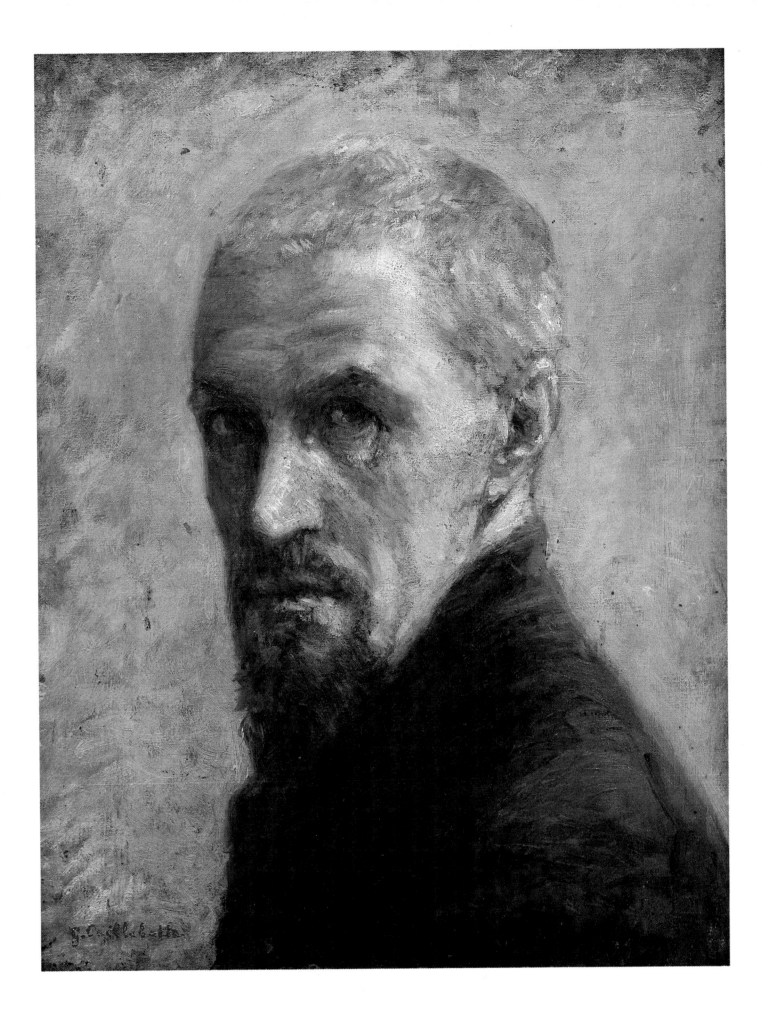

CHEZ MM. LES PEINTRES INDÉPENDANTS, PAR DRANER.

— Dans l'état où est madame, je crois de mon devoir de vous déconseiller d'entrer à notre exposition.

— Voilà déjà plusieurs fois que j'entends dire que cette toile aurait dû figurer au Salon.
— Nous aurions dû la refuser alors !

— Ne vous effrayez pas, monsieur, nous connaissons ça. Voici la boîte de secours.

Le veau (en est-ce bien un°) phéno-ménal. — Destiné au musée des antiquités anté-diluviennes.

— Ça peut être drôle pendant une heure, mais voir tout ça pendant sept heures, en v'là une rude corvée !

CHANTEUSE DE CAFÉ.
Unique occasion à 7 fr 50 la paire ! Huit boutons ! Quelle excellente enseigne pour un commerce de gants !

VUE DE TOITS.
Zinguerie sentimentale pleine de poésie. Inspirée de l'Assommoir.

— Mossieu! Vous vous êtes permis de rire en regardant mon portrait...
— C'est vrai; aussi je vous engage à envoyer vos témoins à votre peintre.

— Mais cet éventail ne représente rien du tout?
— Eh bien ! mais... et la signature ?

Ex-refusé, ci-devant réaliste, antérieurement impressionniste, intentionniste, luministe, actuellement nihiliste.

PAYSAGE A COURBEVOIE.
— Mais on ne voit que le milieu d'un arbre !...
— Dame ! si le sujet plaît, l'artiste peut le compléter en vendant deux autres toiles.

— Madame peut, avec ce mètre, mieux apprécier le relief de ma peinture; personne n'a encore atteint mes épaisseurs.

PARTIR DE BATEAU
... à vapeur.

FEMME DANS UNE LOGE.
Ne serait-elle pas mieux à l'amphithéâtre?

— Pour en apprécier le mérite, ces tableaux doivent être vus de loin.
— Certainement, et c'est pour cela que je m'en éloigne.

CANOTIERS.
Qu'est-ce qu'il peut bien faire?

L'artiste a pris soin de délayer du savon de Marseille dans son eau.

— Cette visite m'a fait une impression telle que mon mari me semble presque moins laid.

La morale de la chose.

Fig. 1. Page of caricatures from *Charivari*, 23 April 1879. The cow at upper right, the roof view upper center, and the three pictures at lower left are caricatures of Caillebotte's work. The oarsman at lower left, No. 7, is Pl. 20 in this book; the oarsman above this to the right with the smoke-stack hat is Pl. 21.

1

PORCHERON, EMILE
"Promenades d'un flâneur—Les Impression-istes," *Le Soleil*, 4 April 1876

. . . Dans la deuxième salle, arrêtons-nous devant les toiles de M. Caillebotte, les moins mauvaises de l'exposition. Une des missions que l'impressionisme semble s'être imposé, c'est de martyriser la perspective: vous voyez d'ici à quels résultats on peut atteindre.

Un monsieur touche du piano sur un Erard vu à vol d'oiseau, mais l'un des pieds de l'instrument manque et l'empêche d'être d'être [sic] d'aplomb. Deux toiles, représentant des *gratteurs de parquet*, sont par trop originales; dans l'une d'elles, un de ces messieurs a quitté son ouvrage pour se livrer sur sa personne à une chasse que la propreté rendrait inutile; c'est douteux comme goût.

Le *Déjeuner* est insensé, on n'y retrouve aucune des qualités que nous relevons plus haut; c'est le comble de l'impressionisme. Qu'on se figure le dessus d'un guéridon rond dans la nature, mais démesurément allongé par suite d'une perspective si mal entendue, que la table semble avoir au moins douze mètres de long; le cadre coupe en deux l'assiette d'un des trois convives et les deux autres personnages placés à l'extrémité du meuble sont tellement éloignés, qu'on ne les comprend plus.

In the second room, let us stop in front of the canvases of Monsieur Caillebotte, the least bad of the exhibition. One of the missions that Impressionism seems to have set for itself is to torture perspective: you see here what results can be attained.

A fellow plays the piano on an Erard seen from a bird's-eye view, but one of the feet of the instrument is missing, and this keeps it from being level. Two canvases, representing the *floor-scrapers*, are excessively original; in one of them,

one of the men has stopped his work in order to undertake on his person a hunt that cleanliness would have rendered unnecessary; this is in dubious taste.

The *Luncheon* is insane, one finds there none of the virtues we saw above; this is the height of Impressionism. Imagine the top of a table actually round but inordinately elongated by a perspective so misunderstood that the table seems to be at least twelve meters long; the frame cuts the plate of one of the three diners in two, and the other two people placed at the far end of the table are so far away that one no longer takes them in.

2

CHAUMELIN, MAURICE
"Actualités: L'Exposition des Impressionistes," *La Gazette (des Etrangers)*, 8 April 1876

Qui connait M. Caillebotte? D'où vient M. Caillebotte? A quelle école s'est formé M. Caillebotte? Personne n'a pu me renseigner. Tout ce que je sais, c'est que M. Caillebotte est un des peintres les plus originaux qui soient révélés depuis quelques années, et je ne crains pas de me compromettre en prédisant qu'il sera célèbre avant peu.

Dans ces *Raboteurs de parquet*, M. Caillebotte s'annonce comme un réaliste aussi cru, mais bien autrement spirituel que Courbet, aussi violent, mais bien autrement précis que Manet. Dans son *Jeune homme à la fenêtre* et dans son *Jeune homme jouant du piano*, il a peint ce qu'il y a de plus insaisissable, l'air, la lumière, avec une intensité et une justesse d'effet extraordinaires. Ces deux derniers tableaux m'ont rappelé Van der Meer, de Delft, et Pieter de Hooch, à qui Rembrandt avait enseigné l'art d'arrêter le soleil.

Si l'intransigeance consistait à peindre de cette façon, je conseillerais à notre jeune école de se faire intransigeante.

Who knows Monsieur Caillebotte? Where does Monsieur Caillebotte come from? In what school was Monsieur Caillebotte trained? Nobody has been able to inform me. All I know is that Monsieur Caillebotte is one of the most original painters who has come to light for several years, and I don't fear compromising myself by predicting that he will be famous before long.

In his *Floor-scrapers*, Monsieur Caillebotte shows himself a realist just as raw, but much more witty, than Courbet, just as violent, but altogether more precise, than Manet. In his *Young man at the window* and in his *Young man playing the piano*, he has painted what is the most impossible to capture, air, light, with an extraordinary intensity and an accuracy of effect. These latter two pictures reminded me of Vermeer of Delft and of Peter de Hooch, whom Rembrandt had taught how to stop the sun.

If intransigence consists of painting this way, I would advise our young school to become intransigent.

3

BLÉMONT, EMILE
"Les Impressionistes," *Le Rappel*, 9 April 1876

. . . M. Caillebotte est un nouveau venu qui sera le bien venu. Son "Jeune homme à la fenêtre," son "Jeune homme jouant au piano," ses "Raboteurs de parquet" sont d'une modernité frappante, et contiennent des parties fermement modelées. C'est étonnant de verité, de vie, d'intimité simple et fraîche. M. Caillebotte n'a pas été admis l'an dernier au jury avec un des tableaux qu'il nous montre. Un très mauvais point à MM. les jurés officiels!

Monsieur Caillebotte is a newcomer who will be welcome. His "Young man at the window," his "Young man playing the piano," his "Floor-

scrapers" are strikingly modern, and contain firmly modelled areas. They astound by their truth, their life, their simple and fresh intimacy. Monsieur Caillebotte was not admitted [to the Salon] by the jury last year with one of the pictures he shows us here. A very bad mark for the official jurors!

4

ENAULT, LOUIS
"Mouvement Artistique—L'Exposition des Intransigeants dans la Galerie de Durand-Ruel," *Le Constitutionnel*, 10 April 1876

Que M. Gustave Caillebotte sache son métier, c'est ce qu'il ne viendra à personne l'envie de contester. Il y a certainement un faire assez habile dans les deux tableaux qu'il vient de consacrer à la gloire de MM. les raboteurs de parquets, qui, peut-être, ne s'attendaient à tant d'honneur. Le sujet est vulgaire sans doute, mais nous comprenons pourtant qu'il puisse tenter un peintre. Tous ceux qui ont eu le plaisir ou l'ennui de faire bâtir connaissent la façon de travailler de ces robustes gaillards, qui mettent franchement de côté tout costume gênant, ne gardant du vêtement que sa partie la plus indispensable, et livrent ainsi à l'artiste désireux de faire une étude de nu, un torse et un buste que les autres corps de métiers n'exposent pas aussi librement.

Les raboteurs de M. Caillebotte sont certes point mal peints, et les effets de perspective ont été étudiés par un oeil qui voit juste. Je regrette seulement que l'artiste n'ait pas mieux choisi ses types, ou que, du moment où il acceptait ce que la réalité lui offrait, il ne se soit pas attribué le droit contre lequel je puis l'assurer que personne n'eut protesté, de les interpréter plus largement. Les bras de ses raboteurs sont trop maigres, et leurs poitrines trop étroites. Faites du nu, messieurs, si le nu vous convient; je ne suis pas bégueule, et je n'aurai point l'esprit assez mal fait pour le trouver mauvais. Mais que votre nu soit beau ou ne vous en mêlez pas!

Je ferai à peu près les mêmes observations au sujet du *Jeune homme qui regarde par la fenêtre*. Les objects materiels ne sont pas mal peints et l'artiste a eu surtout le mérite de bien les placer à leur plan. Mais n'est-ce point un assez piètre emploi de son temps, de sa couleur et de sa toile, que de les consacrer à peindre le dos d'un monsieur habillé d'un paletot de drap brun, acheté à la maison de confection qui est—ou qui n'est pas—au coin de la rue ou au coin du quai?

Le jeune homme jouant au piano m'inspire des craintes sérieuses. Cet élève de Marmontel est assis devant un magnifique Erard de grandes

dimensions, mais, soit que ce beau meuble palissandre ne soit pas suffisament calé, soit que les lois de la perspective auxquelles j'ai hâte de le dire, M. Caillebotte se montre ordinairement plus fidèle, n'aient pas été aussi strictement observées, l'instrument de musique menace de devenir un instrument de torture; on craint à chaque instant de le voir tomber sur ce bon jeune homme qui va être infailliblement écrasé. Il ne faut pas faire aux gens de ces peurs-là.

That Monsieur Caillebotte knows his profession, no one will want to dispute. There is certainly an adroit enough execution in the two pictures that he has just dedicated to the glory of the floor-planers, who, perhaps, were not expecting such an honor. The subject is surely vulgar, but we can understand how it might tempt a painter. All those who have had the pleasure or the bother of having a house built know the way these robust fellows work, unabashedly putting aside any encumbering outfit, leaving only the most indispensable clothing, and thus offering to the artist who wants to make a study of the nude, a torso and a bust that other trades do not expose as freely.

Monsieur Caillebotte's planers are certainly not at all badly painted, and the effects of perspective have been studied by an eye that sees correctly. I only regret that the artist did not choose his types better, or, once he accepted what reality offered him, that he did not give himself the right, which I can assure him no one would have denied him, to interpret them more freely. The arms of the planers are too thin, and their chests too narrow. Do the nude, gentlemen, if the nude suits you; I'm not prudish, and I won't be so wrong-headed as to find it bad. But may your nude be handsome or don't get involved with it!

I shall make roughly the same observations about the *Young man who looks out the window*. The material objects are not badly painted, and the artist places them especially well in their respective planes. But is it not a rather pitiful use of his time, his colors and his canvas, to dedicate them to painting the back of a man dressed in a coat of brown cloth, bought ready-made at the shop that is—or that is not—at the corner of the street or the corner of the quai?

The young man playing the piano arouses in me serious apprehensions. This student of Marmontel is seated before a magnificent Erard of huge size, but whether this beautiful piece of rose-wood furniture is not sufficiently propped up, or whether the laws of perspective, to which, I hasten to say, Monsieur Caillebotte normally

shows himself more faithful, have not been as strictly observed, the instrument of music threatens to become an instrument of torture; one fears to see it fall at any instant on this nice young man, who without a doubt will be crushed. One should not scare people like that.

5

RIVIÈRE, GEORGES
"Les Intransigeants de la Peinture," *L'Esprit Moderne*, 13 April 1876

M. Caillebotte est l'élève de M. Degas. Le *Canotier* à demi couché près d'une table, est son meilleur tableau; son *Jeune homme au piano* a de grandes qualités, ainsi que ses *Rabotteurs* [sic] *de parquet*, qui ont un cachet d'originalité incontestable. Dans le *Jeune homme à la fenêtre*, le fond qui represente le boulevard est d'un paysagiste de talent.

Monsieur Caillebotte is the student of Monsieur Degas. The *Boatsman* half reclining near a table is his best picture; his *Young man at the piano* has great merit, as well as his *Floor-scrapers*, which has the stamp of uncontestable originality. In the *Young man at the window*, the background showing the boulevard is by a landscape painter of talent.

6

BURTY, PHILIPPE
"Fine Art: The Exhibition of the Intransigeants," *The Academy*, 15 April 1876

A young man, Caillebotte by name, who makes his first appearance in this exhibition, has attracted a [great] deal of attention. His pictures are original in their composition, but, more than that, so energetic as to drawing that they resemble the early Florentines. These pictures would create a scandal in an official Salon amid the false and sinewless figures of the school, and we applaud the juries' wisdom in keeping them out. Here it is a different matter. Their success is fair and honest and due to their faithful representation of life as it expresses itself in the working functions, and of the members as they come to look when modified by the constant pursuit of some one particular occupation. M. Caillebotte has sent *Des racleurs de parquet*, joiners bare to the waist scraping the parquet floor of a room with iron blades. The drawing in his picture of a gentleman, seen from behind, standing at a window which looks on to the street is no less clever. He sends, besides, a portrait, marvelous in sincerity, of a pianist at her [sic] piano.

7

BERTALL

"Exposition des Impressionistes, Rue Lepeletier," *Le Soir*, April 1876

. . . M. Caillebotte, si remarquable par son profond mépris de la perspective, saurait très bien, s'il le voulait, faire de la perspective comme le premier venu. Mais son originalité y perdrait. Il ne fera pas cette faute. Dans son *Déjeuner*, ses *Gratteurs de parquet* et son *Jeune Pianiste*, l'intention est évidente; il sait bien que c'est ainsi qu'il fera son nom, et alors il pourra montrer qu'il a un certain talent, témoin le petit racleur de parquet, assis au fond de son tableau Nº 27.

Monsieur Caillebotte, so remarkable in his profound scorn for perspective, could, if he wanted to, handle perspective as well as anyone. But his originality would lose something thereby. He will not make this mistake. In his *Luncheon*, his *Floor-scrapers* and his *Young Pianist*, the intention is clear; he knows this is how he will make a name for himself, and then he can show that he has a certain talent, as is demonstrated by the little floor-scraper seated in the background of his picture No. 27.

8

ZOLA, EMILE

"Deux Expositions d'Art en Mai," *Le Messager de l'Europe*, June 1876

Caillebotte a exposé les *Raboteurs de parquet* et *Un jeune homme à sa fenêtre* d'un relief extraordinaire. Cependant c'est une peinture anti-artistique, une peinture proprette comme du verre, une peinture bourgeoise, en raison de la précision de la copie. La photographie de la réalité qui n'est pas marquée du sceau original du talent du peintre—c'est une piètre chose.

Caillebotte exhibited the *Floor-scrapers* and *A young man at his window*, which are of an extraordinary three-dimensionality. However, it is anti-artistic painting, painting as neat as glass, bourgeois painting, because of the exactitude of the copying. Photography of reality which is not stamped with the original seal of the painter's talent—that's a pitiful thing.

9

ANON

"L'Exposition des Impressionistes," *Le Temps*, 7 April 1877

Les toiles les plus remarquables sont, sans contredit, celles de M. Gustave Caillebotte, un millionaire qui fait de la peinture à ses moments perdus. Citons surtout deux immenses tableaux—tous deux trop uniformément gris, mais très bien dessinés.

L'un représente une *Vue* du pont de l'Europe. Le principal personnage est le peintre lui-même, causant de près avec une très jolie femme—encore un portrait sans doute. Nos compliments, Monsieur Caillebotte. . . . Vous deviez avoir, ce jour-là, des *impressions* gaies.

L'autre toile, c'est le carrefour formé par les rues de Turin et de Moscou, vu par un jour de pluie. Encore très bien dessiné. . . . Seulement, M. Caillebotte a oublié de représenter la pluie. Il parait que ce jour-là elle ne lui avait pas laissé d'impression.

The most remarkable canvases are, without argument, those of Monsieur Gustave Caillebotte, a millionaire who paints in his spare time. Two immense pictures should be especially mentioned—both too uniformly grey, but very well drawn.

One represents a *View* of the Europe bridge. The principal figure is the painter himself, chatting intimately with a very pretty woman—doubtless another portrait. Our compliments, Monsieur Caillebotte. . . . You must have had gay *impressions* that day.

The other canvas is the intersection formed by the rue de Turin and the rue de Moscou, seen on a rainy day. Again, very well drawn. . . . Only, Monsieur Caillebotte forgot to represent the rain. Apparently on that day it made no impression on him.

10

SEBILLOT, PAUL

"Exposition des Impressionistes," *Le Bien Public*, 7 April 1877

La *Rue de Paris* de M. Caillebotte offre des morceaux d'une réalité saisissante: les maisons sont bien observées et bien à leur plan, il y a de fines colorations dans la tête de la jeune femme et du monsieur qui se promènent sous leur parapluie; mais pourquoi ce réverbère qui étale juste au milieu du tableau sa désagréable perpendiculaire? pourquoi ce monsieur en gâteuse coupé juste par le milieu du corps par le cadre? Avec ce dédain de la composition et de la mise en toile, ce tableau, malgré d'incontestables qualités, étonne et n'émeut pas; cela donne l'idée de ce que sera la photographie quand on aura trouvé le moyen de reproduire les couleurs avec leur intensité et leur finesse.

The *Street in Paris* by Monsieur Caillebotte offers some areas of arresting reality: the houses are well observed and well set in their plane, there are fine colorations in the head of the young woman the gentleman who are strolling under their umbrella; but why this street lamp that displays its disagreeable perpendicular just in the center of the picture? And why this gentleman in his ample overcoat sliced right down the middle by the frame? With this disdain for composition and the placement on the canvas, this painting, despite incontestable qualities, astounds but does not stir us; this gives an idea of what photography will be like when the way is found to reproduce colors with their intensity and finesse.

11

LEPELLETIER, E.

"Les Impressionistes," *Le Radical*, 8 April 1877

L'oeuvre le plus saillante de l'exposition est la *Rue de Paris*, impression de pluie de M. Gustave Caillebotte. Il y a du talent et beaucoup de talent dans cette toile que la bizzarerie de certains détails et le heurté du rendu, n'empêcheraient point, selon moi, de figurer avec honneur à côté des tableaux consacrés par le suffrage du jury des Champs-Elysées.

C'est un carrefour spacieux, avec ses trottoirs et ses pavés lavés par les eaux du ciel, comme les mauvaises briques d'Amsterdam par les ménagères hollandaises. Chaque pavé se détache avec une précision inouïe. On peut les computer, les mesurer, les étudier en géologue, en chimiste, en géomètre et en paveur. Du premier coup, le défaut, le vice plutôt de l'impressionisme, nous saute aux yeux. C'est l'exagération du détail, c'est le grandissement de l'accessoire, c'est le soin, le toucher, la lumière, le talent de l'artiste concentrés sur les objets secondaires, c'est l'oeil du spectateur tiraillé en tous les sens par les choses de seconde importance et de troisième plan traitées et mises en avant comme les masses principales et les points capitaux de la composition. Le talent de l'artiste et l'attention du spectateur s'éparpillent également dans cette diffusion.

Continuons l'examen de la toile de M. Caillebotte: sur le pavé méticulieusement nettoyé et où j'ai peine à reconnaître mon vieux et toujours gras pavé parisien, plusieurs groupes circulent. Ils circulent réellement, car c'est le grand talent de M. Caillebotte de donner une intensité de vie extraordinaire à tous les personnages de sa composition. Il la distribue trop même, cette vie, puis qu'il en doue des objets qui en sont aussi dépourvus que des

parapluies ou des roues de voiture. . . . Deux figures au premier plan se détachent en pleine carté crue; un monsieur et une dame, costume moderne, physionomies contemporaines, abrités sous un parapluie qui semble décroché fraîchement des rayons du Louvre et du Bon Marché. Au deuxième plan, autre monsieur à parapluie, levant avec précaution le pied droit, s'appuyant du talon, et faisant seulement porter la pointe de pied gauche sur le pavé mouillé. Très vivante aussi cette figure. L'homme marche, et l'on sait sur le pantalon le jeu des muscles. Au fond de la toile s'ouvrent, profondes, des rues enfonçant leurs prolongements dans la ville.

L'air dans lequel se meuvent les personnages animés et inanimés de M. Caillebotte est lourd, gris, chargé de brumes ternes, L'impression de pluie cherchée par l'artiste est obtenue. La *Rue de Paris*, de M. Caillebotte, est un tableau d'une valeur artistique réelle et frappante. Tant pis pour ceux qui ne veulent voir qu'une tentative excentrique.

M. Caillebotte a exposé en outre, un *Pont de L'Europe*, où se retrouvent les défauts et les qualités de l'*Effet de pluie*. Un *Portrait de vieille femme*, et des *Peintres en batíment*, d'une touche bien grise et bien maussade, complètent l'exposition fort intéressante de M. Caillebotte.

The most outstanding work in the exhibition is the *Street in Paris*, an impression of rain by Monsieur Gustave Caillebotte. There is talent, and a lot of talent, in this canvas, which, in my opinion, would not be prevented at all by the bizarreness of certain details and the harshness of the rendering from appearing with honor beside the paintings consecrated by the vote of the jury of the Champs-Elysées.

It is a spacious intersection, with its sidewalks and paving-stones washed by the waters of the sky, like the old bricks of Amsterdam by the Dutch housewives. Each paving-stone stands out with an unheard-of precision. You can count them, measure them, study them as a geologist, as a chemist, as a geometer and as a paver. At once the failing, or rather the vice, of Impressionism leaps to our eyes. It is the exaggeration of detail, the enlargement of that which is accessory, it is the care, the touch, the light, the talent of the artist concentrated on secondary objects, it is the eye of the spectator pulled in all directions by things of secondary importance and of the tertiary plane treated and brought forward like the principal masses and the main items of the composition. The talent of the artist and the attention of the spectator are equally scattered about in this diffusion.

Let us continue the examination of Monsieur Caillebotte's canvas: on the meticulously clean paving stones, where I have difficulty in recognizing my old and always dirty Parisian pavement, several groups move about. They really move, because the great talent of Monsieur Caillebotte is to give an extraordinary intensity of life to all the people in his composition. He even distributes it too well, this life, as he endows with it objects as destitute of it as umbrellas and carriage-wheels. Two figures in the foreground stand out in harsh light: a gentleman and a lady, modern dress, contemporary physiognomies, sheltered under an umbrella that seems freshly taken from the racks of the Louvre [department store] and the Bon Marché. In the middle ground, another gentleman with an umbrella, carefully lifting his right foot, standing on the heel, and putting only the toes of the left foot on the wet pavement. Very lively this figure as well. The man walks, and you know the play of the muscles by the pants-legs. In the background of the canvas streets open up their continuations pushing deep into the city.

The air in which Monsieur Caillebotte's animate and inanimate figures move is heavy, grey, burdened with dull haze. The impression of rain sought by the artist is obtained. The *Street in Paris*, by Monsieur Caillebotte, is a picture of real and striking artistic value. So much the worse for those who want to see in it only an eccentric experiment.

Monsieur Caillebotte exhibited besides a *Europe Bridge*, in which can be found the same failings and virtues of the *Rain effect*. A *Portrait of an old lady*, and the *House-Painters*, in a very grey and very dull style, complete the very interesting showing of Monsieur Caillebotte.

12

Anon
"Le Jour et la nuit," *Le Monituer Universel*, 8 April 1877

M. Gustave Caillebotte expose un *Rue de Paris* (temps de pluie) dont les personnages nous ont fait l'impression des gens qui se promèneraient avec un parapluie ouvert une heure avant que l'averse soit déclarée. Une autre toile du même peintre représente la place de l'Europe avec son gigantesque pont de fer jetant sur l'asphalte blanche ses ombres bleuâtres. Nous aimons mieux ses *Portraits à la campagne*, beaucoup moins impressionistes sans doute, mais infiniment plus artistiques et infiniment plus vrais.

Monsieur Gustave Caillebotte exhibits a *Street in Paris* (rainy weather) whose figures gave us the impression of people who would walk around with their umbrellas open an hour before the storm broke. Another canvas by the same painter represents the Place de l'Europe with its gigantic iron bridge throwing its blue-tinted shadows on the white asphalt. We like his *Portraits in the country* better, a lot less Impressionist no doubt, but infinitely more artistic and infinitely more true.

13

Anon
"Exposition des Impressionistes," *La Petite République Française*, 10 April 1877

M. Caillebotte n'est impressioniste que de nom. Il sait dessiner et peint plus sérieusement que ses confrères. *Le Pont de L'Europe* et *Une Rue de Paris, par un jour de pluie*—ce dernier eût gagné à avoir des proportions moindres—méritent tous les éloges de la critique.

Monsieur Caillebotte is an Impressionist in name only. He knows how to draw and paints more seriously than his colleagues. The *Europe Bridge* and *A Street in Paris, on a rainy day*—this latter might have profited by being smaller—deserve all the praises of the critics.

14

De Lora, Léon
"L'Exposition des Impressionistes," *Le Gaulois*, 10 April 1877

Parlons de M. Caillebotte. La singulière idée qu'il a eue de peindre un coin de rue par un jour de pluie, avec des personnages de grandeur naturelle! Des hommes en paletot; des couples bruns se tenant bras dessus, bras dessous, cheminent sous des parapluies. La toile est trop grande; l'aspect, triste et ennuyeux. M. de Nittis, traitant le même sujet, eût produit un petit tableau très agréable: M. Caillebotte, plus ambitieux, en produit un démesuré, où toutes les qualités qu'il peut avoir sont délayées. Il est heureux qu'il ait daigné d'exposer à côté, parmi cinq ou six autres oeuvres, le portrait de Mme. C. . . ., une vieille dame à cheveux gris, absorbée dans sa broderie, qui est, sinon très bien peint, du moins très vivant.

Let us talk about Monsieur Caillebotte. The singular idea he had of painting a street corner on a rainy day, with life-size figures: men in jackets; couples in brown, arm in arm, moving along

under umbrellas. The canvas is too big, and its appearance sad and boring. Monsieur De Nittis, dealing with the same subject, might have produced a very agreeable little picture: Monsieur Caillebotte, more ambitious, produces an inordinate one, where all the good qualities he may have are diluted. It is fortunate that he deigned to exhibit beside this, among five or six other works, the portrait of Madame C. . . ., an old lady with grey hair, absorbed in her embroidery, who is, if not very well painted, at least very much alive.

15

JACQUES
"Menu Propos," *L'Homme Libre*, 12 April 1877

La *Rue de Paris par un temps de pluie*, de M. Caillebotte, déroute toutes les traditions. Des maisons bien bâties, somptueuses, sans effet de tuiles anciennes ni de mousses, avançant, en une saillie hardie, leur angle sur un pavé lavé, net, mesuré avec une patience—qui me choque un peu—et là des promeneurs hâtis, en habits modernes—que dis-je à la dernière mode—se pressent sous leurs parapluies ruisselants. Le groupe du premier plan me parait un peu grandi, étant posé le rapprochement de l'horizon. Les personnages—la femme exceptée—ont quelques mollesses et manquent peut-être de la distinction voulue. Mais les comparées de la perspective sont si alertes, si complètes, ils ont un tel diable au corps, tout ce monde se meut si aisément, par le vaste carrefour, dans une tonalité grise, savamment mouillée, que je ne me sens pas le courage d'accabler les acteurs principaux.

Néanmoins, je préfère cent fois le *Pont de L'Europe*, dont la composition, sobre, offre plus de vérité en même temps que plus de grâce. Le ciel est d'un azur, le temps clair accuse les ombres doucement, et sur l'espace immense, qui court jusqu'à la Trinité, qu'on devine, deux silhouettes particulièrement se dessinent: un jeune oisif, précédant une élégante, exquise sous la transparence de son voile moucheté: petite comédie commune, que nous avons tous observée, avec un sourire discret et bienveillant. La figure de l'ouvrier, accoudé sur le balustrade, est audacieuse; elle coupe l'action. Cependant, elle est une nécessité. Le peintre ne pouvait laisser tout le devant de sa toile complètement vide. C'est du tact que de l'avoir compris.

Les *Portraits à la Campagne*: toute une famille, mère, fille, grand-mère, amie, cousant ou tapissant honnêtement auprès du pavillon blanc, dont les fenêtres entr'ouvertes envoient des bouffées de parfums bourgeois, sont d'un achevé

qui m'effraie légèrement. Sur le côté, les tilleuls, heureusement symétriques, se perdent, ombrageant des corbeilles fleuries, où les couleurs crûment rouges des pelargoniums, bordés d'herbes, ressortent en répandant comme une clarté gaie derrière ce recueillement terne de provinciales ennuyées.

The *Street in Paris in rainy weather*, by Monsieur Caillebotte, throws off all traditions. Well-built, sumptuous houses, without the effects of old tiles or moss, their corners jutting forward in a brazen sally, on to a pavement that is washed, clean, measured with a patience—which shocks me a little—and there, people hurrying, in modern garb—what am I saying, the latest fashion—press on under their dripping umbrellas. The group in the foreground seems to me a little enlarged, given the nearness of the horizon. The figures—the woman excepted—have a few areas of softness and perhaps lack the desired distinction. But the comparatives of the perspective are so alert, so complete, they have such life in them, everybody here moves around so easily, on the vast intersection, in a grey tonality, skillfully dampened, that I don't have the heart to bear down on the main actors.

Nevertheless, I prefer a hundred times more the *Europe Bridge*, whose sober composition offers more truth and at the same time more grace. The sky is azure, the clear weather accents the shadows softly, and in the immense space, which one imagines going as far as the Trinité, two silhouettes stand out particularly: a young idler preceding an elegant lady, exquisite under the transparency of a speckled veil; a common little comedy that we have all observed, with a discreet and benevolent smile. The figure of the worker, leaning on the balustrade, is audacious; it cuts the action. However, it is a necessity. The painter could not leave the whole foreground of his canvas completely empty. It shows tact to have recognized that.

The *Portraits in the Country*: a whole family, mother, daughter, grandmother, friend, sewing or weaving near a white villa, whose half-open windows send out puffs of bourgeois fragrance, done with a degree of finish that frightens me a little. On the side, the linden trees, happily symmetrical, become lost, shading flower-beds, where the harshly red colors of the geraniums, edged with grass, spring out, offsetting with cheerful light this dull meditation of bored provincial ladies.

SCHOP, BARON
"La Semaine Parisienne," *Le National*, 13 April 1877

Il y a dans l'école des Batignolles, comme dans toutes les écoles, deux catégories de peintres: ceux qui ont du talent, comme MM. Caillebotte, Renoir, Degas, par exemple, et ceux qui n'en ont pas encore, comme MM. Cézanne, Pissarro, etc., sans compter ceux qui n'en auront jamais; mais on peut dire, sans calomnier le jury ni le public, que, dans le grande salle du palais de L'Industrie, M. Pissaro et M. Caillebotte risqueraient de passer également inaperçus, les défauts prétentieux de l'un et les qualités réelles de l'autre n'ayant pas, après tout, un relief considérable, tandis que rue Le Peletier, dans la petite chapelle du cénacle, le public est forcé de tomber en arrêt devant les personnages, grandeur nature, de M. Caillebotte ou devant les paysages extraordinaires de M. Cézanne.

. . . Il reste encore deux ou trois peintres—M. Caillebotte, M. Renoir, peut-être M. Degas—assez complets, s'ils ne mutilaient pas eux-mêmes leurs qualités. Ceux-là sont l'honneur du cénacle, mais ils n'y tiennent que par des liens bien faibles. Tôt ou tard, ils aboutiront au Salon officiel et ils se soumettront au jury comme M. Manet.

There are in the Batignolles school, as in all schools, two categories of painters: those who have some talent, like Messrs. Caillebotte, Renoir, and Degas, for example, and those who do not yet have any, like Messrs. Cézanne, Pissarro, etc., without counting those who never will have any; but we can say, without slandering the jury or the public, that, in the large hall of the Palace of Industry, Monsieur Pissarro and Monsieur Caillebotte would risk passing equally unnoticed, the pretentious failings of the one and the real qualities of the other not, after all, standing out very much, whereas in the rue Le Peletier, in the little chapel of the coterie, the public is forced to halt before the life-size figures of Monsieur Caillebotte or before the extraordinary landscapes of Monsieur Cézanne.

. . . There remain still two or three painters—Monsieur Caillebotte, Monsieur Renoir, perhaps Monsieur Degas—rather accomplished, if they did not mutilate their good qualities themselves. Those are the honor of the group, but they are attached to it only by very weak bonds. Sooner or later, they will wind up in the official Salon and they will submit themselves to the jury like Monsieur Manet.

17

BALLU, ROGER

"L'Exposition des Peintres Impressionistes," *Chronique des Arts et de la curiosité,* 14 April 1877

Est-il impressioniste, par exemple, M. Caillebotte, dans sa grande toile intitulée: *Rue de Paris— Temps de pluie?* Les parapluies ouverts sont tous d'une teinte uniformément argentée. La pluie ne se fait voir nulle part; le peintre n'a pas su rendre cette sorte de brouillard que forment les gouttes en tombant; part contre, il y a une certaine main qui donne l'impression d'un dessin bien pauvre. Il est facile de voir en outre que M. Caillebotte considère la composition d'un tableau comme affaire indigne de lui: ses personnages sont groupées au hasard, le cadre coupe en deux, de la tête aux pieds, une figure d'homme vue de dos. Dans les *Portraits à la campagne,* je signale un joli fond éclairé de soleil, certaines notes justes; mais le premier plan n'est pas d'aplomb, et les robes ne portent pas sur le sol. Je passe sous silence les autres toiles de M. Caillebotte qui toutes sont froides, grises, monotones! L'éclat manque partout; la teinte générale de cette peinture est celle de l'ardoise.

Is he an Impressionist, for example, Monsieur Caillebotte, in his large canvas entitled *Street in Paris—Rainy weather?* The umbrellas are all of a uniformly silvered tint. The rain is visible nowhere; the painter did not know how to render that sort of mist that the drops form in falling; by contrast, there is a certain hand that gives the impression of very poor drawing. It is easy to see furthermore, that Monsieur Caillebotte considers the composition of a picture as a business unworthy of him: his people are grouped by chance, the frame cuts in two, from head to toe, a figure of a man seen from the back. In the *Portraits in the country,* I point out a pretty background, lit by the sun, and certain correct notes; but the foreground is not level, and the dresses don't sit right on the ground. I pass over in silence the other canvases by Monsieur Caillebotte, which are all cold, grey, monotonous! Sparkle is lacking throughout; the general tone of this painting is that of slate.

18

RIVIÈRE, GEORGES

"L'Exposition des Impressionistes," *L'Impressioniste,* 14 April 1877

. . . Mais M. Sisley ne soulève pas de tempêtes, c'est un privilégié. M. Caillebotte est moins heureux sous ce rapport, il est bien peu d'absurdités qui n'aient été dites sur son compte. Un critique a écrit que, dans le "Temps de Pluie," tout y était excepté la pluie, qu'on ne voyait pas tomber; c'est plein de naiveté. Le même monsieur, je crois, est exaspéré à la vue d'un petit chien qui passe sur le "Pont de l'Europe."

M. Caillebotte a cependant des grandes qualités et ne fait pas ce que les critiques aveugles appellent "une débauche de couleurs." Serait-ce donc qu'on critique tout de parti pris? On n'a pas voulu voir dans M. Caillebotte le dessin noble, simple, très sincère et très réaliste qui est la première de ses qualités. On n'a pas voulu y voir non plus la recherche d'atmosphère et de lumière, recherche qui, j'en conviens, arrive peut-être à une légère décoloration, mais ne se rapproche pas moins de la vérité.

Dans le "Pont de l'Europe" il y a des grandes qualités et une heureuse disposition du sujet dans la toile. Les personnages sont dessinés d'une façon très intelligente et très amusante. Le "Temps de Pluie" est un effort considérable, dont on ne tient pas suffisament compte. Ceux qui ont critiqué ce tableau n'ont pas songé combien il était difficile et quelle science était nécessaire pour mener à bien une toile de cette dimension.

M. Caillebotte expose un portrait remarquable, d'un dessin très correct et d'une couleur agréable. Les mains surtout sont très belles comme dessin et comme peinture; il y a dans ce portrait un calme plein de charme. Citons encore un tableau de petite dimension, des peintres en batîment, et un autre ("Portraits dans un jardin"), ce dernier très juste de tons et d'une perspective bizarre, quoique vraie. Pour un homme qui fait de la peinture à ses moments perdus, comme le disait un critique, ce n'est pas mal faire. Mais M. Caillebotte n'en restera pas là, il perdra encore quelque moments pour l'exposition prochaine, espérons-le.

But Monsieur Sisley does not raise storms, he is privileged. Monsieur Caillebotte is less fortunate in this regard; there are few absurdities that have not been uttered on his account. One critic wrote that, in the "Rainy Weather," everything was there except the rain, which one could not see falling; that is certainly naive. The same gentleman, I believe, is exasperated at the sight of a little dog that passes by on the "Europe Bridge."

Monsieur Caillebotte has nonetheless great virtues and does not paint what blind critics call "a debauchery of colors." Could it be that they critize everything from prejudice? They have not wanted to see in Monsieur Caillebotte the noble, simple, very sincere and very realist draftmanship that is the first of his qualities. They have not wanted to see either the investigation of atmosphere and light, investigation that, I agree, results perhaps in a slight discoloration, but which gets no less close to the truth for that.

In the "Europe Bridge" there are great qualities and a pleasing disposition of the subject on the canvas. The figures are drawn in a very intelligent and very amusing way. The "Rainy Weather" is a considerable effort, a fact they do not take sufficiently into account. Those who have criticized the picture have not dreamed how difficult it was, and what skill was necessary to bring off a canvas of this size.

Monsieur Caillebotte exhibits a remarkable portrait, with very correct drawing and agreeable color. The hands especially are beautiful in their draftsmanship and in their painting; there is in this portrait a calm that is full of charm. Let us cite another picture of small size, the house-painters, and another ("Portraits in a garden"), the latter very accurate in tones and with a perspective that is bizarre, though true. For a man who paints in his spare time, as a critic said, that's not doing badly. But Monsieur Caillebotte will not stop there, he will spare a little more time for the next exhibition, let us hope.

19

ZOLA, EMILE

"Une Exposition: Les Peintres Impressionistes," *Le Semaphore de Marseille,* 19 April 1877

Enfin, je nommerai Monsieur Caillebotte, un jeune peintre du plus beau courage et qui ne recule pas devant les sujets modernes grandeur nature. Sa *Rue de Paris par un temps de pluie* montre des passants, surtout un monsieur et une dame au premier plan qui sont d'une belle vérité. Lorsque son talent se sera un peau assoupli encore, Monsieur Caillebotte sera certainement un des plus hardis du groupe.

Finally, I will mention Monsieur Caillebotte, a young painter of the most noble courage, and one who does not shrink from modern subjects in life size. His *Paris street in rainy weather* shows passers-by, especially a gentleman and a lady in the foreground who have a fine truth. When his talent loosens up a little more, Monsieur Caillebotte will certainly be one of the boldest of the group.

MANTZ, PAUL
"L'Exposition des peintres impressionistes," *Le Temps*, 22 April 1877

Les oeuvres de M. Gustave Caillebotte promettent un peintre qui pourra devenir intéressant. Il n'est pas aussi révolté qu'il l'imagine, car il cherche la lumière exacte, et c'est là une ambition qui le sauvera. Lors de l'exposition organisée l'année dernière dans les salons de M. Durand-Ruel, il s'est révélé par un tableau, dont les gens difficiles ont pu sourire, et qui avait cependant de la vigueur. Rien d'héroïque dans cette composition d'un réalisme sans mélange. Il s'agissait de deux ouvriers qui, le torse nu, les bras inondés de sueur, rabotaient péniblement le parquet d'une chambre. La perspective était un peu folle, car, au lieu de travailler sur un plan horizontal, les malheureux manoeuvraient sur un parquet incliné et menaçaient de glisser sur le spectateur inoffensif. Mais les figures étaient bien dans la lumière; le pinceau s'annonçait énergique, et, dans sa grossièreté apparente, la peinture avait des finesses.

M. Caillebotte n'a pas appris la perspective. Les femmes qu'il a groupées dans ses *Portraits à la campagne* sont assises sur un terrain montant qui n'est pas fait pour rassurer le regard. Les verdures de fond viennent trop en avant. Mais ces gaucheries ne sont pas le résultat d'un système, et M. Caillebotte a parfois des sagesses qui, à l'exposition de la rue Le Peletier, doivent passer pour des concessions. Les *Peintres en bâtiment*, le *Temps de pluie* sont de curieux aspects du paysage parisien. M. Caillebotte réduit le plus possible la part de l'idéal; il croit aux pavés boueux, aux parapluies mouillés, aux bottines déshonorés par les éclaboussures. Mais ses coins des rues sont observés avec soin et suffisament justes dans leur effet de lumière voilée. Il semble pourtant que M. Caillebotte pourrait avoir, ça et la, plus de courage; il éteint un peu trop les tonalités locales dans une grande harmonie d'un gris d'ardoise, qui a de la douceur, mais qui n'est pas tout à fait authentique.

The works by Monsieur Gustave Caillebotte announce a painter who could become interesting. He is not as rebellious as he imagines, because he seeks exact light, and that is an ambition that will save him. At the time of the exhibition organized last year in the salons of Durand-Ruel, he showed what he could do with a picture at which difficult people could smile, but which nonetheless had vigor. Nothing heroic in this composition of unadulterated realism. It was a matter of two workers who, bare-chested, arms drenched in sweat, laboriously planed the floor of a room. The perspective was a little crazy, because, instead of working on a horizontal plane, these unfortunates did their work on an inclined floor and threatened to slide out onto the innocent spectator. But the figures were well set in the light; the brushwork gave evidence of energy, and, in its apparent crudeness, the painting had some moments of finesse.

Monsieur Caillebotte has not learned perspective. The women that he grouped together in his *Portraits in the country* are seated on a rising ground not reassuring for the onlooker. The greenery in the background comes too far forward. But these ineptitudes are not the result of a system, and Monsieur Caillebotte sometimes has moments of intelligence that, at the exhibition of the rue Le Peletier, must be considered concessions. The *House-painters* and the *Rainy weather* are curious aspects of the Parisian landscape. Monsieur Caillebotte reduces as much as possible the role of the ideal; he believes in muddy paving-stones, wet umbrellas, and boots disgraced by splattering. But his street corners are observed with care and are sufficiently correct in their effect of veiled light. It seems however, that Monsieur Caillebotte could have, here and there, more spirit; he mutes the local tones a little too much in a large harmony of slate grey, which has a softness, but which is not completely authentic.

BURTY, PHILIPPE
"L'Exposition des Impressionistes," *La République Française*, 25 April 1877

M. Caillebotte s'est signalé, l'année dernière, par des *Racleurs de parquet*, qui témoignaient d'une curiosité, rare aujourd'hui, des types et des occupations strictement professionels. Nous le retrouvons le même dans se *Peintres en bâtiment*. Son *Pont de l'Europe*, son *Temps de pluie*, animés par des personnages grandeur de nature, ont l'inconvénient de provoquer la traduction de parapluies grands comme nature. C'est trop épique pour la peinture de chevalet. Le portrait d'une dame âgée, la mère de l'artiste je crois, est une étude intelligente, serrée, sentie. Elle eut suffi pour mériter au Salon une médaille à ce jeune peintre dont l'avenir est certain.

Monsieur Caillebotte made himself known last year by *Floor-scrapers*, which demonstrated a curiosity, rare these days, about strictly professional types and occupations. We find that same interest in his *House-painters*. His *Europe Bridge*, his *Rainy weather*, enlivened by life-size figures, have the disadvantage of also calling for the rendering of umbrellas as large as life. It is too epic for easel painting. The portrait of an old lady, the artist's mother I believe, is an intelligent study, tight, with feeling. It would have been enough to earn a medal at the Salon for this young painter whose future is certain.

CHEVALIER, FRÉDÉRIC
"Les Impressionistes," *L'Artiste*, 1 May 1877

Le Pont de L'Europe, par M. Caillebotte, est froid. Son carrefour par la pluie est mou et lourd. Mais ses portraits à la campagne offrent de sérieuses qualités d'effet, de ton, et de ligne. L'air circule transparent dans la demi-teinte qui enveloppe les figures, et le jardin, bariolé de geraniums, s'enfonce au loin sous le soleil. L'exécution calme et précise de M. Caillebotte fait de lui un réaliste plutôt qu'un intransigeant.

The *Europe Bridge* by Monsieur Caillebotte is cold. His intersection in the rain is soft and heavy. But his portraits in the country offer serious qualities of effect, of tone, and of line. The air circulates transparent in the half-tint that envelopes the figures, and the garden, gaudy with geraniums, continues far into the distance under the sun. The calm and precise execution of Monsieur Caillebotte makes him a realist rather than an intransigent.

PROTH, MARIO
Voyage au Pays des peintres—Salon de 1877, Paris, Vaton, 1877 (p. 8)

Et puis quelle drôle d'idée ont-ils tous de couper ainsi brusquement leurs sujets, leurs scènes à moitié des corps d'une femme ou d'un homme, à moitié d'un cheval ou d'une voiture, et ainsi de suite. Il ne manquait pas cela aux élaborations de M. Caillebotte pour les faire ressembler à des photographies instantanées, à des photochromies jouant assez adroitement la peinture. Ainsi que M. Caillebotte, M. Sisley pourrait mieux faire que de l'impressionisme.

And then what a strange idea they all have, to crop subjects abruptly in this way, cutting their scenes in the middle of the body of a woman or a man, half-way across a horse or a carriage, and so on. The elaborations of Monsieur Caillebotte did

not need that to make them look like snapshots, like photo-chromes playing cleverly at being paintings. Like Monsieur Caillebotte, Monsieur Sisley could do better than Impressionism.

24

Besson, Louis
"Mm. Les Impressionistes," *L'Evénement*, 11 April 1879

Les vingt-cinq toiles "portraits", "parties de canots", "vue de toits", etc. de M. Caillebotte sont inénarrables. Il y a surtout un veau phénomène qui attirerait sur l'oeil du spectateur les larmes que cet intéressant quadrupède doit tenir en réserve, si le fou rire ne dilatait pas outre mesure la rate dudit spectateur.

The twenty-five canvases ("portraits," "canoeing parties," "roof views," etc.) of Monsieur Caillebotte are unspeakable. There is above all a phenomenal calf that would bring to the eyes of the viewer the tears that interesting quadraped must hold back, if wild laughter wasn't dilating the spleen of that viewer beyond reckoning.

25

Leroy, Louis
"Beaux Arts," 17 April 1879

... avec quel dédain de la forme M. Caillebotte a traité le mufle de certaine génisse au pâturage et la tête de la chèvre, sa compagne: l'un, allongé indéfiniment, a l'air d'avoir été passé au laminoir; l'autre ... n'a l'air de rien du tout. Ce qui est pousser l'indépendance trop loin.

De même: un jeune homme lie de vin assis sur un divan bleu. En contemplant ce portrait, égratigné avec tant de soin, je regrette, hélas! l'aimable indécision de la chèvre précitée: un impressioniste qui pignoche est un homme perdu!

Parlez-moi des luisants blanchâtres prodigués sur l'eau du N° 25! Ces barbouillages triomphants chantent à pleine touche le *Ça ira* de la jeune école.

Beaucoup d'indépendance aussi dans la rivière N° 13: ses ondes gazonnées ont la fraîcheur et la solidité d'une verte prairie avant la fenaison; et ce qui ajoute encore à son agrément, c'est que deux canotiers la labourent sans fatigue apparente avec leurs avirons. De rudes gars pour naviguer ainsi sur l'herbette!

Murger a chanté autrefois la *Symphonie du bleu*. M. Caillebotte l'exécute mieux que personne. Tout est bleu chez lui. Ce qu'il dépense en cobalt, en outremer, en indigo de blan-

chisseuse, est effrayant à penser. Jamais l'azur n'a été prodigué sur une toile avec cette profusion! Si ses rêves sont de cette couleur-là, il doit se voir à l'Institut, décoré, accablé de commandes et détrônant M. Manet dans un avenir très prochain.

... with what disdain for form Monsieur Caillebotte has treated the muzzle of a certain heifer at pasture and the head of the goat, her companion: the one, indefinitely elongated, looks as though it has been put through a rolling mill; the other ... looks like nothing at all. Which is pushing independence too far.

By the same token: a purplish-red young man seated on a blue divan. Contemplating this portrait, scratched with so much care, I regret, alas! the amiable indecision of the aforementioned goat: an Impressionist who paints with tiny strokes is a lost man!

Speak to me about the blue-tinted glimmerings lavished on the water of No. 25. These triumphant daubings sing with thundering touch the *Ça ira* [part of the refrain of a Revolutionary song, signifying "We shall win"] of the young school.

A lot of independence, too, in the river of No. 13: these grassy waters have the freshness and solidity of a green prairie before haytime; and what adds still further to its appeal is that two oarsmen plough through it, without apparent fatigue, with their oars. Tough guys to navigate thus on the greensward!

Murger some time ago sang the *Symphony of blue*. Caillebotte executes it better than anyone. Everything is blue with him. What he spends in cobalt, ultramarine, and washing-woman's indigo, is frightening to contemplate. Never has azure been lavished on a canvas with such profusion! If his dreams are that color, he must see himself at the Institute, decorated, weighed down with commissions and dethroning Manet in the very near future.

26

Montjoyeux, Jules Poignard
"Chroniques Parisiennes: Les indépendants," *Le Gaulois*, 18 April 1879

... Les noms de MM. Degas et Monet ne sont plus inconnus pour quiconque suit, de près ou de loin, le mouvement artistique contemporain. A coté, ceux de MM. Caillebotte et Pizzaro [sic] méritent une mention des plus honorables. ...

Enfin M. Caillebotte, le plus jeune des bons. Trente ans à peine. Ancien élève de Bonnat, dans l'atelier duquel il était encore quand, il y a trois

ans, il exposa ses *Raboteurs* chez Durand-Ruel. J'avoue que cette toile procédait assez peu de l'école du maître. Elle fit quelque bruit, si je me souviens, au moins chez les peintres, et le jeune déserteur ne songea guère à reprendre le chemin de la caserne. Les Impressionistes l'accueillirent avec chaleur, comme une recrue précieuse. Il leur apportait l'appoint de la résistante jeunesse. Cette jeunesse d'âme et de corps, opiniâtre aux mécomptes, rebelle aux désenchantements, victorieuse de la réalité soumise. Il entrait dans la mêlée en enfant gâté. Assuré contre la misère, fort de cette double force: la volonté servie par la fortune. Il eut cet autre courage, qui n'est pas le plus commun, de la richesse laborieuse. Et je n'en connais peu qui aient, autant que lui, oublié qu'ils étaient rentiers pour se rappeler seulement qu'ils se devaient être célèbres.

Célèbre ou non, M. Caillebotte est un valeureux. Son appartement du boulevard Haussmann, qui pourrait être luxueux, n'a que le très simple confort d'un homme de goût. Il y vit avec son frère, un musicien. Fraternité assez bizarre, chacun ramant sa galère, battant des flots divers avec d'égales ardeurs—l'un ignorant où va l'autre, poursuivant des buts différents: celui-ci peignant, celui-la notant, sans échange de pensées, sans choc de sentiments—ne parlant entre eux ni musique ni peinture, et ne se retrouvant frères que dans la plus touchante des amitiés, qui couvre d'une ombre douce et chaude ces deux vies contiguës et distinctes.

M. Caillebotte a exposé un grand nombre de toiles. J'estime assez l'ensemble pour pouvoir y condamner de criardes exagérations, J'aurais souhaité qu'il fit un choix, et je pense que son exposition eut singulièrement gagné à ne produire que ses quatres ou cinq meilleurs tableaux. Mais, dans ce lot, il y a des choses extrêmement intéressantes. ...

... The names of Messieurs Degas and Monet are no longer unknown to those who follow, closely or at a distance, the contemporary artistic movement. Beside theirs, those of Messieurs Caillebotte and Pissarro are worthy of the most honorable mention. ...

Finally, Monsieur Caillebotte, the youngest of the good ones. Scarcely thirty. Former student of Bonnat, in whose studio he still was when, three years ago, he exhibited his *Planers* at Durand-Ruel's. I confess this canvas stemmed rather little from the master's school. It caused a stir, if I remember, at least among the painters, and the young deserter hardly thought about getting back on the road to his barracks. The Impressionists welcomed him with warmth as a

precious recruit. He brought to them the bonus of unyielding youth. The kind of youth, in soul and body, that's headstrong to the point of error, rebellious against disappointments, and victorious over submissive reality. He entered the fray like a spoiled child. Assured against misery, strong with a double strength: will served by fortune. He had that other courage, which isn't the most common, of hard-working wealthy folk. And I know few of them who have forgotten as much as he has that they are *rentiers*, in order to remember only that their fame has to be self-made.

Famous or not, Monsieur Caillebotte is a valiant one. His apartment on the Boulevard Haussmann, which could be luxurious, has only the very simple comfort of a man of taste. He lives there with his brother, a musician. A brotherhood rather bizarre, each one rowing his own boat, cresting different waves with equal ardor—one not knowing where the other is going, pursuing different goals: this one painting, that one doing [musical] notation, without exchanging thoughts, without conflict of feelings—talking neither painting nor music between themselves, and only rediscovering themselves brothers in the most touching of friendships, which covers with a warm, soft shadow these two lives, contiguous and distinct.

Monsieur Caillebotte has exhibited a large number of canvases. I value the ensemble of his work enough to condemn in that group some crude exaggerations. I would have wished that he had made a choice, and I think his show would singularly have profited from only bringing forth his four or five best pictures. But, in this group, there are some extremely interesting things. . . .

27

Martelli, Diego
"Gli Impressionisti, mostra del 1879," *Roma Artistica*, 27 June and 5 July 1879

Caillebotte is a young man who combines a passion for art and a rare talent with the means to practice it on his own terms. And it is he, more than all the others, who provokes the public's outrage at this exhibition. It is difficult to judge impartially the painting of this artist, for he shows himself to us today in a very different light from the one we met him in three years ago. He has changed so much that you do not know if it is good or bad that he left the path already laid down in his painting of the scrapers, a dry painting, full of will and modesty.

On the other hand, should we prefer him now that he gives us almost forty canvases dominated by a palette of bluish tones ranging through all its shadows, and on which color no longer can contain itself, or reels like a bacchante?

28

Bertall
"Exposition des Indépendants, Ex-Impressionistes, Demain Intentionists," *L'Artiste*, June 1879

Disons, tout d'abord, que Monsieur Manet, premier inspirateur de ce groupe curieux, n'est autre qu'un opportuniste. Lui, le chef incontesté jadis, a repoussé du pied la barque qui contenait ses disciples, et la barque néanmoins continue à voguer sans lui dans sa noble indépendance.

Pendant que Monsieur Manet passait avec armes et bagages dans le camp des croisés de l'art, c'est Monsieur Caillebotte qui a pris d'une main ferme le gouvernail de cette barque, qui sans lui voguerait peut-être à la dérive.

La confiance des indépendants est du reste on ne peut mieux placée. Si nous croyons des sources tout à fait autorisées, Monsieur Caillebotte, jeune homme charmant et des mieux élévés, est à la tête d'une centaine de mille francs de rente: il y a là de quoi assurer à tout jamais l'indépendance.

Si Monsieur Caillebotte est assez dévoué à la cause pour payer princièrement de son argent la publicité donnée à l'école dont il est devenu chef vénéré, il paye aussi de sa personne.

Il n'a pas moins de trente-cinq tableaux, magnifiquement encadrés, qui affirment d'une manière énergique son tempérament et ses convictions. Parmi ces trente-cinq toiles, il en est une qui est vraiment le chef-d'oeuvre du genre.

Une vache en bois rouge acajou clair, ornée d'un mufle extraordinaire à rallonges, est placée sur un tapis vert cru: elle est accompagné d'une petite chèvre en feutre qui se tient discrètement dans le coin de la toile pour ne pas troubler le regard qui s'attache forcément sur sa compagne. J'ose le répéter, c'est un chef-d'oeuvre. Cette vache fantastique, grandeur nature ou peu s'en faut, vaut seule le voyage à la salle de l'avenue de L'Opéra, 28.

Parmi les trente-quatre autres toiles du nouveau pontife, il y a quantité de canotiers étonnants, de canotiers apocalyptiques, de paysages prestigieux taillés en plein bleu et plein vert. Il a des amis qu'il aime et dont il est aimé: il les asseoit sur des canapés étranges, dans des poses fantastiques. Coloris des tons les plus étranges parmi lesquels le vert, le noir et le rouge se livrent d'homériques combats. On m'a montré même un de ses oncles, assis inamovible dans un fauteuil qui menace ruine: la parenté n'a pu préserver l'excellent homme de la verve de son neveu. Il est triste, mais semble lui pardonner cependant.

Let us say, first of all, that Monsieur Manet, first to inspire this curious group, is no more than an opportunist. He, formerly the uncontested chief, has pushed away with his foot the boat containing his disciples, and the boat nevertheless continues to sail along without him in noble independence.

While Monsieur Manet went bag and baggage into the camp of the crusaders of art, it is Monsieur Caillebotte who has taken in firm hand the rudder of this boat, which without him would perhaps go adrift.

The confidence of the Independents could, moreover, not be better placed. If we can believe in completely authorized sources, Monsieur Caillebotte, a charming young man, among the best brought-up, is sitting on an income of about a hundred thousand francs: that is something to assure independence forever.

If Monsieur Caillebotte is devoted enough to the cause to give of his money in princely fashion for the publicity accorded the school whose venerated chief he has become, he also gives of his person.

He has no less than thirty-five paintings, magnificently framed, which affirm in an energetic manner his temperament and his convictions. Among these thirty-five canvases, there is one that is really the masterpiece of the genre.

A cow in light red mahogany wood, adorned with an extraordinary extending muzzle, is placed on a harsh green rug; she is accompanied by a little goat made of felt who stands directly in the corner of the canvas so as not to distract the gaze that perforce focuses on her companion. I dare repeat it, it is a masterpiece. This fantastic cow, life-size or not far from it, is in itself worth the trip to the gallery at 28 Avenue de l'Opéra.

Among the thirty-four other canvases of the new pontiff, there are a number of astounding boatsmen, apocalyptic boatsmen, prestigious landscapes dressed out in full blue and full green. He has friends whom he likes and who like him; he seats them on strange sofas, in fantastic poses. Colors of the strangest tones, among which green, black, and red undertake Homeric battles. They even showed me one of his uncles, seated unmovable in an armchair that threatened ruin; kinship could not protect this good man from the verve of his nephew. He is sad, but he seems to forgive him anyway.

29

JAVEL, FIRMIN
"L'Exposition des Impressionistes," *L'Evénement*, 3 April 1880

... Toutefois, les peintres dont nous parlons ne se noient pas tous. Il y a parmi les "impressionistes" trois ou quatre tempéraments sur le sort desquels on peut se rassurer. ...

Ceux-la surnageront longtemps et finiront par atteindre la terre ferme ... ce qu'on est obligé de reconnaître, c'est la conviction avec lacquelle M. Caillebotte et quelques-uns de ses amis étudient la nature et s'éfforcent de traduire leurs impressions. ...

... Monsieur Caillebotte s'attaque aux difficultés les plus inabordables. Il peint l'intérieur d'un café, avec cette atmosphère embrumée dans laquelle brillent ça et là le bord d'un verre ou l'extremité d'un cuiller de vermeil, et il pose, au premier plan, un personnage d'un vérité surprenante.

... Anyway, not all the painters we're talking about are drowning. There are among the Impressionists three or four temperaments on whose fate we can reassure ourselves. ...

Those artists will swim on top for a long time and wind up reaching solid ground ... what one must recognize is the conviction with which Monsieur Caillebotte and some of his friends study nature and try to translate their impressions. ...

... Monsieur Caillebotte goes at the most uncomfortable difficulties. He paints the interior of a cafe, with that fogged-up atmosphere in which gleam here and there the rim of a glass or the end of a vermeil spoon, and he sets down, in the foreground, a personage of surprising veracity.

30

RENOIR, EDMOND
"L'Exposition des Impressionistes," *La Presse*, 9 April 1880

Ses [Caillebotte's] progrès sont considérables: le *Portrait d'homme*, en pied, grandeur nature qu'il expose, est très supérieur à ce que nous connaissions de lui. Apres avoir laché la bride à sa production, il l'a modérée. Sa facture en témoigne: la figure de son personnage est peinte avec beaucoup d'art. Son *Portrait d'enfant* est également bien. L'arrangement de son *Intérieur de café* plaira par sa vérité; l'habitué qui en est la figure principale est pris sur nature.

His [Caillebotte's] progress is remarkable: the *Portrait of a man*, standing, life-size, that he shows, is very superior to what we used to know by him. After having let go the reins of his production, he has now moderated it. His facture bears witness to this: the figure of his personnage is painted with a great deal of art. His *Portrait of a child* is equally good. The arrangement of his *Interior of a café* will please by its truthfulness; the cafe regular who is the principal figure is taken from life.

31

FLOR, CHARLES
"Les Ateliers de Paris: Les Impressionistes," *Le National*, 16 April 1880

Monsieur Caillebotte nous donne comme des portraits des têtes cadavereuses et torturées, avec des cheveux verts et des oreilles bleues. C'est un tort. Le public n'est pas plus sôt que Monsieur Caillebotte; il sait, à n'en pas douter, qu'il n'y a ni cheveux verts ni oreilles bleues. Si donc le peintre voit ainsi tout en vert ou en bleu, qu'il renonce à la peinture.

Monsieur Caillebotte gives us as portraits cadaverous and tortured heads, with green hair and blue ears. This is an error. The public isn't dumber than Monsieur Caillebotte; it knows, have no doubt, that there is no green hair nor any blue ears. Thus if the painter sees everything that way in green or in blue, let him give up painting.

32

EPHRUSSI, CHARLES
"Exposition des Artistes Indépendants," *Gazette des Beaux-Arts*, 1 May 1880

Le bleu, d'ailleurs, est la couleur d'achoppement, le grand écueil contre lequel se heurtent les impressionistes. Ainsi M. Caillebotte, dont les débuts heureux firent quelque bruit, a passé sous le drapeau de M. Pissaro, comme le font aujourd'hui M. Zandomeneghi et surtout M. Gauguin, ou plutôt il a passé dans le coup du bleu.

... M. Caillebotte, en outre, oublie volontiers que Vitruve, Piero della Francesca, Léonard, Albert Dürer et autres ont fixé les lois de la perspective; les plans successifs n'existent pas pour lui; les distances sont supprimées. Et c'est grand dommage, car M. Caillebotte a certaines des qualités du peintre. Quelle lumière douce et chaude éclaire la jeune femme debout, vue de dos, devant un balcon (N⁰ 12)! L'air ambiant est rendu avec vigueur, la figure est bien posée. De même, les deux petits buveurs (N⁰ 6) attablés dans l'arrière salle d'un café du faubourg sont d'un sentiment vif et juste; mais comme la grande figure du premier plan, vraie peut-être et prise sur place, est mal venue! comme la tête a peu d'ensemble! et que les tons sont plâtreux!

Blue, incidentally, is the color on which they stumble, the great rock on which the Impressionists founder. Thus Monsieur Caillebotte, whose felicitous beginning stirred up some notice, has enlisted under the banner of Monsieur Pisarro, as do now Monsieur Zandomeneghi and Monsieur Gauguin, or rather he has enlisted under the banner of blue.

... Monsieur Caillebotte, furthermore, willfully forgets that Vitruvius, Piero della Francesca, Leonardo, Albrecht Dürer and others fixed the laws of perspective; successive planes do not exist for him; distances are suppressed. And it is a great pity, because Monsieur Caillebotte has certain of the qualities of a painter. What a soft and warm light shines on the young woman standing, seen from the back, in front of a balcony (No. 12)! The ambient air is rendered with vigor, the figure is well placed. By the same token, the two little drinkers (No. 6) at the table in the back room of a neighborhood café are keen and accurate in feeling; but this big figure in the foreground, true perhaps and taken on the spot, how ill-conceived it is! how little unity the head has! and how plaster-like the tones!

33

ZOLA, EMILE
"Le Naturalisme au Salon," *Le Voltaire*, 18–22 June 1880

19 June—Enfin M. Caillebotte est un artiste très consciencieux, dont la facture est un peu sèche, mais qui a le courage des grands efforts et qui cherche avec la résolution la plus virile.

Finally, Monsieur Caillebotte is a very conscientious artist, whose facture is a little dry, but who has the courage for large efforts and who researches with the most virile resolution.

34

SILVESTRE, ARMAND
"Le Monde des Arts," *La Vie Moderne*, 1880 (p. 262)

M. Caillebotte qui abuse toujours des tons violacés demeure profondément personnel. Ce que j'aime le mieux de son exposition, c'est son

Portrait de M. G.C. . . . debout et coiffé d'un chapeau. Sa tête rappelle, par le modelé, les manières de Fantin-Latour et la figure tout entière est bien traitée, avec indépendence et vigueur tout à la fois. C'est, de beaucoup, son meilleur morceau. Son intérieur (N° 10) contient une figure de femme assez bien peinte dans un joli ton. Mais l'homme couché sur un canapé au fond de la pièce est sensiblement trop petit pour la perspective et donne l'impression d'une pièce aussi longue que la galerie d'Apollon. Il n'en est pas moins vrai que, sans avoir fait de concessions, M. Caillebotte me semble en progrès. Il s'humanise et consent à ne plus voir la nature tout entière à travers une améthyste.

M. Caillebotte, who always overdoes purplish-blue tones, remains profoundly personal. What I like best in his showing is his *Portrait of Monsieur G.C. . . .*, standing and wearing a hat. His head recalls, by the modeling, the manner of Fantin-Latour, and the whole figure is well treated, with independence and vigor at the same time. It is by far his best piece. His interior (No. 10) contains a figure of a woman rather well painted in a pretty tone. But the man lying on the sofa in the back of the room is noticeably too small for the perspective and gives the impression of a room as long as the Gallery of Apollo. It is nonetheless true that, without having made concessions, Monsieur Caillebotte seems to me to be making progress. He is becoming humanized and consents to see the whole of nature no longer through an amethyst.

35

VERON, EUGÈNE
"Cinquième exposition des Indépendants,"
L'Art, 1880 (pp. 92–4)

M. Caillebotte a une *Scène d'intérieur* qui amuse beaucoup les visiteurs. Une grosse femme à la joue lie de vin, fleurie de poudre de riz, est assise et lit. A côté d'elle, sur un canapé qui touche à sa chaise, est couché un homme qui lit également. Cet homme, le mari sans doute, est réduit à des proportions infinitésimales, sa longueur totale, des pieds à la tête, équivaut à peine à la largeur de la tête de sa femme. On a beaucoup ri du petit mari de M. Caillebotte. Est-ce à dire que M. Caillebotte ignore à ce point les lois de la perspective? Non, mais c'est encore une convention qu'il a couchée en joue. Evidemment, quand il a fait son tableau, l'exiguité du local l'a forcé à se placer trop près de la femme, et il n'a pas voulu corriger le défaut apparent que lui imposait la vérité des choses. Une feuille de saule peut cacher le monde, si on la rapproche suffisamment l'oeil. Il est vrai qu'il aurait peu atténuer cette impression, en faisant sentir un espace quelconque entre la chaise de la femme et le canapé du mari.

Il faut aussi relever à l'actif du même artiste le personnage debout (N° 6, *Dans un café*), qui se présente de face, appuyé sur une table de café. Au milieu de tous les défauts de dessin et de couleur qu'on pourrait relever dans cette figure, il n'est que juste de reconnaître qu'elle a une intensité de vie moderne bien remarquable. Il est facile de trouver dans un certain monde ce personnage. C'est un type saisi sur le vif, et qui appartient bien réellement à notre époque.

Monsieur Caillebotte has an *Interior scene* that greatly amuses the visitors. A fat woman with purplish-red cheeks, sprinkled with rice powder, is seated and reads. Beside her, on a sofa that touches her chair, lies a man who is also reading. This man, the husband no doubt, is reduced to infinitesimal proportions, his total length, from his feet to his head, barely equals the width of the head of his wife. They have laughed a lot about Monsieur Caillebotte's little husband. Is this to say that Monsieur Caillebotte is this ignorant of the laws of perspective? No, but this is yet another convention that he has taken aim at. Apparently, when he did this picture, the demands of the site forced him to place himself too close to the woman, and the truth of things imposed on him. A willow-leaf can hide the world, if you bring it close enough to your eye. It is true that he could have mitigated this impression by making felt some small bit of space between the woman's chair and the husband's sofa.

We must credit the same artist with the standing figure (No. 6, *In a Café*), who faces us, leaning on a café table. Amid all the failings of drawing and color one could point out in this figure, it is only just to recognize that it has a remarkable intensity of modern life. It is easy to find this person in certain circles. It is a type straight from life, and one who really belongs to our time.

36

HUSTIN, ARTHUR
"L'Exposition des peintres indépendants,"
L'Estafette, 3 March 1882

Prenez l'Impressioniste le plus fanatique, M. Caillebotte. Le voilà qui, à de certaines heures, oublie son tube de bleu, son violet pour voir un peu comme tout le monde et chercher son chemin de Damas. Un long séjour en Normandie a éduqué son oeil et le voilà qui nous revient avec des *Bois près de la mer*, des *pommiers* ou les vert commencent à s'assouplir, à devenir plus nature. Regardez son *Homme au balcon*. N'est-il pas d'un dessin amende et d'une facture plus souple? N'y a-t-il quelque chose dans sa *partie de bézique*? dans cette étrange fantaisie où il nous fait voir un *coin du boulevard* entrevu d'un cinquième etage?

Take the most fanatic of the Impressionists, Monsieur Caillebotte. Here now, he forgets for a few hours his tube of blue, his violet, in order to see somewhat like the rest of the world, and to search out his road to Damascus. A long stay in Normandy has educated his eye, and here he is returning to us with his *Wood by the sea*, with *apple trees* where the greens begin to be more supple, closer to lifelike. Look at his *Man on the balcony*. Isn't it contrite in its drawing and more supple in its facture? Isn't there something in his *besique game*? in that strange fantasy where he makes us see a *corner of the boulevard* glimpsed from a fifth floor?

37

SALLANCHES, ARMAND
"L'Exposition des artistes indépendants," *Le Journal des Arts,* 3 March 1882

. . . En dehors de ces quatres artistes d'un réel talent, nous avons encore à citer: M. Caillebotte dont les tableaux frappent surtout par leur originalité; tels sont "Boulevard vu d'en haut"; "Homme au balcon". "La partie de Bézigue", morceau très curieux et bien étudié. L'on se demande qui va gagner des deux individus, la pipe à la bouche, ou de leurs partenaires?

. . . Besides these four artists of real talent, we have yet to cite: Monsieur Caillebotte whose pictures are striking in their originality: such are "Boulevard seen from above"; "Man on the balcony," "The Besique game," a very curious and well-studied piece. One wonders who's going to win between these two individuals, pipe in mouth, or among their partners.

38

DE NIVELLE, JEAN
"Les Peintres Indépendants," *Le Soleil,* 4 March 1882

Un des plus acharnés des indépendants, M. Caillebotte, expose une vingtaine de toiles inénarrables, entre autres un *Homme au balcon,*

qui regarde les boulevards, et un *Boulevard vu d'en haut*, sans doute par ce monsieur même. Un banc semble collé par terre et un personnage qui semble collé sur le banc, puis le grillage qui entoure le peid d'un arbre, voilà le poème. Naturellement, l'homme du premier tableau, celui qui regarde, est vêtu d'une redingote violette, et je ne sais même si sa barbe et son chapeau ne sont point aussi violets. Ceci, c'est le parti-pris absolu, le sacrifice à l'enseigne, à l'etiquette. Pour la peinture, il faut citer des *pommiers*, un peau exagérés, mais bien plantés dans de l'herbe verte, ainsi qu'un *Paysage aux environs de Trouville*. Le peintre, à ce moment, a sans doute mis les bonnes lunettes, car il n'y a pas la moindre violette, dans ce paysage bien vu. Malheureusement ces raretés se perdent dans le nombre des impossibilités.

One of the fiercest independents, Monsieur Caillebotte, is showing about twenty unbelievable canvases, among others a *Man on the balcony*, who looks at the boulevards, and a *Boulevard seen from above*, doubtless by this very gentleman. A bench that seems stuck onto the ground and a figure who seems stuck onto the bench, then the grillwork that surrounds the foot of a tree, there's the poem. Naturally, the man in the first picture, the one who looks, is dressed in a violet overcoat, and I don't know if perhaps his beard and his hat are not just as violet. This is absolute willfulness, the sacrifice to the standard, to the label. For its painting, we have to mention the *apple-trees*, a little exaggerated, but well planted in some green grass, as well as a *Landscape near Trouville*. The painter doubtless put on his good glasses in that moment, as there isn't the least violet in this well-observed landscape. Unfortunately, these rareties get lost in the number of impossibilities.

39

LEROY, LOUIS
"Exposition des Impressionistes," *Le Charivari*, 17 March 1882

. . . Si M. Caillebotte n'y prende garde, il fera défection avant peu. La *Partie de bézique* se tient comme coloration et presque comme forme. Il y a loin de cette toile aux *Canotiers* lilas et au *Veau* légendaire. Heureusement que le *Boulevard vu d'en haut* et la perspective à l'envers de ses boîtes de raisins me rassurent sur la solidité de ses convictions.

If Monsieur Caillebotte doesn't watch out, he's going to defect [from the Impressionists] before long. His *Besique game* holds up in its colors and almost in its forms. It's a long way from that canvas to the [former] *Canotiers* in lilac and the legendary *Calf*. Happily the *Boulevard seen from above* and the inverse perspective of his boxes of grapes reassure me regarding the steadfastness of his convictions.

40

RIVIÈRE, HENRI
"Aux Indépendants," *Le Chat Noir*, 8 April 1882

Quant à M. Caillebotte sa manière s'est sensiblement modifiée, et sa grande toile: *Partie de bézigue*, est, ainsi que ses deux portraits, fort bien traitée. Très bien d'effet son *Homme au balcon*, détachant sa silhouette violette sur le vert ensoleillé des arbres d'un boulevard; comme curiosité je citerai son *Boulevard vu d'en haut*, une singulière étude d'arbres et de personnages en raccourci.

As for Monsieur Caillebotte, his manner has changed appreciably, and his big canvas, *The Besique game* is, along with his two portraits, very well handled. A very nice effect in his *Man on the balcony*, setting off his violet silhouette against the sun-struck green of a boulevard's trees; as a curiosity I'll note his *Boulevard seen from above*, a singular study of trees and figures in foreshortening.

APPENDIX B *Caillebotte's Will and Bequest*

The Will

Je désire qu'il soit pris sur ma succession la somme nécessaire pour faire, en 1878 dans les meilleurs conditions possibles l'exposition des peintres dits intransigeants ou impressionistes. Il m'est assez difficile d'évaluer aujourd'hui cette somme; elle peut s'élever à trente, quarante mille francs ou même plus. Les peintres qui figureont dans cette exposition sont: Degas, Monet, Pissarro, Renoir, Cézanne, Sisley, Mlle. Morizot [sic]. Je nomme ceux-là sans exclure les autres.

Je donne à l'état les tableaux que je possède; seulement comme je veux que ce don soit accepté et le soit de telle façon que ces tableaux n'aillent ni dans un grenier ni dans un musée de province mais bien au Luxembourg et plus tard au Louvre, il est nécessaire qu'il s'écoule un certain temps avant l'exécution de cette clause jusqu'à ce que le public, je ne dis pas comprenne, mais admette cette peinture. Ce temps peut être de vingt ans ou plus; en attendant mon frère Martial, et à son defaut un autre de mes héritiers, les conservera.

Je prie Renoir d'être mon exécuteur documentaire et de vouloir bien accepter un tableau qu'il choisira, mes héritiers insisteront pour qu'il en prenne un important.

—Fait en double à Paris le 3 novembre 1876

II. Ceci est mon testament.

On trouvera chez mon ami Albert Courtier un testament fait par moi en 1876 après la mort de mon frere René.

Je maintiens toute la partie de ce testament qui a trait au don que je fais de la peinture des autres que je possède. Ce qui a rapport à l'exposition de 1878 est naturellement devenu inutile. Mon intention formelle est que Renoir n'ait jamais le moindre ennui à cause de l'argent que je lui ai prêté. Je lui fais remise entière de sa dette et je le dégage complètement de toute solidarité avec M. Legrand.

Je laisse à Mademoiselle Charlotte Berthier une rente viagère de douze mille francs.

Je désire que cette rente soit insaississable et payable tous les mois, j'aimerais même mieux tous les quinze jours. Albert Courtier pourrait se charger de ce soin. Cette rente doit être nette de tous droits des successions.

Je laisse vingt mille francs à ma filleule Jenny Courtier.

Je laisse à mon frère Martial en plus de la part qui lui revient légalement, l'entière proprieté de ce que nous possedons en commun, meubles et immeubles.

—Fait à Paris le vingt november 1883

Je maintiens toutes les dispositions ci-dessus.

Je laisse en plus à Mademoiselle Charlotte Berthier, la petite maison que je possède au petit Gennevilliers, laquelle est louée actuellement a M. Luce—toujours nette de tous droits.

—Petit Gennevilliers le 5 novembre 1889

It is my wish that there be taken from my estate the sum necessary to hold, in 1878, in the best possible conditions, the exhibition of the painters known as intransigents or impressionists. It is rather difficult for me to evaluate this sum today; it could go up to thirty, forty thousand francs or even more. The painters who will figure in this exhibition are: Degas, Monet, Pissarro, Renoir, Cézanne, Sisley, Mlle. Morizot [sic]. I name these without excluding others.

I give to the state the pictures I own; only as I want this gift to be accepted, and accepted in such a way that the pictures go neither into an attic nor to a provincial museum but right to the Luxembourg and later to the Louvre, it is necessary that a certain time go by before the execution of this clause, until the public may, I don't say understand, but accept this painting. This time could be twenty years or more; in the meanwhile my brother Martial, or failing him another of my heirs, will keep them.

I ask Renoir to be my documentary executor and please to accept a picture that he will choose, my heirs will insist that he take an important one.

—Made in duplicate in Paris 3 November 1876

II. This is my will.

There will be found with my friend Albert Courtier a will made by me in 1876 after the death of my brother René.

I maintain the whole part of that will which dealt with the gift I make of the paintings by others that I own. That which concerns the exhibition of 1878 has naturally become unnecessary. My formal intention is that Renoir should never have the least worry as a result of the money I have loaned him, I make complete remittance to him of his debt, and I release him completely from all joint and separate liability with M. Legrand.

I leave to Mademoiselle Charlotte Berthier a life-annuity of twelve thousand francs.

It is my wish that this annuity be unattachable and payable every month. I would prefer even more every fifteen days. Albert Courtier could take care of this business. This annuity is to be clear of all probate duties.

I leave twenty thousand francs to my god-daughter Jenny Courtier.

I leave to my brother Martial, over and above the share that comes to him legally, all of the property that we own together, personal property and real estate.

—Made in Paris 20 November 1883

I maintain all the provisions above.

I leave, in addition, to Mademoiselle Charlotte Berthier the little house that I own at Petit Gennevilliers, which is presently rented to Monsieur Luce—still clear of all probate duties.

—Petit Gennevilliers 5 November 1889

197

★ ★ ★

On 11 March 1894, a letter from Auguste Renoir notified Henry Roujon, Directeur des Beaux-Arts, of the provisions of the will of Gustave Caillebotte. The will, originally written in 1876 and little modified since (see Chapter 1, and transcript of the will above), left to France the formidable collection formed by Caillebotte of sixty-seven paintings and pastels by the artists Manet, Monet, Renoir, Pissarro, Sisley, Degas, and Cézanne (and also two drawings by Millet). It further stipulated that these paintings should go "neither to an attic nor to a provincial museum, but right to the Luxembourg [the Musée de Luxembourg, in Paris's Palais de Luxembourg, at that time the national museum devoted to the work of living artists] and later to the Louvre." Caillebotte had recognized that a certain time, twenty years or more, might have to pass before the public would, "I don't say understand, but accept" this school of painting; and he authorized his brother Martial or other heirs to keep the collection until that time should come. The stipulations of the will posed various difficulties for the government as legatee, and negotiations with the executors ensued. When these concluded, in early 1895, it was agreed that France would take only thirty-eight of the sixty-seven paintings and pastels offered, the rest becoming the possessions of Martial Caillebotte. The accepted collection was put on view in early 1897, in a newly built annex of the Musée de Luxembourg.

★ ★ ★

The sufferings of the Impressionist painters have in general been an indispensable part of the popular success story of modern art. Their lean years and lost battles, official rejections and public ridicule serve as a cautionary tale against short-sighted conservatism, and ennoble modern painting's latterday success. The story of the difficulties attending acceptance of Caillebotte's bequest, and of the opposition to it by academic painters and an uncomprehending public, has been a prime instance among these exemplary scandals of early modern art. Given the sharp reconsideration of what is loosely called "the modern movement," in art and art scholarship of the last two decades, and especially in light of the reevaluation of the formerly black-and-white opposition between "academic" and "modern" painting in the later nineteenth century, it should come as no surprise that the facts and meanings of the Caillebotte affair have been thrown open to new questioning.

Though hindsight may allow us to see elements of myth in such "necessary" stories, some basic truths of the matter seem unshakable. Caillebotte's bequest did meet with outspoken, virulent criticism from the Academy and the press. The painter Jean-Léon Gérôme, for example, offered the opinion that if this collection contained works by Manet and Pissarro, then the state's acceptance would be evidence of moral turpitude, as such painting signalled "the end of the nation."[1] Even if, as we shall see, the brunt of this reaction came too late to be a causal factor in the government's handling of the bequest, it reflected opinions and institutionalized positions whose potential influence would have concerned everyone involved. And in the long run there was a defeat, in the form of pictures lost to France that should have been hers. Even if their numbers and quality were not as high as is sometimes suggested, and even if the definitive rejection really took place only years later, the affair had its symbolic force, and the fact remains that France willfully renounced paintings its museums (or any museum) would now pay dearly for. The questions to be reexamined today are those of the exact mechanics and personalities of the story, and of the lessons to be drawn from a fuller understanding of these facts. These issues have been pointedly raised by recent scholarship, especially in the work of the French historians Jeanne Laurent, Pierre Vaisse, and Marie Berhaut. The present account draws directly on their work, and on the admirable dossier of documentation published by Vaisse and Berhaut.[2]

The dilemma of "l'affaire Caillebotte" lay in finding an accord between two sides each bound by tough, though not wholly inflexible, given conditions. On one side stood Renoir (the executor of the will), aided closely by Martial Caillebotte (the artist's brother), determined to uphold the deceased painter's specific provisions—especially in what came to be referred to in shorthand as the "attic or provinces" exclusion. For them the inviolable core idea of the bequest was the principle that these Impressionist works should be honored by prominent display, rather than shunted offstage.

On the other side stood a diverse cast of government ministers and bureaucrats, headed by Henry Roujon and by Léonce Bénédite, head of the Musée de Luxembourg (Acting Director since 1892, he was confirmed as Director in March 1895).[3] Though different in their goals and motivations, both professed themselves constrained by the same ostensibly iron-clad conditions. First, they held that the Musée de Luxembourg, already badly overcrowded, did not have space to hang the entire Caillebotte collection. And second, they evoked a policy of equitable balance whereby no single artist should have more than three or four works on view in the Luxembourg galleries (the bequest included, for example, fourteen Monets and ten Renoirs). These conditions dictated, they said, that only a portion of the collection could be hung. They later claimed that, at the outset, Renoir and Martial Caillebotte accepted this contingency. But in the end France's failure to commit to full display in the Luxembourg was the unmovable crux of contention.

This apparently clear-cut confrontation of principles was played out against a murkier backdrop of personalities and attitudes. On the side of the will, one has to acknowledge Renoir's unusual double position: as executor, he was dealing with his own work and with that of his friends. The close association of Claude Monet with the procedings further complicated the matter.[4] These men had a stake in how their works would be shown at the Luxembourg, and—especially in the case of Monet, a relentless self-editor from whom Caillebotte had acquired a broad range of major and lesser canvases—that stake did not necessarily argue for the display of the collection as a block. Bénédite and Roujon referred recurrently to critiques the painters

Fig. 1. Edgar Degas, *Femme nue accroupie de dos*, c. 1879. Pastel, 18 × 13 cm. (7 × 5 in.). Musée d'Orsay.

made of some of Caillebotte's choices; and averred (in a self-serving fashion that invites scepticism) that the artists' doubts constituted agreement that the collection be only partially shown. Yet, whatever Renoir's and Monet's reservations, other evidence suggests that adherence to the letter of the will was finally paramount to them, out of loyalty to their deceased friend, and also, one might surmise, for the symbolic prestige that would accrue to the Impressionist legacy.[6]

On the side of the government, one can somewhat appreciate that this golden gift had its rough edges. Still today, any small museum confronted with nearly seventy paintings, particularly recent ones, on a "must-hang" proviso, would be expected to think twice. A national museum would be obliged to think several times, and from different viewpoints—as was the case with this bequest. Certainly it is wrong to adduce from this that the government simply feared or scorned Impressionist paintings. The Luxembourg had accepted Manet's *Olympia* as a gift in 1891, had purchased a Renoir in 1892 (the quite "safe" *Jeunes filles au piano*) and had been actively seeking a Degas.[7] Early on in the arrangements surrounding the Caillebotte bequest, the state purchased a Berthe Morisot at auction (a gesture whose negative reception in parts of the press may well have colored subsequent dealings with the bequest itself).[8]

Pressure had been mounting on the Luxembourg to acquire some of the artists represented in the bequest, whose prices were already increasing sharply, and whose significance for history, if not for the future of French art, was by then a matter of broadening consensus. On the other hand, official policy favored less challenging examples of work from the Impressionist circle;[9] and conservative factions within the Academy were primed to act, through the press and through political channels, to censor any move that threatened the dominance within the Luxembourg of established artists such as Bouguereau, Meissonnier, Cormon, et al. Among the representatives of the state concerned with the Caillebotte bequest, there were differing shades of sensitivity to these conflicting pressures, as there were differing levels of admiration for the individual artists and works included in the collection. Roujon's first written mention of the bequest classed it as an "affaire délicate,"[10] and so it was. On the one hand it was a windfall that would allow the state to answer at a stroke the growing need for representation of the Impressionist artists, without being obliged to take the riskier initiative of purchase; and on

Fig. 2. Alfred Sisley, *Régates à Molesey, près de Hampton Court*, c. 1871. Oil on canvas, 62 × 92 cm. (24⅓ × 36⅓ in.). Musée d'Orsay.

Fig. 3. Paul Cézanne, *L'Estaque*, 1883–85. Oil on canvas, 58 × 72 cm. (22¾ × 28⅓ in.). Musée d'Orsay.

the other it was ticklish if not provocative in its potential to alter radically the balance of power not only in the Luxembourg itself, but in the state's engagement with contentious factions, symbolizing tradition and progress, in cultural affairs.

The bequest was considered by the Comité consultatif des Musées Nationaux (composed of museum curators, and properly empowered to act on such matters) on 20 March 1894. The day before this meeting, Roujon had convoked Renoir and Martial Caillebotte, and several of the curators, including Bénédite, to view the paintings and discuss the terms of the bequest. Kaempfen, the Directeur des Musées Nationaux, reported to the committee on the 20th that this preliminary meeting had been held, in part, to decide with the executors how the will (read in full to the committee) should be interpreted.[11]

According to Kaempfen's account, the executor and the heirs recognized that the will's stipulation of entry into the Louvre could not be dealt with (since by rule no work could enter the Louvre until at least ten years after the artist's

death); and all concurred that the sole question now to be addressed was that of the placement of the bequest in the Luxembourg. This much seems true, for nowhere in the later negotiations is there any indication that the matter of the Louvre was a problem; but after this matters get tricky. Kaempfen then reported that the executor and heirs had been apprised of the double difficulty of limited space at the Luxembourg and of the need to represent artists even-handedly, by showing only three or four works of each. Kaempfen continued that, "Monsieur Renoir having admitted that these observations were well-founded," the meeting was now called to vote only on the total acceptance of the will "*avec placement au Luxembourg*," without there being any obligation for the museum to show all the works involved.[12] There is cause to believe, however, that Renoir and Martial Caillebotte never in fact accepted the notion of such a limited hanging,[13] and that the committee was here being misled as to what they were actually voting on, by being encouraged to believe that the restrictive clauses of the bequest would not have to be enforced as they were written.

Bénédite then laid out the advantages of acquiring the bequest, after which Kaempfen reiterated that only about a third of the collection could now be hung—but added the important addendum that "Monsieur Bénédite thinks it will be possible to construct on the terrace of the Luxembourg a temporary *baraquement* where the Caillebotte collection will be reunited." Again, the committee was encouraged to believe that the restrictive clauses would not form a problem, this time by the suggestion that, with the addition of a new annex, the stipulations would in fact soon be satisfied and the collection displayed as a whole. After looking over the collection, the committee then voted that, leaving aside the stipulation regarding the Louvre, the bequest should be accepted in its entirety "for the national museums, with placement at the Luxembourg."[14]

Nowhere in the accounts of the meeting of 19 March or of the deliberations of 20 March do we find the suggestion that the state ever seriously considered rejecting all, or even the majority, of the paintings presented. But it is clear that several key players harbored serious, even prohibitive, doubts about the practical, aesthetic, or political advisability of accepting the obligation to display the bequest integrally. Apparently here, as on a later occasion, the government's impetus was to possess the paintings first and work out the problems later; and to this end they allowed

themselves to entertain an unduly optimistic assessment of the cooperation of the executor and heirs in the endeavor.

Renoir and Martial Caillebotte, presented with the news of the unconditional acceptance but apparently aware of the doubts of Roujon and Bénédite, were then obliged to decide whether to read the acceptance literally and optimistically, trusting in the good faith of the state *vis-à-vis* the will's provisions, or whether to ask for more explicit guarantees. Renoir, at first suspicious, then had a change of heart, and held there was no real reason to mistrust;[15] but Monet encouraged Martial to make absolutely sure the "attics and provinces" accord was firm.[16] Eventually, acting on advice of legal counsel, Martial and Renoir decided not to agree to the acceptance without first explicitly affirming their intention to have this key provision of the will respected.[17]

On the side of the state, the issue seems to have been more or less camouflaged while those involved sought to figure out a way to get around the difficulty;[18] and in contacts with the executors—during which we may surmise that ambiguous statements were made and misunderstandings proliferated—Bénédite and Roujon seem to have become persuaded that a deal could be struck whereby only part of the collection would be shown. They felt that the state's difficulties of space and diplomacy in the Luxembourg in fact dovetailed with the reservations held by Renoir and Monet regarding the quality and appropriateness for display of many of the pictures Caillebotte had owned;[19] and they professed to see things tending toward an amicable compromise.

In late April Roujon was finally confronted by Martial Caillebotte and Renoir, who wanted the matter of the will's stipulations resolved in explicit fashion. At this meeting Roujon, without consulting Bénédite, accepted an arrangement reportedly proposed by the executors, by which the state would select a group of works for immediate display at the Luxembourg, with Martial Caillebotte holding custody of the remaining works until such time as they, too, could be similarly hung.[20] For Roujon, who seems to have been the principal most obviously nervous about the impact acceptance of the whole bequest might have, this reduction must have seemed a welcome relief.

This arrangement might have worked, and might eventually have brought into the French museums the entirety of the collection. But Bénédite, to his credit perhaps, but to the eventual chagrin of France, held that it was

neither true to the will, which he felt called for the acceptance or rejection of the collection *en bloc*, nor permissable under law, as it would involve private sequestering of works legally belonging to the museum.[21] He wanted secure possession of the entire collection, even if he could not hang it. And in order to satisfy the will, he concocted the solution of consigning the "overflow" portion of paintings to galleries in the chateaux of Compiègne or Fontainebleau— spaces that he felt were, as dependencies of the national museum system, exempt from being classified either as attics or as provincial museums. In June of 1894, he wrote to Kaempfen that the executor, the heirs, and also the painters represented in the collection were in accord with this notion.[22] But the ingenuity of Bénédite's plan seems matched by its disingenuousness, as it aimed at eluding the letter of the will while wholly disregarding the spirit. It seems likely that wishful thinking was once more constructing a picture of accord that did not exist. Martial Caillebotte did not receive official notification of the plan for deposit in the outlying chateaux until December,[23] and there is no corroborating evidence that he ever thought it acceptable.

With these maneuvers, in the summer of 1894, relations between the state and the executors took on an increasingly adversarial tone. Renoir, apparently worried about a preemptive government move to take the paintings, advised Martial

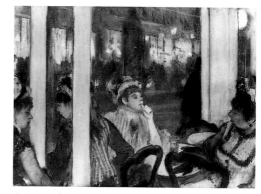

Fig. 5. Edgar Degas, *Un café boulevard Haussmann*, 1877. Pastel over monotype, 41 × 60 cm (16⅛ × 23⅝ in.). Musée d'Orsay.

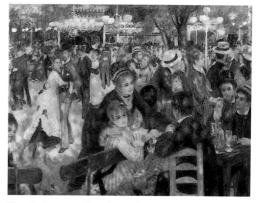

Fig. 6. Auguste Renoir, *Bal du Moulin de la Galette*, 1876. Oil on canvas, 130.8 × 175.3 cm (51½ × 69 in.). Musée d'Orsay.

Caillebotte in September to retrieve them from their temporary storeroom and guard them in his home.[24] Indeed, in December, only three days after Martial's lawyer had communicated to him the state's proposal regarding Fontainebleau and Compiègne, Bénédite announced that he was coming for the pictures.[25] Martial received him on 17 December, but refused to release the bequest, protesting that the state had still not comitted itself to honor the conditions of the will.

Foiled, Bénédite tried to work out a new arrangement by which the bequest would be annulled, with Martial then inheriting the works but formally pledging beforehand to give an agreed list of them to the Luxembourg as a donation, retaining the remainder as his own.[26] This solution was in its result, if not its mechanics, very much like the eventual final accord. But by now the matter had become widely publicized in the press, and new misunderstandings, misquotations, and pressures began to play a role.[27] Everyone involved, and perhaps most of all the state (which was being excoriated by the liberal press for "rejecting" the

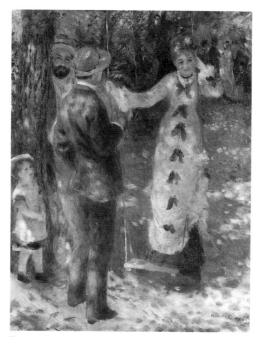

Fig. 4. Auguste Renoir, *La Balançoire*, 1876. Oil on canvas, 92 × 73 cm (36¼ × 28¾ in.) Musée d'Orsay.

bequest), felt a new urgency to conclude the matter; and in a meeting with Renoir and Martial Caillebotte on 17 January 1895, they did. The minutes of the meeting show that Roujon inflicted on those present a long recitation of the history of the negotiations, clearly aimed at exonerating the state and himself, and referring again to the previous occasions on which heirs and executor supposedly assented to government plans for a reduced showing at the Luxembourg. No response by Renoir or Martial Caillebotte is recorded.[28]

It was finally accepted by all present that at present the will could not, or at least would not, be executed as written, and various alternatives, including some previously proposed, were reviewed. Finally, a variant on the arrangement agreed to by Roujon and the heirs, but rejected by Bénédite, was proposed by the lawyer Albert Courtier, life-long friend of Gustave Caillebotte and advisor to Martial.[29] The Musée de Luxembourg would accept only that portion of the collection which it could promise to hang, and the rest of the paintings would become the property of Martial Caillebotte. Bénédite had previously drawn up a list of the works he planned to show. Based on the avowedly firm principle of limited representation for each artist, it included less than thirty works. But confronted with the prospect of losing the other canvases permanently, his scruples regarding equitable balance suddenly melted. He asked for, and readily obtained, the right to increase the roster of accepted paintings.[30] In the end, thirty-eight works were selected, (plus the two Millet drawings that had been immediately accepted for the Louvre), and twenty-nine let go.

After long bureaucratic delays in which the government's agencies pondered the legality of the arrangement, the Conseil d'état finally gave its stamp of approval in the autumn of 1895,[31] and a ministerial decree accepting the bequest as modified was signed in late February of 1896.[32] The collection was received on 23 November 1896, and went on view in a newly constructed annex of the Musée de Luxembourg in early 1897. It was only then, when the partial acceptance of the bequest had long since been sealed, that some of the most virulent protests were mounted. The Académie des Beaux-Arts, meeting at the end of February 1897, approved (though hardly unanimously) a letter officially expressing to the Ministre de l'instruction publique their disapproval of the Caillebotte collection, and their persuasion regarding the noxious effects its display was likely to have on the course of French art.[33] A senator, M. Hervé

de Saisy, rose shortly thereafter in the Senate to denounce the pollution of the great collection of masters at the Luxembourg by the acceptance of the "unhealthy" and "decadent" art of the Caillebotte collection.[34] Roujon himself responded to this tirade, arguing in a notably tepid defense that the reduction of the bequest's size was proof of the state's judicious discernment, and sheltering behind the noncommital claim that, in times of lively opposition over aesthetic matters, the state's best course was an "eclectic liberalism."[35]

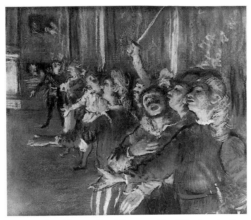

Fig. 7. Edgar Degas, *Les Figurants (Les Choristes)*, 1877. Pastel, 29 × 30 cm. ($11\frac{1}{3}$ × $11\frac{3}{4}$ in.). Musée d'Orsay.

The affair did not quite end here, but Roujon's apologia for the state is perhaps the point at which to review the course of events and ponder where blame might best be assigned for the compromised results of Gustave Caillebotte's bold gesture. Jeanne Laurent has argued, in the context of a more sweeping indictment of the baleful effect of official and Academic influence on French cultural life, that Roujon himself is the villain of the piece, and that his desire for self-promotion within the Academie des Beaux-Arts motivated his excessively cautious, anti-progressive truncation of this great opportunity.[36] Pierre Vaisse's study, offered in part as a direct repudiation of Laurent, has in turn attempted to prove that "The Caillebotte Affair Didn't Happen" (to cite one of his article's titles).[37] Vaisse sees the government as having acted logically and honorably, absolves the state's principals of undue bias against modern painting, and points to Renoir and Martial Caillebotte as the ones who, by changes of heart at crucial moments, upset an otherwise orderly process. Citing the role of the lawyer Courtier in the final agreement, Vaisse even suggests that the

material interests of Martial Caillebotte (who after all was left with a collection that became steadily more valuable in ensuing years) may have been a factor in the final split-up of the bequest.[38] Key aspects of Vaisse's account, based on an acceptance of the the unambiguous veracity of governmental accounts, are however at odds with the evidence of Martial Caillebotte's own archive of correspondence. As published by Marie Berhaut in an account of the affair that is likely to be definitive for some time to come, these documents clearly show Renoir and the artist's brother to have been consistent, patient, and self-sacrificing in their efforts to uphold the will as written.[39]

The legend of the Caillebotte bequest has traditionally been used to damn the willful evils of official conservatism, but the new version seems—through whatever political optic—to reveal the prominent role played by the too-familiar woes of bureaucratic bungling, by which even good intentions go awry. Ironically, it seems that Léonce Bénédite, who of all the government officials had the firmest engagement with Impressionist painting, and who sought most aggressively (to the point of near-piracy) to bring the entire bequest into the national collections, may have been most directly responsible for the partial loss.[40] He vetoed the arrangement whereby Martial would act as custodian for the surplus paintings (a solution to which the state's notary in fact subsequently gave approval) only to find himself confronted at the end with the same separation, but now set in more polarized and permanent terms, with Martial as the legal possessor of the remaining works.

The final selection Bénédite made, apparently with benefit of some advice from Renoir, Monet, and Pissarro,[41] merits review. This Impressionist collection was a quite special one, distinct from those of, for example, De Bellio or Chocquet, by virtue of Caillebotte's special relation as patron, friend, and fellow-worker of the artists. The notion that the collection was determined more by his desire to support needy friends than by a connoisseur's eye will not bear scrutiny, for the choices are too discerning, and several quite needy artists never appear.[42] The collection does show, though, the artist's occasional special interest in works of a sketchier and/or more experimental nature, such as Monet's *Gare St.-Lazare (The Signal)*, and these doubtless provided the pretext for Bénédite's assertion, early in the consideration, that "a part of the canvases in this group is formed by studies, incomplete pieces, that only have an interest in

Fig. 8. Claude Monet, *La Gare St.-Lazare (le signal)*, 1877. Oil on canvas, 65 × 81 cm. (25½ × 32¼ in.). Private collection.

Fig. 10. Paul Cezanne, *Baigneurs au repos*, c. 1876. Oil on canvas 79 × 97 cm. (31⅛ × 38¼ in.). The Barnes Foundation, Merion, Penna.

impetus to build a long-needed addition to the Luxembourg, what constrained him from building it in sufficient scale to hold the remainder of the paintings? One is allowed to surmise simply that his commitment to the work at hand, though certainly greater than Roujon's, had its own clear limits.

Perhaps the crucial point, however, is that the cause of the Caillebotte bequest was not fully lost until more than a decade later. According to the attestation of Martial Caillebotte's widow, Martial continued, in the first years of the new century, to offer to the state the remainder of his collection, to complete the bequest according to his brother's wishes.[45] Indeed it seems plausible that, in accepting the arrangement of January 1895, Martial felt he could revive the spirit of the will, and—legality of possession aside—simply hold the remaining paintings as his brother had supposed he might, until the bequest could be fully realized.[46] However, after a published call for completion of the bequest was ignored in 1904, and yet another formal offer of donation was rebuffed in 1908, Martial swore, and made his family promise, that no future entreaties from the state would be considered.[47] When those entreaties came, in 1928, Mme. Caillebotte's firm negative response left no doubt that the true

the studio."[43] The final choice was nonetheless, to judge from the results, not made not on criteria of "finish" alone. One can imagine that a prejudice against very large canvases excluded the important Pissarro *Louveciennes* in favor of a more manageable work like the *Toits Rouges*, and contributed to what seems now the most damning omission, Cézanne's *Baigneurs* of 1877. For Manet, it is easy to grasp why *Le Balcon* was kept and the smaller, more informal *Partie de croquet* was let go. In Monet's case, though, the superb but very sketch-like small *Régates a Argenteuil* of 1872 and the tempestuous, more abstract Belle-Ile canvas of 1886 were selected, while the far more densely finished, quite "bourgeois" *Déjeuner* of 1873, and the richly scumble-surfaced *Gare St.-Lazare* of 1877, though finally taken, were considered marginal by Bénédite—as well as, apparently, by Monet himself.[44]

With the glaring exception of Cézanne, it is arguable that Bénédite wound up with the cream

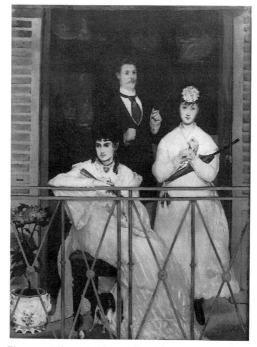

Fig. 11. Edouard Manet, *Le Balcon*, 1869. Oil on canvas, 169 × 123 cm. (66½ × 48½ in.). Musée d'Orsay.

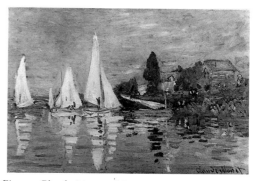

Fig. 12. Claude Monet, *Régates à Argenteuil*, 1872. Oil on canvas, 48 × 75 cm. (18¾ × 29½ in.). Musée d'Orsay.

Fig. 9. Camille Pissarro, *Les Toits rouges*, 1877. Oil on canvas, 54.5 × 65.6 cm (21½ × 25⅞ in.). Musée d'Orsay.

of the collection. The counsel of the artists must figure in this success, and it is fair to note that the situation did not demand exceptional curatorial acumen. The freshest of the works was ten years old, and most were between fifteen and twenty: an equivalent, one might say, to selecting Abstract Expressionist works in the mid-1960s, or vintage Cubist paintings around 1930. The more pointed question is why he chose to choose at all. His last-minute enlargement shows that the law of equitable hanging at the Luxembourg was not a true impediment. More importantly, since the advent of the bequest had provided the

rejection of the remainder of the bequest had been sealed in 1908, not in 1895.[48]

However one might rationalize the official hesitation of 1894 regarding some of the works in Caillebotte's collection, it is difficult to justify similar scruples in 1908. The status and prices of Impressionist painting had continued to mount, and the prestige and power of Bouguereau, et al. had declined. Even someone of goodwill toward modern painting could be allowed a blind spot with regard to Cézanne in 1894, when his works were nowhere shown and without immediately evident impact—hence a possible excuse for

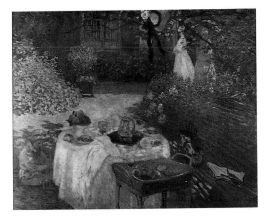

Fig. 13. Claude Monet, *Le Déjeuner (Paneau décoratif)*, 1873. 162 × 203 cm. (63¾ × 80 in.). Musée d'Orsay.

Fig. 14. Claude Monet, *La Gare St.-Lazare*, 1877. Oil on canvas, 75.5 × 104 cm. (29¾ × 41 in.). Musée d'Orsay.

Bénédite's failure to select the major *Baigneurs* canvas.[49] But after the Cézanne shows of the later 1890s at Amboise Vollard's gallery, and the Salon d'Automne retrospective of 1905, it took something like a willful blindness not to recognize the significance of such a canvas for modern art, and for the national museums. Similarly the more experimental or less highly finished works of Manet or Monet, set aside initially, could certainly have been hung with less hesitation in the epoch of the Fauves.[50]

The acceptance of one or two more choice works, however—whether in the initial negotiations or belatedly—would not have altered the notoriety of "l'affaire Caillebotte," which depended on matters of symbolism more than on any specifics. What Gustave Caillebotte intended originally, what the Impressionists' supporters wanted in the 1890s, and what devotees of modern painting have ever since chastized the officials for denying, was the symbolic victory that would have attended the acceptance of the collection as a whole. The

failure to make that wholehearted commitment left ample room for decades of polemic in which, through half-truths and incomplete accounts, the government officials were delineated with ever-more-simplified sharpness as villains of blind conservatism, weakly catering to the wounded bellowings of the philistines. Even in the face of abundant new documentation, and recognizing the nuances that have now replaced such simple notoriety, it is clear that the handling of this extraordinary bequest left a permanent legacy of its own: a zone of open-ended contestation which can continue to serve as a litmus test for political as well as artistic loyalties, and to demonstrate how often in the history and the historiography of modern art these intertwine.

The Caillebotte Collection

(According to research of Marie Berhaut)

★ indicates works selected for the Musée de Luxembourg and now in the Musée d'Orsay; they are listed in the order in which they appeared on the document connected with the final settlement (see Berhaut and Vaisse, 1983, p. 233)—an order that may in some instances reflect Bénédite's preferences (see note 44, above).

All titles given according to designation at time of bequest; these titles often differ both from titles given in the Impressionist exhibitions and from currently accepted titles. References to major catalogues have been given where possible.

EDGAR DEGAS (all pastels)

★ *Femme nue, accroupie, de dos*, c. 1879 (L 547) (Fig. 1)
★ *Femme sortant du bain*, 1877 (L 422)
★ *Les figurants*, 1877 (L 420) (Fig. 7)
★ *Chanteuse de café-concert*, c. 1880 (L 605)
★ *Danseuse assise se massant le pied gauche*, c. 1881–83 (L658)
★ *Un café boulevard Haussmann*, 1877 (L 419) (Fig. 5)
★ *Danseuse sur la scène*, c. 1878 (L 491)

EDOUARD MANET

★ *Le balcon*, 1869 (JW 150) (Fig. 11)
★ *Angelina*, 1865 (JW 118)
 La partie de croquet, 1871 (JW 197)
 Les courses

PAUL CÉZANNE

★ *L'Estaque*, 1883–85 (V 428) (Fig. 3)
★ *Cour de ferme à Auvers*, 1879–83 (V 326)
 Baigneurs au repos, 1875–77 (V 276) (Fig. 10)
 Vase de fleurs, 1875–77 (V 222)
 Scène champêtre

CLAUDE MONET

★ *Les rochers de Belle-Ile*, 1886 (W 1100)
★ *Un coin d'appartement*, 1875 (W 365) (Pl. 13b)
★ *L'église de Vetheuil*, 1879 (W 506)
★ *Le givre*, 1879 (W 555)
★ *Les Tuileries*, 1876 (W 403)
★ *Régates à Argenteuil*, 1872 (W 233) (Fig. 12)
★ *Le Déjeuner*, 1873 (W 285) (Fig. 13)
★ *La gare St.-Lazare*, 1877 (W 438) (Fig. 14)
 La gare St.-Lazare (sous le pont), 1877 (W 447)
 La gare St.-Lazare (le signal), 1877 (W 448) (Fig. 8)
 La plaine d'Argenteuil, 187? (W 437)
 Le Mont Riboudet, à Rouen, 1872 (W 216)
 Pommiers, 1878 (W 490)
 Chrysanthèmes rouges, 1880 (W 635)
 Poiriers en fleurs, 1879 (W 519)
 La Seine entre Vetheuil et la Roche-Guyon, 1881 (W 674)

AUGUSTE RENOIR

★ *Le Moulin de la Galette*, 1876 (D 209) (Fig. 6)
★ *La balançoire*, 1876 (D 202) (Fig. 4)
★ *Le pont du chemin de fer à Chatou*, 1881 (SA 1593)
★ *Bords de la Seine à Champrosay*, 1876 (SA 1585)
★ *Torse de femme au soleil*, 1876 (D 201)
★ *La liseuse*, 1874 (D 106)
 La place Saint-Georges, c. 1878
 Soleil couchant à Montmartre

ALFRED SISLEY

★ *La Seine à Saint-Mammes*, 1885 (Ds 629)
★ *Cour de ferme à Saint-Mammes*, 1884 (Ds 544)
★ *La Seine à Suresnes*, 1877 (Ds 267)
★ *Régates à Molesey, près de Hampton Court*, c. 1871 (Ds 126) (Fig. 2)
★ *Une rue à Louveciennes*, 1876 (Ds 221)
★ *Lisière de forêt au printemps*, 1880 (Ds 350)
 Effet du soir, bords de la Seine
 Station de bateaux à Argenteuil
 Pont de Billancourt

CAMILLE PISSARRO

★ *Les toits rouges*, 1877 (PV 384) (Fig. 9)
★ *La moisson*, 1876 (PV 364)
★ *Chemin montant à travers champs*, 1879 (PV 493)
★ *Potager, arbres en fleurs*, 1877 (PV 387)
★ *La brouette*, c. 1881 (PV 537)
★ *Chemin sous-bois en été*, 1877 (PV 416)
★ *Le lavoir*, 1872 (PV 282)

Louveciennes, 1871 (PV 123)
Paysage avec rochers, 1874 (PV 282)
Les choux, coin du village, 1875 (PV 312)
Le labour, 1876 (PV 340)
Le jardin fleuri, 1876 (PV 350)
Sous-bois avec personnages, 1876 (PV 371)
Vallée en été, 1877 (PV 407)
Les orges, 1877 (PV 406)
Clairière, 1878 (PV 455)

Sous-bois, 1879 (PV 505)
Traveilleurs des champs (fan)

J.-F. MILLET

★ *Paysage* (watercolor), c. 1866–68 (GM 10538)
★ *L'homme à la brouette* (drawing), 1855 (GM 10297)

ABBREVIATIONS

Berhaut, 1978	Marie Berhaut. *Caillebotte, sa vie et son oeuvre.* Paris, 1978.
Berhaut, 1983	Marie Berhaut. "Le Legs Caillebotte: Verités et contre-verités," *Bulletin de la Société de l'Histoire de l'Art français,* 1983, pp. 209–23.
Berhaut and Vaisse, 1983	Marie Berhaut and Pierre Vaisse. "Le Legs Caillebotte; Annexe: documents," *Bulletin de la Société de l'Histoire de l'Art français,* 1983, pp. 223–39.
The New Painting	Charles Moffet (ed.). *The New Painting: Impressionism 1874–1886.* San Francisco, The Museum of Fine Arts of San Francisco, 1986.
Rewald, 1973	John Rewald, *The History of Impressionism.* Fourth, revised edition. New York, 1973.
Vaisse, *BSHF,* 1983	Pierre Vaisse. "Le Legs Caillebotte d'après les documents," *Bulletin de la Société de l'Histoire de l'Art français,* 1983, pp. 201–8.
Varnedoe and Lee, 1976	Kirk Varnedoe and Thomas P. Lee. *Gustave Caillebotte. A Retrospective Exhibition.* Houston, The Museum of Fine Arts, 1976.

Abbreviations used in bequest list

D	Daulte, François. *Auguste Renoir, catalogue raisonné de l'oeuvre peint, Vol. I. Figures 1860–1890.* Lausanne, 1971.
Ds	Daulte, François. *Alfred Sisley: catalogue raisonné.* Lausanne, 1959.
GM	Guiffrey, J. and Marcel, P. *Inventaire général des dessins du Louvre, Ecole Française,* Paris, 1928.
JW	Jamot, Paul and Wildenstein, D. *Manet,* Paris, 1932.
L	Lemoisne, P. A. *Degas et son oeuvre,* Paris, 1946.
PV	Pissarro, Lodovic and Venturi, Lionello. *Camille Pissarro, son art, son oeuvre,* Paris, 1939.
SA	Sterling, Charles and Adhémar, Hélène. *Peintures Ecole Française XIXe siècle* [*Musées Nationaux*], Paris, 1961.
V	Venturi, Lionello. *Cézanne, son art, son oeuvre,* Paris, 1936.
W	Wildenstein, Daniel. *Claude Monet: biographie et catalogue raisonné,* Lausanne and Paris, 1974.

NOTES TO THE TEXT

1 BIOGRAPHY

The fullest source of information on the life of Gustave Caillebotte lies in the research published by Marie Berhaut. Her work, begun with her doctoral thesis (Ecole du Louvre, received 30 June 1947), reached definitive form in her catalogue raisonné, *Caillebotte, sa vie et son oeuvre* (Paris, 1978) (see especially "Biographie," pp. 7–21). For the part of the painter's life that was connected with the Impressionist exhibitions, the other indispensable source is John Rewald's *History of Impressionism* (4th ed., New York, 1973). The first scholarly American research paper devoted specifically to Caillebotte's biography was the M.A. thesis by Hilarie Faberman, "Gustave Caillebotte, 1875–1880" (Queens College, 1975). The brief biography published in Varnedoe and Lee, *Gustave Caillebotte: A Retrospective Exhibition*, (Houston, 1976) drew in varying degrees on the work of Berhaut, Rewald, and Faberman, and on my own work in the archives of the artist's family. In writing a new biography, inevitably, I am often traversing familiar territory and citing familiar landmarks. Especially with regard to the work of Berhaut and Rewald, the present biography is frequently dependent, and as frequently runs the risk of redundancy. I have tried therefore to stress new material from other sources and personal interpretation, and have selectively excluded material covered extensively by these scholars—material that is nonetheless important to establishing a complete picture of Caillebotte in his milieu.

1. The exact amount of Caillebotte's inheritance has not been discovered. An anonymous, undated newspaper clipping in the family archive referring to Alfred Caillebotte, Gustave's half-brother, calls him "le plus riche curé de Paris" (Alfred was a priest at Notre-Dame de Lorette), and gives his inheritance as "50,000 livres de rentes"; the amount bequeathed to Martial, Gustave and René may have been the same.

2. Martial Caillebotte was born in 1799, Céleste Daufresne in 1819. The most valuable older record of the Caillebotte family is the introduction by G. Hubert to a pamphlet, *Journal et notes du citoyen Caillebotte aîné sur les deux guerres civiles*, containing the diary of the artist's grandfather. Only 135 copies of this were printed, by the Imprimerie Follope in Flers in 1938. Hubert states that "Les Caillebottes appartiennent à une famille originaire de Ger, dans le département de la Manche, famille qui s'installa à Domfront par suite de la marriage de Pierre [the artist's great-grandfather]." Marie Berhaut (1978, p. 7) has found evidence of the family's stature in the region dating back to the early seventeenth century; she also identifies Céleste Daufresne as the daughter of a lawyer from Lisieux.

3. According to Berhaut, the family had been in the textile business since the eighteenth century. Family tradition holds that Martial Caillebotte *père* made his business selling heavy-duty cloth to the French army, and this seems confirmed by the name of the business which, according to Berhaut's research, was located in the family home at 52, rue de Faubourg St.-Denis: *Le Lit militaire* (Berhaut, 1978, p. 7).

4. The block of property was near the Gare de l'Est; this information recounted by the family.

5. See discussions of Haussmann's rebuilding of Paris in connection with notes on *Le pont de l'Europe* (Pl. 15). *Peintres en bâtiment* (Pl. 17), and *Rue de Paris: Temps de pluie* (Pl. 18). The first wave of demolition and boulevard-building concentrated on the areas of the Boulevard de Sebastopol and the Boulevard St.-Germain; the development of the area around the Boulevard Malesherbes and the Batignolles hill were part of a clearly defined second, and as it turned out final, effort, begun in the 1860s. On the rue de Miromesnil home, see Berhaut, 1978, p. 7, footnote 3.

6. On the Lycée education (he obtained "de nombreux prix d'excellence dans les disciplines litteraires"), see Berhaut, 1978, p. 8, footnote 12. Family records show that Caillebotte received his *Diplôme de bachelier en droit* in April of 1869.

7. He was enrolled in the army in 1868, and his service record shows him first attached to infantry units in Cherbourg and Rouen (see Fig. 6). He purchased a replacement to serve for him from June 1869 to June 1870. He received his *licencié en droit* on 23 July 1870.

8. Caillebotte was called to serve in the Garde Mobile on 26 July 1870. His card shows him fighting against Germany from 30 August 1870 until 7 March 1871.

9. Marie Berhaut surmises that Caillebotte began studying at Bonnat's studio soon after his demobilization from the Garde Mobile, but there seems no firm evidence to date his beginnings. He passed the entry exam for the Ecole des Beaux-Arts on 18 March 1873, as an "élève de Bonnat." Mlle. Berhaut has found in the Ecole records no indication that Caillebotte took any part in normal critiques or competitions (Berhaut, 1978, p. 8, footnote 13). In a description of Caillebotte written by Jules Montjoyeux in 1879 ("Chroniques Parisiennes: Les indèpendants," *Le Gaulois*, 18 April 1879), it was held that Caillebotte remained in Bonnat's studio into the spring of 1876.

10. See Berhaut, 1978, p. 8, and footnote 15. No documents are cited for the 1872 trip.

11. In discussing Caillebotte's entry into the Impressionist group, Marie Berhaut notes that his name appears on a list of artists in one of Degas's notebooks. She holds that this list pertains to the 1874 exhibition, and thus that Caillebotte was originally intended to appear in that first show. However, other scholars have associated Degas's list with the plans for the 1877 exhibition (see Theodore Reff, *The Notebooks of Edgar Degas*, Oxford, 1976, notebook 27, p. 36) or for the never-realized 1878 exhibition project (see Ronald Pickvance, "Contemporary Popularity and Posthumous Neglect," in *The*

New Painting: Impressionism 1874–1886, San Francisco, 1986, pp. 244–5). Moreover, as we have only one dated pastel from 1873, it is difficult to postulate which Caillebotte works might have been considered for the show.

12. Paul Tucker, "The First Impressionist Exhibition in Context," in *The New Painting*, pp. 93–113.

13. M. Pittaluga and E. Piceni publish, in their *De Nittis*, Milan, 1963, pp. 282 and 353, the correspondence between Marcellin Desboutin and De Nittis in regard to the Salon of 1875, in which Desboutin characterizes Caillebotte as "bien triste du refus de son tableau par le Jury du Salon" (cited in Berhaut, 1978, p. 9). Philippe Burty, in his article "The Exhibition of the Intransigeants" (*The Academy*, 15 April 1876), refers to Caillebotte's refusal at the hands of the jury, as does Emile Blémont in "Les Impressionistes", *Le Rappel*, 9 April 1876. The exceptionally large, bold signature of the *Raboteurs*, clearly intended to be legible at a distance, strongly suggests that this is the picture submitted. Moreover, all the other dated pictures shown at the 1876 Impressionist exhibition are dated 1876, leaving no other credible alternative candidate.

14. Emile Zola, "Deux Expositions d'Art en Mai," *Le Messager de l'Europe*, June 1876 (see Appendix A, No. 8). The fact that this review was published only in a foreign paper gave Zola freedom to be quite affirmative in his likes and dislikes.

15. Edmond Duranty, *La Nouvelle Peinture*, Paris, 1876 (see full text in translation, with commentary, in *The New Painting*, pp. 37–49). Marie Berhaut discusses at length the correspondence between Duranty's text and Caillebotte's pictures, and considers the relationship between Duranty, Degas, and Caillebotte (Berhaut, 1978, pp. 30–33).

16. Information from artist's family; also Berhaut, 1978, p. 7.

17. According to the testimony of the artist's brother Martial, recounted by Martial's daughter, Caillebotte was convinced that "on meurt jeune dans notre famille," and this belief helped prompt him to draft a will at a young age.

18. The reference to Caillebotte's payment for the rent of the studio at 17, rue de Moncey, appears in Daniel Wildenstein, *Claude Monet: Biographie et catalogue raisonné*, Vol. I, *1840–1881*, Paris, 1974, p. 83 (cited by Hilarie Faberman in her research for the biography in Varnedoe and Lee, 1976).

19. As Marie Berhaut has pointed out, all the Caillebotte works "sold" at this 1877 auction were still in his possession at the time of his death, leading one to believe that the high prices paid for them were a manner of Caillebotte's indirect contribution to the group profits. On the sale, see Merete Bodelsen, "Early Impressionist Sales 1874–1894 in Light of Some Unpublished 'Procès-Verbaux,'" *Burlington Magazine*, CX, No. 783, June

1968, pp. 331–48. In "The Caillebotte Bequest to the Luxembourg," *The Art Journal*, 1895, Jean Bernac describes the process by which Caillebotte consistently paid above-market prices for the works he acquired from his fellow painters. In one of the codicils of his will (see Appendix B), Caillebotte explicitly absolved Renoir of obligation with regard to money he had been "lending" to him. See also Mlle. Berhaut's discussion of the continuing aid Caillebotte gave to Pissarro (Berhaut, 1978, p. 17, footnote 81).

20. Richard Brettell, "The 'First' Exhibition of Impressionist Painters," in *The New Painting*, p. 190.

21. Of the Pissarro paintings shown, Caillebotte owned three, including no. 164 of the catalogue, the fine *Le verger, côte Saint-Denis, à Pontoise*, now in the National Gallery, London; of the Renoirs, the superb *Balançoire*, now in the Musée d'Orsay; of the many Monets, the *Intérieur d'appartment*, no. 115, also in the Musée d'Orsay; and of the Degas works, three pastels, all now in the Musée d'Orsay, including the striking *Femmes devant un café, le soir*. The Cézanne *Baigneurs* shown in this exhibition is now thought not to be the canvas Caillebotte owned (now in the Barnes Foundation) but a smaller study for it (see Brettell, loc. cit., p. 196).

22. Berhaut, 1978, pp. 13–14.

23. See Pickvance, loc. cit., esp. pp. 243–8.

24. Diego Martelli, "Gli Impressionisti, mostra del 1879," *Roma Artistica*, 27 June and 5 July 1879, cited in *The New Painting*, p. 275.

25. Jules Montjoyeux, "Chroniques Parisiennes: Les Indépendants," *Le Gaulois*, 18 April 1879, cited in part by Pickvance, loc. cit., p. 252. My thanks to Charles Moffatt and Ruth Berson for supplying me with the text of this article.

26. An undated letter from Degas to Bracquemond, published in Marcel Guérin, ed., *Lettres de Degas*, 1931, p. 51. Cited by Rewald, 1973, and by Berhaut, 1978, p. 12, footnote 41.

27. In her discussion "Caillebotte et la littérature naturaliste" (Berhaut, 1978, pp. 29–32), Marie Berhaut sees little rapport between Caillebotte and Huysmans, apparently considering later Huysmans works such as *A Rebours*. However, earlier Huysmans novels such as *En Ménage* seem closely parallel in subject and treatment to Caillebotte's scenes of Parisian interiors c. 1880.

28. Caillebotte to Pissarro, 24 January 1881. Rewald (1973, pp. 447–9) long ago published major parts of this invaluable letter, which is reproduced in full in Berhaut, 1978, pp. 245–6.

29. Pissarro to Caillebotte, 27 January 1881, published in full in Berhaut, 1978, p. 246.

30. Caillebotte to Pissarro, 28 January 1881, published in full in Berhaut, 1978, p. 246.

31. Caillebotte to Pissarro, n.d., published in full in Berhaut, 1978, p. 247. See the discussion of Caillebotte's efforts by Joel Isaacson in his "The Painters Called Impressionists," in *The New Painting*, p. 376.

32. See Marie Berhaut's discussion of the letters exchanged by Monet and Pissarro regarding a "misunderstanding" in a letter from Durand-Ruel to Monet, apparently proposing that Caillebotte be eliminated from the group (Monet responding that "I would have better liked to have Caillebotte than Messieurs Guillaumin, Vignon and Gauguin put together," and holding that "if I accept showing with them [lesser painters proposed by Durand-Ruel] in order to get rid of Caillebotte who, even if he has caused some howls, has also done a lot for the success of our exhibitions, I could rightly be judged harshly by him." Berhaut, 1978, p. 12).

33. Caillebotte to Pissarro, n.d., published in full in Berhaut, 1978, pp. 246–7.

34. See Isaacson, loc. cit., pp. 377–8.

35. Fichtre [Gaston Vassy], "L'actualité: L'Exposition des peintres indépendants," *Le Reveil*, 2 March 1882, cited

by Isaacson, loc. cit., p. 378.

36. For a full discussion of this "crisis" and of the previous literature concerning it, see Joel Isaacson, *The Crisis of Impressionism: 1878–1882*, University of Michigan Museum of Art, 1980.

37. From an undated, anonymous newspaper clipping in the artist's family's archive.

38. Arsène Alexandre, "Le Legs Caillebotte," *Le Paris*, 13 March 1894.

39. Rewald (1973, p. 456) identifies Caillebotte as the man at right sitting astride the backward-turned chair, while observing—quite rightly—that this figure seems much younger than Caillebotte would have been at that date. Moreover, the figure does not have the beard seen in photographs of Caillebotte. François Daulte, in *Auguste Renoir, Catalogue raisonné de l'oeuvre peinte*, Vol. I, *Les Figures (1860–1890)*, Lausanne, 1971, no. 379, also identifies this figure as Caillebotte. However Georges Rivière, in *Renoir et ses amis*, Paris, 1921, pp. 186–7, does not mention Caillebotte in his description of the painting. Though there is no documentary proof, it seems far more likely (on the basis of physiognomy, age, hair color and beard) that Caillebotte is the figure facing the viewer, seated at a table, in the other, smaller Renoir *Déjeuner des canotiers* in the Art Institute of Chicago.

40. François Daulte, op. cit., no. 432, identifies the subject of an 1883 Renoir portrait as Mme. Hagen, Caillebotte's consort. According to Marie Berhaut (personal communication) Mme. Hagen is not simply another name for Mlle. Charlotte Berthier; they were two different women—Mlle. Berhaut believes the Renoir portrait is actually of Charlotte Berthier. In 1883, the date of the Renoir portrait, Caillebotte added a codicil to his will (see Appendix B) granting a life annuity to Charlotte Berthier. Mlle. Berhaut has found a census record of 1891 (Berhaut, 1978, p. 21, footnote 58) that lists Charlotte Berthier as residing at Petit-Gennevilliers with Caillebotte (the census also shows two deckhands and four house-servants in the menage). Her age in 1891 is given as 28. Thus if they met around 1882 Caillebotte would have been 42 and she 19.

41. See the description of the Impressionist exhibitions in America in Hans Huth, "Impressionism Comes to America," *Gazette des Beaux-Arts*, April 1946. See Berhaut, 1978, p. 250, for a list of works, including the *Raboteurs de parquet*, shown by Caillebotte.

42. Françoise Cachin, Signac's granddaughter, has affirmed that Signac bought his first boat in 1883 under Caillebotte's guidance. There is no firm documentary proof of Caillebotte's connection to Seurat, but given the friendship with Signac at this date—in advance of Signac's real career as an artist—it seems likely Caillebotte would have come to know Seurat as well. See Cachin, *Signac*, 1971, p. 10. (cited in Berhaut, 1978, p. 15).

43. The source for information on these dinners, cited by all authors, are the recollections of Gustave Geffroy (a participant) in his *Claude Monet, sa vie, son oeuvre*, Vol. II, pp. 1–2. These dinners apparently began early on; the Durand-Ruel archives contain a letter from Caillebotte to Durand-Ruel dated 1 June 1885, inviting him to such a gathering. They were reinstituted in the 1890s, as witness a letter from Monet to Caillebotte, 27 March 1890, setting up a lunch on 3 April to be followed by "le diner au Café Riche, car j'espère bien qu'il aura lieu" (Berhaut, 1978, p. 248). Also in the Durand-Ruel archives is another letter from Caillebotte to the dealer, dated 1 November 1891: "Voilà le moment de reprendre nos bonnes habitudes. Je préviens tout le monde et je compte bien que les fidèles seront toujours là. Donc à jeudi 7 h. Café Riche."

44. The account of Caillebotte's activities as Conseiller Municipal is in Jean Bernac, "The Caillebotte Bequest to the Luxembourg"; see Berhaut, 1978, p. 16.

45. The artist's family has in their archive some as yet unpublished correspondence between Caillebotte and Monet on the subject of gardening. It would be an exaggeration to suppose that Caillebotte's garden in Petit-Gennevilliers had a decisive influence on Monet's activities at Giverny. Monet had already shown himself a committed gardener in Argenteuil and Vetheuil before Caillebotte moved to Petit-Gennevilliers. It seems more likely that Monet counseled Caillebotte.

46. For a full account of Caillebotte's activities and reputation as a yachtsman (a subject on which there are surprisingly full contemporary accounts), see Berhaut, 1978, Nos. 15–16.

47. On the plans for a Caillebotte exhibition in 1894, the family archives preserve an anonymous, undated obituary notice that states: "Il est mort, bien avant l'heure, à quarante-six ans, au moment même où ses amis allaient organiser une exposition d'ensemble de ses oeuvres."

48. On the progress of his fatal illness, see Adolph Tabarant, "Le Peintre Caillebotte et sa collection," *Bulletin de la vie artistique*, August 1921, p. 406.

49. Camille Pissarro to Lucien Pissarro, 1 March 1894, in Pissarro, *Lettres à son fils Lucien*, Paris, 1943, p. 336. In citing this letter, Marie Berhaut notes that another great early collector of Impressionism, Dr. De Bellio, had also recently passed away (Berhaut, 1978, No. 18, footnotes 104 and 105).

50. Gustave Geffroy in *Le Journal*, 25 February 1894, cited *in extenso* in Berhaut, 1978, No. 261.

51. See the large excerpts from posthumous articles on Caillebotte in Berhaut, 1978, Nos. 261–2.

52. An annotated handlist of the 1894 exhibition is in the archives of the artist's family. There are indications of a few sales, and some works are listed as already belonging to collectors. A sample of prices: *Intérieur* (Pl. 35) was priced at 2,000 francs, as was *Peintres en batiment* (Pl. 17), while *Rue de Paris; Temps de pluie* (Pl. 18) was priced at 4,000 francs.

53. Alexandre Hepp, "Impressionism," 3 March 1882; cited in *The New Painting*, 399.

54. Gustave Geffroy, *Claude Monet, sa vie, son oeuvre*, Vol. II, p. 32. Hilarie Faberman cited this remark in her research for the biography in Varnedoe and Lee, 1976.

55. Jean Renoir, *Renoir, My Father*, Boston, 1962, p. 265. Hilarie Faberman cited this remark in her research for the biography in Varnedoe and Lee, 1976.

56. See the selections from Salon criticism in 1921, and from other histories of Impressionism, in Berhaut, 1978, Nos. 262–3.

57. Robert Rosenblum, "Gustave Caillebotte: The 1970s and the 1870s," *Artforum*, March 1977, pp. 46–52.

2 CAILLEBOTTE: AN EVOLVING PERSPECTIVE

Given the general nature of this chapter, and the fact that it represents my own speculations, footnotes seemed inappropriate and potentially distracting. I would like, however, to cite a few people and sources who contributed to what is said here. For initially suggesting to me the comparison between Klinger, Tissot, and Caillebotte, I thank Lorenz Eitner. For his help in the style of the chapter, and for the discussions that brought into focus many of its ideas, I thank my brother, Sam Varnedoe, Jr. The initial impetus for the analysis of near and far was stimulated by a mention, in Mario Praz's *Mnemosyne*, (Princeton, 1970), of Rudolf Zeitler's analysis of dichotomous distance structures in Romanticism. Zeitler's discussion occurs in "Dualismus" in his *Die Kunst des neunzehenten jahrhunderts*, Berlin, 1966, pp. 36ff. In relation to what is said here about Caillebotte's self-consciousness of vision, and also in relation to Peter Galassi's conclusion in Chapter 4, Mario Praz's comments in footnote 16, on page 233 of *Mnemosyne*, seem highly germane.

Caillebotte's images of workers would seem exceptions to my last comparison, between his subject interests and those of Degas. However, it should be remembered that this exploration, highly important as an early phenomenon, is not pursued after 1877. Furthermore, Caillebotte painted workers only in his world, not theirs—in the home and in the street, in contrast to Degas's investigations of the coulisses, the bordellos, etc.

3 CAILLEBOTTE'S SPACE

1. Charles Blanc, *Grammaire des arts du dessin*, Nouvelle Edition, Paris, n.d. (after 1880), pp. 512–13. This book, already in a second edition by 1870, was the academician's bible in the latter part of the nineteenth century. Blanc cites Leonardo da Vinci's counsel that all representations should be governed by a standard angle of view, or seen through a single "window," such that the spectator could take in the whole of the picture in one glance, without turning the head. In more or less specific terms, each writer on perspective considered the same problem.

2. Blanc, *Grammaire*, 2nd ed., 1870, p. 542.

3. Blanc's 3:1 ratio would yield an angle of view of only 20 degrees. Armand Cassagne, in his *Traité Pratique de perspective*, Paris, 1858; 3d ed., 1873, advised a 2:1 ratio, or an angle of 29 degrees. Earlier, A. D. Vergran, in his *Nouveau Manuel Complet de Perspective, du dessinateur et du peintre*, 5th ed., Paris, 1841, advises 45 degrees as being still within the range of the normal. The angle of vision of the *Pont de l'Europe*, derived from an overhead plan of the site (see Chapter 4), is slightly more than 80 degrees; from that angle we find that Caillebotte's distance ratio was approx. 3:5, or five times closer than Blanc recommended.

4. "Anamorphoses épouvantables" from A. de M. in "Perspective savante et perspective pittoresque," in *Revue Universelle des Arts*, Brussels, Vol. 10, 1859. "Déformations monstrueuses" from Blanc, *Grammaire*, Nouvelle Edition, p. 512.

5. The 55mm. lens and 35mm. film format gives a 36 degree field of view. In 1867, D. von Monckhoven already counseled that the photographic angle of vision "between 50 and 60 degrees is more than sufficient, because if this angle is more considerable the effect of the perspective is doubtless more astonshing than agreeable" (*Photographic Optics; including the Description of Lenses and Enlarging Apparatus*, London, 1867, trans. from the French, p. viii). A. Soret, in *Optique Photographique: Notions nécessaires aux photographes amateurs. Etude de l'objectif: applications*, Paris, 1891, pp. 79–80, notes that the standard, universally used lenses are standard aplanats, with fields of view around 45 degrees. René Colson, in his *La Perspective en photographie*, Paris, 1894, advises that the best lens for an 18 × 24 cm. format is a 30mm. lens, and this yields an angle of view of 43 degrees. The authoritative modern manual, Ansel Adams's *Camera and Lens: The Creative Approach*, revised ed., New York, 1970, p. 28, specifies that "The focal length of a normal lens for any size picture format is equivalent to the diagonal of the format." For a 35mm. format, this means a 54–55mm. lens. Adam also explains the particular uses of shorter lenses (p. 29):

"Lenses of greater than normal angle of view give the impression of increased space (and reduced image size), and lenses of less than normal angle of view give the impression of reduced space (and larger image size). Lenses of less than normal focal length for any given format size are most helpful in 'near-far' compositions where great depth of field and/or intentional variations of subject-image scale are required."

I would like to thank Prof. Rudolph Kingslake for his patient help with initial research on the optical properties of Caillebotte's spaces.

6. Note that the 55mm. views, Figs. 1, 2, and 3, were taken from a point further back, in order to encompass approximately the same scene elements Caillebotte included. A 55mm. "normal" photo taken from the point where Caillebotte stood, in each case, only shows a very small detail of the central elements shown in each painting. I would like to thank the people who humored me by posing for these photographs: Philippe Brame, the man at the window, who by a marvellous coincidence is in this photograph looking directly across the Boulevard Malesherbes at the art gallery of which he is co-proprietor with Bernard Lorenceau, and from which several important Caillebotte paintings have been sold: and the cast of the recreated *Le pont de l'Europe* and *Temps de pluie*, Bud and Judy Marschner, Bill Logan and Gillian Anderson, and Katherine Davis. Special thanks to Bill Logan and to Bud Marschner for other help in measuring and photographing these sites.

7. "Non, la verité mathématique n'est pas de même nature que le verité pittoresque. Aussi bien, il arrive à tout moment que la géometrie dit une chose et que notre âme en dit une autre. . . . Il n'est sans doute que l'oeil de Dieu qui puisse voir l'univers en géometral; l'homme, dans infirmité, n'en saisit partout que des raccourcis." (Blanc, *Grammaire*, Nouvelle Edition, pp. 512, 513.)

8. op. cit. Cassagne.

9. See Cassagne, op. cit., 3d ed., 1873, pp. 30–31 for advice against off-center viewpoint; p. 17 for counsel against too-close viewpoint and too-wide field; pp. 141–2 for advice to draftsmen about relieving the ungracious effects of odd viewpoints upon forms.

10. The important technical advances in wide-angle lenses were made around 1866, by several different people. See van Monckhoven, op. cit., p. 120.

11. The big advance in this respect was the rise in stereoscopy. The stereoscopic camera was first shown in France at the Exposition Universelle of 1851. An improved model was made available by Duboscq and Hemargis in the late 1850s. See Raymond Lecuyer, *Histoire de la photographie*, Paris, 1945, p. 277. John Szarkowski relates: "Unposed street photographs of one sort or another had been made since the 1850's; the relatively small negatives of the stereograph allowed the use of short focal-length lenses that gave adequate exposure at snapshot speeds, which more or less stopped normal street action if the photographer kept his distance. These were basically photographs of places—generally famous avenues, plus an insect-like pattern of people and carriages. If, on the other hand, the photographer wished to describe the people on those streets, and something of the quality of their lives . . ., he posed the photograph." (*Looking at Photographs*, New York, 1973, p. 54.) Szarkowski's remarks are especially important in distinguishing a work like the *Temps de pluie*, with its looming foreground figures, from the general run of street views, which purposely sought elevated viewpoints. We have yet to find a photo that resembles the *Temps de pluie* in this respect of figure scale. Caillebotte, of course, also used elevated viewpoints, as in *Un Refuge, Boulevard Haussmann* (Pl. 43). Aaron Scharf, in *Art and Photography*, Baltimore, 1974, p. 176 (and illustrations 115 and 116, p. 175), compares Caillebotte's view to that of stereo photos taken from high vantage points, showing similar distortion of a circular form in the field. For further consideration of these issues, see Kirk Varnedoe, "The Artifice of Candor: Impressionism and Photography Reconsidered," *Art in America*, January 1980.

12. See the comments of van Monckhoven, in note 5, above, on wide-angle deformation. The same author goes on to discuss the effects of moving the camera too close to a large building, and warns against "those unfortunate distortions in which the houses are seen falling towards the street, towers leaning, etc., and which cause the photographic art and the objectives to be unjustly accused of deforming the images—a reproach only merited by the operator ignorant of the precepts of optics." Colson, in *La Perspective en photographie*, stated on p. 1: "La fidelité de la perspective et de l'effet est une question capitale en photographie. N'est-ce pas là, en effet, le bût même du procédé? Et ne doit-on pas s'éfforcer d'éviter que la sensation procurée à l'oeil par l'image obtenue allonge, raccourcisse, déforme la perspective, et produise un effet faux, tout different du modèle?" Colson goes on to describe the effects of moving too close to the subject, in terms highly relevant to Caillebotte's work: ". . .l'erreur oculaire consiste dans un allongement de la perspective: les objets paraissent plus éloignés qu'ils ne sont en réalité, et cela d'autant plus que leur distance véritable augmente. On arrive ainsi à prendre pour des lointains des portions de paysages situées, dans le modèle, à des distances médiocres, et à attribuer des longueurs considérables, s'étendant souvent à perte de vue, à des rues, des murs, des allées, des monuments d'un developpement modeste; de même, dans un groupe, les personnages placés en arrière semblent très éloignés. C'est encore ainsi que les différentes parties d'un même objet semblent plus écartés entre elles, dans le sens de la vue." (p. 13).

13. See the comments of Aaron Scharf on Caillebotte's *Boulevard vu d'en haut* in *Art and Photography*, p. 176. Beyond that limited instance of an extreme plunging view, it is true in a more general sense that, if Caillebotte's pictures have a "photographic" look about them now, it is largely due to developments in photography in the twentieth century, and especially since 1920. A composition like the *Temps de pluie*, for example, anticipates by decades the kind of street photography that began to appear after 1920 when photographers consciously began to exploit the potential of the momentarily eccentric, began to control the camera in situations of chance. In this regard, we cannot resist relating a story passed on to us by John Szarkowski of the Museum of Modern Art. Mr. Szarkowski had, for some time, a photograph of Caillebotte's *Temps de pluie* on his bulletin board. One day Henri Cartier-Bresson came to the office, and, glimpsing the *Temps de pluie* from across the room, he stabbed out a finger to point at it. As if sensing a rival or an imitator, he demanded, "Who took that?".

14. Jules de la Gournerie, *Traité de perspective linéaire*, Paris, 1859; 3d ed., 1898, p. 170. La Gournerie discusses the fact that Zoroaster's ball in the fresco is seen as a circle, when an elipse would be the technically correct projection. For a fuller consideration of this phenomenon and the case of *The School of Athens*, see M. H. Pirenne, *Optics, Painting and Photography*, Oxford, 1970, pp. 121–3.

15. In describing Dürer's problems with perspective and the results in *On the Rationalization of Sight* (orig. published 1938, see Da Capo Press reprint, New York, 1975), William Ivins remarks on the following phenomena:

". . . his vanishing point away off towards the edge of his picture in a position which, when emphasized by his "wide-angle" distortion, has the effect of making any picture so constructed appear, in a subtly disturbing way, as though it were only half a picture. . . .

". . . although the architecture and each of the figures was possibly correct from its own special point of view, all but one of them was sadly incorrect from any single point of view.

". . . These distortions were coupled with the utmost realism in the delineation of forms. . . .

". . . The consistency with which he carried out these various distortions amounts almost to a methodical denial of the homogeneity of space. This fundamental contradiction of one of the great intuitive bases of experience produces a subtle psychological malaise in the beholder of his work that, not being readily traceable to

an obvious is doubtless one of the principal reasons for the peculiar fascination that his work has always exercised over the minds of men" (pp. 40–43).

16. See Anne Stiles Wylie, "An Investigation of the vocabulary of line in Vincent van Gogh's Expression of Space," *Oud Holland*, 4 (1970), p. 213. Wylie cites van Gogh's reference to "all Cassagne's books" in an 1881 letter to his brother, and other specific references to some of Cassagne's books. The *Traité Pratique* is not among the titles specifically mentioned, but Wylie makes a strong case that van Gogh made use of it.

17. For the genesis of Munch's *The Scream*, see Reinhold Heller, *Edvard Munch: The Scream*, New York, 1972. As the initial sketches for *Despair* date from soon after Munch's departure from Paris, it seems worth speculating whether a memory of the *Pont de l'Europe* may not be involved (this in light of the other evidence, of Pl. 41, that Munch knew Caillebotte). The similarities of the derbyed man on the rail, the other figures further back, and the general spatial structure, seem to reinforce such speculation. Particularly interesting, too, is the slant of the cloud pattern in the original idea sketch, as this slant seems to echo, in "ghost" fashion, the slant of the trellis-top in the *Pont*.

4 CAILLEBOTTE'S METHOD

1. This chapter deals largely with material assembled by Kirk Varnedoe, and was developed under his attentive tutelage. It also draws on two articles written by him: "Caillebotte's *Pont de l'Europe*: A New Slant," *Art International*, 18, No. 4, 20 April 1974, pp. 28–9 ff. and "Gustave Caillebotte in Context," *Arts Magazine*, 50, No. 9, May 1976, pp. 94–9. I am also thankful for the comments of John Szarkowski.

2. The preparatory works for the *Pont de l'Europe* and the *Temps de pluie* are not dated. Caillebotte may not have followed step by step the hypothetical sequence that is proposed here to rationalize the analysis of the pictures.

3. This chapter deals with four of the six: *Le pont de l'Europe* (Pl. 15), *Rue de Paris; Temps de pluie* (Pl. 18), *Canotiers* (Pl. 20), and the *Paul Hugot* (Pl. 30). The other two are: *Les Dahlias* (Pl. 58) and *Régates à Argenteuil* (Pl. 61).

4. Arthur Chevalier, *L'Etudiant Photographe*, Paris, [1867], p. 58. Chevalier lists the following plate sizes (in cm.) as the most common: 9 × 11, 13 × 18, 18 × 24, 27 × 21, 30 × 34, 37 × 28. The first and third of these correspond to the sizes of known photographs by Martial Caillebotte.

5. The cabinet portrait measured approximately 5½ × 4 inches (14.0 × 10.2 cm.). It was introduced in 1866 and was "universally adopted" by 1868. Helmut and Alison Gernsheim, *The History of Photography*, New York, 1969, p. 303.

6. For a fuller discussion of this and other aspects of the *Pont*, see Varnedoe, "Caillebotte's *Pont de l'Europe*."

7. None of the known photographs by Martial Caillebotte encompasses the abnormally wide view that is represented in the *Pont de l'Europe*, though such wide views were common in photographs of the time (see Chapter 3). But a portion of the drawing, Pl. 15f, defined by a 9 × 12 cm. rectangle (a common photographic format that Martial Caillebotte used), whose upper and left edges are coincident with the same edges in the drawing, describes an angle of view of about 50°. This angle corresponds to the field of view of standard lenses of the period (see Chapter 3); judging from Martial Caillebotte's known photographs, his was such a standard lens. This portion of a drawing, contains more than a sufficient part of the main lines of the bridge; the parts not included could simply have been extended in straight lines. There is some indication in the drawing that it was made in just this way.

8. The rules of linear perspective tell us that since the girders lie in the same plane in space as the top of the trellis and the railing, all the girders, if extended, should meet at either of two vanishing points on a vertical line drawn through the vanishing points for the trellis and railing. Instead, they meet at two points on a vertical line that is distinctly to the left. The girder structure is defined, then, by a slightly different perspective from that which defines the drawing's main lines.

9. The perspective terminology used here is standard with the exception of the term "center of vision," which refers to that point in the construction that is often called the central vanishing point or principal point. The term "center of vision" is borrowed, for its relevance to our problem, from Rudolf Wittkower and B. A. R. Carter, "The Perspective of Piero Della Francesca's 'Flagellation'," *Journal of the Warburg & Courtauld Institutes*, 16, 1953, p. 295.

10. For a careful examination and illustration of this and other aspects of perspective see M. H. Pirenne, *Optics Painting & Photography*, Cambridge, 1970. In regard to the point at hand, Pirenne remarks: "By changing only the orientation of the surface of projection, any number of different photographs, or perspective drawings, can therefore be made of the same identical scene from exactly the same centre of projection.... As a rule, only trained artists and photographers clearly realize the different results which will be obtained if the same view is projected onto planes differing in their orientation." (p. 105).

11. *Grammaire des Arts du Dessin*, 2nd ed., Paris, 1870, II, p. 548.

12. Since we do not have a plan of the entire site that is large enough to indicate the structure of the trellis, Fig. 4 is a composite of two plans: one for the entire site (Fig. 3, on which the painter's field of view can be constructed) and another for the trellis structure (derived from a photograph [Pl. 15e]). In combining two plans so different in scale, the margin of error is large—perhaps as much as ten percent. But the essential purpose of this plan is to demonstrate that the *Pont de l'Europe* represents two separate projection planes. These planes are so different in orientation that the margin of error is inconsequential for that essential purpose.

13. This is possible because the incline of the railing means that at each bay it meets the girder structure at a different height (see the photograph of the site [Pl. 15e]).

14. The specifications for the Place de l'Europe are given in great detail in "Transformation de la Place de l'Europe," *Paris Nouveau Illustré* (supplement to *L'Illustration*), No. 14, n.d., pp. 222ff.

15. It is not demonstrable that all three drawings precede both sketches, although it is certain that Pl. 15f does. Since the drawings deal only with the architecture and the sketches deal mainly with the fit of figures into the architecture and with color, light, etc., it is conceivable that Caillebotte alternated between drawing and sketch. In any case, every step in the development of the picture makes it clear that the painter had always in mind *all* the problems involved in the presentation of his initial conception.

16. Another detail study, depicting the same area of the finished work, does include the worker (Berhaut, 1978, No. 43).

17. The study's center of vision is, horizontally, the midpoint and, vertically, just above the mid-point of the picture. The study is, then, the equivalent of a slightly cropped photograph, made with a camera stationed at the finished picture's viewpoint and aimed at the position of the worker.

The distant architecture in the detail study is slightly lower in relation to the trellis structure than it is in the two oil sketches, indicating that the detail study's viewpoint is slightly lower. The lower viewpoint—so slight a change as to be immaterial to the structure and feeling of the picture—is also evident in the finished painting. Therefore, the detail study probably immediately precedes the final painting.

18. Chevalier, op. cit.; see n. 4.

19. For a definition of the golden section, see the caption to Fig. 6. Some aspects of the picture's surface design, including a few golden section divisions, are identified in Max Imdahl, "Die Momentfotografie und 'Le Comte Lepic' von Edgar Degas," in *Festschrift für Gert von der Osten*, Köln, 1970, pp. 228–34.

20. Gernsheim, op. cit., pp. 254–9.

21. Jules de La Gournerie, *Traité de Perspective Linéaire*, Paris, 1859; 3rd ed., 1898, p. xv.

APPENDIX B
CAILLEBOTTE'S WILL AND BEQUEST

1. Gérôme responded to an inquiry regarding the bequest from the *Journal des Artistes*, 8 April 1894: "Caillebotte? n'a-t-il pas fait de la peinture lui-même? . . . Je n'en sais rien . . . je ne connais pas ces messieurs, et de cette donation, je ne connais que le titre . . . Il y a là-dedans de la peinture de M. Manet, n'est-ce pas? . . . de M. Pissaro [sic] et d'autres? . . . Je le répète, pour que l'Etat ait accepté de pareilles ordures, il faut une bien grande flétrissure morale." Continuing, with specific regard to Pissarro works he had seen, Gérôme ranted: "Je vous le dis, tout ça . . . des anarchistes! . . . et des fous . . . Ces gens-là peignent chez le Docteur Blanche . . ., ils font de la peinture sous eux, vous dis-je . . . c'est la fin de la nation." (Cited in Jeanne Laurent, *Arts et pouvoirs en France de 1793 à 1981*, St.-Etienne, 1982, pp. 89–90.)

2. See Select Bibliography, below. An extensive chronology and appendix of relevant documents was published in connection with the paired articles by Marie Berhaut and Pierre Vaisse in the 1983 *Bulletin de la Société de l'Histoire de l'Art français*. My thanks to Jeffrey Weiss for help in researching the recent debate.

3. Vaisse, *BSHAF*, 1983, p. 203.

4. Vaisse, *BSHAF*, 1983, p. 204 and footnote 15. See also Berhaut and Vaisse, 1983, Appendix X.

5. See Bénédite's remarks in Berhaut, 1983, Appendix XIII, and those of Roujon in Appendix XIX, as well as Bénédite's 1921 recollections of the painters' opinions, cited by Vaisse, *BSHAF*, 1983, p. 204.

6. Berhaut stresses the conflict between Bénédite's affirmations of the painters' doubts about hanging the whole collection, and the evidence of Monet's and Renoir's letters expressing concern that the will be followed as written. See Berhaut, 1983, p. 211. See also Berhaut's strong defense of Martial Caillebotte and Renoir, against the implications of Vaisse's critique, in Berhaut, 1983, pp. 216–17.

7. The Renoir was purchased directly from Renoir, the Manet gift came via public subscription initiated by Monet and other artists. See discussion of the Luxembourg's acquisitions and acquisition priorities in 1892—including published reports of Degas's refusal to cooperate in the attempt to add him to the collection—in Vaisse, *BSHAF*, 1983, p. 204.

8. Jeanne Laurent mentions the purchase of the Morisot *Jeune femme en toilette du bal* from the sale of the collection of Théodore Duret, in March 1894 (precisely at the moment when the Caillebotte bequest was first being considered) and cites Bénédite's 1921 recollection that the clamor surrounding this purchase added to the opposition to the Caillebotte bequest ("L'Affaire Caillebotte, le refus de 29 tableaux impressionistes (1894–1897)," in *Arts et pouvoirs en France de 1793 à 1981*, St.-Etienne, 1982, p. 89).

9. A symptomatic acquisition was the purchase of Fantin-Latour's *Atelier des Batignolles* in 1892. The Luxembourg

thus obtained a picture which "admitted" the Impressionists and Manet via their portraits, but also via a picture of quite sober color and brushwork which had nothing to do with the innovations of Monet, Renoir, *et al.*; see Vaisse, *BSHAF*, 1983, p. 208, footnote 18.

10. These are the first words in a note written by Roujon on receiving notification from Renoir of the bequest. See Berhaut and Vaisse, 1983, Appendix III. Note that Roujon was already wary of the affair, even before becoming aware of the full stipulations of the will.

11. See Berhaut and Vaisse, 1983, Appendix IV, where Kaempfen is recorded as explaining to the committee that the meeting was held "pour examiner à l'avance les ouvrages . . . et s'entendre avec l'exécuteur testamentaire, M. A. Renoir et M. Martial Caillebotte, frère du testateur, au sujet de l'interprétation qu'il serait possible de donner aux termes du testament."

12. See Berhaut and Vaisse, 1983, Appendix IV: "Monsieur Renoir ayant admis le bien fondé de ces observations, le Comité a, en conséquence, à statuer sur l'acceptation intégrale du legs avec placement au Luxembourg, sans qu'il y ait obligation pour l'Administration d'exposer tous les tableaux légués."

13. See the correspondence between Renoir and Martial Caillebotte in April 1894, published in Berhaut, 1983, Appendix IX, which reflects their continuing worry over the state's exact adherence to the will's provisions.

14. See Berhaut and Vaisse, 1983, Appendix IV: "Il reste une question délicate, c'est le placement au Luxembourg. M. le Directeur a fait connaître dans quelles conditions ce legs serait accepté, c'est-à-dire en ne plaçant environ qu'un tiers des collections. La place manque, néanmoins, totalement pour accrocher ces oeuvres. Mais M. Bénédite estime qu'il serait possible de construire sur la terrasse du Musée un baraquement provisoire où serait réuni le legs Caillebotte. L'acceptation de ce legs peut même hâter un peu, selon lui, la question de la reconstruction du Luxembourg qui est posée officiellement." Note the crucial ambiguity here. Does Bénédite imply that the current space will not allow him to hang completely even the reduced selection he wants to hang? Or the whole collection as given? Thus, will the new space allow him only to hang completely the reduced selection, or will it allow what the will intended, the hanging of the entire donation together?

15. The doubts of Renoir in regard to the state's intentions might well have been underlined by the reports published in the press following the announcement of the acceptance. In the *Chronique des arts et de la curiosité* of 24 March 1894, an article reported that "Comme plusieurs oeuvres étaient d'un intérêt médiocre, il a été convenu d'un commun accord que, seules, les principales seraient exposées au Luxembourg . . . il y a deux oeuvres de Manet . . . deux de Renoir . . . plusieurs Degas . . ." The same notion of a partial hanging was reaffirmed in the *Journal des art* the same day (see Berhaut and Vaisse, 1983, Appendix V). On 14 April, Renoir wrote that he did not believe (pending advice of counsel) that the government's simple letter of acceptance should be agreed to on faith; but on 17 April, he wrote that he had had a change of heart, and now thought the government position should be given an optimistic interpretation (see letter in Berhaut and Vaisse, 1983, Appendix IX).

16. See Monet's letter of 22 April 1894, in Berhaut and Vaisse, 1983, Appendix X: "Il faut obtenir de l'Administration des Beaux-Arts qu'aucun des tableaux donnés par Gustave ne soient relégués dans des greniers ou envoyés en province."

17. Martial Caillebotte responded to Renoir (see note 15, above) that "Il ne peut être question de bonne foi sur les intentions de l'Etat—nous avons été prévenus dès le premier jour par M. Roujon lui-même que le Luxembourg ne pouvait accrocher et il résulte de mes renseignements personnels qu'à l'heure actuelle leur intention n'a pas changé." He concluded, after talking to a lawyer, that, given the specter of being forced to bring suit against the state for non-compliance with the will, he should make it known verbally to Roujon that it was their formal intention to have the specific stipulations of the will respected, and then to try to find a way to agree. See Martial Caillebotte's copy of this letter, in Berhaut and Vaisse, 1983, Appendix IX.

18. Monsieur Trawinski, an employee of the Direction des Musées Nationaux, sent a letter to a friend on 11 April 1984, which suggests the attitudes of the government agencies involved. It specifies that immediate hanging in the Luxembourg is impossible, and that an annex is the only possible solution. This, he says, is a "question réservée et il vaut mieux n'en pas parler du tout." (See Berhaut and Vaisse, 1983, Appendix VII.)

19. See note 5, above.

20. See Berhaut and Vaisse, 1983, Appendix XI, for Roujon's report of his meeting with Renoir and Martial Caillebotte.

21. See Berhaut and Vaisse, 1983, Appendix XII, for Bénédite's letter to the Director of the National Museums, regarding the arrangement struck by Roujon: ". . . cette interprétation des termes du testament est fausse. Elle n'est conforme ni à la lettre ni à l'esprit, et je suis convaincu que le Conseil d'Etat ne sanctionnerait jamais cette manière de voir."

22. Ibid.: "Cette manière de voir a été entièrement accepté par M. Martial Caillebotte et M. Renoir, et partagée par M. Claude Monet, présent à l'entretien."

23. See the letter from Martial Caillebotte's lawyer, E. Poletnich, reporting the proposition made to him—essentially the arrangement involving Fontainebleau and Compiègne—by the government's notary, on 12 December 1894 (Berhaut and Vaisse, 1983, Appendix XV).

24. See Berhaut, 1983, p. 212, citing a letter from Renoir to Martial Caillebotte of 29 September 1894, in a private archive in Paris, and also Bénédite's letter to Renoir of 7 December, announcing his intention to take the pictures (Berhaut and Vaisse, 1983, Appendix XIV).

25. See Berhaut and Vaisse, Appendix XIV.

26. See Bénédite's letter to Kaempfen of 22 December 1894 (Berhaut and Vaisse, 1983, Appendix XVI), where Bénédite describes "une combinaison, issue de notre entretien avec M. Martial Caillebotte et qui, je crois, terminerait cette affaire à la satisfaction de tous."

27. See especially the article by Octave Mirbeau ("Le Legs Caillebotte et l'état," *Le Journal*, 24 December 1894; reprinted in *Des Artistes, Première série. 1885–1896. Peintres et sculpteurs*, Paris, 1922, pp. 199–205), and that of Arsène Alexandre ("Opinions. La collection Caillebotte refusée," *L'Eclair*, 12 January 1895). Of special interest in this regard is the long note drafted by Martial Caillebotte in which he attempts to set straight various misunderstandings resulting from the press articles (see Berhaut and Vaisse, 1983, Appendix XVIII).

28. Berhaut and Vaisse, 1983, Appendix XIX. See also Appendix XX, in which Bénédite reviews the results of this meeting. Bénédite comments on a few changes he would like to make in the text of the final transaction with the heir and executor, in a fashion that tends to suggest the purposefully constructed nature of such state documents (including the *procès-verbal* in Appendix XIX). His phrase is provocatively ambiguous in referring to an understood, but never explicitly stated, earlier government policy regarding the loan: "Cette rédaction marque mieux les sentiments de l'Administration, lors qu'elle a formulé ses premières propositions, et ne permet pas de suspecter la mesure qu'elle voulait prendre dans le but d'applanir les difficultés. Elle répondrait mieux au désir qu'avait exprimé M. le Directeur des Beaux-Arts [i.e., Roujon], que les considérants de cet acte établissent d'une façon

très nette son intention d'accepter et d'exécuter loyalement le legs Caillebotte." One wonders if there was not more than a trace of irony in Bénédite's reporting here of Roujon's scruples about the report.

29. As the text of Caillebotte's will shows, it was first deposited with Courtier, at his offices in Meaux. Courtier is, according to Berhaut (1983, p. 219, footnote 30), the gentleman depicted in Caillebotte's *Homme au balcon* of 1880, shown in the 1882 exhibition (Pl. 41)—a canvas that belonged to Courtier, as did the *Nature morte* that appeared in the same exhibition.

30. See Berhaut and Vaisse, 1983, Appendix XIX.

31. See Berhaut and Vaisse, 1983, Appendix XXI.

32. See Berhaut and Vaisse, 1983, Appendix XXII.

33. See Berhaut and Vaisse, 1983, Appendixes XXIII and XXIV.

34. See Berhaut and Vaisse, 1983, Appendix XXVI.

35. See Berhaut and Vaisse, 1983, Appendix XXVII.

36. Laurent, loc. cit., pp. 84–99.

37. Pierre Vaisse, "L'Affaire Caillebotte n'a pas eu lieu," *Le Figaro*, 12 January 1983, p. 26.

38. See Vaisse, *BSHAF*, 1983, p. 206. Vaisse allows that Martial himself was acting in good faith with regard to his brother's wishes, but hypothesizes that the lawyer Courtier may have had Martial's material interests in mind when he proposed the solution that was finally adopted. Berhaut rebuts this hypothesis in Berhaut, 1983, p. 217.

39. Berhaut, 1983, especially pp. 216ff.

40. On Bénédite's important role in promoting Impressionism, see John House, "Impressionism and its Contexts," in *Impressionist and Post-Impressionist Masterpieces: The Courtauld Collection*, New Haven and London 1987, pp. 19–20. On Bénédite's role in the Caillebotte affair, see Berhaut, 1983, pp. 214–15.

41. See Vaisse, *BSHAF*, 1983, p. 206, and footnotes 25 and 26, for evidence of the participation of Pissarro, Sisley, Monet, and Renoir in the final choice. Bénédite claimed in his letter to Kaempfen of 28 February 1895 that the final choice was made "après avoir obtenu le consentement unanime des artistes intéressés." (Berhaut and Vaisse, 1983, Appendix XX) It is highly unlikely that Cézanne, then living in Aix, had any say in the matter.

42. This point is stressed in Berhaut, 1978, pp. 18–19.

43. Bénédite in "La Collection Caillebotte et l'école Impressioniste," an extract published in August 1894, from his book *Le Musée de Luxembourg*, Paris, 1894. In writing on the Caillebotte collection here, Bénédite seemed to feel that its entry into the museum was already a *fait accompli*. (See Berhaut and Vaisse, 1983, Appendix XIII.) In recent public lectures on the question of the sketch in Impressionist aesthetics, John House has shown that Monet made a clear distinction between the more finished view of the Gare St.-Lazare now in the Musée d'Orsay and the other views of the station he sold to Caillebotte, such as the loosely handled *Gare St.-Lazare (Le Signal)*; he set the price considerably higher on the former.

44. Bénédite recounted later (see Adolphe Tabarant, "Le Peintre Caillebotte et sa collection," *Le Bulletin de la vie artistique*, No. 15, 1 August 1921, pp. 405–13) that Monet wanted to withdraw these two canvases (cited by Vaisse, *BSHAF*, 1983, p. 204). When Bénédite submitted the list of his choices, in a letter to Kaempfen of 28 February 1895, he specifically said of the eight Monets that, if the number seemed excessive, then the last two items (*Déjeuner* and *Gare St.-Lazare*) could be eliminated—though Bénédite pleaded that he thought they had "un réel intérêt dans la série de cet artiste." Given this indication, it is tempting to think that the list drawn up by Bénédite (published in Berhaut and Vaisse, 1983, Appendix XXI) may represent in the case of each artist's works ranking by preference. If one reads the Monet list

with such an eye, one notices that the small and sketch-like *Régates* is just above the two problematic works, at No. 6. This hypothesis would seem correct in the cases of Manet and Renoir, where the major pieces (*Le Balcon* and *Le Moulin de la Galette*, respectively) head the lists.

45. Berhaut and Vaisse, 1983, Appendix XXVIII, No. 2, p. 238.

46. As Vaisse points out (*BSHAF*, 1983, p. 206), Martial Caillebotte, in his notes clarifying misunderstandings in the press of 1894–95 (Berhaut and Vaisse, Appendix XVIII, No. 8), states that he does not intend to present the works again. Presumably, he changed his mind in the following years.

47. The 1904 Les Amis du Luxembourg expressed formally the wish that the museum now accept the rest of the Caillebotte collection. This entreaty, made public in *L'Echo de Paris*, 13 December 1904, came to the attention of the administration but was simply filed away without being acted on. (See Laurent, loc. cit., p. 97). The resolve of these "Amis" was doubtless reinforced by the viewing of the exhibition Bénédite had mounted in that same year, of Impressionist masterpieces from private collections (see note 50, below).

48. See Berhaut and Vaisse, 1983, Appendix XXVIII. The entreaty of Henri Verne, Directeur des Musées Nationaux, to Mme. Martial Caillebotte *veuve* in 1928, were doubtless all the less well received for Verne's confusion in addressing Mme. Caillebotte (through the intermediary of a mutual friend) as the widow of Gustave himself.

49. Bénédite pleaded in 1921 (Tabarant, loc. cit.) that he greatly admired the rejected *Baigneurs* now that he had had occasion to see it well; but that his initial choice had been made under such conditions that the picture could not be properly judged (see Laurent, loc. cit., p. 97).

50. In 1904 Léonce Bénédite mounted a major exhibition of "contemporary masters" from private collections, at the Luxembourg, including many of the Impressionist painters represented in the Caillebotte bequest as well as academic masters (House, loc. cit., p. 19). Vaisse also points out, in discussing the role played in 1908 by Henri Dujardin-Beaumetz, under-secretary of the Beaux-Arts (who is reputed to have been instrumental in rejecting the bequest this final time), that the government had accepted another collection containing Impressionists (Moreau-Nelaton) for the Louvre in 1906, and had purchased a Monet *Cathédrale de Rouen* in 1907. Given this apparent openness in official circles to the art represented in the collection, the 1908 refusal seems even more difficult to comprehend.

NOTES TO THE PLATES

PLATE 3

1. See M. Pittaluga and E. Piceni, *De Nittis* (Milan, 1963) for references to the friendship between Caillebotte and De Nittis, reaffirmed in regular Saturday-evening dinners of artist friends at De Nittis's Parisian apartment (cited in Berhaut, 1978, p. 8, note 15).

PLATE 5

1. *Gustave Caillebotte*, Paris, 1951, no. 92.

PLATE 6

1. According to the recollection of the artist's niece, Mme. Chardeau, the home at 77, rue de Miromesnil included, upstairs, a two-story space used by Gustave as a studio (personal communication, May 1976).
2. For Bazille studio views, see François Daulte, *Bazille et son temps*, Geneva, 1952, no. 16 and no. 21, ill. pp. 172 and 174; for Cézanne, see Lionello Venturi, *Cézanne, son oeuvre, son art*, Paris, 1936, no. 64; for Monet and Delacroix, see C. Sterling and H. Adhémar, *La Peinture au Musée du Louvre, Ecole Française XIX Siècle*, Paris, 1959 Vol. 3, No. 1342, and Vol. 2, No. 673.
3. For his interpretations of the Japanese objects in the painting, and his suggestions as to their likely origins, I am greatly indebted to Prof. Hugo Munsterberg.

PLATE 8

1. Rivière referred to Caillebotte in *L'Artiste*, December 1877, p. 301, as "le peintre des *Raboteurs de parquet*." At the time of his death and the 1894 retrospective, the picture was often cited. Arsène Alexandre, in "Le Legs Caillebotte," *Le Paris*, 13 March 1894, said Caillebotte had "au moins une maîtresse oeuvre, les *Parqueteurs*."
2. On the "vulgarity," the 'over-originality,' and the "undiluted realism" of the picture, see Appendix A, Nos. 1, 4, and 20. Arthur Baignières, in *L'Echo*, 13 April 1876, wrote that the *Raboteurs*, as ugly as they were, did not equal Degas's washerwomen on this score. Georges Rivière recalled of Caillebotte that "Le sujet de certains de ses tableaux, comme celui des *Peintres en bâtiment*, par exemple, où l'ouvrier était représenté à la manière réaliste, soulevait des vives protestations. Le réalisme et le naturalisme, qui trimphaient avec Zola dans la litérature, étaient encore réprouvées dans les beaux-arts. Ce n'était pas pour longtemps, et le Palais de L'Industrie donna, peu de temps après, une large hospitalité aux sujets d'un réalisme democratique." (*Renoir et ses amis*, Paris, 1921, p. 159.) For the political implications of the worker in realist art, and other examples of the genre, see Linda Nochlin's discussion of "Hail the Hero Worker," in her *Realism*, Baltimore, 1971, pp. 111 ff. Obviously Caillebotte's picture traces a lineage to Courbet's *Stone-Breakers* in its idea of the semi-anonymous manual laborer shown large. Perhaps the picture should also be considered in the context of Sisley's (very different) treatment of *Cross-Cut Sawyers* (Musée de Petit Palais, Paris) and *The Forge* (Musée d'Orsay) from the same period. Of Caillebotte's own political views, we have no evidence. It is perhaps curious that Caillebotte should choose an occupation associated with the building trade, as this trade suffered a disastrous slump after 1870, when the massive construction of the Second Empire ended.
3. Gustave Geffroy recalled in *La Vie Artistique*, 3d Series, Paris, 1894, pp. 292–3: "On se souvient de ses débuts de ces *Raboteurs de parquet*, qui excitèrent des railleries par leur perspective osée et exacte, mais où il fallut bien reconnaître les qualités d'un observateur dans le modelé des torses et la vérité des mouvements." Charles Bigot, in *La Revue Politique et Littéraire* of 8 April 1876 (pp. 349–52) criticized: "Monsieur Caillebotte fait des bras longs comme des jambes." For fears over the tipped floor, see Appendix A, No. 20.
4. Personal communication with the artist's descendants, May 1976.
5. My information on the trade of floor-scraping by hand comes from a personal interview with Monsieur S. Dagnès, in Paris, November 1972. Monsieur Dagnès, one of the few remaining men who do this work by hand, had been in the trade for fifty years, and learned it from a man with fifty years experience. Monsieur Dagnès appears at work in Figs. d and e.
6. See the discussion of this specific point, in relation to Degas, in Aaron Scharf's *Art and Photography*, Baltimore, 1974, pp. 202–5; and also my reconsideration of photography's role in the proliferation of such imagery, in Kirk Varnedoe, "The Ideology of Time: Degas and Photography," *Art in America*, June 1980.

PLATE 9

1. See Appendix A, No. 1.

PLATE 10

1. In an album of photographs of Caillebotte's paintings, compiled by his brother Martial, this painting is annotated in pencil: *René*. According to the artist's niece, Mme. Chardeau, this annotation was made from information provided by the cousin of Gustave and Martial, Zoé Caillebotte. As Zoé spent a great deal of time with the Caillebotte brothers in the years around 1875, her memory is perhaps our most reliable source.
2. E. Duranty, *La Nouvelle Peinture*, Paris, 1876. For Mlle. Berhaut's discussion of the remarkable rapport between Duranty's words and Caillebotte's pictures, see her *Caillebotte, L'Impressioniste*, Paris, 1968, pp. 20–24.
3. The quoted phrases are from Schiller, cited by Lorenz Eitner in "The Open Window and the Storm-Tossed Boat: An Essay in the Iconography of Romanticism," *Art Bulletin*, XXXVII, No. 4, December 1955, pp. 281–90.
4. Caillebotte also increases the movement into space by a subtle piece of manipulation; in order to open up a passage into space through the man's legs, he displaces one of the pillars in the balustrade, making the spacing of those pillars irregular, and likely impossible. This anomaly was pointed out to me by Marjorie Munsterberg.
5. See Helmut Borsch-Supan, "Caspar David Friedrich's Landscapes with Self-Portraits," *Burlington Magazine*, CXIV, September 1972, pp. 620–50, for instances of similar symbolic self-images.

PLATE 12

1. Personal communication from Mme. Chardeau, May 1976.
2. See Appendix A, Nos. 1 and 4.

PLATE 13

1. See Appendix A, No. 1.
2. I arrived independently at the Signac comparison, and cited it in a talk at the College Art Association in February 1976. Subsequently I found that the same comparison was made by Hilarie Faberman in her unpublished Master's thesis: "Gustave Caillebotte, 1875–1880," Queens College, 1975. Ms. Faberman pointed out to me that this comparison was made by John Russell in "Art News From London: Caillebotte," *Art News*, LXV, No. 5, September 1966, pp. 22–3. I owe my knowledge of the Vuillard luncheon scene to Professor Theodore Reff, who showed the picture in a lecture on Matisse. The connection of this sequence of bourgeois tables with Matisse's *Dessert* of the late '90s is logical, but the Matisse seems much more closely related to the intervening Nabi works than to the Caillebotte. For another Nabi echo of Caillebotte's picture, see Bonnard's *À Table*, 1899 (Bührle Collection, Zurich).
3. Monet's work of the 1870s is far more structured than it is generally taken to be, and one can find fairly frequent divisions of the surface at or near the midline, by the reflections of sailboat masts, for example. But Monet's characteristic "open-span" architecture usually involves flattening of scenes seen from a distance—not, as here, a prominent foreground and perspective. These devices seem much more like Caillebotte (compare the floor of the Monet apartment with that in Caillebotte's *Raboteurs de parquet*, Pl. 8).

PLATE 14

1 See Appendix A, Nos. 15, 17, and 22.
2. Georges Rivière, see Appendix A, No. 18; also No. 20.
3. The girl in the foreground is Marie Caillebotte, the

cousin of the artist (Marie's sister Zoé later owned this picture, and appears in another Yerres garden scene, Pl. 25). Seated on the bench with her back to the house is the mother of Marie and Zoé; opposite her is Mme. Hue, a friend of the family. Caillebotte's mother is the furthest figure, reading while the others sew and embroider.

4. Caillebotte's mother was an extremely avid and talented needle-worker. She made by hand the curtains that appear in the views of the home on the rue de Miromesnil, and Gustave created designs which she embroidered for clothing, tablecloths, etc.; unfortunately none of these survive. She also decorated the vestments of her stepson Alfred, the priest (information from Mme. Chardeau, niece of the artist, personal communication, May 1976).

5. Léonce Bénédite, "Léon Bonnat," *Gazette des Beaux-Arts*, January 1923, p. 3.

6. Hilarie Faberman also noted this fact, in her unpublished M.A. thesis "Gustave Caillebotte, 1875–1880," Queens College, 1975, p. 35.

PLATE 15

1. There is a massive literature on this subject, but two brief treatments give both an overview and helpful bibliographies: David Pinkney, *Napoleon III and the Rebuilding of Paris*, Princeton, 1958 (new edition 1972); and Howard Saalman, *Haussmann: Paris Transformed*, New York, 1971.

2. For example, in the same year that Caillebotte showed his three city views, the Impressionist exhibition also contained three market scenes by Piette, and a *Place Pigalle* by Maureau; while the Salon included city views by Béraud, De Nittis, and Goeneutte. The life of the boulevards, particularly in relation to entertainment and the demi-monde, was of course a major source for Degas. Both Monet and Renoir painted over-views of the new spaces: for example, Renoir's *Place St.-Georges*, owned by Caillebotte, and Monet's *Boulevard des Capucines* (see Pl. 18). Relevant to this Impressionist and Realist theme, see Linda Nochlin's discussion of cityscapes in her *Realism*, Baltimore, 1971, pp. 165–78; also Cesar Graña, "French Impressionism as an Urban Art Form," in his *Fact and Symbol*, New York, 1971, pp. 65–94.

3. The coloration of the painting does not owe to changes in the pigment; it was noticed already by the photographer Nadar, who referred to "Caillebotte avec sa Place de l'Europe violette vue au sortir de l'atelier de Manet," in *Quand j'étais photographe*, Paris (n.d.), p. 23. My thanks to Maria Morris for this reference.

4. Marie Berhaut, drawing from recollections passed by Caillebotte's brother to his descendants, has stated that "il fit construire un omnibus afin de pouvoir peindre par tous les temps," in "La Vie et L'Oeuvre de Gustave Caillebotte," in *Gustave Caillebotte*, Paris, 1951.

5. See Appendix A, No. 9; also Marie Berhaut, *Caillebotte, l'Impressioniste*, Paris, 1968, p. 34.

6. See Chapter 4 for a detailed description of the perspectival anomalies (e.g., multiple planes of vision) that make the worker and his area into a "separate picture" demanding separate attention. See also Chapter 3 for a larger consideration of Caillebotte's use of conflicting attention centers. For a contemporary reaction to the interrupting presence of the worker, see Appendix A, No. 15. Richard Thomson has argued for a different interpretation of the relationship between the figures in this painting, seeing the presence of the dog as not only compositionally but also symbolically obtrusive, in relation to the interchange between the top-hatted stroller and the lady with the parasol. See Thomson, "Les Quat' Pattes: The Image of the Dog in

Late 19th-Century French Art," *Art History*, V, No. 3, September 1982, pp. 33172.

7. For a more detailed consideration of the history of the bridge, and of this picture, see my article, "Caillebotte's *Pont de l'Europe*: A New Slant," *Art International*, April 1974, pp. 28 ff. There I suggest that another reason may contribute to the sense of extraordinary pressure on the artist in this self-portrait: his brother René died unexpectedly in 1876, and the artist had a fear that he, too, would die young. He made his will in November of 1876, leaving money to cover the next Impressionist exhibition. Thus there is reason to believe that while working on this picture he feared he might be dead when it was displayed.

PLATE 16

1. The note in the catalogue *Gustave Caillebotte*, Wildenstein, London, 1966 (No. 5) described this picture as "a study representing part of the large composition . . . painted in 1876."

2. In a previous article ("Caillebotte's *Pont de l'Europe*: A New Slant," *Art International*, April 1974) and in the description of the other version (Pl. 15), I have pointed out the specific location from which the Geneva *Pont de l'Europe* was painted, and have considered at some length the importance of the deep slant of the road towards the bottom of the bridge trellis in the Geneva version. Obviously, that slant does not appear in the present version, where the railing is little separated from the top of the trellis. This view most likely depicts a point in the Place de l'Europe, at the center of the bridge, where the rail and roadbed levels would accord with the levels shown here.

3. See the remarks of Gerald Needham on the relation between this composition and Japanese prints: No. 183, p. 134 of the catalogue *Japonisme*, Cleveland Museum of Art, 1975. In the same catalogue, see No. 160, Vuillard's *Sur le Pont de l'Europe*, which applies a similar composition but apparently lies about the diagonals of the bridge trellis (which it shows as cruciforms rather than Xs).

4. Family tradition has it, as stated in relation to Pl. 15 above, that the artist arranged to work from a glassed-in carriage on the bridge, so that he could study it in all kinds of weather. For a discussion of Monet's early practice of painting pairs of pictures of the same subject, see Steven Levine, "Monet's Paris," *Arts Magazine*, June 1975, pp. 72–5.

5. Apparently the Pont de l'Europe was a place which made some distinct, and not wholly pleasant, impression on the feelings of those who traversed it. René Héron de Villefosse, in *Le Coeur Battant de Paris* (Paris, 1968), quotes a Paris guidebook of 1867 describing the bridge as a structure "qui étonne par sa forme bizarre et par son immensité," and goes on to recall the times he crossed "les mêmes âcres fumées opaques, où je regardais les trains s'engouffer au loin dans le noir tunnel des Batignolles, géante souricière" (p. 246). My thanks to Peter Galassi for this reference. The poet Mallarmé, who crossed the bridge to get to his job teaching class (he lived on the rue de Rome, just adjacent), confessed to George Moore that each time he crossed he was nearly overcome by the desire to jump off onto the tracks, to die under the wheels of a train (cited by Daniel Halévy in *Pays Parisien*, in turn cited by Mina Curtis in a note in her translation of Halévy's *My Friend Degas*, Middletown, 1964, p. 43).

PLATE 17

1. For negative reactions to the color harmony of the picture, see Appendix A, Nos. 11, 17, and 20. The appreciation of the observation of the workers is found

in reviews of the retrospective following the artist's death, and most notably in "The Caillebotte Bequest to the Luxembourg," by Jean Bernac, originally in *The Art Journal* in three parts in 1895, but easily available by virtue of having been reprinted in its entirety in the catalogue of the 1966 Wildenstein exhibition in London, *Gustave Caillebotte*, pp. 31–5. Bernac described: ". . . house-painters carelessly look at the little work which, without doubt, they have less than completed. The attitude is most natural, and renders perfectly the exact note of *flânerie* of the Parisian workman, who is a good fellow, jolly and light-hearted, but has a touch of the loafer in his temperament."

2. The quote from Hugo is cited in Paul Léon, *Paris: Histoire de la rue*, Paris, 1947, p. 204: "Que c'est beau, de Pantin on voit jusqu'à Grenelle! / Le vieux Paris n'est plus qu'une rue eternelle / Qui s'étire élégante et droite comme l'I / En disant 'Rivoli, Rivoli, Rivoli.'" Léon also cites the words of Victor Fournel, whose *Paris Nouveau et Paris Futur* of 1867 is a major document of contemporary reaction against Haussmann's transformations of Paris. Fournel remarked "Nous n'avons plus qu'une rue, c'est la rue de Rivoli. Non contente d'avoir poussé sa trouée jusqu'au bout de la ville, elle reparait partout, en se déguisant sous une multitude de noms." (p. 15.)

3. Note that the same effect occurs, somewhat less obviously, in the *Pont de l'Europe*. There, it is the X-form structures of the girder trellis that repeat the X-form of the major compositional lines.

PLATE 18

1. The rue de Moscou, running into space diagonally on the left, was begun in 1847 and finished in 1867. The rue du Turin was begun in 1847 and finished in 1857 (Marquis de Rocheguide, *Promenades dans toutes les rues de Paris*, Paris, 1910, pp. 43, 44). The rue Clapeyron, directly in the center of the canvas, was wholly created under the Second Empire, and named for a famous mines engineer who died in 1864. The rue St.-Petersbourg, which runs roughly laterally across the scene, was opened in 1826 from the Place de l'Europe as far as this intersection; but the intersection itself, and the extension of the rue St.-Petersbourg as far as the Place Clichy, date from the Second Empire (Hippolyte Bonnardot, *Monographie du VIIIe arrondissement de Paris*, Paris, 1880, pp. 89, 150.

It is amazing how consistently the scenes Caillebotte painted fell within the scope of Baron Haussmann's "second program" (see Pl. 15). Haussmann's first work had been on the rue de Rivoli, Boulevard Sebastopol, and around the Louvre, Halles and Hôtel de Ville. The second phase, made possible when a new treaty between city and state was obtained in 1858, included as priority items the rectification of the Pont de l'Europe, the opening of the Boulevard Malesherbes, the piercing of the rue Halévy, and the opening of the Boulevard Haussmann—each one a Caillebotte site, and not one extant on the map of Paris in 1855 (see Jules Ferry, *Comptes Fantastiques d'Haussmann*, Paris, 1868, p. 73).

The area around the Moscou-Turin intersection was part of the large area between the center of Paris and the outer fortifications, annexed into the city by Napoleon III. The plan was to make these areas into deluxe residential sections; and, after the annexation, Haussmann quickly started to lay the area out in star-form intersections like this one. (See Pierre Lavedan, *L'Oeuvre de Baron Haussmann*, Paris, 1954, pp. 65–6.)

2. The same critic who called the foreground figures "un monsieur et une dame, costumes modernes, physionomies contemporaines," remarked how brand-new even the umbrella looked: "un parapluie qui semble decroché fraîchement des rayons du Louvre et du Bon Marché." (Appendix A, No. 11). Another described

"des promeneurs hatifs, en habits modernes—que dis-je, à la dernière mode . . ." (Appendix A, No. 15.) Mlle Madeleine Delpierre, Conservateur du Musée du Costume de la Ville de Paris, confirmed to me that the fashions shown here were the up-to-the-minute winter fashions of the "bourgeoisie élégante" of that year.

There is only one note of less than ultra-modernity in the picture: the lamppost dominating the center. This kind of gas lamp was actually the first model put in general service after gas lighting appeared in 1829. It was designed in 1830, and served as the standard fixture in Paris until 1865. However, since the initial design carried the flame too high for proper illumination, the shafts were systematically truncated. The resulting effect was thought to lack grace; and, after the advent of the more elegant, florecte-patterned Oudry lamps in 1865, these old models were progressively uprooted and moved to peripheral areas. The presence of this anachronism in the midst of the raw newness of the architectural ensemble would, then, have been an obvious indication that Caillebotte's scene was a peripheral area, a new suburb, rather than a part of central Paris. Coincidentally, in the year after this painting was done, the first electric lighting appeared in the Place de la Concorde. (See R. Bouteville, L'Eclairage public à Paris, Paris, 1925, especially p. 45.)

3. See also the Adolf von Menzel Weekday on the Paris Boulevard, 1869, Kunstmuseum, Dusseldorf. There was a good deal of city painting being exhibited both with the Impressionists and in the Salon in this period. In the 1877 Impressionist exhibition, Piette showed three market scenes, and Maureau showed a Place Pigalle. At the Salon, Caillebotte's former studio-mate (under Bonnat) Jean Béraud showed Le Dimanche près de Saint-Philippe du Roule (Metropolitan Museum of Art, New York, see Fig. 1 in Chapter 2) and Goeneutte showed Le Boulevard Rochechouart.

4. ". . . la monotone égalité d'une magnificence banale, en imposant la même rue géometrique et rectiligne, qui prolonge dans une perspective d'une lieue ses rangées de maisons, toujours les mêmes" (p. 221). "Il voit sous ses pieds s'aligner à l'équerre, s'allonger au cordeau, une ville auguste et majestueuse. . . . Les étroites et bizarres ruelles de la vieille cité sont devenus de larges artères, croisées à angles droites, le long desquelles une population correcte circule au pas d'ordonnance, sous le regard paternel et satisfait des sergents de la ville" (p. 12). Victor Fournel, Paris nouveau et Paris futur, Paris, 1865. Fournel's book is a major document of the contemporary reaction against Haussmann, and many of his descriptions find an echo in Caillebotte's work. His general view, for example, about the real monuments of the new Paris, is clearly that of the artist: "Les monuments où s'affirment et se démontrent le génie particulier de l'administration comme celui de l'époque présente, ce ne sont pas ceux qui affichent la prétention d'arriver jusqu'à l'art et de relever de lui seul, ce sont ceux qui offrent avant tout le caractère d'utile, le cachet industriel et commercial, . . . les gares, les ponts, . . . les casernes, tout se qui est oeuvre d'ingénieur plutôt que d'architecte, voilà les vrais edifices, avant le Louvre et la fontaine Saint-Michel" (p. 208). Fournel also explains in simple terms the economic and legal roots of the phenomenon seen in the big block of buildings in the background of the Temps de pluie: the absolute regularity of heights and designs, to the extent that the block looks like one mammoth building (p. 62).

On the influence of, and general reaction against, Hausmann's plan, see Françoise Choay, The Modern City: Planning in the 19th Century, New York, 1969, and Howard Saalman, Haussmann: Paris Transformed, New York, 1971. Especially relevant to the opposition to the Haussmann conception is George Collins and Christiane Crasemann Collins, Camillo Sitte and the Birth of Modern City Planning, New York, 1965. I would like to thank George Collins for helping me again and again with my thinking on the city in relation to Caillebotte's art.

5. For the classic essay on the urban phenomenon, see "The Metropolis and Mental Life," by Georg Simmel, in Kurt Wolff (ed.), The Sociology of Georg Simmel, New York, 1964, pp. 409–24.

PLATE 20

1. For one of the other earlier precedents for this kind of specificity of position in a boating scene, see Carl Gustav Carus's On the Elbe Near Dresden, 1827, reproduced on the cover of German Painting of the 19th Century, Yale University Art Gallery, 1970.

PLATE 21

1. See Joanna Richardson's discussion of "Hunting, Fishing, and Crikett," in La Vie Parisienne 1852–1870, New York, 1971, pp. 107–21.

PLATE 28

1. The building from which the view was painted is now the annex of the Galeries Lafayette department store. There is another view painted from the same spot, and nearly identical to the present, but far less finished (Berhaut, 1978, No. 114).

2. My view of the site, Pl. 28a, is made with a 55mm. lens, the same lens that proved absolutely inadequate in capturing earlier site views (see Chapter 3). If one applied to this site the angle of vision seen in the Pont de l'Europe (Pl. 15), for example, the area framed in this painting would represent only a small section of the center of the image.

3. See Oscar Reutersvard, "The 'Violettomania' of the Impressionists," Journal of Aesthetics and Art Criticism, IX, No. 2, December 1950 for a discussion of the critical opinion that this coloration was the result of a kind of derangement.

PLATE 30

1. See Anne McCauley, A. A. E. Disderi and the Carte-de-visite Portrait Photograph, New Haven and London, 1985.

PLATE 34

1. See especially "L'Exposition des Indépendants en 1880," in L'Art Moderne, Paris, 1883, and also the "Appendice" in the same volume, covering the exhibition of 1882.

2. Perhaps closest in direction to Caillebotte's domestic scenes would be Huysmans's En Ménage (Paris, 1881). For a more general consideration of Huysmans's ideas at the time, see H. Trudgian, L'Esthetique de J.-K. Huysmans, Paris, 1934.

3. See discussion of the identification and/or mis-identification of these pictures, in regard to comments by the critic Ephrussi, in the notes to Pl. 45. Ruth Berson of the San Francisco Museum of Fine Arts also points out that Armand Silvestre, writing in La Vie Moderne of 24 April 1880, describes the present picture while referring to it as No. 10 (rather than as No. 9, as indicated by Marie Berhaut) in the catalogue of the 1880 exhibition.

4. Eugène Veron described her as having cheeks the color of wine dregs, coated with rice powder (see Appendix A, No. 35). J.-K. Huysmans, however, approved: "I recommend to all those painters who have not been able to render the cosmetic tint of the Parisian woman the extraordinary skin of this one, a skin worked up like velveteen, but without rouge. And that's still another very exact observation [on the part of Caillebotte]. In this household there is none of the make-up used by actresses or girls, but instead the simple compromise of a number of bourgeois women who, without painting themselves up like the latter, cloud their skin quite openly with bismuth powder, tinted rose for blonds, or in Rachel tone for brunettes." (From "L'Exposition des Indépendants en 1880," in L'Art Moderne, Paris, 1883, pp. 95–6)

5. See Appendix A, No. 35. Even Huysmans (see note 1, above), found this effect of perspective "bizarre and incomprehensible."

6. See Appendix A, No. 34.

PLATE 35

1. See Appendix A, No. 32.

2. From "L'Exposition des Indépendants en 1880," in L'Art Moderne, Paris, 1883, pp. 93–4.

3. The picture has been recently restored, and in-painted, along the lower edge.

4. For Caillebotte's opinion of Flaubert, see his letter to Monet of 18 July 1884, quoted in Gustave Geffroy, Claude Monet, sa vie, son temps, son oeuvre, Paris, 1922, p. 180, and cited by Sutton in the 1966 catalogue of the Wildenstein London exhibition, Gustave Caillebotte, p. 18.

5. See the charcoal study of the woman alone, reproduced in Françoise Cachin, Paul Signac, Greenwich, 1971, p. 22; and the even more tellingly related study in which the seated man reads a newspaper, reproduced in John Rewald, Post-Impressionism, 2d ed., New York, 1962, p. 129. I am grateful to Hilarie Faberman for bringing this latter drawing to my attention; she had made the connection between the two paintings, independently of my research, in her M.A. thesis, "Gustave Caillebotte, 1875–1880," Queens College, 1975.

6. The research team for The New Painting: Impressionism 1874–1886 (San Francisco, 1986), led by Charles Moffett, has pointed this out to me, with regard to Ephrussi's article in the Gazette des Beaux-Arts, 1 May 1880.

PLATE 36

1. Robert Rosenblum suggested that Caillebotte's nude may have been inspired by Gervex's Rolla, and remarked how idealized Degas's "keyhole" nudes seem in comparison to Caillebotte's, in "Gustave Caillebotte: The 1970s and the 1870s," Artforum, March 1977, p. 52.

2. See Hollis Clayson, "Avant-Garde and Pompier Images of 19th Century French Prostitution: The Matter of Modernism, Modernity, and Social Ideology," in B. Buchloh, S. Guilbaut, and D. Solkin, eds., Modernism and Modernity, Halifax, 1983, especially pp. 47–8 and 56, for a discussion of the critical reaction to the clothing in the picture.

3. The reader may wish to compare the present reproduction of this painting with the reproduction on p. 141 of Varnedoe and Lee, 1976. The latter photo was taken at the time the painting entered the collection of the Minneapolis Institute of Arts. It shows that, at some point between the departure of the painting from the collection of Caillebotte's descendants and its purchase by the museum, a restorer was employed to "shave" the figure's crotch—doubtless to make the picture more palatable for the market. The Minneapolis Institute has subsequently removed the overpainting.

PLATE 38

1. According to Martial Caillebotte's notations (kindly communicated to me by his daughter, Mme. Chardeau), the man seated on the sofa in the left background is Paul Hugot (see his portrait by Caillebotte, Pl. 30). The man playing cards on the left side of the table is Maurice Brault. Seated on his right is Monsieur Dessomes, and

standing on his left is Monsieur Gallo. Observing from the right of Martial Caillebotte is A. Cassabois.

2. In an article in the *Gazette des Beaux-Arts*, 1 May 1880 on the "Exposition des Artistes Indépendants," Charles Ephrussi compared the Impressionist efforts to the Dutch, but remarked that the contemporary painters did not have the discretion to keep their works in a minor key: "Ces Ostades, ces Teniers, ces Brouwers contemporains ont la passion du commun, mais sans la relever par la bonhomie piquante de l'expression, et en donnant aux figures des proportions que ne comportent pas de pareils sujets. Les grands Flamands comprenaient que des buveurs de quinquette devaient être de dimensions discrètes, en accord avec la banalité même de leur occupation, et se noyer dans les teintes argentées ou dorées d'un clair-obscur savamment étudié. Nos modernes font grand, sans se demander si la valeur du sujet permet de si ambitieuses proportions; ils font laid, systématiquement, par opposition au beau suranné, ils font vulgaires, par haine de l'élégant . . ." (one wonders whether these remarks were not directed at Caillebotte's *Dans un café*, in the 1880 exhibition [see Pl. 39]).

J.-K. Huysmans found that Caillebotte's card players were less affected, and thereby more honestly realistic, than the older versions: "plus véridiques que celles des anciens flamands où les joueurs nous surveillent presque toujours du coin d'oeil, ou ils posent plus ou moins pour la galerie, surtout dans l'oeuvre du bon Teniers, Ici, rien d'équivalent. Imaginez qu'une fenêtre s'est ouverte dans le mur de la salle et qu'en face de nous, coupés par le cadre de la croisée, vous apercevez, sans être vus par eux, des gens qui fument, absorbés, les sourcils froncés, les mains hésitantes sur les cartes, en méditant le coup triomphant de 250!" (from "Appendice" in *L'Art Moderne*, Paris, 1883, p. 262).

3. Perhaps the most striking similarity is the point of view, looking slightly down on the table-top with the two opposing players in profile. Cézanne has no figure in the position of the seated observer in the left foreground, nor any figure seated at the back left; and he has a third player where Caillebotte has none, facing directly out. On the other hand, the idea of two observing figures, one standing left and one seated right, as additions to the table group, is shared by both pictures. Martial Caillebotte's gesture of reaching for the card gives Caillebotte's picture a sense of the moment that is not present in the Cézanne; but the positions of the hands of the players on the left of the two pictures are not dissimilar. The idea of a rectangular accent in the upper left corner recurs in the Cézanne, though it is provided by a shelf and pitcher; while the picture on the rear wall is centered by Cézanne. In Caillebotte's picture, a wall-moulding descends to the front of Martial Caillebotte's head, in much the same place that the curtain descends behind Cézanne's player. The lower edges of the two pictures crop the figures in roughly the same place, and Cézanne's picture has a prominent triangular void under the center of the center of the table, with a subsidiary triangle to the left of it, in much the same fashion as the Caillebotte. Cézanne then makes this pattern symmetrical, adding another void, just as his table is insistently square to the picture plane and his space much shallower, in comparison to the more realist-inclined, less obtrusive structuring of the Caillebotte.

4. Cézanne was in Paris for a period of six months beginning in February 1882. (See John Rewald, *Paul Cézanne, A Biography*, New York, 1968, p. 131). The *Partie de bésigues* was not, to my knowledge, reproduced in any form until 1895, when it appeared in a small, insufficient reproduction in "The Caillebotte Bequest to the Luxembourg," by Jean Bernac, *The Art Journal*, 1895 (3-part article, pp. 200–32; 308–10; and 358–61; the *Partie* appears on p. 309.)

5. Theodore Reff, "Cézanne's Card Players and Their Sources," *Arts Magazine*, November 1980, pp. 104–17. My thanks to Professor Reff for supplying me with a reproduction of the Raffaëlli.

PLATE 39

1. Joris-Karl Huysmans, "L'Exposition des Indépendants en 1880," in *L'Art Moderne*, Paris, 1883, loc-cit pp. 96–7: "Un monsieur, debout, nous regarde, appuyé à rebord d'une table où se dresse un bock d'une médiocre bière, qu'à sa trouble couleur et à sa petite mousse savonneuse nous reconnaissons immédiatement pour cet infâme pissat d'âne brassé, sous le rubrique de bière de Vienne, dans les caves de la route de Flandres. Derrière la table, une banquette en velours amarante, tournant au lie de vin par suite de l'usure opérée par le frottement continu des râbles; à droite, un joli coup de lumière temperé par un store de coutil rayé de rose; au milieu de la table, fichée au dessus de la banquette, une grande glace au cadre d'or tiqueté par des points de mouches, reverbère les épaules du monsieur debout et répercute tout l'intérieur du café. Ici encore nulle précaution, nul arrangement. Les gens entrevus dans la glace, tripotant des dominos ou graissant des cartes, ne miment pas ces singeries d'attention si chères au piètre Meissonier; ce sont des gens attablés qui oublient l'embêtement des états qui les font vivres, ne roulent point de grandes pensées, et jouent tout bonnement pour se distraie des tristesses du célibat ou du ménage. La posture un peu renversée, l'oeil un peu plissé, la main un peu tremblante du joueur qui hésite, la tête penchée en avant, le geste haut et brusque de l'homme qui bat about, tout cela est croqué, saisi, et ce pilier d'estaminet, avec son chapeau écrasé sur la nuque, ses mains plantées dans les poches, l'avons-nous assez vu dans toutes les brasseries, hélant les garcons par leur prénoms, hablant et blaguant sur les coups de jacquet et de billard, fumant et crachant, s'en fournant à crédit des chopes!"

2. According to Peter Galassi's analysis of this picture, its divisions are consistently based on three kinds of proportions: a 2 to 1 ratio (that is, areas divided evenly in half): a 1.62 to 1 ratio, the "golden section" (a division such that the smaller sub-length is to the larger as the larger is to the whole); and a 1.77 to 1 ratio. The latter, which has no particular precedent or geometrical logic known to us, is the most frequent, and determines the most prominent divisions of the canvas. These proportions work both horizontally and vertically. Vertically, the distance from the bottom of the picture to the base of the large mirror is in a ratio to the whole height of the picture of 1 to 1.77. The distance from the top of the picture to the base of the reflected "background" mirror is in a proportion to the distance from the top of the picture to the base of the large "foreground" mirror of 1 to 1.77. While the front edge of the foreground table is at the half-way mark between the base of the large mirror and the bottom of the picture, the back edge of the same table marks the golden section division of the same distance. Horizontally, the hanging coat (measured at the point where it hangs) divides the width of the foreground mirror's glass into two widths related by a 1 to 1.77 ratio. The frame of the "background" mirror marks the golden section division of the whole picture's width. These indications give an idea of the consistency, without cataloguing all instances.

PLATE 40

1. When Baron Haussmann pierced the boulevards and widened the major streets of Paris, he greatly reduced the amount of available building surface. Partially as a result of this, land prices in Paris doubled in a steady progression between 1860 and 1870 (Pierre Lavedan, *L'Oeuvre de Baron Haussmann*, Paris, 1954, p. 50). Builders, anxious to take maximum advantage of space, began systematically to suppress the large inner courts that had previously been the center of domestic life. The buildings turned inside out, now looking to the street as never before for light and air (Paul Léon, *Paris, Histoire de la rue*, Paris, 1947, p. 205). This change in orientation seems an appropriate architectural symbol of the giving-way of the older, more closely bound traditions of the family before the new life of the metropolis. Pierre Larousse's. *Le Grand Dictionnaire Universel du XIXe Siècle* remarked in 1867 (p. 97): "Aujourd'hui que le beau sexe n'est plus condamné à vivre renfermé dans l'intérieur des maisons, que le plaisir de voir les passants et d'en être vu est devenu général, il n'y a presque pas de maisons importantes sans balcons découverts . . . Aujourd'hui, la mode des balcons est devenue générale . . . on en compte aujourd'hui plus de cent milles à Paris."

2. Easily the most familiar balcony image is Manet's *Le Balcon* of 1867 (Musée d'Orsay, Paris)—a work Caillebotte purchased after Manet's death. Like several other balcony scenes one could name, however, Manet's does not really correspond to the Caillebotte series, which focuses specifically on a person or persons looking off a balcony. In this latter category, there are more limited number of examples. Probably working under Manet's influence, if not with his assistance, Berthe Morisot painted a lady and child looking over a railing, *On the Terrace, Meudon* (formerly Ittleson Collection; see also the watercolor version in the Art Institute of Chicago). There is also a work attributed to Mary Cassatt, from the early 1870s, showing a *Young Woman Standing by Railings* in the same basic mould as the Caillebottes (see Adelyn Breeskin, *Mary Cassatt*, Washington, 1970, No. 9). One of the most interesting such parallels, possibly inspired by Caillebotte's *Homme au balcon, chapeau haut de forme* (Berhaut, 1978, No. 139), is Anton Romako's *A Balcony in Paris* (Gemäldegalerie, Vienna). My thanks to Valerie Fletcher for pointing out the Romako to me. See also the curious precedent by Chassériau in the Louvre, *Juives au balcon*, 1849 (C. Sterling and H. Adhémar, *La Peinture au Musée du Louvre, École Française XIX Siècle*, Paris, 1959, Vol. 1, No. 313).

PLATE 41

1. The building at the left is the one from which Caillebotte painted *Rue Halévy, vue d'un sixième étage* (Pl. 28).

2. In his book *Edvard Munch: The Scream* (New York, 1972), Reinhold Heller suggests (pp. 62, 64) that the *Rue Lafayette* may relate to Caillebotte's *Homme au balcon* (Pl. 40). The present juxtaposition, however, seems more telling. *Un Balcon* was in Caillebotte's own collection, and not exhibited at any time, during Munch's visits to Paris, both in 1885 (when Munch came for a few weeks) and in 1889–91 (when he came with a fellowship to study, coincidentally, under Léon Bonnat, Caillebotte's former teacher). The influence of Impressionism on Munch has always been acknowledged in general terms; however, there are specific instances beyond the *Rue Lafayette* that suggest Munch's knowledge of Caillebotte's work. The *Military Band on Karl Johan Street* of 1889 (Kunsthaus, Zurich) and *Spring Day on Karl Johan Street* of 1891 (Billedgalleri, Bergen) both show a kind of composition, and a feeling for the empty spaces of the city, that have an appreciable similarity to Caillebotte's cityscapes. Munch may originally have made contact with Caillebotte through the former's friend and mentor Christian Krohg, a Norwegian Realist painter much affected by developments in France. Krohg visited Paris in the early 1880s, and his *Portrait of Karl Nordstrom* of 1882 suggests that he may

have known Caillebotte's balcony and window spectators (see *Homme au balcon* [Pl. 42] and the comparison there with Krohg's *Portrait of Karl Nordstrom*, painted after Krohg had seen the 1882 Impressionist exhibition).

The special nature of Caillebotte's perspective, particularly in the *Pont de l'Europe* (Pl. 15), may figure in the origins of Munch's *The Scream* of 1892; see Chapter 3 for a consideration of this point.

3. Despite the different titles of the two works, they show the same view. In Munch's picture, the rue Lafayette is the street entering the Boulevard Haussmann from the left. The reader will note discrepancies between my photo (Pl. 41b) and both the Munch and Caillebotte paintings. First, in the deep space, Caillebotte shows houses that are no longer present; the Boulevard Haussmann had not yet been pierced as far as its present end-point at the Richelieu-Drouot intersection. Also, neither Munch nor Caillebotte shows the ornamental sculpture and extra-high roof that appear on the central pavilion of the building, just beyond the figure in my photo. It is possible that these embellishments had not yet been added, as the building was still very new. It was one of a group built to provide an architectural frame for the new Opéra, and the designs, uniform all the way around the Place de l'Opéra, were specified by the initial Opéra architect, Rouhault de Fleury. The building was built for the Société Générale bank; according to a plaque in the bank entrance, it was only officially inaugurated in 1912.

4. As Reinhold Heller has pointed out in his *Edvard Munch: His Life and Work*, Chicago, 1984, pp. 72–3 and p. 230, footnote 56, Caillebotte did not reside in the Boulevard Haussmann apartment after his brother married in 1887; he lived full-time in Petit Gennevilliers. The actual disposition of the apartment in the early 1890s when Munch visited Paris and painted his balcony views—who owned it, who lived there?—has not been established.

PLATE 42

1. Nordström recalled the circumstances of the portrait thus: "We had studied the Impressionists at an exhibition in Paris and we were filled with new ideas. Krohg saw me one day at the open window wearing my blue suit silhouetted against the garden. He asked me eagerly to stand still in my pose, fetched a canvas, and in a few seconds the work was in full action." (Oscar Thue, *Christian Krohgs portretter*, Oslo, 1971, p. 25.)

PLATE 43

1. Aaron Scharf, *Art and Photography*, Baltimore, 1974, p. 176; see illustrations, p. 175.

2. In a work like Monet's *Impression, soleil levant* of 1873 (Musée Marmottan, Paris), there is, as Theodore Reff pointed out to me, a clear 1-2-3 progression from the foreground boat back diagonally to two other boats, each less distinct than the previous, and the last all but invisible. Also, in Monet's *Boulevard des Capucines* of the same period (Nelson Gallery of Art, Atkins Museum, Kansas City), the concentration of strong contrasts and close-knit brushwork in one area of focus—on the sidewalk to the right, about one-quarter of the way up the canvas from the bottom edge—is clear. These effects can be easily studied in the reproductions of both paintings in *Impressionism: A Centenary Exhibition*, New York, Metropolitan Museum of Art, 1974. The relevant part of the weighted area in the *Boulevard* appears in the detail on p. 162.

PLATE 44

1. Other comparisons come to mind, but seem less exactly applicable. Nadar's balloon photographs of Paris from above are taken from too high a distance to provide any model for this kind of view. There is apparently also a written mention of trick photos taken from a similar viewpoint by Count Aguado in Paris. See consideration of these points in Aaron Scharf, *Art and Photography*, Baltimore, 1974, p. 176. Caillebotte's view also prefigures the interest of Bonnard in views looking down onto streets, as for example No. 156, p. 105 of the catalogue *Japonisme* (Cleveland Museum of Art, 1975); but Caillebotte's view is far more radically abstracted.

Coburn's photos of the early twentieth century do not seem as close to Caillebotte, since they see the ground pattern of New York from a much greater distance. Among the other photographers of the '20s and '30s that should be mentioned as following the kind of vision announced by Caillebotte's painting is Lazlo Moholy-Nagy (as Scharf points out) in his photos of Berlin. See Beaumont Newhall on "The Quest of Form," in his *The History of Photography*, New York, 1964, pp. 160, 165. For further consideration of these questions of photography's possible influence on Impressionist painting, see Kirk Varnedoe, "The Artifice of Candor: Impressionism and Photography Reconsidered," *Art in America*, January 1980.

On the relationship of Impressionist compositions like Caillebotte's to Russian and German photography of the later 1920s, see also Wolfgang Kemp, "Das Neue Sehen: Problemgesichtliches zur fotografischen Perspektive," in *Foto-essays zur Geschichte und Theorie der Fotografie*, Munich, 1978. I was unfortunately not acquainted with this stimulating essay when I published my own overview of some of the same issues in the 1980 essay.

PLATE 45

1. See the discussion, in the context of the notes for *Intérieur* (Pl. 35) of the possibility raised by the research team of the 1986 exhibition *The New Painting* that No. 12 in the 1880 exhibition may instead have been an interior scene with a woman at the window. Further confusion arises from the fact that some copies of the 1880 catalogue give the title as *Vue prise à travers un balcon (Vue de l'Opéra)*; while this title would be even less applicable to *Intérieur* (Pl. 35), it would not correspond in any absolutely provable way to the street-corner view seen behind the ironwork here. No critical review of the 1880 exhibition thus far brought to light describes the *Vue prise à travers un balcon* in terms precise enough to allow resolution of the question. Such critical silence in the face of a painting as unusual as this one might seem difficult to comprehend, but it would not be incommensurate with the relatively sparse comment, in 1882, regarding the equally unusual *Boulevard vu d'en haut* (Pl. 44).

2. Zola's famous formula appeared at the end of his treatment of the Salon of 1868, in "Les Paysagistes," *L'Evènement illustré*, 1 June 1868: "Il suffira que j'aie essayé une fois de plus de montrer que la personnalité féconde le vrai, et qu'un tableau est une oeuvre nulle et médiocre, s'il n'est pas un coin de la création vu à travers un tempérament," (Zola, *Mon Salon, Manet, Ecrits sur l'Art*, Paris, 1970, p. 161). In a letter of 1864, Zola was even more specific: "Toute oeuvre d'art est comme une fenêtre ouverte sur la création; il y a, enchâssé dans l'embrasure de la fenêtre, une sorte d'Ecran transparent, à travers lequel on aperçoit les objets plus ou moins déformés . . . Ces changements tiennent à la nature de l'Ecran. Nous voyons la création dans une oeuvre, à travers un homme, à travers un temperament, une personnalité . . ." (to Valabrègue, 1864, in Zola, *Correspondance*, [1858–71], Vol. 48 of *Les Oeuvres*

Complètes, Paris, 1928, pp. 248–57). I am indebted to Valerie Fletcher for this latter reference. Duranty's discussion of the window (see also my consideration in the description of Pl. 10) occurs in his *La Nouvelle Peinture*, Paris, 1876, p. 29.

3. For my knowledge of the Van Gogh and Cézanne works, Pls. 45d and e, I am very much indebted to Valerie Fletcher and Theodore Reff, respectively.

4. See Albert Elsen's discussion of the closing window in *Purposes of Art*, 3rd ed., New York, 1972, pp. 431–8. For full selections of window images from all periods, see J. A. Schmoll (gen. Eisenworth), "Fensterbilder," in *Beiträge zur Motivkunde des. 19. Jahrhunderts*, Vol. 6 of *Studien zur Kunst des 19. Jahrhunderts*, Munich, 1970, pp. 13–166; and also the catalogue of the recent exhibition *Einblicke-Ausblicke; Fensterbilder von der Romantik bis heute*, Recklinghausen, 1976.

5. A prime example of closure would be Manet's *Gare St.-Lazare* of 1873 (National Gallery of Art, Washington, see Pl. 15d). There is also a little-known etching by Fantin-Latour's English friend Edwin Edwards, showing a Parisian boulevard seen through a balcony railing whose configuration is like that of the fence in the Manet; however, the Edwards view is from a point further back from the railing than the up-close view of the Caillebotte. In the 1870s, Monet sometimes used a screen of branches as a virtually complete interruption of a view: see Daniel Wildenstein, *Claude Monet, biographie et catalogue raisonné*, Vol. 1, *1840–1881, Peintures*, Paris, 1974, Nos. 455, 456, 457.

PLATE 46

1. According to Marie Berhaut, this painting was executed from a balcony at 2, rue Lafitte, at the corner of the rue Lafitte and the Boulevard des Italiens. The large building across the boulevard is the Credit Lyonnais bank. My thanks to her for this information.

PLATE 48

1. My thanks to Hilarie Faberman for bringing this caricature to my attention.

PLATE 49

1. For anticipations of Thiebaud's repeat-pattern display formats in food still lifes, see the Caillebotte images of cakes and hors-d'oeuvres, Berhaut, 1978, Nos. 208 and 209; for the other, more macabre aspect of Caillebotte, see the square-on, close-up studies of butcher-shop meat, Berhaut, 1978, Nos. 221 and 222.

PLATE 50

1. Compare, for example, Monet's *The Pheasants*, 1879–80, No. 549 in Daniel Wildenstein, *Claude Monet: biographie et catalogue raisonné*, Lausanne and Paris, 1974.

PLATE 51

1. The best source of information on Cordier's life is by Cagnat, *Notice sur la vie et sur les travaux de M. Henri Cordier*, a transcript of a talk on Cordier given at the Institut 22 November 1929, published with other such proceedings of the Institut in the volume 1929–1929ter (Paris, 1929). The *Catalogue des Peintures, Pastels, et Sculptures Impressionistes*, Paris, 1958, with an introduction by Germain Bazin, states (No. 18) that Cordier is shown here working on the proofs of the *Biblioteca Sinica*. Given the date of publication of the latter, and the dating of the portrait 1883 by the artist, this observation would seem inaccurate.

PLATE 55

1. See Daniel Wildenstein, *Claude Monet: Biographie et catalogue raisonné*, Vol. I, *1840–1881, Peintures*, Paris, 1974, Nos. 278, 311–15. This bridge was destroyed during the Franco-Prussian war of 1870, and some of Monet's most interesting views show it under reconstruction: ibid., Nos. 194, 195.

 Marie Berhaut dates Caillebotte's painting 1885, but the force of the composition seem to me unlike his work at that period. The palette, and the confidence of the Impressionist technique, do suggest that it does not date from prior to 1880, but, barring further evidence, I would prefer a date earlier in the '80s.

PLATE 59

1. Thomas P. Lee pointed to this connection in his remarks on this Caillebotte painting, in Varnedoe and Lee, 1976, p. 73.
2. Caillebotte created a large decorative panel, showing a scene from the boating life at Petit-Gennevilliers, for his brother Martial's new apartment on the rue Scribe, in 1890; see Berhaut, 1978, No. 378. For the panels painted to fit the doors of his own dining-room at Petit-Gennevilliers (panels that would have tended the replicate the views from the interior of his greenhouse), see Berhaut, 1978, Nos. 464–74. For a discussion of Caillebotte's decorative schemes in relation to Monet, see Charles Stuckey, "Blossoms and Blunders: Monet and the State," Part I, *Art in America*, January 1979, pp. 102–17.

3. According to Marie Berhaut, the still life of fruit Caillebotte showed in the 1882 exhibition (Pl. 48) was destined to be a decorative panel in the dining-room of his friend Albert Courtier; in that case as well, the decorative intention may have helped determine the conception of an unusually shallow space and an edge-to-edge even-weightedness in the composition.

PLATE 62

1. For Cézanne self-portraits that employ a similar pose, see Lionello Venturi, *Cézanne, son art, son oeuvre*, Paris, 1936, Nos. 514, 515, 517, 578, and 589.

SELECT BIBLIOGRAPHY

Note: Since the publication of the 1976 catalogue, *Gustave Caillebotte. A Retrospective Exhibition*, two works have appeared which make available a broad range of quoted material and/or bibliographic references relevant to Caillebotte: first, Mlle. Marie Berhaut's *Caillebotte, sa vie et son oeuvre* (1978) not only synthesized and updated material found in her previous publications on the artist, but also included large appendices of citations from letters and critics' accounts; second, the catalogue edited by Charles Moffett for the Fine Arts Museum of San Francisco, *The New Painting: Impressionism 1874–1886* (1986), included an exceptionally complete listing of reviews of the original Impressionist exhibitions; a forthcoming companion volume of documentation will make available the texts of those reviews. In view of these new sources, and given the availability of the 1976 bibliography for specialist researchers, we include here only a highly select bibliography of major sources published prior to 1976, and a somewhat fuller selective list of publications since 1976.

General

(Texts on the Impressionist epoch or artists with special material relevant to Caillebotte.)

Bazin, Germain. *French Impressionists in the Louvre*. Translated by S. Cunliffe-Owen. New York, 1958.

Bénédite, Léonce. *Le Musée National du Luxembourg*. Catalogue raisonné et illustré. Paris, 1898.

Bodelson, Merete. "Early Impressionist Sales 1874–1894 in the Light of Some Unpublished 'Proces-Verbaux'," *The Burlington Magazine*, CX, No. 783, June 1968, pp. 331–48.

Duranty, Edmond. *La Nouvelle peinture: a propos du groupe d'artistes qui expose dans les Galeries Durand-Ruel* (1876). Avant propos et notes par Marcel Guérin. Paris, 1946.

Fénéon, Félix. *Oeuvres plus que complètes*. Textes réunis et présentés par Joan U. Halperin. 2 Vols. Geneva, 1970.

Geffroy, Gustave. *Claude Monet, sa vie, son oeuvre*. 2 Vols. Paris, 1924.

Mack, Gerstle. *Paul Cézanne*. New York, 1935.

Moffet, Charles (ed.). *The New Painting: Impressionism 1974–1886*. San Francisco, The Museum of Fine Arts of San Francisco, 1986.

Nochlin, Linda. *Realism*. Harmondsworth, 1971.

Rewald, John. *The History of Impressionism*. Fourth, revised edition. New York, 1973.

Scharf, Aaron. *Art and Photography*. Baltimore, 1974.

Thompson, Richard. "Les Quat' Pattes: The Image of the Dog in Late 19th-Century French Art," *Art History*, V, No. 3, September 1982.

Varnedoe, Kirk. "The Artifice of Candor: Impressionism and Photography Reconsidered," *Art in America*, January 1980.

————. "The Ideology of Time: Degas and Photography," *Art in America*, summer 1980.

Venturi, Lionello. *Les Archives de l'impressionisme*. 2 Vols. New York-Paris, 1939.

Caillebotte's Life and Work

Berhaut, Marie. *Gustave Caillebotte*. Introduction par Daniel Wildenstein. Paris, Galerie des Beaux-Arts, 1951.

————. *Caillebotte, sa vie et son oeuvre*, Paris, 1978.

Besson, Georges. *Caillebotte et ses amis impressionistes*. Chartres, Musée de Chartres, 1965.

Faberman, Hilarie. *Gustave Caillebotte 1875–1880*. Unpublished M.A. thesis. Queen's College, 1975.

Glueck, Grace. "Art: An Impressionist Re-emerges," *New York Times*, 11 February 1977.

Rosenblum, Robert. "Gustave Caillebotte: The 1970s and the 1870s," *Artforum*, March 1977.

Russell, John. "Art News from London: The Perception of Caillebotte," *Art News*, LXV, No. 5, September 1966, pp. 22–3.

Sutton, Denys. *Gustave Caillebotte 1848–1894*. Preface by D. Wildenstein. London, Wildenstein Gallery, 1966.

Varnedoe, Kirk. "Caillebotte's *Pont de l'Europe*: A New Slant," *Art International*, XVIII, No. 4, 20 April 1974, pp. 28ff.

————. "Gustave Caillebotte in Context," *Arts Magazine*, L, No. 9, May 1976, pp. 94–9.

Varnedoe, Kirk and Lee, Thomas P. *Gustave Caillebotte. A Retrospective Exhibition*. Houston, The Museum of Fine Arts, 1976.

The Caillebotte Bequest

(Listed in chronological order from 1894.)

BACKGROUND

Alexandre, Arsène. Articles in *Le Paris*, 14 March 1894 and 9 June 1894.

Crevelier, Jacques. Article in *Le Soir*, 8 June 1894.

Mirbeau, Octave. "Le legs Caillebotte et l'état," *Le Journal*, 24 December 1894 (reprinted in *Des Artistes, Première série. 1885–1896. Peintres et sculpteurs*, Paris, 1922, pp. 199–205).

Alexandre, Arsène. "Opinions. La collection Caillebotte refusée," *L'Eclair*, 12 January 1895.

Anon. "Au jour le jour. Le Legs Caillebotte," *Le Temps*, 13 January 1895.

Anon. "La Collection Caillebotte," *L'Eclair*, 14 January 1895.

Bernac, Jean. "The Caillebotte Bequest to the Luxembourg," *The Art Journal*, 1895, pp. 230–32, 308–10, 358–61.

Bénédite, Léonce. "La Collection Caillebotte au Musée de Luxembourg," *Gazette des Beaux-Arts*, XVIII, 1897, pp. 249–58.

Tabarant, Adolphe. "Le Peintre Caillebotte et sa collection," *Le Bulletin de la vie artistique*, No. 15, 1 August 1921, pp. 405–13.

Geffroy, Gustave. *Claude Monet, sa vie, son oeuvre*, Vol. 2, Paris, 1924, pp. 29–35.

Mack, Gerstle. *Paul Cézanne*. New York, 1935, pp. 330–38.

Perruchot, Henri. "Scandale au Luxembourg," *L'Oeil*, No. 9, September 1955, pp. 15–19 and 45.

RECENT DEBATE

Laurent, Jeanne. "L'Affaire Caillebotte, le refus de 29 tableaux impressionistes (1894–1897)," in *Arts et pouvoirs en France de 1793 à 1981*, St.-Etienne, 1982, pp. 84–99, 175–7.

Vaisse, Pierre. "L'Affaire Caillebotte n'a pas eu lieu," *Le Figaro*, 12 January 1983, p. 26.

Anon. "A propos de Caillebotte," *Le Figaro*, 2 March 1983 (brief report on dispute between Pierre Vaisse and Jacques Chardeau, published in lieu of full response letter sent by Chardeau).

Vaisse, Pierre. "Le Legs Caillebotte d'après les documents," *Bulletin de la Société de l'Histoire de l'Art français*, 1983, pp. 201–8. (Note that this article refines and updates material originally presented in Vaisse's doctoral thesis, *La Troisième République et les peintres*, Université de Paris IV, 1980.)

Berhaut, Marie. "Le Legs Caillebotte: Verités et contre-verités," *Bulletin de la Société de l'Histoire de l'Art français*, 1983, pp. 209–23.

Berhaut, Marie, and Vaisse, Pierre. "Le Legs Caillebotte; Annexe: documents," *Bulletin de la Société de l'Histoire de l'Art français*, 1983, pp. 223–39.

Chardeau, Jacques. "L'Affaire Caillebotte," in *Gustave Caillebotte 1848–1894*. Pontoise, 1984.

Chardeau, Jean. "Auguste Renoir exécuteur testamentaire de Gustave Caillebotte," *L'Amateur d'Art*, May 1985, XXVIII–XXXI.

Foucart, Bruno. "Caillebotte, le militant de l'Impressionisme," *Beaux Arts Magazine*, January 1986, pp. 38–47.

Emanuel, Jean, "L'héresie de la peinture 'pompier'," *Le Petit Bonhomme. Journal de l'Association des Amis de J. et O. Freundlich*, 15 April 1986.

INDEX OF ARTISTS' WORKS